Understanding Architecture

An introduction to architecture and
architectural history

Hazel Conway and Rowan Roenisch

London and New York

For our families

First published 1994
by Routledge
11 New Fetter Lane, London EC4P 4EE

Simultaneously published in the USA and Canada
by Routledge
29 West 35th Street, New York, NY 10001

Reprinted 1995 and 1997

© 1994 Hazel Conway and Rowan Roenisch

Typeset in Garamond by Florencetype Ltd, Stoodleigh, Devon
Printed and bound in Great Britain by
Redwood Books, Trowbridge, Wiltshire

British Library Cataloguing in Publication Data
A catalogue record for this book is available from the
British Library

Library of Congress Cataloguing in Publication Data
Conway, Hazel.
 Understanding architecture : an introduction to architecture
and architectural history / Hazel Conway and Rowan Roenisch.
 p. cm.
 Includes bibliographical references and index.
 1. Architecture. 2. Architecture and society. I. Roenisch,
Rowan. II. Title.
NA2500.C62 1994
720 – dc20 93–47002

ISBN 0–415–10465–3 0–415–10466–1 (pbk)

Understanding Architecture

'A remarkable book of great value . . . A great introduction to questions in theory, history, environment/behavior studies and cultural approaches to architecture.'

David G. Saile, University of Cincinnati

'Inspiring! . . . An excellent introduction for any student embarking on the study of architecture as well as for anyone who is interested in or concerned about the built environment.'

Anthea McCullough, Colchester Institute and Open University

Understanding Architecture is a comprehensive introduction to architecture and architectural history and exceptional in its approach. It explores architecture as a current practice in relation to its history and in relation to the wider context of cultures, conservation, planning and the environment. It introduces issues of urbanism, feminism and ethnicity, concerns which are at the forefront of current debates on architecture.

Its aim is to help people make sense of the experience of architecture and the built environment by understanding more about the form, construction, meaning and history of the subject. Lavishly illustrated, it will be of interest to students of architecture, architectural history, interior design, planning, leisure, and heritage and design. The full appendices include a glossary, suggestions for further reading and useful addresses.

Hazel Conway is a freelance architectural and landscape historian, a committee member and Parks and Gardens Advisor to the Victorian Society and on the advisory panel of the Open Spaces Society. Her books include *People's Parks* (Cambridge University Press, 1991). **Rowan Roenisch** is Senior Lecturer in Architectural History at De Montfort University and caseworker for the Victorian Society in Leicester. She has studied Mashona architecture in Zimbabwe and is researching late twentieth-century architecture in India and mud and pole vernacular architecture.

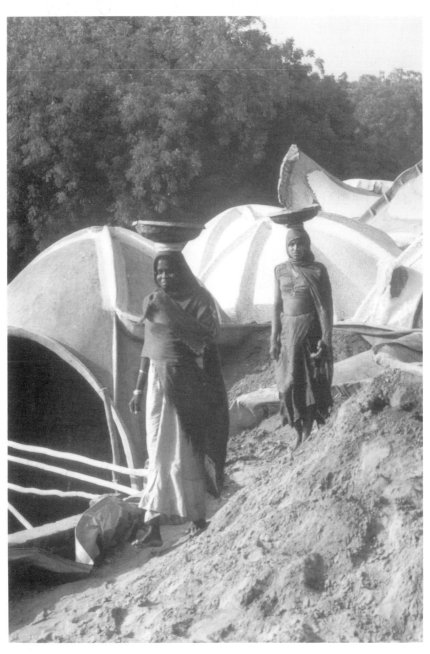

Frontispiece Women working on the building site of the Doshi Gupta (Cave), Ahmedabad, 1994 (Balkrishna Doshi) (photo © Rowan Roenisch)

Contents

Illustrations

Foreword

Professor Colin Stansfield Smith

Any book which helps in an understanding of architecture has my support. This is a difficult task, so when some of its complexities are unravelled easily, lucidly and without pretension, then I express my unfettered enthusiasm. This is a book which makes no apologies for being aimed at students and at anyone who is interested in the subject of architecture.

There is so much indifference about the nature of our built environments, how they happened, what sustains them and revitalises them and why some of them decay as they lose their sense of purpose or being. Our environments are a reflection of ourselves – we are all contributors no matter how small or modest, because we are all users of buildings. It is this last fact which becomes important in the late twentieth century. The public and semi-public realms of our urban and suburban environments have so often been dominated by agencies other than the user and the citizen. This book suggests that the balance of influence in a democratic society should be redressed. The issues of participation, civic pride, vandalism, litter, all demonstrate an attitude to the places where we live and work, whether they contribute to our well-being or whether they detract and debilitate. Some of the obvious non-caring attitudes could so easily be turned into a sense of responsibility if people knew a little more about the meaning and intention involved and understood more about why and how things happen. The aim of this book is to make these complex issues clearer.

We are faced with the problems of urban congestion, pollution and resource exhaustion. These are not peculiar to the late twentieth century. What is unique to this period is the capacity and the technology to overcome these problems in the face of vested interests, if there is the will. Architecture should express our aspirations and our sense of optimism about the future, without losing a sense of historical continuity. Architecture is only part of our environment and if this is to be life-enhancing, it has to take account of settings and the spaces between buildings. The great spaces of our cities are like the living rooms of a great house, but so many are spoiled and cluttered unnecessarily.

It goes without saying that architecture is a public art and architects should have a social responsibility. They are taught to look at environments holistically. So often the needs and complexities of urban design go far beyond the scope and influence of any single discipline, yet arguments about our urban fabric degenerate into shallow exchanges on style and taste. They represent a superficial cosmetic, when the scale and nature of the problem demand a much more rigorous and searching analysis of not only how things should be built, but what should be built. Many of the mistakes that were made in the recent past will have to be redressed and perhaps the governmental machinery to achieve what is needed will have to undergo radical change.

These are challenging times for our urban environments, and their destinies depend on the understanding of the ordinary citizen. This book attempts to elucidate that understanding.

Acknowledgements

This book has evolved out of the ideas and experience of architecture that we have gained over many years and it is impossible to mention by name all the many people who have helped us in this. For more than a decade we worked together as colleagues in what was then the School of Art History of Leicester Polytechnic. It was the head of that department, Mary Stewart, who encouraged the development of our passion for architecture with her insight, wit and criticism.

While we were exploring the form that this book should take, we discussed our ideas with many people and we would particularly like to thank Anthea McCullough and David Saile for their constructive criticisms. We should point out, however, that the responsibility for the contents of this book rests entirely with the authors. John Newman and Peter Howell both spent time encouraging our efforts and we would like to express our thanks to them for this. We would also like to thank Neil Jackson for his comments and help on American sources of information. In gathering together the illustrations which form an essential part of this book we have often been accompanied, in all types of weather, by tolerant friends and family who sometimes might have preferred other destinations. Many organisations and institutions have gone out of their way to answer queries, provide help and lend us photographs; we would particularly like to thank Craig Anders, Neil Bingham, Brian Ford, Sir Norman Foster & Partners, Donald Gimson, Edward Hollamby, Michael Hopkins & Partners, Alan Love, George Michel, Richard Rogers Partnership, Alan Short, Ian Spencer, Colin Stansfield Smith, Tesco Stores Ltd and the owners of Downton Castle. We would also like to thank the School of Arts and Humanities, De Montfort University, for generously contributing a grant towards the cost of illustrations.

Chapter 1

Introduction

This book is about the experience of architecture and the built environment and the desire to make sense of that experience by understanding something more about the form, construction and history of buildings. It is for students and everyone concerned about the urban environment who would like to take a more active part in its future, and it is for all who are concerned to understand more about the architecture of today and yesterday.

It may seem that there are so many books published on the subject of architecture and architectural history that there is little need for another one. Our aim, however, is not to write another history, but to try to indicate how that history all around us is available for us to explore and enjoy if we wish to do so. Here we should make it clear that we will not be trying to persuade you to like buildings that you find uncongenial, nor will we be promoting the merits of any particular architectural style. This book is about understanding buildings: this means not just the way they look, or their construction and materials, but the processes whereby they came into being and how they were used. In order to understand the complexities of the built environment we need to know something about the decisions that have led to building developments, the economic and political context of patronage, the role of developers and the social and cultural context of building use. Studying the past enables us to understand today more clearly. It frees us from becoming impotent prisoners of the present and enables us to see the possibilities of choice. This applies to any area of history, including architecture and the built environment. Writing books that attempt to cover every aspect of a discipline that itself touches on so many other disciplines might appear foolhardy, but it is essential in any attempt to democratise the subject.

Consciously or unconsciously everyone is affected by their environment. Recently we have seen an increasing interest in the subject of architecture, in television programmes, regular articles in the daily press and royal pronouncements. Prince Charles's *A Vision of Britain* (London, 1989) was a most important book, not so much for the ideas propounded, or whether one agrees with them, but because of the Prince's position. He articulated

what many people felt and because he holds the position that he does, people listened to him. As a result many more people now feel encouraged to join in the debate on architecture, particularly when new developments affect their own locality. Some new and important developments mark this broadening of interest. Many countries have museums of architecture which feature architectural proposals for the future as well as exhibitions on the architecture of the past. In Paris the Pavillon d'Arsenal shows some of the new developments proposed for Paris, while in London many organisations are now pressing for an architecture centre which would feature exhibitions on new proposals for London's development. For these ideas to succeed it is essential that visitors be encouraged to look critically at photographs, plans and models of buildings and to understand something about the language of architecture. This book represents a step in that direction. Some of the discussions and writing on the subject can seem daunting and impenetrable because of the use of technical terms. In addition, ordinary terms are used in a specialised way that can be quite different from our day-to-day language. While it is all very well to have a dictionary at hand, it does tend to be offputting if one needs to use it too frequently. So this book is about how to understand architecture and its history in a very practical way.

We live our lives in and around buildings, even those of us who live in the country, yet although our surroundings are familiar, their details can prove elusive. We can describe our homes so that a new visitor will recognise them, and perhaps we could even sketch them with a reasonable degree of accuracy. Further afield, however, even the most familiar buildings can acquire a certain fuzziness, rather like an out-of-focus photograph. Think about any journey that you take regularly, such as to a friend's house, to the shops or to work. Then select a small group of buildings, of not more than 50 metres' street frontage, such as the buildings that form a group with the post office, or those alongside the bus stop or station that you use regularly, or even closer at hand, those on the corner of the street in which you live. Then try to describe that group of buildings, or sketch them, as accurately as possible. To do so you will need to remember what the roofs, windows and entrances are like, how many storeys there are, what the materials of construction are, and their colour and texture. You will also need to remember how each building relates to its neighbour. It is surprising how difficult many of us find this. If a new building has recently appeared in our familiar surroundings, however, we tend to look very closely at it. We compare it with what it has replaced, we look to see how it relates to its neighbours and we often develop a clear opinion as to whether we think it is a positive addition to our environment, or a negative one. After a short while, however, it becomes virtually impossible to remember the building that it replaced.

Buildings may form the background to our lives, but most of the time we do not look at them very critically or in any detail, unless we have a particular need to do so. If we are considering moving house we think about

such things as the neighbourhood, the number and disposition of rooms, the cost, the location of shops and schools and available forms of transport, but the appearance of the building may not necessarily be an important consideration. Yet learning to examine buildings in a critical way can add another dimension to our daily lives, for it brings greater understanding of the environment we use. Our reactions to buildings depends very much on our backgrounds, interests and expertise. An architect will think about how a building was designed, why it was constructed in its particular way and how it relates to the other buildings nearby. An industrial or commercial organisation will consider the appropriateness of a particular building to its business, and the facilities offered by its specific location, while a developer will look at the economic potential of a building and its site.

Most of us feel powerless to influence new building developments, yet a recent English MORI poll showed that 68 per cent of respondents thought that the public should have more say in the decisions regarding the uses of major urban sites and 80 per cent thought that they should have more influence on the look of new buildings.[1] There is a well-established strategy for informing the public of new proposals, but only the broadest outlines may be given at the preliminary stage, and these may be radically altered at a later stage. Plans and models may be displayed at the town hall, city hall or in libraries, but even if people have the time available to go and see them, they may not have the skills necessary to read and interpret them. A new development may take years to evolve, but if people are informed of a new proposal only in its final stages their role is often limited to the negative one of rejecting it; their protests are seen by planners and developers as an expensive nuisance, so the public become the 'enemy'. The MORI poll revealed that many people wanted to take a leading role from the initial stages of any proposed new development, instead of appearing on the scene in the last stages of an application. Rather than seeing this as a two-way process, beneficial to all parties, whereby the users of buildings and spaces could have a voice, many architects and developers see this as a threat and an affront to their professional skills. Of course the public cannot design a building, but their involvement at an early stage would not only add to the information available, it would replace a confrontational 'them and us' situation by a democratic process of participation and consultation. This book aims to provide those who are interested in the built environment and new developments with some of the skills necessary to participate in this process.

You may wish to learn more about architecture because you feel strongly about particular buildings, or groups of buildings, but there is a great difference between appreciating or criticising architecture and understanding it. Appreciating architecture can take many forms and many of us develop an interest in the subject because we find particular buildings or environments

pleasing. The wonder of a gothic* cathedral or the charm of rustic cottages can encourage us to find out more, and this delight can be one of the reasons why we want to take the subject further. There may also be buildings that we detest. Appreciating architecture has a lot to do with personal attitudes and we all have our personal prejudices about most things, including architecture. These prejudices can come between us and our understanding and we need to be aware of them and try to stand back from them. The ways in which people have responded to particular building forms or styles have changed from period to period and from culture to culture. These changes are continuing today and interpretations vary according to the taste, likes and dislikes of the period. In order to understand a building of any period, we need to be as objective as possible and we need to develop empathy with our period, so that we understand what was happening from the point of view of those who were present at the time. We examine some of the techniques which enable us to begin to do this.

Understanding buildings means what it says, going out and about and looking at buildings for oneself, not just from the outside but inside as well. This is the only way we can begin to understand them, and the importance of first-hand experience cannot be overestimated. No photograph, film or video can reproduce the sense of form, space, light and shade, solidity and weight that is gained from a personal visit. These qualities are lost in photographs, for an external view of a building can rarely indicate how thick the walls are, or give a sense of the space around the building or inside it; and since most photographs are of single buildings, their surroundings are absent. In this book we have perforce to make do with photographs. Another advantage of visiting buildings is that a close examination may help to show how they were constructed and also how they have been altered. However, with the problems of security the number of buildings that one can visit without making prior arrangements is rather limited. Even churches nowadays tend to be closed unless there is a service on, and if a service is in progress then it is not possible to walk about. Public buildings such as railway stations, libraries, museums, stores or banks present fewer problems and provide varying opportunities for seeing a range of buildings both inside and out. Museums of building also provide excellent opportunities for seeing a range of buildings that have often been moved from their original location in order to preserve them. Houses open to the public such as those run in Britain by English Heritage or the National Trust offer another excellent way of visiting buildings inside and out. There are also many amenity and specialist interest groups which arrange visits to buildings that are not accessible to general members of the public. Joining them also provides an excellent opportunity for contributing to saving historic buildings. We list some of them in Appendix III.

* Words marked with an asterisk are explained in the Glossary, pp. 219–34.

The built environment consists of a wide range of types of building, some of them dating from the earliest periods of history. Some of them have been considered architecture, some engineering and others have been termed building. Our understanding of the term 'architecture' is quite different today from what it was when the history of architecture first began to be studied seriously. In order to define the scope of the subject matter of this book clearly, we discuss what we mean by the term 'architecture' and what should be included in it. We examine some of the broad range of buildings that have been included under the term and we look at traditional buildings such as cottages or barns and other building types that have been excluded. Our examples include a wide range of different types of building, from many different countries, and our illustrations indicate where they are located. Where this is not specified, then the building is in Britain. We look at the changing role of the architect and at the reasons why attention has been focused so strongly on the architect and on monumental architecture*.

We also look at some of the terminology used to discuss this architecture. Architecture is not only about the material environment, for buildings express our aspirations, our hopes for the future and our beliefs. Meaning and metaphor are important parts of our subject and we look at some of the ways in which these are conveyed.

We then go on to examine what architectural history is, how the subject developed, how it has been used and how we can begin to understand it. To understand why new building types and styles developed we need to look at the social, political, philosophical, technological and economic changes that were taking place, for these provide the context of the development. We have to try to enter into the minds of those who created and criticised the buildings at the time they were constructed, for this is the only way in which we as individuals can hope to stand outside the subjective prejudices of the personal likes and dislikes to which we are all prone. This is a complex task, for architectural history in its broadest sense encompasses a number of specialist areas, each of which necessitates asking different questions and applying different methodologies. Architectural history includes histories of materials, of construction, of particular building types, such as public houses, hospitals or working-class housing. It also includes histories of building and planning legislation, archaeology and industrial building and many other areas. Each of these histories offers different insights and has enriched the subject. We look briefly at the development of architectural history as a subject and we look at some of the explanations offered to account for architectural change. Historians, writers and critics of architecture not only developed reasons for architectural change, they evaluated the architecture of their day and of the past according to particular criteria and we introduce some of these.

Next we come to the buildings themselves, their spaces, functions, materials, methods of construction, their exteriors and their location.

Buildings may have a practical and a symbolic purpose and the allocation of the interior spaces for particular functions is related to the form of buildings. The space of a building includes not only the internal space, but the space around, under and above it, such as gardens and roof gardens. It also includes transitional space such as porches that link the inside and outside. We look at the size and shape of spaces and the reasons for them, at proportion and at the relationship between spaces. The allocation of living space is economically, socially and culturally determined and we include examples from Europe and from southern Africa. Control of the internal environment and finding solutions to the problems of heating, lighting and cooling buildings in various climates makes it possible for us to live and work in extremes of temperature and humidity. We examine how some of these solutions have affected building design, we look at the difference between active and passive methods of environmental control and at the spaces needed to house services such as water, electricity and sewage waste.

Buildings are constructed of a wide range of materials, the most common being wood, brick and a variety of types of stone. Each material has particular strengths and weaknesses which offer potential and provide limitations to the ways in which they can be used, and we introduce some of these. If buildings are to survive for any length of time they need to be well-constructed and stable. We introduce the main types of construction and how to recognise them, the various means of spanning space, the various forms of roof construction and the types of foundation that have been developed for different terrains. Having established that the space, function, material and construction of a building are important in determining its form, we are now in a position to examine its exterior. The exterior of a building is the part that we often see first. Indeed as we travel around from home to work or out to enjoy ourselves, we are surrounded by the exteriors that form the urban environment. Often these exteriors are discussed primarily in aesthetic terms and the value of a whole building is judged in terms of the aesthetics of the façade*. Many of the details that we respond to with pleasure on the exterior of buildings have their roots in a practical response to a particular problem. Climate, security, privacy, lighting requirements and the expression of structure or status are just a few of the factors which influence the design of exteriors. Much of the current debate on new developments and much of the antipathy towards the architecture of the 1960s and 1970s focuses on the relationship between ornament, decoration and communication; we introduce some of the issues in this debate.

The location of a building is important to our understanding, for it provides the physical context. Land values and patterns of land ownership affect decisions on building development, while topography and orientation may influence building design. The approach to buildings and their positioning in the urban environment is another important factor in our understanding of their physical context, as are the gardens and landscape

around them. Environments change, cities develop and as they do so areas change character. The surroundings to buildings may change radically and buildings may change their use or become redundant. We need to be aware of these changes if we are to understand the physical context of buildings. Some environments are more attractive than others and those that we warm to and enjoy visiting have particular qualities that give them an individual character and sense of place. Various steps are now being taken in order to preserve the special qualities that give particular towns and areas their individuality.

Many books focus on the architecture of a particular period, such as the medieval period or the 1930s, or on a particular style, such as gothic or art deco*. The number of such books is indicative of the interest in these approaches to architecture. Recognising periods and styles are important steps to becoming familiar with architecture, for they enable us to build up a vocabulary and discuss the subject with more confidence. Rather than providing a checklist or catalogue of the various periods and styles, our aim in this chapter is to examine some of the problems of grouping buildings in this way. In many instances buildings just do not fit neatly into a particular stylistic category, nor can history be divided clearly into discrete periods.

In any historical subject, the facts, however they are determined, are just the starting point. The challenge comes in evaluating and ordering those facts, determining which are significant and which are not and asking questions of the material that we acquire. We indicate where to look for information, the differences between primary and secondary sources, the range of sources that are available, such as guide books, journals, title deeds, wills or company records, and the type of information that they will give us. Further reading to supplement this chapter appears in Appendix II.

One of the ways in which architects develop their ideas and communicate them to clients and to the public is by plans*, drawings and models. We introduce some of the various types of drawings and discuss some of the problems of interpreting them. It is impossible to visit the inside of many buildings, but the plans and drawings enable us to see how the interior works. Models may seem to be easier to interpret than drawings, but again there can be many problems in interpretation.

The aim of this book is to help as wide a range of people as possible to begin to understand architecture and all forms of building. We hope to encourage readers to look at architecture with new critical eyes and to enable them to participate in decisions affecting their own environment. We set out not to provide answers but to raise questions, and then to indicate which paths might lead to possible answers. This book is about the subject of architecture, building and the built environment in all its forms: a vast subject that encompasses many different disciplines. It takes many years before any of us can claim to be competent architectural historians or critics, and we emphasise that here we are concerned with the first basic steps only.

It is the complexity and the multiplicity of roles performed by architecture that makes it such a challenge to study, for it is at the same time an art, a technology, an industry and an investment. It provides the physical framework for our lives, so it has a public role, but it is also where we live, work and play, so it has a private role. It has material form, but it also represents our ideals and aspirations. Housing, buildings for recreation, government buildings, temples, churches, mosques and town planning illustrate not only how we live, but our aspirations for the future. Architecture is as much concerned with beauty, style and aesthetics* as it is with technology, economics and politics. It is the product of architects, engineers, builders and entrepreneurs; it is used by ordinary people whose voices until recently have rarely been heard.

Chapter 2

What is architecture?

The question 'What is architecture?' may at one level seem so obvious that it hardly warrants a whole chapter. Yet there has been and continues to be considerable debate about what should be included in the term and we all have our own ideas and preconceptions. So this chapter is about the problems of defining architecture as a subject and giving boundaries to it, by looking at some of the ways in which it has been defined in the past. It is also concerned with some of the reasons for studying architecture and with breaking down some preconceptions.

According to Le Corbusier*, 'Architecture is the masterly, correct and magnificent play of masses seen in light.'[1] For him Architecture with a capital A was an emotional and aesthetic* experience, but if we restrict our definition of architecture solely to those buildings that raise our spirits, then we would end up with rather a short list. According to which dictionary you use, architecture is defined as the art, or science, of building, or as one of the fine arts, that is to say it is concerned with the aesthetic arts as opposed to the useful or industrial arts such as engineering. When the Crystal Palace was erected in Hyde Park, London, in 1851 it was praised for its space, lightness and brilliancy and for its 'truthfulness and reality of construction', but 'the conviction has grown on us that it is not architecture: it is engineering of the highest merit and excellence, but not architecture', (Figure 2.1).[2] The foremost critics and theorists of the day such as John Ruskin* and William Morris* contributed to the debate. Generally they agreed that the distinction between architecture and building could be summarised as:

<p align="center">Building + Art = Architecture.</p>

It is a definition that some people would still agree with today, but this dualism between art on the one hand and utility or function on the other is an unsatisfactory one. It does not tell us about the relationship between art and utility, and it omits our experience of the reality and meaning of architecture.

If we consider the enormous variety of types of building that exist in different parts of the world, we still find that there is considerable debate

about what should be included in the term 'architecture' and what should not. Many would agree that important buildings such as palaces, temples, cathedrals and castles should be included, but would disagree about the inclusion of cottages, garages or railway stations. So although we may take great delight in the moss-covered thatched roofs and mellow walls of country cottages, or the way that pole and *dhaka* (mud) homesteads blend into the African landscape, some would argue that they are not architecture because they were not designed by architects. So although such buildings may be visually pleasing, they were not deemed worth studying as architecture. These cottages and homesteads are examples of traditional or vernacular* architecture, which embodies particular ideas and aesthetic notions. They were consciously designed, following traditional patterns that evolved and were handed down from generation to generation. Although vernacular architecture has influenced individual architects and indeed was the inspiration behind both the British and American domestic revivals* of the 1880s, it has generally been studied separately from polite, or monumental architecture and has been seen as a branch of anthropology, of construction history, or of social history. Bernard Rudofsky's *Architecture without Architects* (London, 1965) was a pioneering study of traditional architecture, and the title is revealing.

Because architecture is such a vast subject there have been many attempts to limit it, or to break it down into more manageable areas. Limiting the definition of architecture to polite or monumental works such as castles, palaces or cathedrals is a way of defining the boundaries of the subject, and many of the older books adopted this stance. The narrow definition of architecture which limits it to polite architecture, or to the works of those considered to be key architects, has meant that those who wished to study other building types have had to do so outside what was defined as architecture. Factory buildings were studied as industrial archaeology and as an aspect of labour and industrial history; railway stations as part of engineering and transport history; and steel-framed* buildings such as skyscrapers, or iron and glass buildings such as the Crystal Palace, as construction history. Grouping buildings according to their use, such as castles, palaces, factories or railway stations, is another way of breaking the subject down, as is grouping them according to the methods or materials of construction.[3]

THE ROLE OF THE ARCHITECT

Most of us would agree that the term 'architecture' includes the great medieval cathedrals that were built in western Europe, but were they designed by architects? From the evidence available some argue that these cathedrals were designed by the monks as builders and as patrons. Others stress the role of the master masons and emphasise the mechanics of construction, particularly of large and complicated churches, so that the

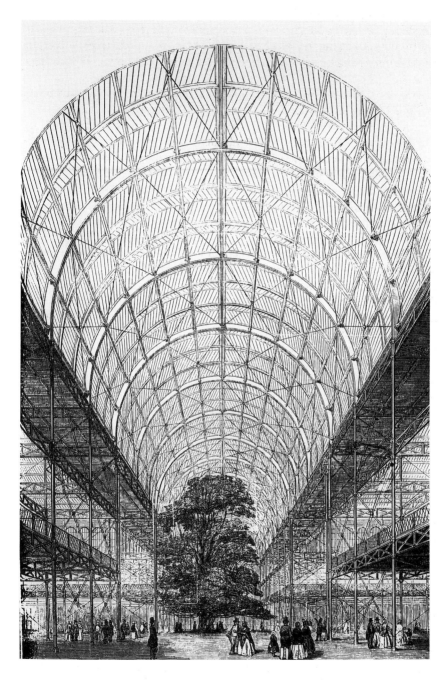

Figure 2.1 Crystal Palace, London, 1851 (Joseph Paxton*)
(© *Illustrated London News*, 1851)

architect is seen in effect as a practising engineer. Another interpretation is to see the creation of cathedrals as the achievement of collectives of craftsmen contributing their individual skills and working cooperatively. There is still controversy about even the existence of architects in the Middle Ages. Although historians have different interpretations of the evidence as to who built these cathedrals, we still appreciate them as architecture, whether or not an architect was involved. We perceive these magnificent buildings as art and recognise the resources that enabled them to be built and the purpose that they served.

The word architect derives from the Greek work for 'builder' (*archi* meaning 'chief' and *tecton* meaning 'builder') and until quite recently, within the last 150 years, the role of the architect included surveying and building, as well as military and civil engineering. Vitruvius*, the Roman architect active in the first century BC, included a whole range of examples of civil and military engineering in his influential ten-volume book, *De Architectura*. Similarly the important renaissance* architect Palladio* included designs for civil engineering as well as for churches, palaces, farms and villas in his *Quattro Libri dell' Architectura* (1570). It was only with the increase of specialisation within the building industry that the architect ceased being a tradesman and achieved professional status, a process that in the west had its roots in the eighteenth century. In China there are records of named architects dating from the tenth century and the earliest surviving manual by Li Chieh, *The Treatise on Architectural Methods*, was published in 1103. Li Chieh was in the Directorate of Buildings and Construction *c*.1092 and was a distinguished practising builder as well as a writer.[4]

In France the separation of civil and military engineering as disciplines distinct from architecture dates from 1747 when a school of civil engineering was set up in Paris, organised by Rudolphe Perronet. In Britain the Society of Civil Engineers was set up in 1771, the Surveyors' Club in 1792 and the Institution of Mechanical Engineers in 1847. Howard M. Colvin's *A Biographical Dictionary of British Architects 1600–1840* (London, 1978) lists some 1,500 architects. Of these only about forty were involved in building the factories that we associate with the early stages of the industrial revolution. It was the engineers who designed the machinery and it was mainly they who designed the structures to house them. The reasons for these changes relate not only to the changing practice of building which was occurring in the mid-eighteenth century, but also to the increasing division of labour, the changes taking place in building technology and the development of new types of building. In the process of these changes what we understand by the term 'architect' changed its meaning.

The development of the architectural profession in Britain is marked by the foundation of the Institute of British Architects launched by T.L. Donaldson in 1834, and the setting up of the first chairs of architecture in the universities. Donaldson held the first chair of architecture when it was

set up at University College, London, in 1841. The Royal Institute of British Architects (RIBA), as it subsequently became, was designed to prevent 'the great contaminating trade element' such as builders, carpenters, cabinet makers, ironmongers, painters and undertakers from undermining the professional status of architects. The aim of Donaldson, the Institute's first secretary, was 'To uphold in ourselves the character of Architects as men of taste, men of science and men of honour'.[5] The use of the term 'men' is significant, for women were not admitted to the architectural profession until the late nineteenth century, when Ethel Mary Charles became the first woman member of the RIBA in 1898. Women have nevertheless practised architecture throughout history although their contribution has been largely unrecognised. In peasant communities they were often both architect and builder and we can still see examples of this in some developing countries today.

HEROIC ARCHITECTS AND HEROIC ARCHITECTURE

The professionalisation of architecture brought with it an increased emphasis on the importance of the individual architect, an emphasis that continues today. It is in the studio that architectural students learn how to shape the spaces we live in and how to form our environment, and it is in the studio that the practice of architecture as a solitary creative activity is inculcated. Great architects are seen as heroes who create sculptural objects alone, often in the face of incomprehension and opposition. This focus on architects as heroes also entails the disparagement of those who do not understand them, namely the clients, town planners and the public. Teamwork and collaboration between architects and other disciplines, or between architect and client, are rarely emphasised and this attitude is reinforced by a whole range of professional architectural publications. The results of this privileging tendency is to emphasise originality and novelty, and this is also evident in current practice and in histories of architecture. It creates a predominantly aesthetic emphasis, with much less stress on the teams of people involved in the production of buildings, or appreciating the needs of prospective users.

Architecture is not an isolated activity: today it can only be carried out within a network of other political, social and economic institutions such as local authority planning, housing and environmental health departments, financial institutions such as banks and insurance companies and the changing legislation which may at one time promote development and at another seek to control it. It is necessary to understand these institutions in order to understand the factors which affect the built environment. If architecture is seen solely as the province of architects, whether heroic or not, then it is likely that people may not only misunderstand their role in creating the built environment, but also become suspicious of their activities and blame them if they do not like the results.

The ideology of individualism and art that surrounds architecture is often in sharp contrast to the realities of practice, in which architects work as part of a team. From the seventeenth century onwards in Britain those who designed buildings were either wealthy amateurs or highly skilled building craftspeople such as masons or carpenters. By 1788 John Soane* was able to describe the architect's work as not only designing, but making estimates, directing works, controlling costs, acting as agent between the patron and builders and even promoting speculative development. In the nineteenth century the work of many architectural practices consisted more of surveying, providing bills of quantities, arranging leases and assessing rents than designing. With the demise in the nineteenth century of the building trades and the rise of the general building contractor, such as Cubitts in London, architects took on the important role of supervising works on site and communicating to builders the full details of the building work required. These architects could be self-employed, or salaried and working for large architectural practices, local authorities or commercial and industrial companies. Philip Hardwick* was a salaried architect working for the London and Birmingham Railway in the late 1830s. He was required to design and provide specifications for all new buildings, advertise for tenders, enter into contracts, measure buildings and superintend building work, examine and certify building accounts, direct and superintend all repairs and alterations to company buildings, collect rents and prepare plans of company property and any additional property that might be acquired, value all property being purchased or sold, attend meetings of committees and report on all business.[6]

In the late twentieth century there are again great variations in the architect's role. In some 'design and build' projects the work of the architect has declined to that of supplying outline drawings, the final detail being developed by the builder during construction. Some architects may be little more than technicians or draughtspeople, while at the other end of the scale they may act as entrepreneurs and developers, particularly in the United States. A developer raises capital, acquires and assembles the site, hires a development team and when the project is complete sells the site, often at a considerable profit. In contrast to the prevailing ideology of professionalism, architects in this role are more like business managers.

The nature of patronage and the relationship of architects to users is also important in understanding the role of the architect. Until the eighteenth century patrons had a strong involvement in the design of buildings, which were usually to be used by them. By the nineteenth century the clients of civic and commercial buildings might be committees of people with little knowledge of architecture. The buildings that they commissioned ranged from town halls, hospitals and prisons to office buildings, warehouses and factories. With the rise of developers and the involvement of pensions funds and investment trusts in financing building development, many buildings are

constructed speculatively. In such projects those who commission the building may be far removed from the users and this raises particular problems for the architect who also has little or no contact with the users. Underlying all projects is the need for finance, and in many cases this will determine whether or not a scheme goes ahead. It can be quite difficult unravelling the contributions of all the individuals and organisations involved in the production of buildings, but it is important in order to understand the final form of the building and the processes involved. The notion of the architect as hero and supreme artist is somewhat diminished when we consider the role of the architect in the context of these realities.

The idea of the heroic architect relates partly to the romantic view of architects as artists, partly to the ideology of individualism and partly to the perception that promoting individual architects is good for business. Indeed several American architects, including Michael Graves* and Robert Venturi*, have built up reputations as signature architects, who are brought in after an important building has been designed inside and out, to add their recognisable signature to the façade.

The heroic approach to architecture reinforces the idea that it is the individual architect who makes history and consequently that the history of architecture is the history of great architects and great buildings. Memoirs, monographs, biographies, exhibitions and films all reinforce this tendency. New research on an important but neglected building, or architect, remains unpublished because commercial publishers like safe, recognised subjects and do not want to risk investing in a topic hitherto unknown. The strength of this approach lies in its clearly defined subject, the individual architect; but a weakness could lie in the tendency to isolate the architect and neglect the context within which the individual worked, the influences that were significant, the clients and patrons, the needs of the prospective users and the development of the architectural language that they used. While it is important to recognise that some architects are more important and more influential than others, it is also important to recognise that individuals are products of their society and it is only by fully exploring that context that we can begin to understand their work. There are many exemplary studies of individual architects which place their subject fully within their contexts. Among those published recently are A. Vidler's *Ledoux, Claude-Nicolas, 1736–1806** (Cambridge, Mass., 1983) and W. Curtis's *Le Corbusier, Ideas and Form* (Oxford, 1986).

The counterpart to the heroic architect is the heroic building, presented as an individual star. If a sufficient number of publications focus on the same buildings the process becomes self-reinforcing and it becomes very difficult to alter. With sufficient exposure to this approach there is a danger that we almost cease to see the building concerned. The Eiffel Tower is so closely linked in our minds with Paris that we cease to think about it as a building constructed for a particular purpose and greeted with outrage initially. The

Sydney Opera House, Australia, which was completed by Ove Arup* in 1972, six years after its architect Jorn Utzon* left the project, has been voted one of the wonders of the twentieth century by readers of the London *Times Saturday Review*, and it remains one of Australia's most potent symbols. Tower Bridge in London and the Taj Mahal in Agra, Central India, are other examples of cultural monuments isolated from the context in which they developed. We tend to view them uncritically and yet accept the strength of their symbolism.

The idea of heroic or notable buildings is in one sense obvious, for some buildings do stand out more than others. Lewis Mumford in his important book *The City in History* (Harmondsworth, 1961) argued that cities always reflect the societies that built them. The buildings that dominated a medieval city, the church and the castle, reflected the power structure of society at that time. The major buildings in renaissance and baroque* cities similarly reflected the power of church, state and royalty. Heroic architecture visually reinforces the power structure in any period, today and yesterday. Concentrating on heroic buildings, or applying the star system to architecture leads to a very partial view of our subject, comparable to studying history only in terms of kings and queens.

One of the most extensive surveys of notable buildings ever undertaken is the forty-six-volume *Buildings of England* series undertaken by Nikolaus Pevsner, which took forty-five years to complete. Pevsner and his assistants did not restrict themselves only to such obviously notable buildings as churches and palaces: nevertheless they had to evolve criteria to enable them to decide which buildings to include and which to omit. Bridget Cherry and her team are now resurveying British buildings for revised editions and they are having to make similar decisions about what to include.[7]

The key buildings that form what we call heroic architecture are only a small part of our built environment, as are the works of heroic architects. Most of the urban environment has not been designed by heroic architects and clearly a view of architecture which ignores where the vast majority of people live and where they work and play is extraordinarily limited. If we want to try to understand architecture and the built environment generally, then we need to begin to determine what is significant and what is not. For most of us where we live is very important, yet unless we live in a palace, or in a house designed by a major architect, the heroic approach would not see this as a suitable topic.

It is essential to consider the full range of buildings in any society and indeed to examine also those societies which at certain periods produced little architecture. In ancient Sparta there was little if any monumental architecture and the city had no city wall; yet Andrew Ballantyne has argued that this is a most telling expression of the formidable military might of the Spartans who required no protective architecture and lacked 'vanity and indulgence'. He has contrasted this with the 'conspicuous consumption' of

the contemporary ancient Athenians whose city is well known for its vast numbers of magnificent buildings for every civic function.[8] The lacunae and the everyday offer as much insight into architecture as the grand monuments and they are essential to enable us to make informed judgements about a society's priorities and achievements.

Studying any type of building is revealing whether or not it was designed by an architect. Every building had to be paid for, whether by a patron, the builder or a commercial organisation. All buildings stand in a particular relationship to their site and to neighbouring buildings. Their form relates to their use and to the materials of which they are constructed. Their success as buildings relates to their form, construction, materials and physical context, and to how well they accommodate the functions required by those using them. They proclaim symbolic and metaphorical messages to which we respond on a variety of levels. The scope of the subject is enormous and buildings do not need to be aesthetically pleasing, intellectually stimulating or architect-designed to warrant further study.

THE PROBLEM OF TASTE

Often we are drawn into studying architecture because we have strong feelings about our environment and about what we like and dislike. Among the most popular contemporary buildings today in western Europe in terms of the numbers of people visiting them are the Pompidou Centre in Paris (Renzo Piano* and Richard Rogers*, 1974), Lloyds Insurance, London (Richard Rogers, 1986) and the Staatsgalerie Extension in Stuttgart (James Stirling* and Michael Wilford, 1984). When local citizens were given the opportunity to vote on rival plans for Richmond Riverside, west of London, Quinlan Terry's* classical* design (1988) (Figure 2.2) was three times more popular than the modernist* alternative. The demonstrated popularity of these buildings is important in that it underlies the growing public interest in architecture, but taste can prove fickle. When the National Theatre (Denys Lasdun*) opened in London in 1975, it was thought by critics to be possibly the greatest modern building in Britain (Figure 2.3). Some fifteen years later Prince Charles thought it was 'a clever way of building a nuclear power station in the middle of London without anyone objecting'.[9]

We all have our preferences and prejudices in architecture as in anything else and our experiences determine our attitude. All of us are different, but it is important not to draw historical conclusions from personal likes and dislikes. Because we do not like a particular building style, it does not mean that that style was not historically important, or that the architects involved in producing such work were totally mistaken in their aims. This is particularly important now, for many architectural critics, writers and historians are so against any form of modernism* that to try to understand such buildings in an objective way becomes very difficult. If we are to try to

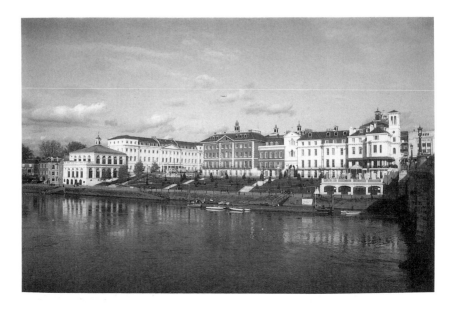

Figure 2.2 Richmond Riverside, Surrey, 1988 (Quinlan Terry)
(photo: © Hazel Conway)

understand the National Theatre as a building it is no use averting our eyes and saying it is horrible. We would have to look at the ideas and ideals which inspired Lasdun at the time the building was being designed. We would have to look at the brief of the client, at the funding, at the way crucial decisions were taken at various times during the long-drawn-out process of the building's construction. We would have to look at the way the building performs, that is to say how theatregoers, actors and other staff respond to it. We would also have to question the now almost pathological hatred of concrete* in order to distance ourselves from today's prejudices and try to reach an understanding of the building that is as objective as possible.

It is true that interpretations do change and we look at the past quite differently according to our present concerns and outlook. Different facts from the past become significant and affect our interpretations, and these in turn affect how we see and understand the present. We need to try to be as objective as possible, while recognising that our ability to be so is affected by our present assumptions and the limits of our historical period and place. Later historians may well see our interpretations quite differently and what we find difficult to understand, or impossible to see as pleasing, may prove a delight to later generations.

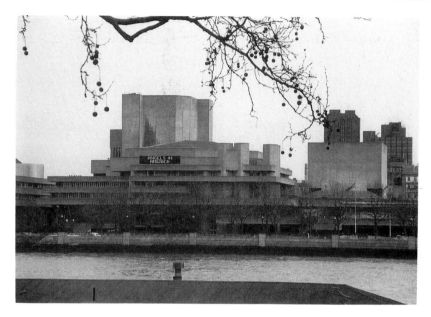

Figure 2.3 National Theatre, London, 1975 (Denys Lasdun)
(photo: © Hazel Conway)

ARCHITECTURAL TERMINOLOGY

If we are to understand buildings and communicate our understanding to others we need to be able to identify particular details and give them their correct name. Learning architectural terminology is like learning a new language and unfortunately there are no short cuts. In this book we introduce terms as we need them and brief definitions are given in the Glossary (Appendix I). There are a number of architectural dictionaries, including illustrated ones which are particularly useful for acquiring the vocabulary necessary to discuss buildings in detail. Owning your own copy is essential in order to be able to look terms up as you come across them. Acquiring an architectural vocabulary not only enables us to read about and discuss the details of buildings, it is also an essential part of acquiring the confidence to do so. One of the most direct and enjoyable ways of building up this new language is to visit buildings with a good guide book. This will direct your attention to the most significant features to look at and, with the correct terminology, will enable you to identify them. Many of us in Britain who developed a passion for architecture acquired our architectural vocabulary largely through travelling around the country with the appropriate Pevsner *Buildings of England* in our hands.

Another aspect of architectural terminology concerns the way in which

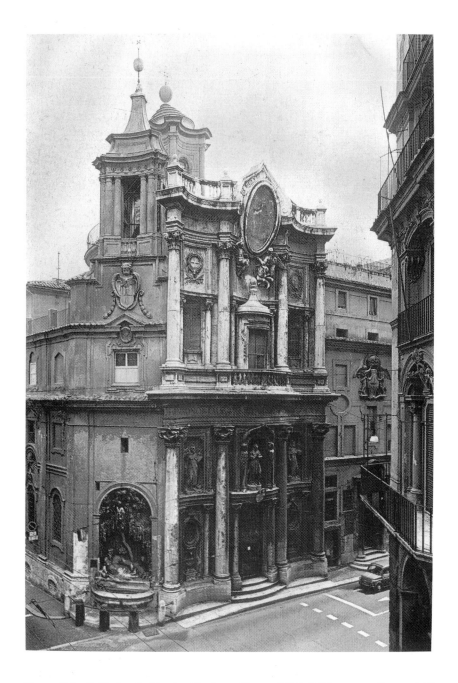

Figure 2.4 S. Carlo alle Quattro Fontane, Rome, 1665–7 (Francesco Borromini*)

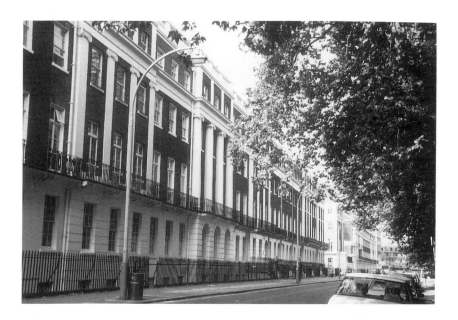

Figure 2.5 Tavistock Square, London, *c.* 1780 (photo: © Hazel Conway)
The centre of the terrace is emphasised by a giant order* two storeys high.

architecture is discussed in books, or by architects and architectural critics. When we hear people discussing buildings that have movement, that have masculine or feminine characteristics, buildings that are sick and buildings that speak, we may wonder if we do indeed speak the same language. Buildings that have movement may mean that they are suffering from subsidence, or are crumbling away, but when architects and architectural writers talk about a building having movement, they could mean something quite different. If we compare a baroque exterior with a Georgian* one we see that the latter has a façade that is flat (Figures 2.4 and 2.5). The door and windows are set into the wall so that they are almost level with the wall plane*. In other words, they do not break the overall flatness of the façade and this enables one's eye to run over it without interruption. The baroque church, with its columns* and pilasters*, ornate doorway and bold mould-ings* over the windows, has a façade that is elaborately modelled. The windows and doors are deeply recessed, the detailing around them is very sculptural and projects from the wall plane, casting shadows which vary according to the time of day and time of year. There are also columns and pilasters which project from the wall plane. The Georgian terrace with its symmetrical flat façade looks static and in repose, in comparison to the façade of the baroque church, whose varied forms and undulations give it movement.

The implication behind the application of terms such as 'masculine' and 'feminine' to buildings is that we can equate particular forms with a particular gender. Thus the straight lines and qualities of massiveness that we might see in a fortified castle connote masculinity, whereas curves such as those we associate with the style of art nouveau* connote femininity. Some see masculine and feminine attributes in a variety of architectural features: towers are phallic and masculine; domes represent breasts and are feminine. The use of this sort of terminology and this type of interpretation does not add very much to our understanding of architecture. Moreover, it promotes a stereotyped view of what constitutes masculinity and femininity, and is therefore something of which to be very aware.

A 'sick building' is shorthand for sick building syndrome (SBS), meaning that users become sick by being in a particular building. The indoor environment of such buildings causes malaise to people while they are in them and this ceases when they leave. Allergies, asthma, headaches and lethargy are the symptoms of SBS and they can result from a number of causes. Ventilation systems, the chemicals used in the building fabric, in the furnishings or in the equipment, dust, mould and fumes may all play a part and air-conditioned office buildings seem particularly prone.

'Buildings that speak' is another phrase that is often used about architecture today. Some architectural writers argue that there is a building syntax with words, phrases and grammar and they imply that buildings speak a language comparable to that which we speak.[10] Language is about communication and expression and buildings do indeed embody ideas which they express and communicate by a variety of means.

MEANING AND METAPHOR

We experience buildings in terms of their form, their structure, their aesthetics and how we and others use them. This constitutes the reality of our physical experience, but buildings not only have an existence in reality, they also have a metaphorical existence. They express meaning and give certain messages, just as the way we dress or furnish our homes gives people certain messages about us. The dramatic roof lines of Sydney Opera House have been described variously as looking like sea-shells and sails. Its physical form, in other words, also has a symbolic message which refers to the building's maritime position and to the sailing boats in Sydney Harbour. When Adolf Loos* entered the competition for a building to house the offices of the *Chicago Tribune* newspaper, his design took the form of a column, a pun on the idea of a newspaper column (Figure 2.6).

Buildings are central to our need for shelter and security, and they symbolise aspects of these needs in their form. A house not only provides shelter and warmth, it also symbolises home on a very deep level. A young English child drawing a house will characterise it very simply, with a pitched

roof and maybe a door and windows. In the north European climate the pitched roof evolved because this was the form that shed rain and snow most effectively. This form came to symbolise shelter, just as the chimney came to symbolise the existence of warmth. Together their message is home. Many architects have exploited this symbolism in their work, among them the American architect Frank Lloyd Wright*. In his prairie houses* of the early twentieth century, the dominant features were the centrally placed hearth and chimney, symbolising the heart of the home and the dramatic roofs with large overhanging eaves* symbolising shelter (Figure 2.7).

Buildings have intrinsic meanings which result from their spatial and visible forms and extrinsic meanings which have evolved out of tradition and social use. A doorway is a means of gaining access to a building: its significance and function can be recognised from its scale and type. Thus the meaning of a door is intrinsic to it. In the housing of certain periods and places we can recognise which rooms are the most socially significant by the size of their windows. In the Georgian terrace the windows at the first-floor level are larger than the rest and indicate the importance of the reception rooms on this floor (see Figure 2.5). The exterior indicates how the interior of the building functions and this intrinsic meaning becomes part of the architectural language of the period.

The ways in which the form of particular buildings relates to their function is part of their extrinsic meaning. Because north European houses traditionally had pitched roofs, this form has come to mean home and if a flat roof is introduced it will appear alien and may be disliked because of its lack of meaning and semantic content. This dislike may be rationalised in practical terms, with the argument that such roofs are inappropriate and not weatherproof, but this may not be the real reason for the dislike.

Architecture provides the environment for our lives. Buildings are not just places of physical shelter, but places in which our social rituals are enacted. During the nineteenth century a range of new building types evolved to house the new developments of that prodigiously inventive century. Banks, railway stations, theatres, law courts, shops, town halls, apartment blocks and offices developed forms that were not rigidly fixed, but were nevertheless recognisable. You did not enter a theatre expecting to see the bank manager, nor did you confuse the town hall with the railway station. The overall form of these buildings communicated their purpose. Over a period of time the buildings which housed social, legal, religious and other rituals evolved into forms that we subsequently have come to recognise and associate with those buildings' function. This is a two-way process, the building provides the physical environment and setting for a particular social ritual such as travelling by train or going to the theatre, as well as the symbolic setting. The meaning of buildings evolves and becomes established by experience and we in turn read our experience into buildings. Buildings evoke an empathetic reaction in us through these projected experiences, and

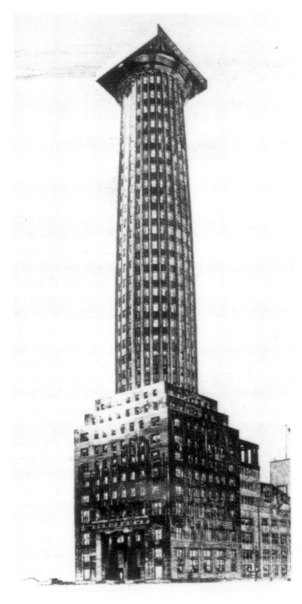

Figure 2.6 Chicago
Tribune Tower,
competition entry,
1922 (Adolf Loos)
(© *Chicago Tribune*)

Figure 2.7 Robie House, Chicago, 1908 (Frank Lloyd Wright)

the strength of these reactions is determined by our culture, our beliefs and our expectations. They tell stories, for their form and spatial organisation give us hints about how they should be used. Their physical layout encourages some uses and inhibits others; we do not go backstage in a theatre unless especially invited. Inside a law court the precise location of those involved in the legal process is an integral part of the design and an essential part of ensuring that the law is upheld. If a building gives us an incorrect message about its role and function then we are liable to become confused or irritated.

The postmodern* architecture of today is essentially about communication. Postmodernism* was initially a reaction against the high-rise apartment blocks, the commercial developments and the use of concrete that is associated with modernism in the 1960s. Such architecture alienated people, said the postmodernists, because it did not communicate; so postmodernism set out to communicate. This it does by borrowing styles from previous periods, or by 'quoting' details from adjacent buildings and the surrounding environment. New housing developments may be neo-Georgian*, or they may incorporate elements such as gables*, dormers* and tile hanging* which are derived from the traditional architecture of the preindustrial era. Postmodern commercial buildings feature classical, gothic and many other styles on their façades as a means of communicating and as a way of attracting prestigious clients. These elements are restricted to the exterior of the building only and are in effect masks which have little or nothing to do with what goes on inside.

One of the aims of modernism in the 1920s and 1930s was to try to evolve a new architecture fitted to the twentieth century, based on new materials, new techniques of construction and a rethinking of the uses of buildings. It

tried to liberate architecture from an obsession with style and its aims were universal. Modernism became an international force, but in so doing modernist buildings tended not to respond to particular cultures or to particular environments. By contrast postmodernism is trying to reassert a sense of local identity, as one example illustrates. Richmond Riverside is an office development by Quinlan Terry on the river Thames, that is widely liked by the local residents of Richmond (see Figure 2.2). They like its scale, which is in harmony with the adjacent townscape, the variety of the materials used and the traditional feel to the whole complex. This has been achieved by using a classical vocabulary which is claimed by the architect to constitute 'real architecture'. Real architecture in this particular instance means solid brick walls and slate roofs, or roofs hidden behind parapets* and classical elements which according to the architect are eternal and universal, and therefore appropriate to all periods. The complex looks like a series of eighteenth-century town houses, but Terry has applied these recognisable classical models to new buildings and a new purpose: commercial offices. He did not evolve a new classical language out of the past, as happened in the time of the renaissance, and many critics think that the ultimate effect of his design is one of pastiche, a stage set which clashes discordantly with the clearly visible open-plan offices within. Others, including many Richmond residents, argue that Richmond Riverside is a series of 'real' neo-Georgian buildings and since Richmond is a largely eighteenth-century town, Terry's design is true to its context and appropriate, although it would not be appropriate for the modern commercial centre of New York or Paris.[11]

ARCHITECTURE TODAY

The whole subject of architecture is acquiring a thorough overhaul as a result of current concerns for today and for the future. Its content and the approaches to it are being widened, as we explore in later chapters. Today we accept that it is just as valid to examine an industrial building such as a gasholder as it is to examine castles, cathedrals and dwellings of all types (Figure 2.8). Stylistic analysis and the search for the principles of beauty are still with us and we all want to improve our environments, but we no longer seek to do this in isolation or just in terms of individual buildings, but in terms of the built environment as a whole. Greater awareness of what architecture is about is vital if we are to develop an environment that means something to us all. We need to understand how we have arrived at today and that means that we need to see today within the context and perspective of the past. Understanding history helps us to understand how we have arrived at today, it empowers us to work for a better future and prevents us from passively accepting what we find unacceptable, whether as the users of architecture, as architects or as architectural critics. Architecture affects everyone and so we all need to take responsibility for it, but we can only do

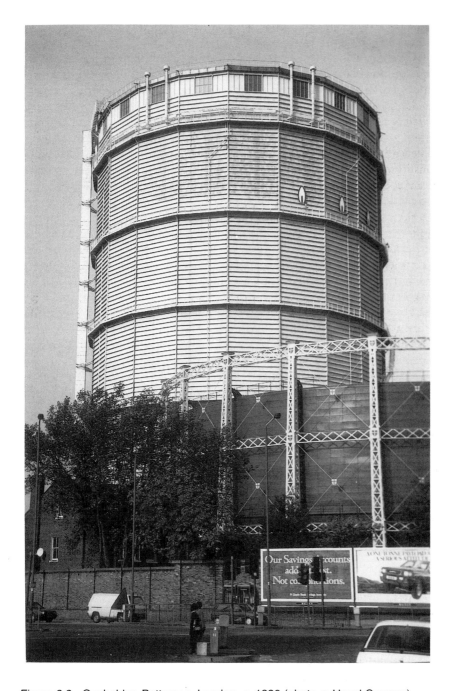

Figure 2.8 Gasholder, Battersea, London, *c.* 1880 (photo © Hazel Conway)

so when we understand more about it. Architecture is something to be enjoyed and shared. If it is shared more widely because more people understand it, take it seriously and are not frightened by it, then the chances are that the urban environment will improve and architects will no longer be seen as responsible for all that we dislike but as part of a team which enables us to achieve our ideals.

Chapter 3

What is architectural history?

Architectural history is like other histories in that it is concerned with understanding and finding explanations for the past. Where it differs is in the nature of the evidence available and in the techniques that have been developed to evaluate that evidence. In its initial stages any historical study involves collecting facts, but facts by themselves tell us nothing. In order to make any sense of those facts they must be selected, ordered, evaluated, interpreted and placed in context. E.H. Carr in *What is History?* (Harmondsworth, 1964) explains this very clearly. History begins today, but one of the main difficulties about studying the recent past is the sheer volume of information available and the problem of determining what is significant and what is not.

Architectural history is different from antiquarianism, nostalgia and the heritage industry. Antiquarians love ancient objects and buildings, and facts about them, because they are ancient, but they may not necessarily be interested in the reasons that lie behind their development. Nostalgia and the heritage industry are about escaping into the past in order to enter a different world, a world that may be of beauty and interest, but one which could have little to do with the realities of that past. Now we are not suggesting that it is wrong to want to have a heritage experience, or to visit a beautiful historic house, rather that we should be aware that we may be seeing only a partial or distorted picture of the past.

History is about trying to understand the past in a critical way, its negative as well as its positive features. It is a dynamic process, not a static one, and the history unfolding before our eyes, the present, is part of that process and informs our understanding of the past. History is not a jigsaw puzzle which can be completed and put away, and the accuracy of any historical interpretation is always open to reinterpretation. There will never come a time when we can claim we know all there is to know about, say, medieval architecture. That is not the purpose of the discipline. We believe that the purpose of studying architecture and its history is not only to try to understand the past, but also to try to understand how the past and the present engage. Studying architectural history, as with any historical study,

relates to our need to understand the present. It is based on the belief that this understanding is impossible without a knowledge of the past, for it is only by studying the past that we can hope to understand how we have arrived at today, and something of the complex choices and decisions that were involved. The study of history, whether contemporary history or the distant past, encourages us to think critically about both today and yesterday. It is only by understanding the past that we can understand the present that has grown out of it and it is only by understanding how past and present interact that we can hope to build a better future. Without that perspective we become prisoners of the present, for our understanding will be limited, so we will be unable to foresee alternatives, or recognise the possibilities of choice.

Architectural history is not isolated in the past: it takes on an active role in improving our contemporary and future architecture, town planning and urban environment. Indeed some would argue that a passionate interest in architectural history can only come from an intense commitment to current architectural practice and that without a commitment to attaining the highest ideals in architecture and the urban environment today, one's ability to study the past is limited. If architecture embraces the whole of the built environment, as we think it does, then its history concerns us all. Because studying history encourages us to think critically, one of the objections voiced against the study of contemporary history in any area, including architectural history, is that it could be controversial or even dangerous. If people start to think critically about the recent past, they will then be in a more informed position to do something positive and this could be construed as dangerous.

Historians use evidence from the past in order to reconstruct what happened and why it happened. In architectural history this evidence may take the form of the buildings themselves or their remains, and documents such as plans, drawings, descriptions, diaries or bills. Our picture of any period of history is derived from a multitude of sources, such as the paintings, literature, buildings and other artefacts that have survived. The problem of survival lies at the root of many of the historian's problems, for what has survived may not be more significant than what has not survived. The Egyptian pyramids have survived thousands of years, but historical significance is not just a question of durability. These buildings were part of a rich and diverse culture. They are historical facts, but facts by themselves, even such massive facts as the pyramids, are just the first stage in any historical study, and until they have been evaluated, placed in context and interpreted they tell us little. Different historians may place different values on the same facts and the discovery of new evidence may modify or change existing theories and interpretations.

HISTORIOGRAPHY

Architectural history, like any other branch of history, is not a static subject; interpretations often change quite radically, for we see things in a new light from new evidence and from the changing perspectives of the day. Historiography is the study of the ways in which historical interpretations have changed over a period. The changing tastes of one period may lead to once great architecture being completely reinterpreted. In the 1950s and 1960s Victorian architecture was despised, particularly by modernists who could see nothing to commend it. Yet today we take great delight in the richness and complexity of Victorian architecture and seek to preserve it wherever possible; and now modernism is anathema to many people. It is not just a question of changing tastes. New issues encourage us to ask different questions, questions that had hardly been thought of a century ago, or if they were, it was only by a very few. Today our concern for the environment makes us question the use of energy both in the production and in the maintenance and use of buildings. Feminist issues lead us to question the role of women in the built environment and the ways in which design assumptions have reflected gender. Recognition of these issues may encourage us to look at different strategies for design and building today.

Asking different questions about the past can lead to changes of emphasis and new interpretations. When Tim Mowl was researching Bath for his book *John Wood: Architect of Obsession* (Bath, 1988), he found that John Wood* (the elder) had surveyed Stonehenge and the moon temple at Stanton Drew. The diameter of the Circus at Bath is 318 feet, the same as that of Stonehenge and this was, so Wood argued, equal to 60 Jewish cubits, that is to say the dimensions of the second temple at Jerusalem. Bath was the first Masonic city of England and John Wood was a typical member of the Society of Freemasons. He was convinced that Bath had been the principal Druid centre of Britain and he based his design of the Circus not on the Roman Colosseum, as previous writers had assumed, which in any case was elliptical, but on the most important remaining Druidic edifice in the west of England, Stonehenge (Figure 3.1). By looking at the historical evidence and asking questions of that evidence, Tim Mowl arrived at a new interpretation of one of the most important architectural features of Bath, yet he was advised by other well-established figures in this field not to mention Wood's emphasis on Druids as his book might then not be treated seriously.

As different facts become significant they affect our interpretation of both past and present, for as we appreciate the past differently, so this affects our understanding of the present. In other words the process is dialectical. Our perceptions of both past and present are determined by the period we are living in and our ability to understand our period and situation. Objectivity is relative to the period in which we live and to the sort of people we are. Some people have a broader understanding than others and some are better

Figure 3.1 Stonehenge, Wiltshire (© Unichrome, Bath)

able to question the assumptions of their period than others, but this does not mean that we should not try to be as objective as possible.

THE DEVELOPMENT OF ARCHITECTURAL HISTORY

Architectural history is concerned with understanding all types of building and studying the built environment in its historic context. The subject is in a sense as old as architecture itself, but in another sense it is a comparatively new one. The first Society of Architectural Historians was founded in the United States as recently as 1940. Because the separation of architectural history as a discipline distinct from that of architecture is comparatively recent, architectural histories have in the past tended to be written mainly by architects. Moreover, from the period of ancient Greece and Rome until the sixteenth century, architectural critics wrote about contemporary architecture. It was not until the sixteenth century that this changed. When the renaissance architect and painter Vasari* wrote about the architecture of the past, it was in relation to the architecture of his day and as a justification of its superiority.[1]

The idea that architecture progresses and that the buildings of one period are better than their predecessors is a theme that runs through much of the writings on architecture from the sixteenth century onwards and is still

evident today. The stance taken by architects in their historical writings tended to be a polemical one, in which they used the past in order to justify and validate the present. In many periods architects have been strongly influenced by the architecture of the past. That influence may take the form of reacting against the past in order to establish a new and 'better' architecture, or finding inspiration from the architecture of the past. The surviving remains of ancient Roman buildings in Italy provided a positive inspiration to the architects of the early renaissance there. By contrast, to A.W.N. Pugin*, intent on re-establishing gothic architecture in Britain at the beginning of the nineteenth century, classical architecture was pagan, barbaric and particularly inappropriate for Christian churches. Pugin's negative attitude towards classical architecture was an important part of his argument for the merits of the gothic, which led to the development of the gothic revival*. In each of these examples the new contemporary architecture was seen as an improvement on what had preceded it.

The eighteenth century was an important period for the development of architectural history. Instead of simply seeing contemporary architecture as the latest or best expression of a tradition of architecture inherited from the past, some architects and intellectuals began to appreciate past periods and styles of architecture as discrete phases with distinct merits. They began systematically to explore earlier architecture in order to identify the principles and criteria by which to measure great architecture. In doing so they embarked on the road to understanding architecture rather than simply using it to support current practice. Johann Joachim Winckelmann* (1717–68) is sometimes called the father of modern art and architectural history. His *History of the Arts of Antiquity* was published in Dresden in 1767, but it was not the first work of its kind. J.B. Fischer von Erlach* (1656–1723), one of the leading baroque architects in Austria and designer of the Karlskirche in Vienna (1716), published an earlier history, *The Design of Historic Architecture*, in Vienna in 1721. This was the first book to include Egyptian, Chinese and Islamic buildings and could indeed claim to be the first comparative history of world architecture.

In France the earliest group of architectural historians was to be found in the circle connected with the Académie Royale d'Architecture, which was founded in 1671. In 1687 J.F. Félibien (1658–1733), who was secretary of the Académie, published *The History of the Life and Works of the Most Celebrated Architects*. Unlike Vasari, this provided an account of past architecture which did not interpret it as a prelude to the superior architecture of the present day.

The eighteenth-century enlightenment encouraged the development of architectural history. During this period many intellectuals questioned the rational basis of society and everything that had been taken for granted, religion, the monarchy, aesthetics, and history. It was this questioning which ultimately gave birth to the French revolution and to the industrial

revolution. The enlightenment examined the past in order to discover why the world was as it was and what the alternatives were. Excavations of Pompeii and Herculaneum began to reveal something of the past, as did visits to ancient classical sites and to Egypt. The newly developing subject of architectural history tended to be encyclopaedic in scope and to concentrate on form, styles and heroic building types such as palaces, castles, churches and temples. In the United States the development of architectural history in the nineteenth and twentieth centuries was strongly influenced by both Germany and France. Hundreds of American students studied architecture in Paris at the Ecole des Beaux-Arts* and associated studios, and took that influence home with them. The close ties between American and German scholarship in the area of architectural history persisted during the major part of both centuries.[2]

SCOPE

In any new and developing subject the first problem is to identify and catalogue the material that forms the core of the subject. Early architectural histories sought to identify and differentiate between the architecture of different periods and different geographical areas primarily through an analysis of architectural form and style. One book based on this approach is still in print after almost a century and is familiar to generations of architectural students as 'Bannister Fletcher'. *A History of Architecture for the Student, Craftsman and Amateur, being a Comparative View of the Historical Styles from the Earliest Period* was first published in 1896. With the fifth edition in 1905 it changed its title to *A History of Architecture on the Comparative Method*; and the nineteenth edition was published in 1987. The comparative section was omitted from this edition and from its predecessor, partly in order to keep down the size of the publication. The method adopted by the father and son team was to apply the techniques of comparative anatomy and comparative biology to architecture.

Comparing and contrasting buildings in order to reveal similarities and differences is still a technique that is applied today by both critics and historians and it can be a useful one if the buildings being compared have something in common. For example it can be revealing to compare a medieval church with a Victorian gothic revival one, or a Roman arena with a modern football stadium, since each pair is concerned with similar functions. There would, however, be little point in comparing buildings that had nothing in common, such as a Roman arena with a Victorian church. The technique has also been used very successfully for didactic purposes. A.W.N. Pugin's *Contrasts* (1836) was a polemical blast against what he saw as the horrors of the architecture and urban environment of the time. In the 1841 edition of this book Pugin juxtaposed illustrations contrasting the negative qualities of contemporary cities and their architecture with the

Figure 3.2 An early Victorian town compared with an imaginary medieval town (A.W.N. Pugin, *Contrasts*, 1841 edition)

positive qualities of the medieval equivalent (Figure 3.2). In so doing he celebrated the virtues of gothic architecture and at the same time drew attention to the 'barbarism' of the classical architecture of the day. The walled medieval town with church spires punctuating the skyline is surrounded by open countryside. In the nineteenth-century town, factories and factory chimneys vie with the spires. The open fields now feature a lunatic asylum, a gas works and a radially planned prison, and the medieval gothic church has been replaced by a classical one.

Architectural history developed in Europe and although Fischer von Erlach included non-European architecture in his early history of the subject the main focus of study has been and continues to be on European

Figure 3.3 Great Zimbabwe ruins (photo: © Rowan Roenisch)

architecture. Indeed until 1959 Bannister Fletcher omitted any reference to African architecture. Furthermore if the architecture of continents other than Europe or north America was discussed, it tended to be from a Eurocentric point of view and vernacular architecture was regarded as primitive, unchanging and therefore non-historical. To those sharing this overwhelming European focus it was impossible to believe that a major African building such as the thirteenth-century Great Zimbabwe ruins could have been built by the local people; it was argued that they must have been built by early Arab or European traders and explorers (Figure 3.3). In this book we have tried to avoid concentrating solely on European architecture and have included examples of architecture from all over the world.

APPROACHES

Since the history of architecture spans a chronology of thousands of years, embraces the whole world and all types of building, it is not surprising to find that a wide variety of approaches to it have developed. Some see the subject in terms of three main approaches: practical, historical and aesthetic.[3] The practical aim seeks to establish what was built, when it was built and by whom, so it would include the architect, the patron and system of patronage. The historical aim seeks to establish why a building was built and

its relationship to the social, economic, political, cultural and religious environment. The aesthetic aim seeks to account for visual and stylistic differences and to explain how styles change and why they do so. Older histories of architecture tended to focus on the practical and the aesthetic approaches.

We believe that architecture is an all-embracing subject, but many of the approaches that have been developed for studying it have tended to be reductionist in attitude. That is to say there has been a tendency for the subject to be broken up into a myriad specialisms, some with their own society and journal. This was partly the result of the way in which architectural history was identified in the early stages of its development. Today architectural history reflects the impact of feminist, Marxist, structuralist, psychological, semiological and socio-political ideas. It is responding to the linguistic theories of Althusser, Barthes, Saussure and Derrida, just as much as it is to the historical and anthropological models of Foucault and Lévi-Strauss, and to the cultural psychoanalyses of post-Freudian critics such as Lacan. Part of its aim is to deconstruct tradition and to question the most familiar and unquestioned ideas. Here we can only introduce the first steps in various approaches to understanding architecture. Every approach has added to the richness of the subject. By including a chapter on periods and styles we might appear to be advocating that particular approach, but this is not so. We have included it because it is one of the most widespread of approaches and our aim is to examine, clarify and deconstruct some of its concepts. Our approach is one which is concerned about both practical and aesthetic needs and this includes both a green and a feminist stance. Underlying this whole book is our hope of extending democratic participation in architecture.

EXPLANATIONS OF ARCHITECTURAL HISTORY

The quest for understanding why the architecture of any place or period developed as it did has led to many explanations. These explanations have helped historians to understand the period being studied and they have helped to define organising principles for selecting and differentiating between the wealth of information, but they can also lead to serious problems. Explanations for architectural change generally fall into four main groups: rational, technological and constructional; social and religious; economic, cultural and political; and the spirit of the age. The technical and rational explanation of architecture may seek answers simply in terms of new technological or constructional developments, or it may see the development of architecture in any period as the result of applying logic to technological or practical problems. If we look at the medieval cathedral according to this logic, then the reason why gothic cathedrals evolved their complex forms was in response to the practical problems posed by building high buildings,

spanning wide spaces and incorporating increasingly large glass windows. The rational explanation of architecture was an approach largely developed by French architects and theorists such as Laugier* and Viollet-le-Duc*.

The explanation that architecture expresses the social, moral and philosophical conditions of the period implies that a sufficient knowledge of those conditions should make it possible to forecast what the architecture will be. But in a sense this begs the question, for what is sufficient knowledge? It also implies a simple, direct, relationship between architecture and these conditions, rather than acknowledging that all societies are complex organisms. If there is a moral justification for architecture then it becomes possible to argue that some architecture is moral and truthful and some is not. From A.W.N. Pugin came the idea of architectural morality and truth. In *True Principles of Pointed or Christian Architecture* (1841) he analysed gothic buildings and equated architectural truth with religious truth. He argued that gothic was not a style, but a principle of building and that those principles were as relevant to the 1840s as they were to the medieval period. All buildings reflect the society in which they are built, but the gothic had particular lessons to teach us, said Pugin, which concerned constructional truth and material truth. Constructional truth meant that the construction of a building should be evident: ornament could be used, but it should not obscure the construction and it should be appropriate in form and meaning. Truth to materials meant that all materials should be chosen for their particular qualities and they should not be painted to look like other materials. Pugin's ideas were developed by John Ruskin, William Morris and others and provided one of the inspirations for the arts and crafts movement* and for modernism.[4]

The explanation that architecture reflects the material, economic and cultural conditions of the time seeks to set architecture in the broadest sense in its material context, by focusing on buildings, either singly or in groups, and placing them firmly within their economic, social and political context. Then by characterising their function, form, construction, materials and location, this approach attempts to explain how and why they came to be built and the critical responses to them at the time that they were built.

The explanation that sees architecture as reflecting the spirit of the age, or *Zeitgeist*, comes from Hegel and has provided a conceptual framework for understanding the historical development of art and architecture for the major part of this century. Central to the concept of the *Zeitgeist* is the idea of history as a progressive process. The motor underlying the processes of history and giving rise to each period was thought to be an evolving 'spirit', which pervades and gives unity to every area of human endeavour – religion, law, customs, morality, technology, science, art and architecture. Any historian must identify and classify material, and in the process of doing so common ideas and themes will become apparent. Those who accepted the concept of the *Zeitgeist* suggested that because styles such as neo-classicism

in the mid-eighteenth century, modernism in the 1920s or postmodernism today have shown themselves in different areas of the arts such as architecture, painting, furniture, ceramics, dress and literature they are manifestations of the *Zeitgeist*. The similarities in the work of architects, painters, designers and writers were the result of living in the same period. Another interpretation might be that each period and place, with their evolving material and spiritual conditions, give rise to their own unique cultural forms and that although many styles may coexist at any one time, only one major style truly reflects the *Zeitgeist*. The danger of this explanation is that it encourages the search for consistency in order to build a coherent picture. Anything that does not fit into this picture would then tend to be ignored or to be undervalued as it does not show the all-pervading *Zeitgeist* spirit.

In an attempt to establish modernism as the only true style, early twentieth-century historians such as Nikolaus Pevsner and Siegfried Giedion employed the concept of the *Zeitgeist*. Well before modernism had reached the pre-eminence that it achieved after the Second World War, they identified mass production, glass, steel, reinforced concrete, new forms of transport and increasing urbanisation as the main features that distinguished the modern world of the twentieth century from preceding ages. They went on to argue that modernism was the only style which accorded with these features and thus with the spirit of the age. The modernist architects and designers were committed to the use of new materials and technology, and explored forms appropriate to them. They questioned the function of architecture in order to arrive at novel and socially progressive plans and designs, and they particularly welcomed projects for mass housing, health centres, industrial buildings and town planning. At the time, that is between the wars, modernism was practised by only a small group of avant-garde architects and designers, located mainly in Germany and France. Modernism coexisted in Europe with art deco, classicism, the vernacular revival and national romanticism*. These styles were not seen by modernist historians as genuine products of the age but rather as the result of crass commercialism, wayward individualism or as the archaic remnants of styles belonging to previous periods.

The concept of the *Zeitgeist* seems to have informed Dennis Sharp's approach in *A Visual History of Twentieth Century Architecture* (London) which was first published in 1972. From the title we might expect a survey of building in the twentieth century, but this is not the case. The works that Sharp selected were those produced by one stylistic movement only, modernism. Like his predecessors Pevsner and Giedion, Sharp found in modernism a style that he believed was the true and ultimately hegemonic style of the period. Few would find it satisfactory that all the other building styles produced throughout the world in this century have been ignored.

All approaches and explanations of architecture and architectural change

have a grain of truth. Buildings reflect moral values and the economic, social and political context of the period in which they are produced. They may, for example, be the product of rationalism or of new technology, but in each building and in each period the balance of influences varies.

BUILDINGS AND ARCHITECTURAL HISTORY

Buildings themselves provide evidence of their history but the problem of disentangling that evidence may prove very complex. Most buildings that have existed for more than a few decades have been altered and the longer a building has been in existence, the more likely it is to have been altered a number of times. If drawings have been made they may provide clues to some of the alterations, but if there are no drawings the evidence is restricted to the fabric of the building itself, including its foundations and drains. Some large building projects such as the great medieval castles and cathedrals were built over many years or centuries. During that time their plan and form changed as resources became available, as technology, materials, need and tastes changed, or as a result of damage by fire or from war. Evidence of these changes can be seen in the construction and a visit to any of the larger cathedrals will almost certainly reveal parts from very different periods: perhaps a Norman*-style nave*, a decorated*-style transept*, and a perpendicular*-style chancel*.

Throughout history people have sought to alter and convert buildings to new uses as the situation demanded. As the methods for importing and exporting goods by sea have changed, so old docks and warehouses have become redundant. Rather than being demolished they have been converted into apartments, museums, shops and restaurants. During our lives our family size changes and if it is not convenient to move house we may accommodate those changes by altering our houses, adding extensions and making rooms in the attic. We may be able to identify some of these changes by examining a building's fabric. We may notice variations in the ornament, changes in the brickwork, windows that have been blocked off or are of a different size, and changes in the roof pitch and form. We may discover, for example, that a church chancel was not just a late addition, but was rebuilt at a later date. Churches in the twelfth century had steeply pitched, high roofs, but by the fifteenth century the roof pitch had become shallow. If we look at a twelfth-century church with a fifteenth-century chancel, we may see in the stonework of the wall at the east end of the nave, above the chancel, traces of an earlier higher, steeper chancel roof. In a Victorian terraced house, the two living rooms on the ground floor may have been made into one through room by knocking down the wall separating them. If we look where the wall used to be we may see a large beam or RSJ (reinforced steel joist) spanning the opening and resting on the end walls. This was inserted to carry the weight of the upper floors. With the advent of central heating chimneys

became redundant and in order to give more internal space, they may have been removed.

Today many churches have become redundant, as congregations have dwindled. Some have been subdivided to cater for smaller congregations, and others have been converted to new uses. If the conversion makes use of the original large space, then something of the quality of the original church may have been retained, but if the whole building is divided up into flats, then the whole significance of the church is lost, except perhaps for its exterior silhouette. The awesome space of the nave, the aisles used for processions, the stained glass windows and the chancel with its sacred altar will all have been destroyed. The tower might provide an eccentric, if somewhat poky, living space, but the bells will no longer broadcast the presence of the church to the neighbourhood. Inside isolated floriated* capitals* and angel corbels* may end up decorating the walls of individual flats, where they will seem quite out of place. Outside the traces of the new use will inevitably scar the exterior, with new windows for the new floor levels, skylights in the roof for the upper floors and a car park, garden and garages instead of the churchyard (Figure 3.4). Identifying the alterations and changes will place us in a better position to understand the design of the original buildings, but it might take a great leap of the imagination to appreciate the character of the original spaces and forms that no longer exist. Examining buildings for evidence of alteration and change of use provides

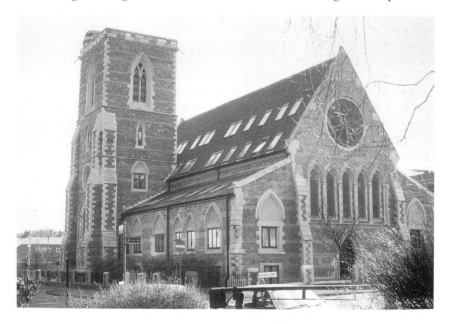

Figure 3.4 Converted Victorian church of St John the Divine, Leicester (1853–4) (G.G. Scott*) (photo: © Rowan Roenisch)

the starting point from which to explore the reasons for these changes. These in turn provide the context from which we can begin to understand a building's history.

Many buildings have been completely destroyed, but occasionally one that has been destroyed is reconstructed. Reconstructions provide an interesting problem, for although drawings of the original may be in existence so that the reconstruction is accurate in form and measurement, there may nevertheless be differences between the two. As part of the celebrations for the Barcelona Olympics, 1992, it was decided to reconstruct Mies van der Rohe's* original Barcelona Pavilion in its original location on the site of the Barcelona International Exhibition of 1929. No detailed drawings of the original existed and the reconstruction was worked out from photographs and with the help of the architect. This proved a mixed blessing for Mies saw the reconstruction as an opportunity to improve upon the original. When the reconstruction was built it was so accurate that the location of the pillars fitted exactly with those in the original foundations. There are, however, a number of significant differences between the two. The original building did not have a basement and was subject to flooding; the reconstruction has a basement to house the heating and water. Onyx, travertine, marble and stone from the same quarries as the original were used, but it was not possible to manufacture glass of the exact tint of the original, so clear glass is used in the reconstruction (Figure 3.5).

ARCHITECTS AND ARCHITECTURAL HISTORY

'The study of architecture without its historical bearings would be truly frightful in its results.'[5] Since the latter part of the nineteenth century the teaching of architectural history in architectural schools in England has been seen as an essential part of the curriculum, but the way in which it has been taught has varied widely. At the beginning of this century W.R. Lethaby* at the Central School of Arts and Crafts and the School of Building in Brixton, London, argued against a concern with style and instead presented architectural history as a series of experiments in construction. He looked at the conditions and materials which gave rise to Roman vaulted* structures or to gothic cathedrals, and saw architecture as the rational solution to structural problems.

At the English universities a different approach was initiated and Reginald Blomfield* was its most strident exponent. Blomfield was an advocate of the system taught at the Ecole des Beaux Arts, Paris. He argued that the masterpieces of the past should be studied in order to understand how they achieved their beauty. He analysed the principles of composition of these masterpieces, in terms of the disposition of planes, masses, form, proportion and treatment of materials, and he thought that from such analyses students could learn to make pleasing forms themselves. Blomfield was

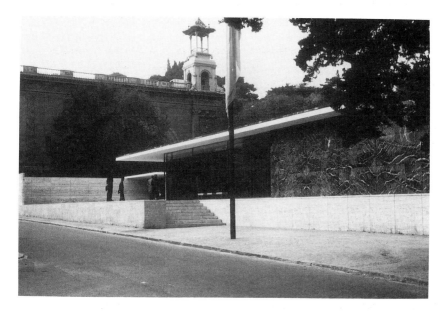

Figure 3.5 Reconstruction of Barcelona Pavilion, 1992 (Studio PER and the Mies Foundation) (photo: © Hazel Conway)

concerned with a limited range of building types and he was not interested in how buildings were constructed or why they were built.

After the Second World War the main influence on architectural schools was the approach initiated by Walter Gropius* at the Bauhaus, set up in Weimar in 1919. There history was seen as an obstacle inhibiting the development of creativity, so it initially had no place in the curriculum. Principles of design were to evolve from the practical activity of designing and making. However, after three years, architectural history was introduced at the Bauhaus, as a means of verifying the principles that the students discovered. Gropius saw the architecture of specific periods of the past as the product of the unique social and material conditions of that period. From them students could verify what they had discovered about their own period, that is that designing for modern needs and using modern materials would lead to the development of new appropriate forms. Each of these approaches offered a partial view of the architecture of the past and pre-judged the architecture of the future. The past was used to confirm a particular view of how to proceed into the future, instead of being explored in as open-minded a way as possible.[6]

Recently there has been a change in how the history of architecture has been seen in relation to the training of architects. The tendency of using a selective study of the past in order to support a particular design approach

that occurred in schools influenced by the Beaux Arts system, and in post-Second World War modernist courses, is now no longer seen as valid. Today architectural history is seen as a subject in its own right, but nevertheless attitudes towards it vary. Some see the architecture of the past as a continuum and argue that studies should concentrate on recurring ideas and themes, for similarities of approach can be found between the past and current architectural practice. Others argue the opposite, that history should be interpreted as a process of continual change and that it is important to emphasise the ways in which the past differs from the present. Seeing architectural history as part of a wider social process implies a rigorous historical approach which does not focus primarily on architects and their ideas. Other architectural schools such as those in France emphasise sociology and urbanism in their architectural history.[7]

The role of architectural history in architecture today is evident from the variety of styles that are used in contemporary buildings. Architects, architectural critics, developers and planners have strong and conflicting views on the role of architectural history and on the appropriateness to today of particular styles from the past. In order for architects to respond to the past knowledgeably, they need a good understanding of it and they need to be able to place current architectural ideas within a larger historical framework. To those of us who have lived most of our lives in large cities, with their wealth of architectural history, it may come as something of a surprise to find that there are people in certain rural states in the USA who may never have come across buildings that are more than fifty years old and who may never have seen a large city. Such people have an even greater need for adequate experience of architectural history.[8]

Chapter 4

Function, space and the interior environment

Architecture is a practical subject and most buildings were built for the purpose of housing an activity or sheltering objects. It is for this reason that we start by looking at function, space and the internal environment. We usually see the exterior of a building first and it is very easy just to look at this and confine one's appreciation to the façade. This can lead to a very superficial understanding of buildings, particularly where the discussion is mainly about whether one likes the forms and the decoration. We may love the great outdoors but we find reasons to build structures to encircle our activities or to protect ourselves and our goods from the weather and other environmental elements such as noise. We may need a controlled temperature, security against theft, damage or fire, and privacy. Different activities such as work, recreation, bringing up a family and worship require different kinds of buildings, perhaps in special locations, with varying internal spaces, environments and form. The functions of buildings are often complex and they are not all utilitarian in the sense of serving a practical purpose. Many buildings are designed to express emotions or symbolise ideas and this can be of importance in determining the final form of the building.

We are not clear about the function of some ancient structures such as Stonehenge, Wiltshire (see Figure 3.1). Stonehenge probably did not shelter anyone or anything, but it may have provided a focus for ceremonies and rituals and had a changing but carefully considered relationship to the rising and setting of the sun and moon. Some religious buildings in certain cultures and periods seem to embody something of the spirit of the religion. They may also be designed to put the worshipper in an appropriate frame of mind or even to attract non-believers to the faith. The space inside medieval cathedrals was often large and of great height. This cannot be accounted for simply in terms of acoustics or the space and air requirements of the clergy and congregation. The space creates an overpowering sense of awe in those visiting the building. The height would often be exaggerated by numerous slender vertical shafts* on walls and clustered around piers*. Appropriately these shafts seem to direct the eye heavenwards (Figure 4.1) We might regard the domed* form of Indian stupas* as having been derived from ancient

burial mounds for practical reasons. The round form and encircling pathway encourage worshippers to circulate around the building which, according to tradition, contains the cremated remains of the Buddha or his disciples (Figure 4.2). However, the stupa's hemispherical form is also imbued with cosmological symbolism, representing the dome of heaven, or the lotus flower which is itself symbolic of the place of the gods. The finial at the top with its umbrella-like tiers suggests the ascending heavens of the gods or the trunk of a cosmic tree.[1]

Symbolism is not only confined to the religious realm, it has secular counterparts. In the late eighteenth century in France, some architects became particularly interested in the symbolic aspect of architecture. Claude-Nicolas Ledoux's house and workshop of the coopers, c.1804, is composed of forms which look like double interlocking barrels. The form derives from the product of the resident's occupation, that is the making of barrels. Often the forms of buildings are a mix of practical, expressive and symbolic functions and we discuss these in more depth as we explore the space, internal environment and form of buildings.

ENCLOSING SPACE

Because most buildings shelter and contain activities and objects, they are about space enclosed by floors, walls, ceilings or roofs. The space inside may be a cosy sitting-room, a dance floor or an open-plan* office. We usually think of this space as being inside, but it may also be outside and include a courtyard or a walled garden. It may also be a transitional space that is neither inside nor out but flows between the two, such as a verandah, covered terrace or an open area under the building. Flowing internal spaces and the use of transitional spaces can be found in the Robie House, Chicago, 1909, by Frank Lloyd Wright (see Figure 2.7). The living, dining and relaxation areas are not separately enclosed spaces but open into each other around a central fireplace. Bands of windows, balconies, terraces and projecting eaves partially define and create transitional spaces close to the house before it merges into the open space of the garden. Wright's houses tended to be built in suburban locations, yet his passion for nature and for the wide open prairies of the United States imbues his domestic architecture. Space is created underneath tower-block flats which are on pilotis*. These enable the air to circulate under the building, provide a sheltered place for children to play in bad weather, and offer views through and past the building. Because we see through the space underneath, the building appears to float and to be lighter than it is in fact. Shelter in the form of a huge umbrella is how we might describe a railway station train shed. At St Pancras Station, London, by W.H. Barlow & R.M. Ordish*, 1863–5, the iron and glass roof spans a vast space over the lines and platforms so that passengers waiting to board the trains are sheltered from the weather (Figure 4.3). One end of the shed is

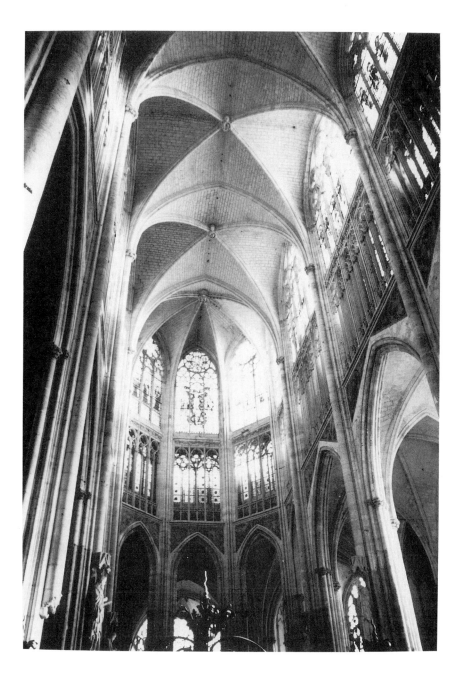

Figure 4.1 St Maclou, Rouen, France (photo: © Hazel Conway)

totally open so that trains can enter the terminus. The enormous space above passengers' heads and the open end of the shed would have served to disperse the smoke from the steam trains in the era before electric and diesel engines.

Walls define or subdivide space and affect the way we experience it. The transparent glass walls of iron and glass buildings like the Crystal Palace, 1851, or the Palm House at Kew do not sharply define the barrier between inside and out visually (see Figure 2.1). From outside we can see what goes on inside and vice versa. When dark glass is used the effect is rather different. The dark glass wall in Norman Foster's* Willis, Faber & Dumas building in Ipswich, 1977, acts as a mirror and on a sunny day the form of the building becomes ambiguous because of all the reflections of the adjacent townscape (Figure 4.4). By contrast at night when the lights are on inside the walls dissolve completely and the interior is revealed. The Barcelona Pavilion (now known as the German Pavilion) was designed by Mies van der Rohe for the international exhibition in Barcelona in 1929 to be part of space rather than enclose it (see Figure 3.5). The roof defines the space below it but the glass walls do not always meet to subdivide the space fully. Instead of corners there are gaps which allow people to move fully around the free-standing walls. The walls of glass direct the flow of visitors through the building and their transparency denies any sense of enclosure and gives a feeling of space and light throughout. In traditional Japanese domestic architecture the spaces are subdivided not by thick walls but translucent paper screens and movable partitions, some not even reaching the ceiling, so there is little sense of enclosure. We need to be aware of the way buildings define and enclose space, and how the experience of space relates to the materials deployed.

FUNCTION AND SPACE

Some buildings such as the medieval barn, which was devoted to threshing and grain storage, consist of one huge space. More often buildings are composed of several juxtaposed spaces catering for a complex of associated activities. A dance hall, for example, needs a large open space with sufficient room for the band and a bar and maybe for tables and chairs around the edge so that people can sit and chat. Space for sitting and chatting may also be allocated on a balcony. There will be a need for separate rooms for toilets, cloakrooms and an entrance hall where tickets may be purchased.

There is no simple way that architects and builders determine the number of spaces in buildings. Spaces for a particular function in a given period and cultural and geographical context may be allocated in a variety of ways within the limitations posed by materials and finance. In addition social and political norms and attitudes, status and the desire to be expressive may lead to other solutions. Medieval houses in Britain consisted of one large, tall

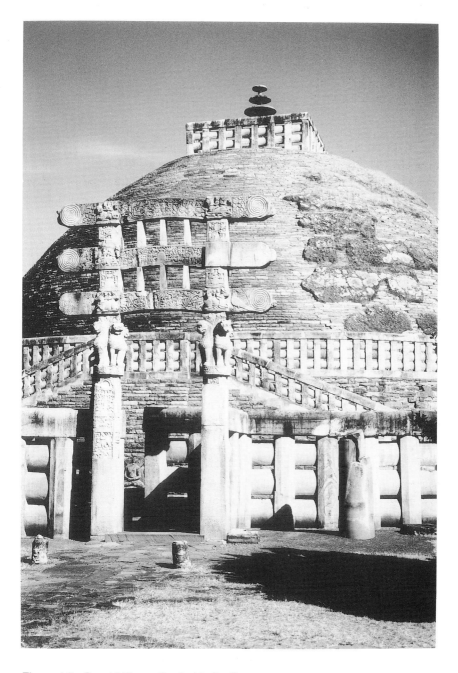

Figure 4.2 Sanchi Stupa, Central India, first century BC
(photo: © David McCutchion)

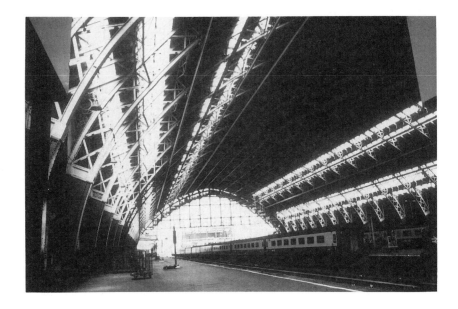

Figure 4.3 St Pancras Station train shed, London, 1863–5 (W.H. Barlow & R.M. Ordish) (photo: © Hazel Conway)

room or hall, which served as living room, bedroom and kitchen. In time separate spaces or rooms were allocated at either end of the hall: at one end rooms for food preparation and at the other end a bed-sitting-room. By the fourteenth century the latter might be divided into an upstairs bedroom and a downstairs parlour. By the sixteenth century many halls were subdivided horizontally to provide further rooms above. Edinburgh in Scotland was bounded by a wall in the sixteenth century and as the density of the town increased so it became common to build upwards. Stone tenements of up to ten storeys were constructed and each floor housed a family. The families in each building or tenement shared communal staircases and, later, lavatories. When Sir Titus Salt, an affluent British factory owner of the mid-nineteenth century, surveyed his employees' housing needs, he built houses in Saltaire, Yorkshire, for families according to their social status. Workmen's cottages were small, with cellar, pantry, living room, scullery and three bedrooms upstairs; the houses of overlookers had, in addition, a parlour, washroom and from three to six bedrooms. Family size seems not to have been a major factor in influencing the overall size and quantity of accommodation provided in these dwellings. Salt saw himself as a new kind of feudal grandee and lived in an expensive mansion 'furnished with all the elegance and luxurious taste that wealth can command'.[2]

Figure 4.4 Willis, Faber & Dumas Building, Ipswich, 1974 (Sir Norman Foster & Partners) (photo: © Hazel Conway)

Most houses and apartments in western cultures have been designed by men as single family units. The majority of dwelling designs today assume a nuclear family of two parents and two or three children. In reality of course, families are of varying size and type, many people live on their own and some choose to live communally. The spatial arrangements in many homes assume the existence of a full-time housewife and there is little consideration for community space. Each home has its own kitchen and, unless open plan, has the disadvantage of isolating the person working there from the rest of the family. If there is sufficient space a spare room will be made into a study or 'den' for the man of the house, but the woman has no similar private space of her own. As early as 1813, Robert Owen in Britain published plans for alternative communities that catered for the needs of working mothers. Kitchens and dining-rooms were communal facilities shared by the whole community, not rooms in individual homes. He also proposed the building of community nurseries so that child care took place largely out of the home. These ideas have been developed further during the nineteenth and twentieth centuries by feminists and socialists in Europe and the USA such as the American Maria Stevens Howland*. Howland argued for professional child care and domestic services, and with J.J. Deery and A.K. Owen made unrealised plans for apartment hotels, patio houses and cottages with

communal kitchens, dining-rooms and laundries for the experimental community of Topolobampo in Mexico in 1885.[3]

In the temperate climate of the west rooms for different purposes in the home are linked and sheltered under one roof, whether in an apartment or bungalow, a maisonette, a terraced house or a detached dwelling. In the mainly hot sunny climate of southern Africa peasant families dwell largely in the open air with perhaps a tree for shade and there are many separate huts for sleeping, cooking or storage irregularly scattered around the outdoor living space (Figure 4.5). The family unit is more likely to be extended to include grandparents and the families of several brothers. The home of a Mashona family in the rural areas in Zimbabwe consists of a large, central space outdoors perhaps sheltered by a tree. This is adequate for most domestic activities – relaxing, socialising, playing, washing up, making baskets or preparing food. Shelter, warmth at night, propriety, security and practicality determine that sleeping space and the areas for cooking, food storage and hygiene should be inside buildings. Each is housed in its own relatively small circular space or hut with thatch roof. There are separate, segregated communal single-cell sleeping huts for girls and boys, a single-cell sleeping hut for each married couple and storage huts subdivided with partitions for keeping different kinds of grain. Instead of one kitchen there might be several, one for each married couple. Inside the circular space of the kitchen, an area is also set aside for religious ritual and for sleeping babies. At some distance from the homestead separate unroofed, grass-walled enclosures are used for toilet and washing facilities and there may even be a small enclosure for chickens or a goat. Visitors to the homestead have no door to knock upon but will recognise they are entering a home either because there is a fence or because the space around is well swept, and they can announce their presence by calling.

THE SIZE OF SPACES

The size of spaces may result from a variety of considerations including the limitations posed by the finances and materials available for construction and, in a temperate climate, the costs involved in heating large as opposed to small spaces. 'Scale' is the term we use to discuss the size of the space relative to the size of something else. A space may be physically large or small but we can only judge this by making comparisons with the number of people who use the space, the furnishings and objects that are to be contained within it, neighbouring spaces or our expectations. Small rooms in a terraced house may suggest snug comfort, but if a whole family had to live in one small room, as many people did in the nineteenth century, then the space is overcrowded and uncomfortable. Today we would consider the scale painfully small. Spaces where lots of people congregate, a chapel, a sports hall, parliament or a factory, need to be large so that they can

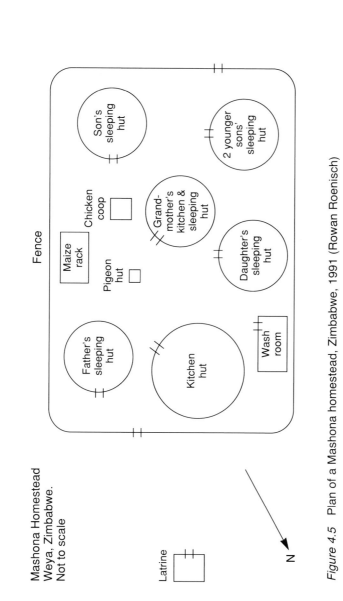

Mashona Homestead
Weya, Zimbabwe.
Not to scale

Figure 4.5　Plan of a Mashona homestead, Zimbabwe, 1991 (Rowan Roenisch)

accommodate the numbers and the activity. We would call their scale large if, for example, the great height of their internal space was not just for reasons of acoustics, the provision of air and the need to reduce the sense of enclosure. The earlier example of a medieval cathedral illustrated that if it went beyond these requirements or our expectations it would evoke a feeling of awe, grandeur and monumentality.

Sometimes the juxtaposition of different-sized spaces is such that the visitor is encouraged to experience or be impressed by the change. Moving from a small, confined porch or vestibule into the main large open space of a church or mosque emphasises the drama as well as symbolising the transition between the world outside and the religious world within. At the Ennis House in Los Angeles, California, 1924, Frank Lloyd Wright deliberately designed a small dark entrance hall with a low ceiling as a dramatic contrast from the glare of the sun outside. In a way similar to the medieval hall, Le Corbusier in the 1920s reserved the large spaces in his villa designs for the main living rooms where people relaxed or entertained. These were double height, opened out onto terraces and offered an elegant, light and airy contrast to the utilitarian kitchens, bathrooms and bedrooms. These were as small and as compact as the ship's cabins Le Corbusier admired for their efficient use of space. Such small spaces might be justified on the grounds that in bathrooms or bedrooms the basic activity involves simply getting in or out of clothing and jumping into or out of bath or bed. The small kitchen, by contrast, perhaps suggests that the cook would be a paid servant.

Theatres vary in form, theatres in the round being designed so that the stage is surrounded by the audience. Others cater for a linear relationship between audience and stage, and are rectangular in shape. In general the largest spaces in a theatre are reserved for the stage and the auditorium. The broad and high auditorium space is designed to be airy, to encourage good acoustics and to pack in a big audience with adequate sight lines to the stage. Supplementing the raked seating in the main body of the hall, the rear space of the auditorium is often subdivided horizontally to give a gallery or tiers of balconies. In a rectangular theatre further seating spaces may also be provided in cantilevered* boxes distributed one above the other along the side walls. The stage area (which may include an orchestra pit in front) may appear to be a small box shape to the audience, but in order to permit stage scenery to be lifted up and down, a tall rectangular space above the stage is essential to house the hoist mechanism and the raised scenery. The types of performance for which the theatre caters, the facilities identified as essential for the audience and the artistes, and the significance conferred on these will all determine both the relative size of the stage and auditorium and the range and size of other spaces.

The importance of the Paris Opéra, designed by Charles Garnier*, 1861–74, is reflected in its overall size as a theatre and in its elaborate

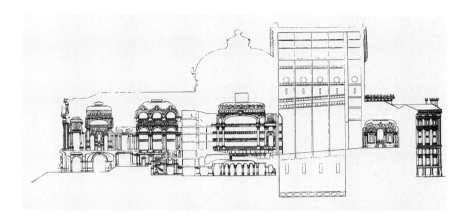

Figure 4.6 Longitudinal section, Paris Opéra, France, 1861–75 (Charles Garnier)

decoration and grandeur which emulated the magnificence of imperial Rome (Figure 4.6). The rear of the building (right) houses a complex of tiny cells utilised for dressing rooms, administrative activities and storage. The stage and auditorium combined are allocated a far larger space. The stage is a tall rectangular box shape. The auditorium, which is lower, is roofed over with a dome, its shallow rounded form inside pleasingly echoes the circular tiers of balconies beneath and symbolically unites the audience in a shared ambience. Poor visibility of the stage, however, is offered to those not fortunate enough to be in the front row of the boxes and balconies. The special status of the Emperor Napoleon III is indicated by the fact that he was allocated his own private entrance to the theatre by a circular ramp to the side of the auditorium. This leads through into an elegant, small-domed circular hall which gives access to the royal box. Perhaps surprisingly, by far the largest space in the building is allocated to the front portion of the building (left) which houses the main entrance, a large vestibule leading to a two-branched grand staircase overlooked by galleries, and beyond it a large foyer adjacent to the auditorium. The grandeur and complexity of these spaces makes them as significant as the auditorium and stage for the presentation of dramatic spectacles. These are large ritual spaces designed to enable the audience to promenade elegantly and show off their costly and glamorous clothing during intervals and when entering or leaving the building.

PROPORTION

The dimensions of rooms in buildings may be carefully calculated to create pleasing or related proportions and sometimes they are seen to have a wider significance. In Japan, the size of the tatami mat* became the common module for calculating the dimension of rooms in traditional houses. The harmony of parts in Buddhist, Jain and Hindu temples was seen to reflect the order of the cosmos. The measurements were based on modules derived from the dimensions of the sanctuary* or of the image located in the shrine. The Roman architect and engineer Vitruvius in his book on architecture, *De Architectura*, argued that the diameter of the base of a column provided a module for all the dimensions of a temple. Its size was based on the length of a man's foot, which is one-sixth of a man's height. The height of a Doric* column should be six times the diameter of the base of the shaft. Ionic* and Corinthian* columns were more slender and reflected the proportions of the female body.[4]

During the renaissance in Europe architects became very interested in recreating what they saw as the beauty and harmony of the universe in their buildings. Architects used proportion to relate each part of a building to every other part harmoniously and they sought mathematical relationships for the length, width and height of rooms. Andrea Palladio utilised three different sets of ratios to obtain good proportions in his villas and churches in Italy. These were based on arithmetic, geometric and harmonic relationships. The first might give a room which measures 6 feet by 12 feet, with a height of 9 feet. The terms 6, 9, 12 are related arithmetically because the second term exceeds the first by the same amount as the third term exceeds the second. In geometric proportion the first term relates to the second as the second to the third. We might then have a room which measures 4 feet by 9 feet with a height of 6 feet, because the width of the room is two-thirds of the height, and the height is two-thirds of the length. In the more complex final example the terms are in harmonic proportion when the difference of the two extreme terms from the third or intermediate term are in the same proportion. For example, if a room measures 6 feet wide by 12 feet long and 8 feet high the intermediate measurement is that of the height which is 8 feet. The smallest dimension is the width which is 6 feet and the difference between 6 feet and 8 feet is 2 feet or a third of 6 feet. The largest dimension is the length at 12 feet and the difference between it and the height is 4 feet which is a third of the length.[5]

In the twentieth century the French architect Le Corbusier used the human body as a basis for proportions and combined it with the golden section. The golden section is a set of proportions based on the division of a line into two unequal parts. The smaller part relates to the larger part in the same ratio as the larger part to the whole. To obtain the initial dimensions Le Corbusier used two lines, the length of one based on a man's height at 6 feet

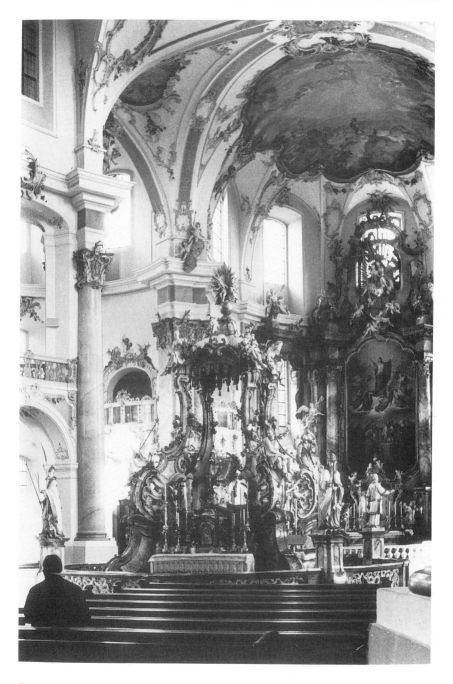

Figure 4.7 Interior of the pilgrimage church of Vierzehnheiligen, Franconia, 1743–72 (Balthasar Neumann*) (photo: © James Stevens Curl)

or 183 cm and the other based on the height of a man with his arm held aloft at 7 feet 5 inches or 226 cm. The two lines were then subdivided to create related measurements based on the golden section. Called the Modulor, it was used by Le Corbusier to provide the dimensions of buildings such as the Unité d'Habitation, Marseilles, in France 1947–52.[6]

THE SHAPE OF SPACES

Most buildings in the western urban environment have been predominantly rectangular and examples such as Antonio Gaudí's* Casa Milá, Barcelona, 1905–10, with its curving forms and rooms are rare (see Figure 10.2). In other cultures non-rectangular forms predominate particularly for traditional dwellings such as the ice houses of the Inuit of North America, and as the example of African housing illustrates (see Figure 4.5). Tombs and religious buildings are commonly of shapes which have symbolic significance. Renaissance architects used geometry to obtain ideal shapes for buildings and Alberti* preferred circular, centrally planned churches not for practical reasons, but because he saw the circle as an absolute and perfect shape, common in nature and an appropriate expression of the divine.[7]

At certain periods architects have chosen to create exciting, complex spaces with curving, undulating walls. The period of the baroque and rococo* in Europe was one such time when interiors were designed to entice and captivate the onlooker and draw them into a world of illusion created through painting, sculpture and the curving forms of architecture (Figure 4.7). In the period of art nouveau architects wanted to create a new style not based on past forms, so they explored new materials such as iron, glass and concrete to create curved and irregular spaces. These are best exemplified in the interiors of Antonio Gaudí in Spain and Hector Guimard* in France. The expressionists* also created unusually shaped interiors such as those in the Goetheneum or temple of spiritual science, Dornach, Switzerland, by Rudolph Steiner*, 1913–14 (the original building was destroyed by fire in 1923).

Some building types such as libraries, sports stadia, concert halls and station booking halls offer practical opportunities for non-rectilinear forms. In the nineteenth century fine circular spaces were created in London for the British Museum Reading Room by Sydney Smirke*, 1854–7, for the Royal Albert Hall, 1867–71, by Captain Francis Fowke and Henry Scott*, and in Leeds for the Corn Exchange, 1861, by Cuthbert Broderick*. More recent examples of curved spaces are the spiral forms of the Guggenheim Museum, New York, by Frank Lloyd Wright, 1944–57 and the organic shape of the TWA Terminal, Kennedy Airport, New York, 1960, by Eero Saarinen* (Figure 4.8). The rationale for the choice of spatial configurations varies. The swirling forms of baroque churches were part of a campaign to excite and encourage people to the Catholic church. The organic forms of Steiner's

Goetheneum were considered conducive to contemplation. Frank Lloyd Wright's spiral was designed to provide a predetermined path for visitors to walk along past the works of art, and the bird-like forms of the TWA terminus were designed to suggest flight and so provide an analogy with the function of the building.

THE RELATIONSHIP BETWEEN SPACES

Some buildings are constructed as designed, others evolve; some architects design their buildings from the outside in, others from the inside out; others

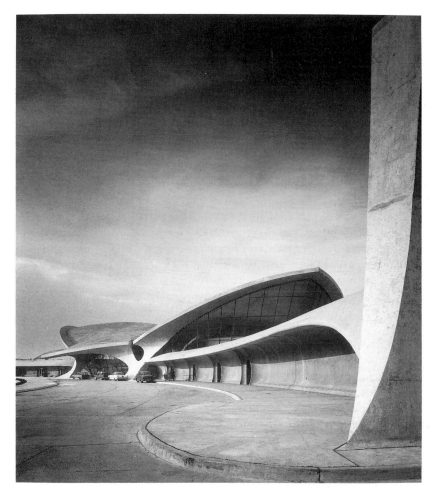

Figure 4.8 TWA Terminal, Kennedy Airport, New York, USA, 1962 (Eero Saarinen) (photo: Ezra Stoller © Esto)

place great emphasis on the circulation route. The relationship between spaces and the building as a whole will depend on factors such as these. In considering where to locate spaces or rooms architects have to think about the ways in which they are to be used. Today we think a kitchen is best located near the dining area so that food arrives warm on the table. In medieval Britain the kitchen was sometimes built separate from the rest of the house because of the danger of fire. Some large institutions such as hospitals or prisons inevitably have kitchens far from the point of consumption because patients or prisoners cannot be brought to one large dining area but eat within each of the many wards or cells.

James Stirling at the Staatsgalerie, Stuttgart, 1984, wished to encourage people to visit the museum so he designed the building around a series of pedestrian routes, courtyards and terraces which entice passersby into the complex. There they can see sculpture and obtain tantalising glimpses of the art works within the building. Architects with a classical training will tend to start with a single geometrical form such as a cube, into which they will then distribute the various functional spaces required, seeking as far as possible to do this in a symmetrical manner. We will see this when we look at the plans of Syon House (see Figure 10.6). Modernist architects of the twentieth century, such as Walter Gropius, first identified sizes appropriate for the function of the individual rooms or spaces making up a building and then sought practical ways to link them, so creating buildings of irregular outline. A good example of this is the Bauhaus building at Dessau, a design school in Germany, of 1925–6. The carpentry and weaving workshops along with the preliminary course studios are in one block. This is linked to the classrooms, laboratories and library, which are in another block, by a bridge over a road containing offices for the administration of the school. A third wing contains the hall, canteen, kitchens and finally the multilevel students' hostel. Each area is clearly defined by its distinct form.

COMMUNICATION SPACES

In many buildings access from one room to another is by additional spaces or communication areas, corridors, passageways or halls in order that different users do not have to pass unnecessarily through rooms to reach the spaces they need within the building. If there is more than one floor then there will be stairs or lifts. Careful planning is required to make routes short and direct. In Victorian country houses the route through the house and the location of rooms were related not only to aesthetics and practicality but also to questions of propriety. As Jill Franklin says in discussing the communication spaces, 'the dinner route was noble, the servants invisible and the boiled cabbage kept at bay'.[8] Corridors and stairs were either grand and very evident to guide and impress guests or hidden away and narrow, for servants to use (see Figure 10.5). As we have seen, for some architects the

route through the building becomes an important part of the design and indeed largely controls the overall layout. Le Corbusier's villas of the late 1920s such as the double villa La Roche-Jeanneret, Paris (now the Fondation Le Corbusier), have ramps and stairways to achieve the *promenade architecturale*. This was designed to provide a pleasing and varied walk of changing visual experiences within the building. In the entrance hall of the house of Raoul La Roche, 1923, the space is exhilarating. The hall rises through the two floors above it and can be overlooked by people standing on balconies at each level. Architects' plans are extremely valuable in helping us to understand the relative size, allocation and relationship between spaces in buildings; we discuss these in Chapter 10.

THE INTERIOR ENVIRONMENT

So far we have discussed buildings in terms of space and the way those spaces house various activities. Buildings are also about creating a comfortable and safe environment, for working, living or housing objects. The temperature, light and the transmission of noise need to be controlled, we may need warning of fire and we often need facilities for hygiene. A building with many floor levels such as a shopping mall, block of flats or offices may require mechanical means of access such as lifts and escalators. Space must be found to house these services and the pipes and wires.

The materials and the design of the fabric of the building, the size of interior spaces, the nature and frequency of openings as well as the means used to heat, ventilate and control the temperature all contribute to the quality of the interior environment. One of the most important requirements in buildings is adequate light, although buildings such as warehouses need less light than those where people live, work or spend large amounts of time. In museums light is required to view the exhibits but it can also damage them. Top lighting that avoids the direct rays of the sun and the fitting of ultraviolet filters to windows are means used to reduce this problem. In order to engender a sense of awe and mystery some churches have dark gloomy interiors and even though they may have large windows, the stained glass colours the shafts of light entering.

The quantity of natural light that we can use in buildings depends on the geographical location, the climate, the building materials, constructional system, the design and the use of the internal spaces. In different parts of the world and at different times of year the amount of natural light available varies. Around the tropics the hours of daylight vary little from a twelve-hour norm. In Britain we have very long hours of daylight during the summer but much less in the winter. In the polar regions, the sun hardly sets during the short summer, but in winter the hours of daylight are minimal. Buildings need to take account of these regional variations. Medieval cathedrals in Europe were designed with larger and larger expanses of

stained glass windows to illustrate biblical stories and to dramatise God's house, but it was not until the sixteenth century that glass was widely used in domestic buildings, since it was a very expensive material. In Europe's temperate climate the advantage of unglazed openings in the wall, which let light into buildings, had to be weighed against the disadvantage of cold, wind and rain entering. Shutters were therefore vital. Buildings with load-bearing* walls tend to have relatively small windows admitting only small amounts of light from outside; therefore various methods have to be devised to obtain sufficient natural light. To obtain light at the centre of buildings, so that rooms which run deep into the interior can take advantage of daylight, there may be roof lights or, if it is a multistorey building, a light well. In Chicago, in the late nineteenth century, some architects who employed loadbearing masonry walls for their office buildings introduced lots of windows and designed them in the form of projecting bays to capture as much natural light as possible. The development of metal and reinforced concrete* frame* buildings seemed to offer great opportunities to take full advantage of the available natural light by having complete walls of glass, but as we shall see there are side effects of heat loss and gain because of the effect of large areas of glass on the building's internal environment.

Despite the ferocious heat in parts of Africa, traditional buildings with walls of wooden poles and clay, thatched grass roofs and mud floors have cool interiors. The thatch and clay shield the interior from the blast of the sun. The open door and the gap between eaves and wall permit sufficient air and light without the need for windows. If a building in a hot climate has thick walls they will absorb and hold the heat from the sun during the day, reducing the rate at which the spaces within become hot. At night the heat from the walls will be slowly emitted to mediate the effects of the colder air. In the twentieth century the modernists rejected loadbearing walls. The frame structure with a thin covering skin of glass which they favoured has posed many problems in terms of the interior environment of their build-ings. Walls of glass reduce the need to provide artificial light in buildings during daylight hours, but this has to be weighed against the effects of overheating in the summer sunshine (the greenhouse effect), the temperature drop in the winter and the consequent need for high energy consumption. To shade glazed walls from the sun, Le Corbusier from the 1930s employed a thick grille of concrete called a *brise-soleil**, a device which has been employed by many other architects since (Figure 4.9). Alternative methods of reducing these effects are the use of double and triple glazing to keep out the cold as in Ralph Erskine's* The Ark, Hammersmith, London, 1992, or the use of reflective coatings, sometimes tinted bronze or blue, which permit the entry of light but not heat.

Today we are ever more aware of the danger of fire particularly in buildings used by large numbers of people. To ensure a safe interior environ-ment, spaces within buildings are often subdivided to prevent the spread of

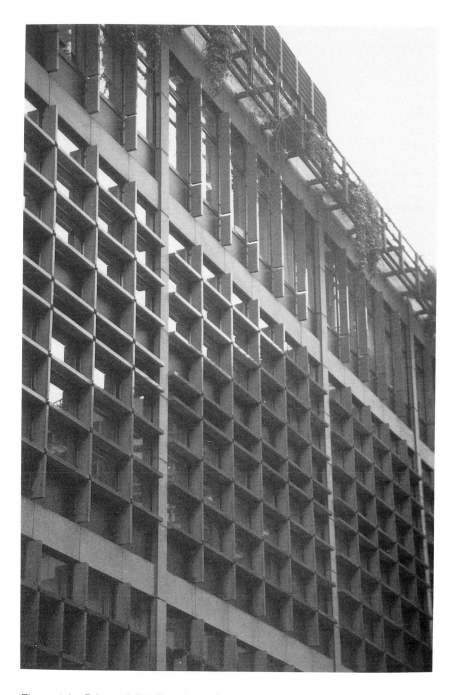

Figure 4.9 Brise-soleil at Broadgate, London (photo: © Hazel Conway)

fire. Escape routes are provided and fire-resistant materials for walls, floors and doors are used to give people time to evacuate the building. At the London Ark the aim was to create as far as possible an open unified interior space. The nine floors of offices are not divided off from the central atrium* but open out into it to encourage the development of social interaction and a sense of community for all the different firms and individuals who use the building. This may seem to be a generous invitation to the spread of fire but to compensate for the reduced subdivision of the interior this building was designed with sufficient exit routes to evacuate users quickly and all at once. Only the highest office floor is partitioned off to enable the upper part of the central atrium to provide a smoke reservoir in the event of a fire.

ACTIVE ENVIRONMENTAL CONTROL

Active methods of controlling the interior environment of buildings have changed over the centuries and vary from country to country. Illumination by artificial means had a long history from the flickering light of fires and candles to that of oil lamps. Then, in the nineteenth century, gas lighting – the gas transported in pipes to individual buildings – created a more regular form of light, but like candles and lamps it had the major disadvantage of polluting the atmosphere and leaving deposits of soot within the interior. The development of electric lighting in the late nineteenth century has transformed the interiors of buildings by creating a bright, even and clean source of illumination.

The most common method of heating medieval houses in Britain was by an open hearth with a fire in the centre of the floor. The smoke was filtered through the thatched roof, a louvre or gablet*, and often polluted the atmosphere on its travels. The Normans introduced wall fireplaces into their castles and fortified houses in Britain, and by the thirteenth and fourteenth centuries these were serviced by stone chimneys. Both types of fireplace coexisted during the middle ages. With the development of brick–making came the desire to reduce fire hazards and direct the smoke out of the building efficiently; brick chimneys became widespread by the sixteenth century. Fireplaces and chimney breasts constructed against external walls waste the heat, which spreads throughout the wall, so internal walls became preferred locations for fireplaces. Often fireplaces are constructed back to back in adjacent rooms so that the building capitalises on the heat generated and economies are made in the construction of chimneys, each of which may have several flues belonging to different fireplaces. In central Europe large wood-burning or coal stoves were more common by the nineteenth century to heat domestic interiors.

We do not associate modern tall, glass-walled office buildings with chimneys at roof level because they tend to employ central heating. Many may have windows that do not open because mechanical means are used to

condition the air. Although the Romans developed systems of underfloor heating known as hypocausts, it was not until the mid-nineteenth century that it became common in commercial and public buildings to use boilers to generate hot water or steam which was distributed by pipes and radiators throughout the building. By contrast buildings in hot climates often need the air within to be cooled by fans and refrigeration to create a comfortable environment. Air conditioning first became widely available in industrial and commercial buildings, cinemas and theatres early in the twentieth century, particularly in the United States, but in recent years we have come to recognise that sealed interior environments with air conditioning need very careful design, otherwise they may lead to sick building syndrome and encourage Legionnaire's disease and allergic reactions.

PASSIVE ENVIRONMENTAL CONTROL

Today environmentally conscious architects are seeking passive means of controlling the interior environment of buildings in order to reduce global warming and energy consumption. Reintroducing massive stone or brick loadbearing walls offers good thermal insulation, and many small windows, roof lights and light wells can be included to admit as much natural light as possible. In Hyderabad Sind, in west Pakistan, where temperatures may exceed 50°C, it has been the tradition for 500 years to install windscoops on roofs to channel the cool breezes into the rooms.[9] Today green architects are re-exploring natural ventilation in buildings. They may utilise the thermo-syphonic stack effect created by vents in roofs, towers or chimneys. In addition by locating windows on opposite sides of rooms cross ventilation encourages a breeze to cool the interior. In the summer the vents encourage warm air to rise out of the building and at the same time bring cool air flowing down into it. At the De Montfort University Engineering Building, 1993, Alan Short & Brian Ford*, the use of numerous computers by the staff and students within the building creates tremendous heat (Figure 4.10). In winter this can be exploited to reduce the need for artificial means of heating. In warm weather the heat generated by the computers is too much and has to be expelled through vents in the roof and chimneys. These chimneys have a dual role of expelling warm air and catching breezes which can be circulated around the building to cool or ventilate it passively.

SPACE FOR SERVICING TECHNOLOGY

Essential services like heating, air conditioning, lighting, lifts and water-borne sewage systems require machinery, boilers and tanks as well as pipes and wires which need to be appropriately housed somewhere within the building. They need space just as much as the activities for which the building is constructed. Early equipment, particularly for lifts and central

Figure 4.10 De Montfort University School of Engineering and Manufacture, Leicester, 1993 (Alan Short & Brian Ford) (photo: © De Montfort University)

heating, was often bulky and took up much valuable space. Since the late nineteenth century in the commercial centres of cities like London, New York and Chicago, where land values are high, architects of speculative office buildings have had to confront the problem of finding space for essential equipment and services as well as creating as much rentable space as possible.

Some architects tried to play down the visual impact of such necessary services, hiding much of the equipment in the basement or the attic, within the walls or under the floors. Central heating radiators and pipes are often devised to intrude as little as possible. By contrast the traditional fireplace has played a major role in the form of buildings, for an open fire was often a focal point either as an open hearth at the centre of the room around which people gathered or as a fireplace with mantelpiece at one end of the room. Inglenook* fireplaces further welcomed occupants to sit in the draught-free warm space located around the fire. The fireplace has come to symbolise the heart of the home. With the arts and crafts revival of vernacular architectural forms in the late nineteenth century in both Britain and the United States, the inglenook fireplace was nostalgically reintroduced into bungalows. A good example is the Gamble House, by Greene and Greene*, 1908–9, in Los Angeles, California, with its 16-foot-wide inglenook.

Some elements used in servicing technology are most appropriately

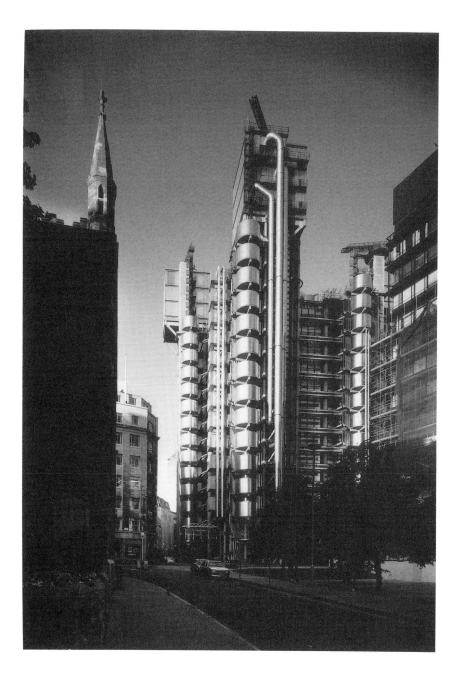

Figure 4.11 Lloyds Building at night, London, 1986 (Richard Rogers Partnership)
(photo: © Richard Bryant)

housed on the exterior of the building. Chimneys were a necessary and prominent feature on many traditional buildings in Britain, particularly large and elaborately decorated brick chimneys on houses in the Tudor period in England. On cold days they remind us of the warmth to be found within. For reasons of access and hygiene water-borne sewage systems have pipes which usually run down the external walls of buildings although in the eighteenth and nineteenth centuries it was not uncommon to find them located within internal walls. In hot climates water tanks are often placed on the exterior of the building but the danger of freezing prevents this elsewhere. More recently architects have shown that placing servicing equipment on the exterior can be both visually exciting and leave more free space for commercial use within the building. At the Lloyds Building in London by Richard Rogers, 1978–86, the toilet and washroom 'pods', the water tanks, glass lifts and piping are on the exterior leaving the interior spaces completely free of such encumbrances (Figure 4.11). The deep spaces between the floors and ceilings house cables and pipes which carry electricity, air and water, bringing warmth, lighting and air conditioning, as well as providing fire-detectors and fire-fighting sprinklers at each work-station through grilles, hatches and other fixtures in the ceilings and floors.

The creation of artificial environments, which is largely what many buildings are, is a complex task. Many factors go towards resolving the size and shape of spaces and the environmental conditions to be found within buildings. However, often the solution is circumscribed by the available materials and the methods which the client can afford, the location of the building and the nature of the site.

Chapter 5

Materials and construction

The subject of materials and construction concerns not only physical uses but also the production of materials and the nature of the building industry. Buildings have been built of a very wide range of materials, the most common being timber, baked and unbaked clay, stone, slate, reeds, grass or straw, glass, concrete, iron and steel. The fabric of a building, the choice of materials and constructional system sets limits as well as creating opportunities for architects and builders. Some materials such as brick, wood and stone may be very familiar but it takes careful observation to enable us to recognise particular varieties of timber such as oak or ash, and it takes experience to learn the difference between the many varieties of stone such as sandstone, limestone and granite. The best way to become adept at recognising these differences is to travel widely to look at the materials used in buildings, read a guide on the local architecture which identifies materials and indicates which are used in particular buildings, and visit geological or local museums which often display local building materials.

Locating the source of materials is important in understanding the social organisation, the time, the energy consumption and effort that went into the acquisition, manufacture or transportation of the materials. A quarry may be local but it may not be easy to extract the good quality stone. The huge monoliths* that form the stone circle at Stonehenge, near Amesbury in Wiltshire, constructed in 2100 BC were brought by late Neolithic people over 135 miles from Carn Meini, Dyfed, Wales (see Figure 3.1). The fact that these stones were transported such a distance indicates something of the sophisticated social organisation of these people and the significance which they attached to this site. Many of the large medieval cathedrals and European building projects employed English lead for their roofs, windows and rainwater drainage systems and there are records of the lead being taken in carts across the bleak and hilly moors to Boston and the Humber for shipment to the continent in the twelfth century. Rivers were also used to transport this material to the coast and we know that until the late eighteenth and nineteenth centuries the Derbyshire lead fields in England were amongst the richest in Europe.[1] In the nineteenth

century Britain exported cast iron all over the world. The names of British ironworks emblazoned on cast-iron columns used for the porches and verandahs of buildings exported to the former British colonies during the late nineteenth and early twentieth centuries remind us of Britain's thriving colonial export trade.

POTENTIAL AND LIMITATIONS OF MATERIALS

Once we have identified the material, we need to understand its limitations and possibilities. The size of the material components employed may be determined by natural or artificial limitations and is an important consideration affecting the final dimensions and form of buildings. The height and width of a tree trunk and the length and width of its branches determine the ultimate size of timber. The methods of transport may limit the weight that can be carried and therefore the size of materials but, as we have mentioned, some early societies pushed the boundaries beyond what might seem possible, carrying huge stones very long distances. In the case of modular materials such as brick, the size may be determined by what it is practical to handle. Other building components, such as beams, panels, window frames and doors, may today conform to dimensions determined by a government or institutional standard. There is no agreed international standard although a standard size or module of 100 millimetres (4 inches) is very commonly applied to coordinate the dimensions of components. Mass production of standardised components offers great economies and flexibility within the building industry, enabling components produced by different manufacturers to be used together, or the same component to be employed in many different building types.

The choice of material may be determined by availability, cost, strength, fire-resistant qualities, weathering, maintenance requirements and aesthetic possibilities; the physical properties of materials determine how they are used. Stone is able to withstand compression or great weight without crushing, so it has been found suitable for walls and columns. Like stone, timber is strong in compression, and is also one of the few natural materials strong in tension, so it can withstand forces that stretch the material. For this reason it has been widely used in beams. Cast iron is a material strong in compression, wrought iron is strong in tension. Mass concrete (made of cement plus aggregate, such as sand or broken stone, and water combined without any reinforcement) is strong in compression but reinforced concrete is good in both tension and compression. The steel rods or mesh embedded in the concrete take the tension, and the concrete the compression.

Brick and stone are generally porous and absorb rain but allow it to evaporate afterwards; other materials such as concrete are relatively impervious to moisture. Many 1960s blocks of flats made from concrete panels

were not designed with adequate ventilation, so the moisture created in kitchens and bathrooms was trapped and resulted in mould on walls. Some materials such as wood and metal prove hazardous if fire breaks out. Techniques to prevent or delay the buckling of the metal by fire in metal-frame buildings include cladding the frames with hollow ceramic tiles or painting them with intumescent paint which swells up and provides a barrier to the fire.

Some materials pose maintenance problems or do not weather well. Mud walls need to be regularly replastered and maintained, thatched roofs have to be replaced every twenty years or so and brick walls require repointing. Stone can be damaged by frost and is corroded by atmospheric pollution. While historical factors such as destruction by war or natural disaster such as the volcanic eruption that buried Pompeii in AD 79 can lead to the premature loss of many buildings, the weathering properties of materials may lead to some buildings decaying more quickly than others. In Virginia, USA, the only surviving farmhouses of the seventeenth century are of brick. Yet wooden houses would have been far more numerous, certainly before 1650. The fact that wood is far less durable than brick accounts for the lack of extant examples of wooden buildings.[2] Many of the concrete buildings constructed after the Second World War now look grey and their surfaces are streaked with dirt. Yet concrete does not have to be grey in colour. Pigments and coloured aggregates* can be added to it or chemical stains painted onto the surface after the concrete has been cast. Techniques are also being developed to create hard-wearing surfaces with fine detail which are more resistant to soiling.

We may think that the huts of clay and timber poles that are common in Africa require only a basic understanding of materials. Greater acquaintance with these buildings and their builders reveals broad knowledge and skill. In Zimbabwe, builders have an intimate knowledge of the local trees, carefully selecting timber that is straight, durable and proof against termites and insect attack, and they use the inner bark of suitable trees to make a strong string. They use a wide variety of clays, including cow dung which deters insects, to build floors, to infill between upright timbers, to plaster and decorate walls. Women do much of this work.

Until the nineteenth century there was little scientific understanding of materials, but with the introduction of new manufactured materials and an increasing concern for safety it has become necessary to undertake tests to measure their properties, and we have become aware of the health hazards posed by a wide range of materials. Although reinforced concrete was largely developed and deployed in buildings in Europe in the nineteenth century concern for the fireproof qualities and structural safety of the material led Americans to initiate systematic research in the 1870s.[3] Much of the early research into the structural properties of steel was undertaken, not by those in the building industry but by railway engineers who first used

this material. Many countries have now established research institutes devoted to research and testing of materials.

HEALTH AND SAFETY

Manufactured materials should be made in conditions where workers are protected from dangers associated with the processes or materials. All materials should be thoroughly tested before use in large-scale construction. This is not always the case. Knowledge of the working practices in the manufacturing and construction industries and the hazards of certain materials helps one appreciate the costs, whether financial, human or environmental, involved in the production and use of buildings.

In the nineteenth century when dome-shaped down-draught kilns were used to fire bricks, pressure on production sometimes meant that workers had to enter the kilns to empty and fill them before they had properly cooled from the previous firing. High-alumina cement, used since 1908 because of its quick-setting properties, has been shown to require very careful supervision and on-site control, otherwise it can develop marked constructional weaknesses. Despite the fact that it was banned in France from 1943 and the risks involved in its use were published in Britain in 1963, it continued to be used in buildings in Britain and some roofs collapsed in the early 1970s. The dust from asbestos, a material employed for its fire-resistant properties, has been found to be dangerous to health, as is paint with a lead base. Yet these materials are still being used in some countries. The construction industry in Britain today still has a very poor record in terms of industrial injuries yet there is little attempt to deal with one of the main causes, which is widespread casual labour.

Today the urgent demands of the ecosystem are having an impact on the choice of building materials. In some cases a return to natural and local as opposed to manufactured materials is encouraged, in order to cut down on energy consumption, pollution and global warming. It can be seen that issues broader than simply the financial cost and the creation of an appropriate or pleasing structure influence the choice of material.

CONSTRUCTION

When we have identified the materials, the next step is to find out how the building was constructed, by looking at it from both the outside and inside. Identifying the method of construction is not always easy because it may be concealed or covered by other materials. We may be able to see that a roof is tiled or slated, but if it is hidden behind a parapet, or inside the building the roof construction is masked by a ceiling, it may not be so easy to find out how it is constructed. Visiting building sites or decayed buildings may reveal parts not normally visible but such places are very dangerous, so supervision and permission are essential.

The method of construction is most important: this is the means for ensuring that a building lasts and withstands the weather, sheltering in appropriate ways the activities or contents for which it is designed. In order to understand why buildings stand up we need to understand the causes of instability. In all building the weight of the materials has to be supported so that the final structure is stable. Thrusts or forces act within the structure: the weight of roofs and floors on the walls and supports, wind loads and the nature and stability of the ground upon which the building stands are among the factors that determine its instability. We can only discuss some of the most basic problems connected with stability in buildings.[4]

Loadbearing walls

Building construction may be divided basically into two types: frame construction and loadbearing wall construction. Loadbearing walls can be of masonry, wooden logs (log cabins) or a number of other materials such as mud or blocks of ice as in the houses of the Inuit (commonly but incorrectly known as igloos). Even the most humble materials have been used to create buildings with loadbearing walls of great power and beauty. In New Mexico, USA, seventeenth-century Spanish missionaries encouraged the building of new churches as part of their campaign to convert the Pueblo Indians. They were built by the Indians themselves utilising the traditional material, adobe (sun-dried bricks made of a mixture of clay, straw and water). The large churches with their clay-plastered walls, while austere, are impressively monumental. Today we associate glass with windows and the thin sheets of plate glass used to clad* office buildings, but loadbearing walls made of glass bottles were used to construct the General Store at the Silver Mine, Colorado, USA.

Loadbearing walls, as their name implies, are designed to carry their own weight and also the weight of the rest of the building. The weight of floors or roofs may exert pressures which can cause the walls to collapse by crushing, buckling or leaning outwards. The thickness of a wall needs to be related to the capacity to resist crushing from the weight bearing down on it (compression) or buckling which results from a lack of stiffness in the wall. High walls may need buttresses (projections from the walls which give additional strength and support) or great thickness to prevent buckling. The Monadnock Building, 1884–5, in Chicago has external loadbearing walls of stone and brick which had to be 6 feet thick at the ground floor to give sufficient support to the tapering masonry walls above, which rise to sixteen storeys. This was probably the ultimate height for masonry loadbearing walls.

The corners of a building and the internal joists, flooring and cross walls act as internal bracing* and help to prevent the walls from falling in. Masonry is weak in tension, so the corners and cross walls do not prevent the walls

from leaning outwards. In the eighteenth century builders wanted to put up multistorey buildings such as mills and factories with relatively thin walls with many windows to light the interior. Rather than construct bulky buttresses to counteract the tendency for walls to lean out under the weight of the roof and the machinery, they often employed wrought-iron tie* bars or rods at ceiling level. These acted in tension, tying together opposite walls and preventing them from leaning outwards. Lateral pressure on walls may develop later, for example if a roof has been re-covered with a heavier material, and a common remedy is to employ tie bars. Tie rods are often visible on the exterior walls of buildings, their ends being in the form of an X or a star. Lateral pressure can also result from other alterations. One of the authors was awakened one night by what appeared to be an explosion. A neighbour had created an open-plan house out of an Edwardian one and had removed the internal loadbearing walls and chimneybreasts which supported the upper floor. The explosion was the whole of the rear façade falling like a pack of cards into the garden.

Frame construction

In a frame construction it is the frame that carries the weight of the building. Frames may be of wood, as in medieval timber frame houses and barns, or of iron, steel or reinforced concrete. The weather is kept out either by infilling between the frame or by hanging a skin of glass or other material onto it. This latter is known as a curtain wall. To withstand lateral forces such as wind, either the joints between vertical and horizontal members have to be rigid, as they are in reinforced concrete frames, or bracing or stiffening of the structure is required. This may consist of diagonal struts, rigid panels inserted into the frame at intervals or the use of masonry walls. The Crystal Palace, London, designed by Joseph Paxton, 1851, was a frame building infilled with glass (see Figure 2.1). The frame was largely made of cast and wrought iron and stiffening was provided by curved braces between each stanchion or column and by the wrought-iron floor girders.

Frames may be inside the building and invisible from the exterior, outside or part of the wall of the building, and the infill material will not be loadbearing even if it is capable of being so. Infilling materials include reeds, straw, laths* and plaster, and sheet glass which could not be loadbearing, as well as mud and bricks which could. Framed buildings have been constructed of a timber frame with panels of wire-reinforced paper at the office and residence of the Mine Manager, Globe and Phoenix Gold Mine, Kwekwe, Zimbabwe, 1895 (Figure 5.1), and sackcloth dipped in concrete which was utilised by Bernard Maybeck at a house on the campus of Berkeley University in California. Hardy, Holzman, Pfeiffer's* extension to the Museum of Contemporary Art, Los Angeles, USA, is a framed building

Figure 5.1 House and office of the mine manager, Globe and Phoenix Goldmine, Kwekwe, Zimbabwe, 1895 (photo: © Rowan Roenisch)

Figure 5.2 Squatter home, Cardboard City, London, December 1990 (photo: © Rowan Roenisch)

where glass bricks are used as an infill to create walls, as they are at the Maison de Verre, Paris, 1928–32, by Pierre Chareau* and Bernard Bijvoet.

Frames may also be clad or covered by hanging clay tiles, slates or wooden shingles*, or covered with skins, fabric or plastic. Temporary homes constructed by squatters or the homeless may consist of a nailed timber frame draped with discarded plastic or fabric and may have panels of cardboard, timber or corrugated iron on the roof or leaning against the sides to create walls (Figure 5.2). A tent or the tipi of native Americans could be considered a kind of frame building, the cone of tall wooden poles forming the frame and the skin or canvas covering draped over it to keep out the weather. The principles of the tent structure lie behind some of the most advanced architecture of today such as the huge Munich Olympic Stadium by Behnisch & Partner with Gunther Grzimek, 1972, and Michael Hopkins's* Schlumberger Petroleum Research Laboratories, Cambridge, 1985 (Figure 5.3).

Spanning space

An important part of building construction concerns the techniques used to span space, provide entrances and windows, and protect buildings from the weather. Much ancient architecture in Egypt, Greece, India and the Far East, including China and Japan, was based on the principle of the post (vertical) and the lintel (horizontal) to span spaces. Trabeated architecture is another term for this mode of construction which is a relatively stable one. Horizontal roof or floor beams transmit their weight, and that of anything resting on them, vertically down through the walls that support them. Sometimes beams are cantilevered beyond the supports as in some medieval houses where the upper floor is jettied* out, and in some contemporary architecture.

Another method of spanning space is by arches, vaults and domes.[5] An arch is a structure of wedge-shaped blocks of brick or stone supporting each other by mutual pressure and able to support a weight from above. Arches may be openings in walls, they may form an arcade and be supported by columns, piers or pilasters, or they may be freestanding as in ancient Roman aqueducts and triumphal arches or gateways. The most common arches are flat*, semi-circular, segmental* or pointed but there are other more complex shapes such as the ogee* and the four-centred* arch. Fully developed brick arches can be found as early as c. 3600 BC in Egypt and Mesopotamia. The wedge-shaped stones or bricks are called voussoirs. The voussoir at the top of the arch is called a keystone and is sometimes larger than the other blocks. An arch transmits its own weight and that of the wall or roof above it laterally or obliquely on each side. This transmission of weight is known as a thrust or pushing force and if it is a lateral thrust it takes a curved path sideways to the ground. The voussoirs in an arch are in compression. The

Figure 5.3 Schlumberger Petroleum Research Laboratories, Cambridge, 1985
(Michael Hopkins & Partners) (photo: © Dave Bower)

lateral thrusts push the voussoirs against one another and they push against
the springings and the abutments of the arch. The springing is the point at
which the arch rises from its support, which might be a pier or a wall; the
abutment is any solid structure such as a pier or wall which resists the thrust
of an arch or vault. During construction arches require a supporting frame-
work because until the last stone is inserted, usually the keystone at the top,
the structure is unstable. If the arch is an opening in a masonry wall then the
lateral forces are taken by the wall on either side.

A vault is an arched roof or ceiling. It may be tunnel-shaped or it may be a
groin vault which consists of two barrel- or tunnel-shaped vaults joined at
right angles. The junctions between the curved vaults are called groins (see
Figure 4.1). A domical vault sits on a square, circular or polygonal base and
is a groined vault in which the groins are semi-circular (rather than semi-
elliptical as in a groined vault). A rib vault is a framework of diagonal arched
ribs which support the infilling of stones or panels in between and a fan vault
consists of a series of curved semi-cones radiating out from an impost* to
meet or nearly meet at the apex of the vault. Vaults have provided many
opportunities for ingenuity, and careful observation will reveal many
patterns of ribs and types of vault.

A dome is a convex covering over a circular, square or polygonal space
and domes may be hemispherical, semi-elliptical, pointed or onion-shaped

(Figure 5.4). Vaulted roofs and domes can be found in many ancient Roman buildings such as basilicas* and bathing establishments. They are also found in Byzantine churches, some ancient Buddhist stupas or burial chambers and in mosques. In Europe, gothic architecture of the middle ages exploited the vault and during the renaissance it became a challenge to revive the Roman dome for centrally planned churches. Vaults and domes historically have been constructed of stone and brick but concrete was first employed in a dome by the Romans. The Pantheon in Rome, c. AD 100–125, was the largest concrete dome of its period. In the twentieth century domes are frequently built of reinforced concrete.

Like the arch, vaults and domes produce lateral forces which need to be counteracted. The thrusts acting within the structure of a dome have a tendency to split it open at the bottom. To counteract this horizontal or outward thrust, renaissance domes constructed of stone were sometimes encircled with iron chains. In ancient buildings the lateral forces from roof vaults or domes were resisted by the exceedingly thick walls upon which they rested. Large windows to admit plenty of light were not easily made in such thick walls. Large windows and thinner walls required the use of buttresses or other means to take the lateral thrust of the vaults and domes. The work of the buttresses was sometimes supplemented in medieval cathedrals by the walls of side chapels located at right angles to the nave* wall. Flying buttresses carry the weight of the vaulted roof laterally via an arch over side aisles, ambulatory* or chapels to the vertical part of the buttress. This enabled later churches and cathedrals to have tall naves pierced with large clerestory* windows. We tend to think that the pinnacles on top of buttresses in gothic churches, or the statuary and balustrades encircling domed roofs, are there for purely aesthetic reasons. The additional weight on walls and buttresses that they provide helps to stiffen the wall and deflect any lateral thrusts towards a more vertical path and safe transmission to the ground.

Roof trusses, ubiquitous since the middle ages, but originating in Rome are triangular structures which span space.[6] The lower beam, or collar, is in tension holding the ends of the diagonals of the truss in place. The thrust of a truss resting on walls is vertical. However, if the collar is not located low on the truss there is a tendency for the diagonals or rafters* to spring outwards, taking the walls beneath with them. Trusses are usually named after particular features in their construction. A king post truss has a central vertical member standing on the tie beam which rises to the apex of the roof. Queen posts consist of a pair of vertical timbers placed symmetrically on a tie beam which rise to the side purlins* and principal rafters. During the middle ages builders in Britain, keen to make use of the space in timber trussed roofs or at least enjoy it unobstructed by tie beams, sought ingenious methods of dealing with the lateral thrusts. The hammerbeam* truss is one example but there are many other varieties of truss construction (Figure 5.5). Barns,

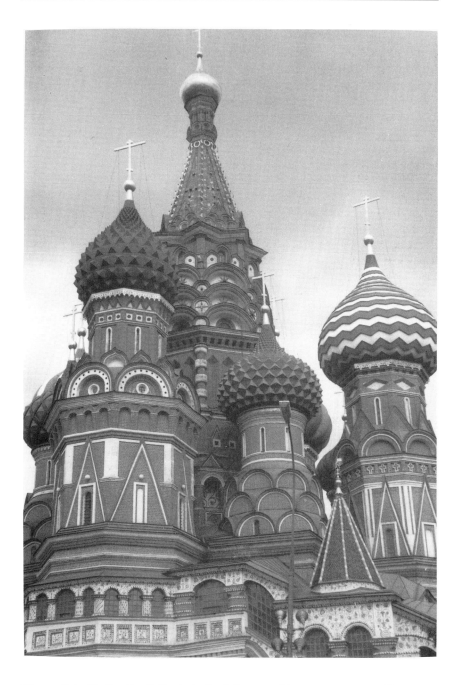

Figure 5.4 St Basil's Cathedral, Red Square, Moscow, 1554–60 (Barma & Postnik) (photo: © Hazel Conway)

agricultural buildings and churches, where ceilings have not been put in to hide the roof construction, offer wonderful opportunities to explore this variety. A good architectural guide book will help in identifying the names of the different types.

Developments in steel technology and, in recent decades, in computers to calculate the forces at work in particular structures have led to the application of the space frame to span very large spaces with a minimum of intervening vertical supports. Made up of numerous connecting bars or tubes and struts, some space frames are curved and others form an extensive horizontal platform. These complex structures are able to resist forces in any direction and to span far greater areas than any traditional methods of building, so achieving the uninterrupted open floor spaces which are now demanded in supermarkets, offices and factories. They were pioneered by designers such as the American R. Buckminster Fuller* who developed geodesic domes in different materials such as timber, plywood, aluminium and prestressed concrete* from the late 1940s (Figure 5.6). Recent pioneering examples include the Bartle Exhibition Hall, Kansas City Convention Centre, Missouri, 1976, by Helmut Jahn of C.F. Murphy Associates; the Sainsbury Centre for the Visual Arts, Norwich, 1975–8, by Norman Foster Associates, and the Waterloo Station Extension, London, 1992, which is curved in two directions (Figure 5.7).

Floors

In many vernacular structures ground floors may consist of soil or clay rammed until firm and in some cases covered with flagstones or bricks. Problems of cold and damp, particularly in temperate climates, led builders to construct raised timber floors supported on low brick walls or, more cheaply, to create solid ground floors of concrete. Where necessary, these latter are protected by a dampproof membrane of bitumen, asphalt or polythene sheet on top, within or underneath the concrete. Timber floors, whether at ground level or at upper levels, are composed of joists (or beams) which span the smaller width of rooms and rest either on corbels or timber or metal wall plates on or within the wall. The joists are usually boarded over. From the seventeenth century in England there is evidence of the upper floors of buildings being constructed by laying down bulrushes or fixing reeds to laths and then covering them with plaster. This made a very durable floor. If the floor is at an upper level the underside may be covered by a lath and plaster ceiling, although today such ceilings would probably be constructed of plasterboard. In order to leave space for services such as electric wiring or pipes, false or suspended ceilings made of timber, metal or other material may be hung from the floor to leave a gap between the boarding and the ceiling.

Reinforced concrete floors may span wider spaces, are more fire-resistant

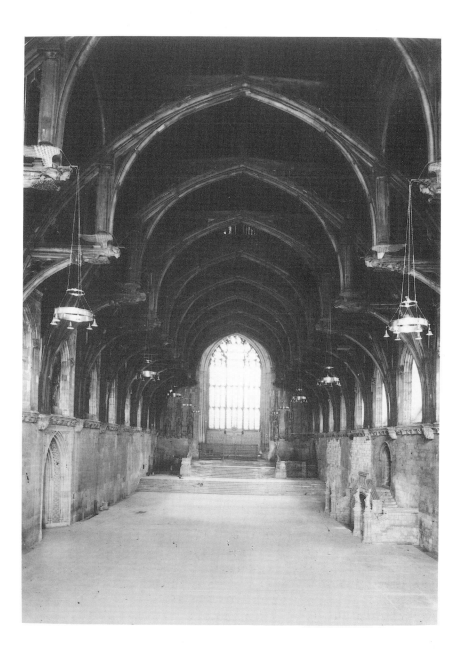

Figure 5.5 Hammerbeam truss, Westminster Hall, London, 1394–1401 (Farmer Collection, House of Lords Record Office: reproduced by permission of the Clerk of Records)

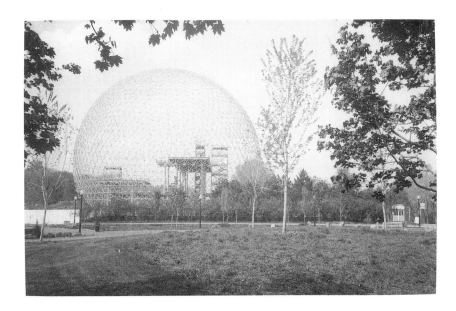

Figure 5.6 Geodesic dome, Montreal, 1967 (R. Buckminster Fuller)
(photo: © Hazel Conway)

Figure 5.7 Waterloo Station Extension, London, 1992 (Nick Grimshaw)
(photo: © Hazel Conway)

and may support greater loads than timber floors of similar dimensions. They can be of varying design from monolithic slabs to closely spaced hollow reinforced concrete beams covered with a layer of concrete.

Roofs

Roofs protect buildings from the weather and may be flat, pitched or curved. Vaults often have a timber truss built over them to protect them from the weather and flat roofs may consist of a timber, metal or reinforced concrete-framed horizontal platform. Pitched roofs are supported on a triangular frame or truss made of wood or metal and they can be of many different shapes, some of the most common types being the simple pitched roof, the hipped and the mansard roof.

The gables or end walls of a building with a simple pitched roof rise straight up and form an inverted V shape which conforms to the slope of the roof. Sometimes the roof is carried over the gable and shelters the wall. Bargeboards are constructed to protect the ends of the roof timbers and these may be ornamented by carved detail. Roof timbers might also be protected at the end by taking the gable wall above the roof. The sides of such gables might be raked, shaped with curves and capped with a pediment as in Dutch gables or the brick courses may be left uncut at the ends and staggered to provide a stepped profile as in Scottish crow-stepped gables.

Hipped roofs have no gables: the ends slope like the sides. Mansard roofs, or gambrel roofs as they are called in the USA, are pitched or hipped roofs with two inclined planes, the lower slope being longer and steeper.

The construction of flat roofs, whether of timber or reinforced concrete, is similar to that of floors. Although they were made fashionable by modernists in the twentieth century and have been much criticised in Britain owing to poor design, inadequate materials and bad construction, flat roofs have been common in Mediterranean vernacular architecture for centuries. Flat roofs can be horizontal or inclined, the slope being designed to permit rainwater to run off. In timber roofs the slope is generally achieved not by sloping the joists, but by nailing lengths of timber to the top of each joist. These strips or firring pieces are either tapered or vary in height on successive joists.

The appearance of roofs can be greatly affected by the materials employed to cover them. Domes may be covered with lead, copper sheeting or tiles. Flat roofs, which may encourage water to settle, need a material with few joints for water to seep into, and so large sheets of asphalt*, bitumen felt or non-ferrous metals such as lead, copper, zinc or aluminium are employed. Pitched roofs may be thatched or covered in overlapping flat, modular materials such as slates, stone slates, tiles of clay or concrete, which are fixed to the roof timbers using wooden pegs or nails. They may be finished at the apex or ridge with plain or decorative clay ridge tiles. In rural areas roofs

may be covered in turf or more commonly thatch. Among the most common thatching materials are sedge, reeds, heather, grass and straw. Thatch is relatively lightweight and is employed where walls are least substantial, for example as a roofing material for cob* or mud-walled cottages. Roof pitches often depend on the type of roof covering employed and can vary greatly although the minimum pitch tends to be 25 degrees. To ensure the rain is thrown off quickly before it can sink in, thatch roofs are usually fairly steep. When pantiles* are employed, the roof pitch is sometimes gentler towards the eaves to check the flow of rainwater where it might splash uncontrollably into the gutter. If a very heavy covering material is used such as stone slates, common in the Cotswolds in England, then the roof support needs to be very sturdy.

Roof texture and colour differ according to the covering materials. Hand-made tiles and some slates are not of very regular size and shape, and can vary substantially in colour. This irregularity gives roofs a soft rustic appearance compared with the mechanical look of machine-made tiles or Welsh slate, which by the nineteenth century could be cut with great precision into evenly shaped and sized pieces. Some of the most beautiful slate or stone roofs use graded units with large slates at the eaves and decreasing sizes towards the apex of the roof. In Mediterranean countries the Spanish clay tile* or curved tile is common. Each course is laid with convex and concave surfaces alternatively facing upwards. Clay pantiles which are S-shaped each incorporate both concave and convex shapes, so that every tile can overlap the next. Both Spanish tiles and pantiles create roofs of very bold texture and make a comparatively heavy roof covering. They are particularly good on shallow pitched roofs but their form is not very suitable where roofs have dormers, hips* and gables because the sharp angle of the junction between adjacent roofs, for example where a dormer window breaks through a roof, is difficult to make weatherproof. The simplest solution is to cover the junction with lead or specially moulded tiles. Where flat tiles or slates are employed on the main body of the roof and no time or expense is spared, small wedged-shaped flat tiles or slates can be carefully overlapped across the junction to create a gentle curve or swept valley.

Foundations

Foundations distribute the loads of a building over a sufficient area of ground to prevent the subsoil spreading and to avoid unequal settlement of the building. Unequal settlement may be caused by variations in the weight of the building at different points and by differences in the nature of the subsoil which could damage the building's structure. The design of foundations depends on the nature of the subsoil and the size and weight of the building. Historically, foundations have varied considerably. Some buildings, such as pole and *dhaka* huts in Africa where posts are set into holes in

the ground, have none, others have brick footings or courses at the bottom of the wall, and some may have piles* or rafts of timber or reinforced concrete. A tall building with an adjoining low-rise block will require two different types of foundation with a flexible joint between the two which will accommodate the differences in settlement.

There are basically four main types of foundation, strip, pad, raft and piled, which may be designed in a variety of ways. Essentially strip foundations consist of a continuous strip running the length of loadbearing walls, and pad foundations are square or rectangular blocks placed under individual piers of brick, masonry, steel or reinforced concrete. The weight on the ground of columns or piers of multistorey framed buildings can be very great, particularly in locations where the subsoil is particularly unstable. A raft foundation is a platform which floats on the subsoil and supports all the bearing* elements of the building, spreading the load over a larger area of ground than that directly under any one element. In parts of Chicago the depth of the Niagara limestone bedrock is over 100 feet below ground level. The soil above this consists of sand, clay and gravel interspersed with waterpockets which created great problems for the builders of the earliest US skyscrapers.[7] Until the development of drilling techniques that enabled builders to sink firm foundations down to the underlying rock, Chicago engineers developed a reinforced concrete raft on which all the piers rested. Pile foundations are columns, of wood or reinforced concrete, driven or cast into the ground in order to carry foundation loads. They may be taken down to a deep, firm subsoil or rock or, if they are friction piles, they are held up by the friction and adhesion to the soil in contact with them.

In areas subject to earthquakes the building design itself has to be sufficiently elastic to take the movement of the ground. Traditional Chinese buildings of wood employed mortice and tenon joints. This is a joint between two members or pieces of timber at right angles to each other. The mortice is a slot in one member into which a tenon or projection from the other member is inserted and glued or pinned. In ancient Chinese buildings these joints could move and there were no deep foundations under columns, so that the whole building was able to shift during an earthquake. A building which did withstand an earthquake when all else succumbed was Frank Lloyd Wright's Imperial Hotel in Tokyo, 1916–22. Unable to take foundations down to rock, Wright floated the foundations on the mud. The building itself was constructed of many parts which could move independently and under the centre of each section of the hotel he built reinforced concrete posts upon which the floor slabs were cantilevered out like a waiter carrying a tray with upraised arm and fingers at the centre. The perimeter walls were supported on their own system of posts and only lightly touched the ends of the floor slabs. This permitted each part of the building to move independently during a tremor and then return to its original position.[8]

THE METHODS AND PROCESSES OF CONSTRUCTION

If we look at building sites today we can see that even with advanced technology an enormous amount of human labour is still used in construction. Employing skilled and semi-skilled labour may be expensive, and construction using manual labour can be a slow process. There may be problems with quality control and in a climate such as Britain's, work may be held up for days by bad weather.

Prefabricated buildings, the components of which are manufactured prior to quick assembly on site, can minimise some of these problems. Timber-framed buildings are an example of prefabricated buildings. They are composed of a series of frames, such as the side walls, cross walls, floor frames and roof trusses, which are made up before building begins. Iron buildings, the parts of which are manufactured in a factory, have been known for more than a century and they were made for a wide variety of purposes from chapels to exhibition buildings, railway sheds and baths (Figure 5.8). The best-known early example was the Crystal Palace erected in Hyde Park in 1851: its iron frame, wooden glazing bars and glass were manufactured elsewhere and brought to the site for assembly, and the whole building was completed in eleven weeks. The prefabricated buildings exported from Britain in the mid-nineteenth century were initially made of cast-iron columns and panels and subsequently of corrugated iron panels, which were lighter in weight and cheaper. Hospitals for the Crimea, churches and houses for prospectors in Colorado, and cotton factories for Egypt were among the buildings that were exported and assembled on arrival at their destination (see Figure 10.12). These were transportable buildings and temporary in that sense, but permanent in the sense that the materials were virtually indestructible.

Today many high-rise buildings are constructed by the fast-track or design-and-build method. This means starting the construction on site before the design is complete. Waiting for the full details of the design to be completed is costly in time and money so building starts on the basis of roughly estimated costs and a schematic design which defines the main structural system and its materials. The design is then developed by the architect and engineer, or builder in design-and-build, as building proceeds.

Modular materials

Some of the materials used in buildings are modular consisting of small units which are brought together in a variety of ways to construct walls, to span spaces, to infill wall frames or to cover roofs. One of the most ubiquitous is stone. There are many varieties of stone that have been used in buildings, each with its own special qualities of colour, texture, weathering properties and possibilities for carving or cutting. There are numerous ways to cut,

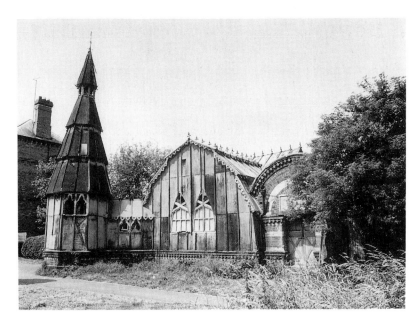

Figure 5.8 Baths, Tenbury Wells, Worcestershire, 1862 (James Cranston) (photo: © Rowan Roenisch)

dress and lay stone, each affecting the look of the final building. Some stone is naturally fissile* and therefore can be made into thin slabs suitable for roofing or facing walls. The majority of stone is used for walling.

Many stone-walled buildings are of rubblestone. This means that the stone is of uneven shape and size and is generally relatively hard. It is common in humble buildings and is economical because every piece of stone can be used. Rubblestone may be employed in its rough form, that is randomly, to build walls that are levelled up every foot or so in height, or it may be roughly squared and placed in courses according to the size of the stone. Because of the unevenness of the material, rubblestone walls require large amounts of mortar to bed each layer of stone. Mortar is usually made from lime, sand and water.

In drystone walling no mortar is used and the stability of such construction depends on the weight of the stone and the accuracy with which it is positioned. The wall tends to be battered* or slanted inwards, the two sides of the wall being constructed separately of carefully laid rubblestone so that rainwater runs away from the centre of the wall. The centre is filled with large stones and every so often long stones are laid which run right through the wall. Drystone walling is common in many parts of the world for low walls between fields. A monumental use of drystone walling can be found at

Great Zimbabwe, a royal palace constructed in southern Africa from the thirteenth century onwards. The hill and valley enclosures and the tall conical tower are built of huge curving walls of granite (see Figure 3.3).

Ashlar consists of smoothly cut stone, usually in thin slabs, which is used to face walls built of rubblestone, brick or concrete. Often of comparatively large size, the blocks of stone are squared and the smooth sides make fine joints and level courses possible. Limestones and sandstones make good ashlar walling but only certain selected stone from the quarries is suitable: this is called freestone. Freestone is stone that is of sufficiently even and fine grain to permit cutting in any direction. Because of the work involved in cutting and dressing the stone, that is trimming and finishing the surface, and the high quality of the stone involved, ashlar tends to be very expensive. Sometimes buildings have only the front wall in ashlar, the rest being of rubblestone. On other occasions buildings with rubblestone walls may have ashlar dressings. This means that the stonework at the quoins or corners, around openings and perhaps the stonework of the plinth*, and along the top of the wall under the eaves would be of ashlar masonry in order to give a more precise or refined finish. The dressings of stone buildings may also be of contrasting materials such as brick (Figure 5.9).

Brick

Brick made by hand or machine is one of the most commonly manufactured walling materials. Made of clay pressed into a mould to create an appropriate shape, bricks can be sun dried or baked (fired) in a clamp or kiln. There are many varieties of fired bricks and they differ widely in colour, texture and form. In general bricks are rectangular and of a size to be easily held in the hand. When looking at a wall we sometimes see the small end of the brick only: this we call a header. If the long side is on the surface of the wall we refer to it as a stretcher. However, the size and shape of bricks varies substantially. Thin Roman bricks, which look more like tiles, were used by the ancient Romans to create bonding courses at intervals in rubblestone walls or for the facing of walls. In the middle ages bricks tended to be large and rectangular and were often of rough and uneven texture and colour, some being blackened by over-firing, others pale because of variations in the composition of the clay or because they were under-fired. From the seventeenth century onwards soft bricks suitable for carving were made. Specials, or special bricks, would be moulded to virtually any size or shape and used for vaulting, chimneys, stringcourses*, plinths, copings* and the detailing of eaves and openings. Today bricks can be of very smooth texture and very hard. Powered machinery is used to mix the clay and remove impurities and large stones from it so preventing a rough texture. Architects may choose strong bricks that are impervious to water to build dampproof courses at the bottom of walls or they may select bricks of a particular dimension, texture

Figure 5.9 Cottage of granite with brick dressings, Newtown Linford, Leicestershire, (photo: © Rowan Roenisch)

or combination of colours for decorative purposes. Frank Lloyd Wright, for example, wished to emphasise the horizontal in his prairie houses and used a long, narrow brick as one of the techniques to achieve this.

The many different methods for laying or bonding bricks subtly affect the appearance of the wall. The bond is the regular pattern in which the bricks are laid in courses. Two common and structurally strong bonds to look out for are the English and the Flemish: the former has alternate courses of stretchers and headers, the latter has alternating stretchers and headers in each course. Both these bonds create firm walls that are two bricks thick with bricks that run through the thickness of the wall. Stretcher bond consists of courses made up of stretchers only. The wall may be an infill wall, just one brick thick, which we call a half brick wall, or it may be a cavity wall. A cavity wall is composed of three elements. It has separate inner and outer leaves of brickwork and an air space between for insulation and to prevent damp passing between the two leaves. Cavity walls became common in the west from the beginning of the twentieth century. In barns where ventilation is required brickwork may form an openwork honeycomb pattern. If bricks are used as an infill material in a frame structure – called brick nogging – a more imaginative pattern such as herringbone* may be deployed.

From the seventeenth century in England craftsmanship in brick began to reach unprecedented levels. Sometimes the joints between bricks are extremely fine and the decorative aprons or panels under windows, sunken panels over windows and the columns and pilasters are also in brick. To achieve these effects, either bricks were moulded or special fine, soft bricks were used which could be cut and rubbed; this is known as gauged brickwork.

Mortar

The character of stone or brickwork can be affected by the colour of the mortar and its usage. Mortar may be coloured to match the main walling material or made to contrast sharply. Jointing may be deeply recessed, project boldly as in ribbon pointing, be very fine or weathered, that is angled to throw rain from the joints. Where stones are very irregular and require large quantities of mortar, galleting, or small stone wedges, are set into the mortar to counteract the rocking or movement of the stones. Sometimes this technique is used more decoratively, as by Antonio Gaudí at the Finca Güell in Barcelona where sparkling, coloured glass fragments are employed.

Wall finish

The regularity, size and shape of modular building components used for walls, together with the type of joint, determine the pattern or texture or the

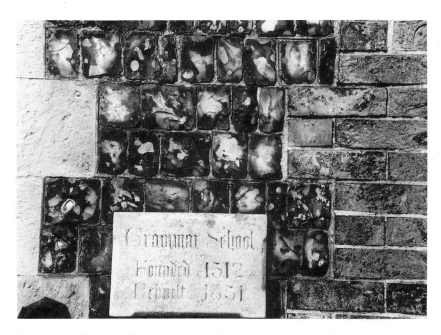

Figure 5.10 Knapped flint wall, Lewes Grammar School, Sussex, 1512
(photo: © Hazel Conway)

wall and the appearance of scale. Modular materials produce a variety of textures. Figure 5.10 shows the texture of knapped flint, which is called flushwork*.

Smooth textured walls may be made of any material if the surface is planed or finished but this can be an expensive process and a common method is to use a clay or cement render. Render may be made of wet clay or plaster or a mix of cement, lime and sand. Generally walls are rendered when they are made of inferior materials such as mud, rubblestone or poor-quality bricks. In Scotland harling has long been a vernacular technique to protect walls from the driving rain. Called roughcast or pebbledash in England, harling is a render in which the final coat of mortar contains pebbles which give a rough texture to the wall and are believed to provide good resistance to wet.

Clay render may be decoratively moulded or have painted patterns; plaster render is sometimes pargeted, that is decorative designs are moulded or incised in the plaster surface. From the late eighteenth century in England to the mid-nineteenth century it was fashionable to render and paint the brick walls of classical-style buildings in imitation of fine ashlar stone work. In classical buildings the plinth or basement is often made of large, roughly hewn blocks of stone called rustication. Mortar joints are deeply set so that deep shadows are cast giving an appearance of massiveness or heaviness even

in quite a small building (Figure 5.11). An illusion of heavy rustication may be achieved on a brick or stone wall by the use of sgraffito. That is, a plaster or stucco* render is incised so that the differently coloured coat underneath shows through. At the Schwarzenberg Palace, 1545–67, in the old city of Prague, the whole building is covered in sgraffito to give an appearance of heavy rustication (Figure 5.12).

In many early modernist buildings the architects wanted the walls to look as smooth as possible to suggest that they were just a lightweight protective skin with an underlying supporting frame structure of steel or reinforced concrete, so they used cement render and paint to give a smooth finish (see Figure 8.3). However, in line with a further desire for simplicity and a break from traditional detailing, many modernists also eliminated details that would have deflected rain away from wall surfaces. Walls soon became streaked and required regular maintenance. Le Corbusier had to confront the problem of concrete finishes not matching at the Unité d'Habitation, Marseilles, 1946–52, owing to the employment of many different contractors during the long period of construction. At a time when he was also becoming more interested in rough textures his solution was to express the wood grain finish left by the shuttering once the concrete was struck. Concrete surfaces can have a wide range of textures depending on the grade of the aggregate used, the surface of the mould or shuttering into which the concrete is poured and the tooling or dressing of the surface afterwards. Much labour may be employed in tooling or bush-hammering concrete surfaces after they are removed from the shuttering to give an appropriate texture.

Materials as a means of dating

With experience, the use of particular materials, constructional techniques and types of detail may offer clues to the dating of buildings. The dating of natural materials is often difficult although there are scientific tests available for some of them. For example the horizontal section of a tree trunk reveals growth rings of differing width as a result of weather variations each year that the tree was growing. Specialists in dendrochronology can use their knowledge of the pattern of tree ring widths as aids in the dating of timber. Other authorities have attempted to date medieval timber-framed buildings by identifying changes in the techniques for joining timbers together.[9]

If we know when certain materials were manufactured or when certain techniques were in use, then we may be able to date a building. The rough textures and uneven shape and size of hand-made medieval bricks in England gave way in the seventeenth century to bricks which were still hand-made but of more even texture, shape and size. A fashion also developed in this period of using Flemish bond. Early hand-made bricks contrast sharply with the smooth texture, regular colour and precise shape and size of

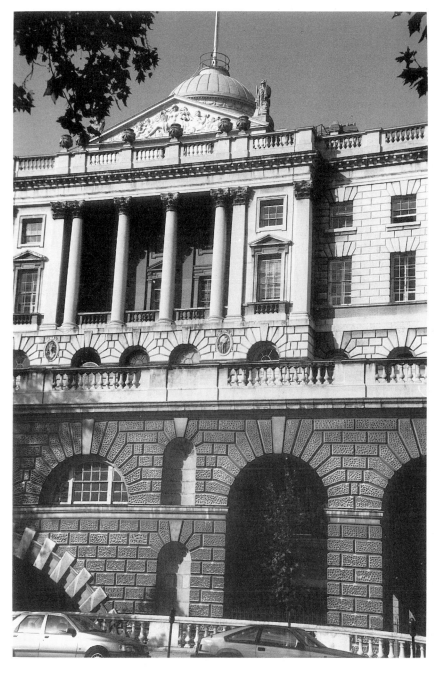

Figure 5.11 Somerset House, London, 1776–1801 (Sir William Chambers*)
(photo: © Hazel Conway)

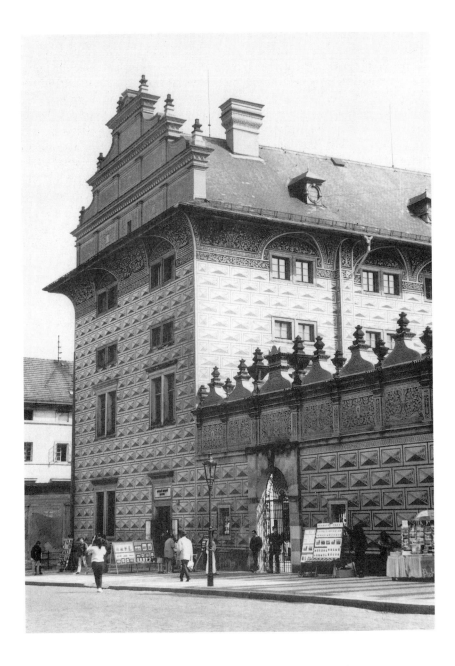

Figure 5.12 Schwarzenberg Palace, old city of Prague, 1545–67
(photo: © Hazel Conway)

machine-made bricks which were introduced and widely used from the mid-nineteenth century. However, in the late nineteenth century arts and crafts architects disliked the regularity and monotony of machine-made bricks and again began to use bricks made by hand. We therefore need to be careful in dating buildings by their materials and cannot assume once a new method of manufacture is introduced that it will always be used from that date. Older, redundant buildings are often ransacked for materials which can be reused in new buildings. We know for example that the Anglo-Saxons, who did not make bricks themselves, reused the distinctive, large flat bricks of the Romans who had conquered England centuries before. During the Reformation, with the dissolution of the monasteries, many churches and religious buildings were used as quarries for building materials and stone from these buildings can often turn up in a later building. We may be able to date a piece of medieval timber but may not know when it was used for construction purposes or whether it had been removed from an earlier building. We need to be wary of making quick assumptions about date, and cross-check with stylistic and documentary evidence.

Chapter 6

The exterior

The external appearance of buildings is the result of many factors, some of them practical, others cultural or geographic. How the spaces within are arranged, the materials and system of construction, the way the architect has designed the building to take account of the weather or express the status or function of the building, largely determine what we see as we approach. In northern Europe or the United States of America domestic buildings today may be recognised by the scale of the front door, the chimneys, or the shutters and curtains at the window. But if we are in North Africa or the Middle East then all we might see of a dwelling would be a blank wall facing the street and a small entrance, for all the rooms face onto an interior courtyard. In Britain we have come to associate churches with towers and spires, and castles with turrets* and battlements*, but we should not assume that all buildings with these features are either churches or castles (Figure 6.1).

SIZE AND SCALE

The overall proportions and scale of a building are often largely determined by the spaces within and are related to the type of building, its status and location. Some of the buildings which are large and can be readily seen rising above their surroundings do so for practical reasons. Mills, factories, grain stores, power stations and gasholders are required to be large to house many people, big machinery or products (see Figure 2.8). The silhouettes of dominating chimneys belonging to mills and factories are designed for the mundane but essential purposes of carrying smoke and fumes up into the higher currents of air and providing sufficient draught for the boilers. Cinemas of the 1930s were big because they had to accommodate large audiences and some had a tower and neon-lit signs to attract attention. Today the largest buildings are often office blocks, but in cities such as Paris the height of new buildings is controlled to maintain the character of the historic fabric and tall office buildings have been confined to outlying areas such as La Défense. By contrast in the 1950s the ban on high buildings was

lifted in London and the city witnessed an outcrop of commercial skys-
crapers positioned at the intersection of major roads. The idea was to
terminate vistas, but it led to a scattered effect and dwarfed neighbouring
buildings.

In many cultures the buildings which are large and stand out from their
surroundings are those that serve a civic, religious or community purpose.
They may be large for practical or symbolic reasons or both. Religious
buildings, in particular, reveal much ingenuity and variety of form such as
the tall pagodas in the Far East which pile up tier upon tier, pyramids in
ancient Egypt, the stepped forms of pre-Columbian temples in Central and
South America and the flying buttresses, towers, spires and domes of
churches and cathedrals in western Europe. Important government and civic
buildings are often monumental. Their size is partly dictated by the number
of people who use the building and partly to suggest the dignity, seriousness
and the significance of their status in society. In the nineteenth century some
British city administrations proudly vied with each other to create the most
spectacular and impressive town hall (Figure 6.2).

A building may be a large or small example of its type. The main branch of
a bank in the town centre will probably be large and grand whereas the
subsidiary branch on a shopping street in the suburbs will be smaller and less
conspicuous. The home of an important landowner in the country may be a

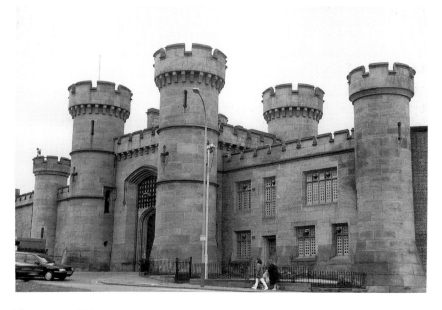

Figure 6.1 H.M. Prison, Welford Road, Leicester, 1825–8 (William Parsons*)
(photo: © Rowan Roenisch)

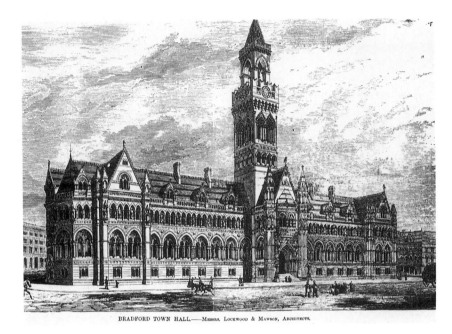

BRADFORD TOWN HALL.——Messrs. Lockwood & Mawson, Architects.

Figure 6.2 Bradford Town Hall, 1870–3 (Lockwood & Mawson*) (*Builder*, 1872)

grand mansion on a prominent site while a rural worker's cottage will be small with a comparatively modest garden. While the size and complexity of a building may be a sign of wealth, this is not necessarily so. Chiswick House is set in spacious grounds on the west side of London and seems quite elaborate at first glance, although it is comparatively small (Figure 6.3). Indeed according to Horace Walpole it was too small to live in and too large to hang upon one's watch chain and he thought that in order to enjoy it, it would be better to live opposite rather than in it. In fact Lord Burlington* built Chiswick House to house his collection of paintings and he lived in the house next door. Mies van der Rohe's Farnsworth House, Fox River, Illinois, 1946–50, is the antithesis of elaborateness, yet it was so expensive to build that it led to the most acrimonious court case between the patron, Dr Farnsworth, and her architect (Figure 6.4).

Sometimes the scale of a building is designed to deceive us. A large building may be detailed so as to look smaller or larger. Barningham Hall, Norfolk, designed for Sir Edward Paston, is a very large building but it appears smaller because it is divided up vertically into a number of different elements (Figure 6.5). Terry Farrell's* dramatic Embankment Place over Charing Cross Station (Figure 6.6) may not be much taller than other buildings alongside it but its horizontal scale makes it appear considerably

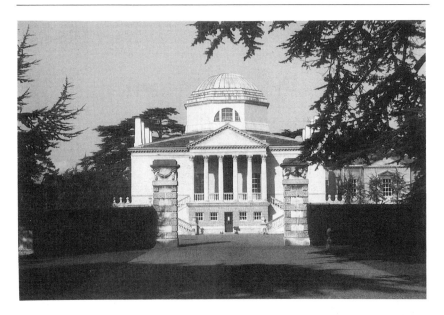

Figure 6.3 Chiswick House, London, 1725 (Lord Burlington) (photo: © Hazel Conway, courtesy of English Heritage)

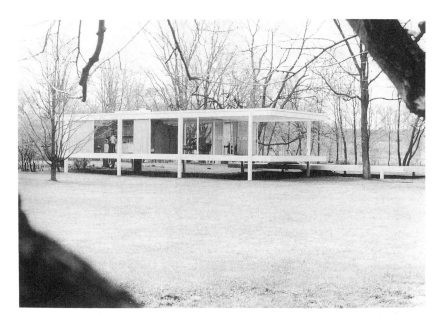

Figure 6.4 Dr Edith Farnsworth House, Plano, Illinois, USA, 1946–50 (Mies van der Rohe) (photo: © Adrian Gale)

bigger than its neighbours. The lateral expansion and bulk of such buildings has given them the name groundscrapers. A tall building may have its height minimised by the horizontal emphasis of ribbon or long windows, balconies or a flat roof. Alternatively Louis Sullivan's* tall, multistorey office building, the Guaranty Building, Buffalo, 1894–5, has its height exaggerated by increasing or emphasising the vertical elements of the façade such as the vertical supports of the frame and the window mullions. An emphasis on tall chimneys, a steeply pitched roof or tall, narrow windows will have the same effect.

Scale may be used to emphasise certain features of a building. The scale of an entrance may be enlarged to draw attention to it or to lend significance to the building; or it may simply be large because it is to be used by large numbers of people. At Amiens cathedral, the doorways in the west front are made to appear larger and more impressive than they really are (Figure 6.7). The huge buttresses between each doorway are united with the architrave* to create great cave-like porches lined with multiple tiers of elaborately carved sculptural decoration. The use of rusticated stonework on the ground floor or basement of palaces and banks is designed to give a sense of massiveness and protection. Sometimes relatively small features may be exaggerated to lend unexpected drama to a façade. A common example is the use of an enlarged keystone over an opening, a feature that was developed in mannerist* architecture of the sixteenth century in Italy.

FAÇADES

Although buildings are three-dimensional and may be viewed from four sides, and from above if from an aeroplane, we usually only see one side at a time. Most commonly it is one façade that first confronts us and makes the initial impression on us. Many buildings front onto a street and are designed so that the street façade is more important than the others. The street façade is usually the one that contains the main entrance and often the most important rooms will look over the street. We call this the main façade. It is often designed to impress visitors and it will perhaps include sculpture or elaborate decoration. The rear and sides of the building which are not seen so often may employ cheaper materials and be relatively plain. The first-century BC Indian stupa (see Figure 4.2) was designed to be viewed all round by devotees who walked round its periphery. In the twentieth century modernist architects chose to design their buildings like discrete sculptural objects to be viewed from any side. They rejected as 'façadism' the idea of giving special attention to one façade, so in many of their buildings no one façade is given prominence and the quality of materials and design is maintained all around the building. We need to learn to look at buildings all the way round in order to discover where the main emphasis is and whether there is a principal façade.

Figure 6.5 Barningham Hall, Norfolk, 1612, west façade (photo: © Hazel Conway, courtesy of the owner)

Figure 6.6 Embankment Place, London, 1991 (Terry Farrell) (photo: © Hazel Conway)

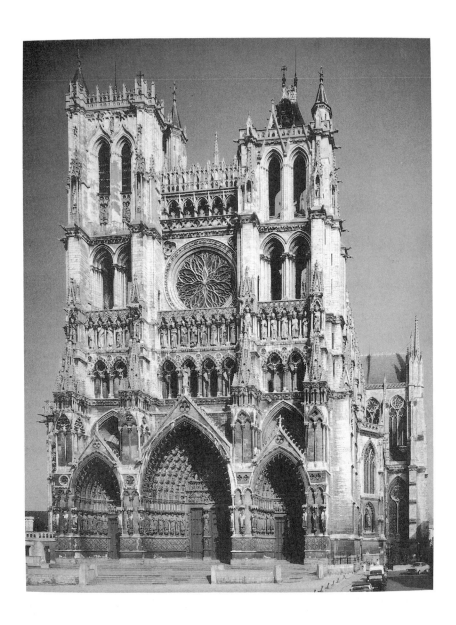

Figure 6.7 West Front, Amiens Cathedral, Amiens, France, begun *c.* 1220
(© Hermer Verlag)

DESIGN AND THE CLIMATE

The exterior is designed to keep the heat or rain out, and the warmth in. Small windows with louvred shutters are common where there is strong sunlight, for when closed the shutters permit air to circulate but keep out the hot sun. Bungalows in the British colonies traditionally employed large verandahs on those sides of the building which faced the sun. In hot climates large overhanging roofs with deep eaves may both effectively shade a building and shed heavy tropical rains. The gutters and drainpipes on such buildings are very capacious compared to those necessary in more temperate climes. When Le Corbusier designed the government buildings in Chandigarh, the capital of the Punjab, India, he created huge, overpowering sculptural roofs which not only shield the buildings from the monsoon rains and the blast of the sun but lend monumentality to the building, and perhaps represented an expression of the westerner's response to such dramatic weather (Figure 6.8). However, he also used a huge overpowering sculptural roof on that little jewel, the chapel at Ronchamp in France, where the climate is temperate.

Very steeply pitched roofs are necessary where there is heavy snowfall for if the snow cannot be thrown off its weight puts great pressure on the structure beneath. The positioning of gutters and drainpipes will provide

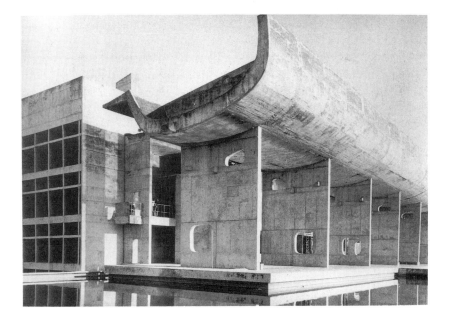

Figure 6.8 Palace of Assembly, Chandigarh, India, 1956–62 (Le Corbusier) (© Fondation Le Corbusier/Spadem)

clues as to how the rain is kept out and the detailing of walls and openings may be indicative of a response to climate. The coping of walls and parapets, projecting cornices, drip moulds* over openings and sills beneath windows are all designed to throw the rain clear of the wall, windows or doors. Stringcourses which mark the floors in buildings of more than one storey may also be designed to deflect the rain. Windows are often set back from the face of the wall to protect them from the rain but the London Building Act of 1709 required openings to be set back 4 inches from the face of a wall as a fire precaution to reduce the risk of the flames licking across the façade and setting alight adjacent openings. Wooden cornices at eaves level had also been forbidden in an earlier Act of 1707 for similar reasons. In other words, many of the details that we today regard as adding character to a building had practical origins.

In some buildings elements which are essential to protect the building from the weather may be hidden and their visual impact minimised. In classical buildings where clarity of form is given precedence it is often difficult to see how the rain is dispersed from the building since drainpipes are hidden within walls or relegated to the rear, parapets hide the pitched roof and gutters, and in the case of some buildings by Edwin Lutyens* the gutters are set into the sloping roof and can only be detected by a break in the slates two or three courses from the eaves. To create crisp, geometric, undecorated forms modernists designed buildings with minimal, if any, sills below windows or weather coping above openings and at the top of walls. This has led to the concrete surfaces of the walls becoming streaked where the rain washes over them in areas where the climate is inclement.

In countries where there is little rainfall flat roofs offer opportunities for roof gardens and solariums. Modernist architects used flat roofs and roof gardens regardless of the weather. Central to the modernist use of the flat roof were Le Corbusier's 'Five Points of Architecture' in which he argued the merits of the frame structure in an urban context where space was at a premium. He suggested that if a building was raised on pilotis or piers, there would be no damp basement, and gardens and pedestrian routes could be placed under it. Instead of losing the land to buildings the flat roof and the space beneath the building could be used to bring nature back to the city. In the reaction against modernism flat roofs have been criticised for leaking and considered alien to cultural traditions in countries such as Germany and England. For the postmodernists the flat roof has become synonymous with the evils of modernism and, to make buildings homely to look at and weatherproof, a pitched roof is now obligatory.

SECURITY AND PRIVACY

While some buildings have exteriors that are open and welcoming to strangers others are deliberately forbidding. Forts and castles require

massive, battered walls with few openings, save slits for firing arrows to deter attackers. Their defensive purpose lends a bleak monumentality to their form. Prisons too are usually encircled by high walls with few openings. At the Bank of England, London, John Soane ensured that natural light only entered at roof level through lanterns and clerestory windows set high in the walls. In southern Africa the windows in the bungalows of Europeans have burglar bars and the gardens are usually surrounded by high walls and fences sporting obvious alarms and 'fierce dog' notices. Similarly the houses in Los Angeles with their notices 'armed response' are witnesses to the gap between rich and poor. Today shopping malls may attract shoppers with a broad colourful canopy over a large doorway but architects of blocks of flats, concerned to minimise vandalism and crime, may deliberately design the main door to be unobtrusive to discourage casual visitors.

Light within interiors is usually essential but the design, size and location of windows may be related to other factors, not least privacy. The increase in window size in the mid-nineteenth century in England may be attributed to the ending of duty on glass in 1845, coupled with the repeal of the window tax in 1851, and the availability of plate glass from the mid-1840s. As a result four-pane sash windows and bay windows became very fashionable and contributed to the move away from classical proportions in façades. Concern for maintaining the dignity of church services has encouraged architects to design urban churches with no aisle windows low enough for people in the street to peep through; windows are placed at higher levels in the triforium* or clerestory. Although propriety and the need for privacy ensure that the windows of bathrooms and toilets in dwellings are often small and glazed with frosted glass some modernist architects were so keen to light their interiors well and to express all the internal spaces of the building that they designed prominent glazed staircases on the exterior. Perhaps they forgot that at night residents would be seen moving about the dwelling in their night attire, or not as the case may be, unless the windows were well draped by curtains.[1]

MASSING AND LIGHT REQUIREMENTS

Except in classical buildings the location and the varied sizes and shapes of the internal spaces tend to be expressed in the external massing of the building, its overall proportions and shape. In India, the Middle East or any country where there is a sizeable Muslim community a domed building adjacent to a tower will indicate the large central praying space of a mosque, the tall minaret or tower offering a place from which the muezzin or crier calls the faithful to prayer (Figure 6.9). In Christian communities a cross-shaped building with a tower and spire may tell us that this a church. The cross is composed of a long nave and transepts where the worshippers are seated and processions of the clergy take place. The smaller block at the east

end of the church which houses the altar is called the chancel or apse*. Comparable to the function of the minaret, the tower is designed to attract worshippers, in this case through the chiming of the bells which are housed within. Sometimes the windows may hint at the nature of internal spaces and their functions. A large rectangular building in a town centre which has a large display window at ground-floor level is probably a shop. A large building with many regularly spaced large windows and a chimney may be a nineteenth-century mill or factory. If there is no chimney and the windows are small it may be a warehouse but in Manchester cotton warehouses needed large windows so that the cloth could be examined. The particular characteristics which indicate that a building was designed for a specific purpose often result from the expression of internal spaces and lighting requirements on the exterior.

From the mid-nineteenth century arts and crafts architects designed asymmetrical buildings with irregularly spaced and sized windows to try to suggest something of the layout and lighting of the internal spaces. The exterior forms of Philip Webb's* The Red House, 1859–60 (Figure 6.10), built for writer and designer William Morris, are fairly explicit in this respect. The main living spaces for the owner are in a separate wing of the house (right); the service and servants' wing is in a block at right angles (left). Jutting out from the internal angle between the two wings is a smaller rectangular block with its own hipped roof containing the main staircase with a window on each face lighting each of the two flights of stairs. Internal passageways running between the two wings are lit by a series of regularly spaced tall rectangular windows at ground-floor level and a row of circular windows on the first floor. Above the garden entrance (right) are two windows sheltered by a roof at right angles to the main roof of this wing. This roof hints at a room, the study, running across the end of the block at first-floor level. It is well lit by the double windows. In contrast a single window lights a small servant's bedroom upstairs at the end of the service wing. In this wing the small servants' stair is lit by a tall, narrow window symbolically suggesting in its form vertical access, and around it tiny windows illuminate separate utilities such as pantry, larder and lavatory.

The internal arrangements of spaces within buildings are not always explicitly revealed to the viewer outside. The regular spacing of windows one above the other in a symmetrical, classical house will indicate the number of floors in the building (see Figure 2.5). It may suggest through the use of taller windows the significance and grandness of the first-floor reception rooms called the *piano nobile*. The façade would, however, offer few other clues as to how the space within is subdivided. Each window could represent one room, or several windows could line the wall of one large room. Some classical buildings of the eighteenth and early nineteenth centuries may reflect something of internal needs. During this period many classical buildings in England had blocked-in windows. Although it may be

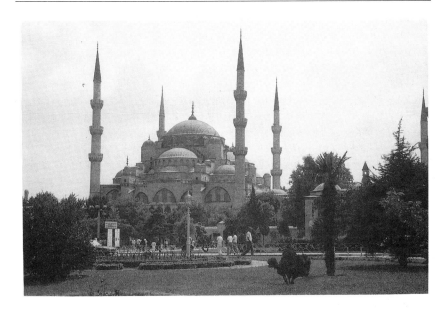

Figure 6.9 Suleimaniyeh Mosque, Istanbul, Turkey, 1550–6 (Sinan) (photo: © Hazel Conway)

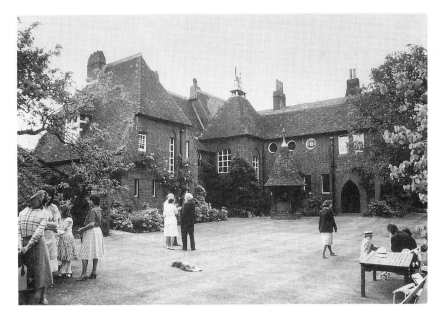

Figure 6.10 The Red House, Bexley Heath, Kent, 1859 (P. Webb) (photo: © Rowan Roenisch, courtesy of E. Hollamby)

tempting to attribute this to the Window Tax, 1696–1851, which was levied on the number of windows in a property, many buildings of this period have blocked-in windows because the size and layout of internal spaces and their air and light requirements did not match the regular layout of openings required by classical design. The exterior of a Georgian terrace has vertical windows aligned one above the other and repeated rhythmically along the row. At regular intervals, at ground-floor level, a door substitutes for the window opening. The strong vertical accent of the façade could be said to suggest the vertical alignment of living spaces within, where residents live in rooms set one above the other with hallway and stair to one side. When such terraces are converted to office use sometimes the internal spaces are united by knocking down walls to create horizontal open-plan office space at each floor level. The internal layout is then no longer reflected in the vertical emphasis of external forms.

A glass curtain-walled office building suggests a large open-plan interior on each floor but in practice the floors may be variously subdivided by partitions as in the buildings of Mies van der Rohe. His buildings were designed to offer open flexible space suitable for the changing needs of the users. Although each was for a particular purpose often the final form is a neutral-looking box that expresses nothing of the particularities of each function so that a commercial office block and residential apartments had little to distinguish them other than curtains in the latter. At Lake Shore Drive apartments, Chicago, 1950, Mies tried to ensure that none of the residents put up curtains as this would ruin the positive forms of the façade. The profiles of skyscrapers do not have to be a single box shape to reflect the frame structure. In New York in 1916 the zoning law required skyscrapers to be stepped back to permit sufficient light and air to reach adjacent closely packed buildings. This created the distinctive staggered profiles of New York's tall buildings. The housing for the lift mechanism and other servicing equipment can offer opportunities for more complex shapes, as we noted in the Lloyd's Building, London, and to provide variety and interest some architects have created gothic profiles such as the Chicago Tribune Tower, Chicago, by Raymond Hood and John Mead Howells*, in 1922, which has gothic pinnacles and flying buttresses. More recently, in 1967, Kevin Roche, John Dinkerloo & Associates* designed three adjacent pyramids to house the College Life Insurance Company of America Headquarters in Indianapolis, Indiana, USA, and Philip Johnson & John Burgee* used the form of a lipstick for 885 Third Avenue, New York, USA, in 1983–6 (Figure 6.11).

Many architects have enjoyed creating sculptural and dramatic effects by the massing of their buildings. In India, the piling up of huge curving forms in Hindu temples to create a series of peaks, the highest placed over the most sacred part of the temple, the *garbhagriha* or sanctuary, was designed to symbolise cosmic mountains or the sacred place of the gods (Figure 6.12).[2] Buildings in the baroque style in Europe were so named because they were

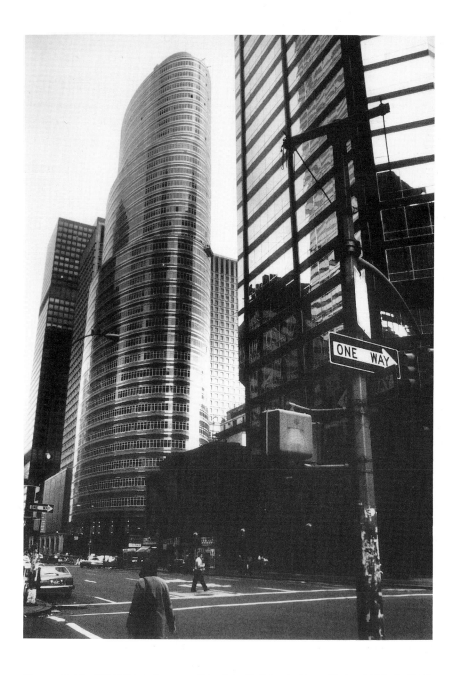

Figure 6.11 885 Third Avenue (Lipstick Building), New York, 1983–6 (Philip Johnson & John Burgee) (photo: © Hazel Conway)

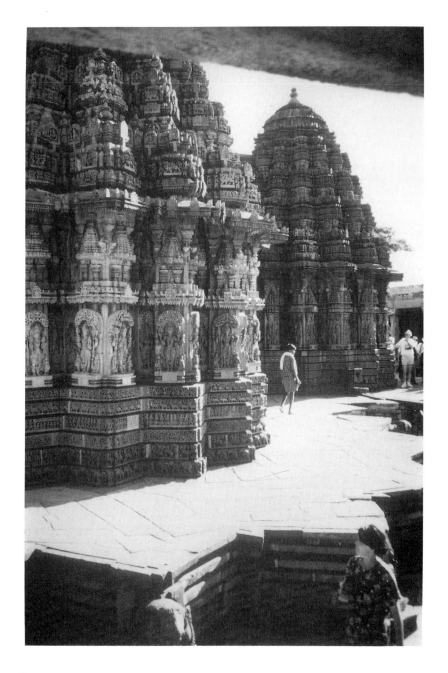

Figure 6.12 Keshava Temple, Somnathpur, southern India, 1268 (photo: © Ian Spencer)

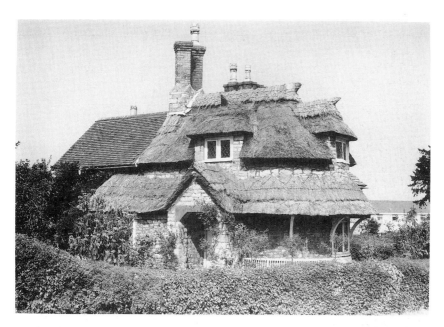

Figure 6.13 Blaise Hamlet, Avon, 1810–11 (John Nash and John Adey Repton) (photo: © Hazel Conway)

originally considered to be of odd and extravagant shape.[3] The word 'baroque' was originally a jeweller's term applied to a rough pearl.[4] The bold, sculptural undulations of baroque façades create theatrical and enticing entrances to buildings in contrast to the symmetrical repose of buildings by Bramante* or the Renaissance architects of the preceding generation (see Figure 2.4).

In England in the eighteenth century architects of the picturesque style* were inspired by seventeenth-century paintings of the Italian countryside by artists such as Nicolas Poussin and Claude Lorrain. The buildings depicted in the paintings seemed to blend harmoniously with the landscape and the architects looked for ways to make their buildings more sympathetic to the natural features of the site. They looked back to the sculptural forms of the baroque and they broke with classical symmetry to create buildings of irregular form. Theorists such as Uvedale Price* argued for the placing of large chimneys, urns, vases and obelisks* on the roofs of buildings to make the roofline more interesting and varied. The small irregular cottages by John Nash* and John Adey Repton* at Blaise Hamlet and the irregular skyline of John Soane's Dulwich Picture Gallery with its lantern, urns and sarcophagi illustrate some of the different interpretations of the picturesque (Figures 6.13 and 6.14). Downton Castle's asymmetrical and castellated*

Figure 6.14 Dulwich College Art Gallery and Mausoleum, London, 1811–14 (Sir John Soane) (photo: © Martin Charles)

forms, designed by the picturesque theorist and architect Richard Payne Knight,* were picturesque in massing as well as being symbolic. The house crowned the natural and rugged hill on which it stood and Knight saw it as representing a crown on the head of Mother Nature (Figure 6.15).[5]

EXPRESSION OF STRUCTURE

Another way to think about the exterior form of buildings is in terms of the structural elements that are essential to making them stand up. Some buildings openly express their structure, in others it is given little prominence.

The huge, defensive loadbearing walls of forts and castles are openly expressed, as are the buttresses to support vaults or domes which regularly punctuate the walls of medieval churches and mosques. In the late eighteenth and early nineteenth centuries in Britain it became fashionable to use stucco to suggest ashlar and disguise brick which was considered a mean material. Later in the nineteenth century, the introduction of ethical principles into architectural design encouraged architects to do away with stucco and expose the brick in all its glory. The arts and crafts architect C.F.A. Voysey* built buttresses to support the walls of the houses he designed for middle-class clients (Figure 6.16). He exploited these structural features to give variety to the very austere, undecorated exteriors and to provide bays with benches sheltered from the wind in which the occupants might sit.

Timber-framed buildings, when they are not covered in plaster, clearly emphasise the structural framework of posts and beams. In the eighteenth century, rationalist theorists and architects in France such as the Abbé Laugier sought a more simplified architecture after the heavy, sculptural baroque and frivolous and ornate rococo styles. Laugier believed that buildings should be stripped to their essentials and that the supporting elements of the structure were the most significant characteristic. The ideal for architects to aim for in the design of buildings was an idealised 'primitive hut'. This he described as a simple structure without walls, an arrangement of vertical tree trunks with branches which arched overhead to provide shelter. This was translated into architectural practice in terms of reducing extraneous ornament and honestly expressing the structural elements of the building, especially columns or piers in trabeated structures. These were principles which twentieth-century modernists admired along with a love of the austere, undecorated forms of much industrial architecture. The designs of Mies van der Rohe best exemplify this with their external expression of the skeletal frame structure. In fact, owing to fire regulations, the structural frames of his buildings are usually cladded and not quite as openly expressed as we might think. Indeed at the Lake Shore Drive apartments non-structural I beams are attached to the façade at regular intervals almost like decoration to give a bold vertical rhythm. Mies spent many hours studying their profile to achieve the precise effect he was looking for.

DECORATION

The decoration of buildings may be the result of the use of particular features or materials, or it may take the form of painted or sculptural surfaces. During the Middle Ages in Europe glass in church windows was subdivided by branching curved mullions* carved in stone which we call tracery, there were diaper patterns in brickwork using burnt headers, and structural timber framing was employed in an ornamental manner. In Italy

Figure 6.15 Downton Castle, Herefordshire, 1772–8 (Richard Payne Knight) (photo: © Rowan Roenisch, courtesy of the owners of Downton Castle)

Figure 6.16 Perrycroft, Colwall, near Malvern, 1893–4 (C.F.A. Voysey) (© British Architectural Library, RIBA)

during the renaissance church façades might be decorated with coloured marble facings. Architects of high Victorian gothic buildings in the mid-nineteenth century in England exploited the many materials that were now more readily available to them owing to the development of canals and railways. Their buildings were designed proudly to expose stone or brick of many different colours which lent a visual richness to the façades and which we call permanent polychromy. Concern for the appearance of buildings in the dirty smog-laden air of nineteenth-century British towns and cities also encouraged the use of coloured terracotta because it was a material that resisted the dirt.

Decoration may take the form of painted or sculpted surfaces. Many of the mud-plastered dwellings of Africa are painted with coloured clays and ashes and the dwelling of the tribal chief may have very elaborate painted or carved decoration to signify his status within the community (Figure 6.17). In India, Hindu temples are strikingly decorated with carved stone figures. These may represent divinities, or maidens and embracing couples which symbolise fecundity; there may be dancers, musicians and foliage. In some buildings these sculptures are set in sheltering niches or recesses in the wall but elsewhere intricate carvings cover the walls regardless of any need for protection from the elements (Figure 6.18). In medieval cathedrals the sculptural decoration is part of a symbolic programme and designed both to educate and impress visitors; at Amiens the sculptural decoration reaches a crescendo in the west front (see Figure 6.7). Tiers of statues representing the Last Judgement flank the deeply projecting portals, the tympana* contain relief sculpture, a row of kings fills the gallery below the huge round or rose window, and stone water spouts or gargoyles are carved into representations of figures or animals.

In the 1930s art deco factories and cinemas were enriched with decorative façades to make them appear up-to-date and enticing and glamorous (Figure 6.19). Instead of utilising tired motifs drawn from the gothic or classical styles architects looked for something more modern or exotic. The Chrysler Building in New York by William van Alen* is appropriately decorated with motor car motifs and has a stainless steel dome. Other buildings eclectically draw motifs from ancient Egypt, Aztec culture, pleated shapes from expressionism, and modernist geometric forms. This colourful and jazzy decoration was applied to tiles, stained and leaded glass, carved in stone, and made of coloured enamel or terracotta. Contemporary with art deco other architects and designers in Europe and the USA sought simplicity as a reaction against what they saw as the over-decorated forms of nineteenth-century architecture. Some were modernists, others were working in a classical style. Classicists reduced or stripped the decorative details of their buildings to the minimum. Modernists employed rational and ethical arguments to justify reduced ornament and in many cases used no ornament. After the Second World War many cities and towns were redeveloped

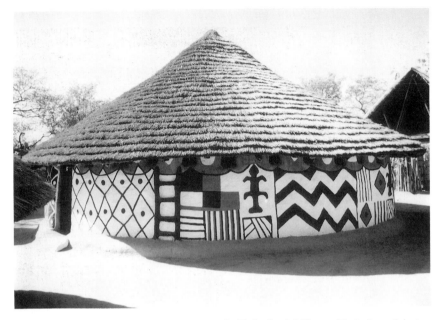

Figure 6.17 Hut of a Venda chief, Victoria Falls Craft Village, Zimbabwe (photo: © Rowan Roenisch)

according to the modernist aesthetic ideal of simplicity, honesty and expression of structure. Often the architects and developers were of modest talent and they created bland, undecorated buildings and severe environments of concrete. In reaction to this the pendulum of taste has swung in the opposite direction in recent years and once again we are learning to appreciate ornament and decoration as part of postmodernism.

There are many approaches to aesthetics and decoration. Postmodernists imply that modernist buildings with little or no decoration are alienating and cannot be expressive or pleasing. While this may be true of some modernist buildings, architects such as Le Corbusier were deeply concerned with aesthetics and the western cultural tradition. The roots of Le Corbusier's architecture lie in the geometry and the proportions of the temples of ancient Greece and the vernacular architecture of the eastern Mediterranean. Far from being a mere 'functionalist' concerned with the practicalities of planning and construction, Le Corbusier wrote in his book *Vers une Architecture* that architecture is 'a thing of art, a phenomenon of the emotions . . . The purpose of . . . architecture [is] to move us.'[6] In buildings such as the Villa Savoye at Poissy of 1928–9, the sculptural forms have beauty because of their clarity and simplicity. Le Corbusier felt that they were appropriate to the modern world because they were similar to the geometric forms of so many contemporary products of mass production and the factory such as

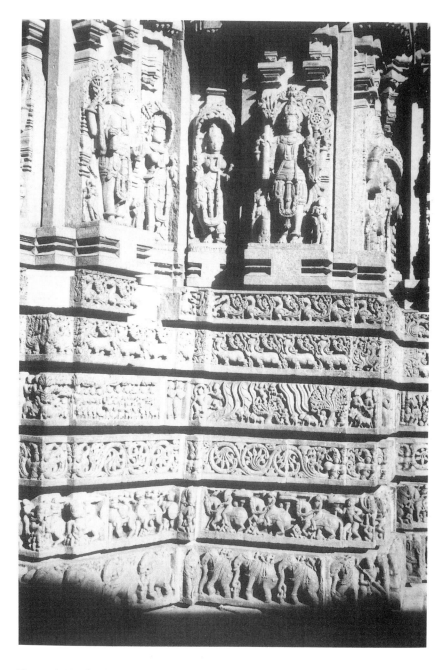

Figure 6.18 Sculptural decoration, Keshava Temple, Somnathpur (photo: © Ian Spencer)

bottles and aeroplanes (see Figure 8.3). In this sense he believed that the forms of his buildings were not only beautiful but expressive of the age in which he lived.

Postmodernists utilise decoration in many different ways. Classical forms and decoration may be used to encourage people to feel comfortable with buildings and to harmonise buildings with their surroundings as at Richmond Riverside, London, by Quinlan Terry, 1988 (see Figure 2.2). The classical forms also lend status to this office complex. In domestic architecture the reuse of the forms of the Georgian town house or the application of classical columns to a porch are seen as metaphors which confer prestige and individuality. Following the sale of council houses in Britain in the 1980s the new owner-occupiers have tried to make their property distinctive, for example by replacing plain glass in windows with patterned stained glass and leaded lights, relining brick walls with stone cladding, painting the woodwork in a bright colour, building a porch or hanging coach lamps on either side of the front door. Decorative and practical elements are combined to express the owners' new status.

A concern to democratise traditional architectural forms underlies the postmodern free-style classicism of the Théâtre and Palaçio d'Abraxis, Noisy-le-Grand, Marne-la-Vallée, France, by Ricardo Bofill* and the Taller

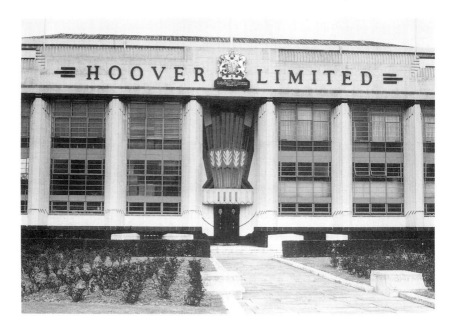

Figure 6.19 Hoover Factory, London, 1931–2 (Wallis, Gilbert & Partners) (photo: © Rowan Roenisch)

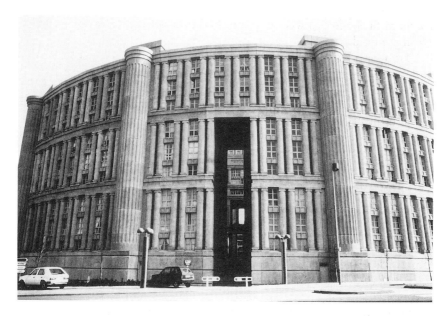

Figure 6.20 Théâtre and Palaçio d'Abraxis, Noisy-le-Grand, France 1978–82 (Ricardo Bofill and the Taller de Arquitectura) (photo: © Rowan Roenisch)

de Arquitectura, 1978–82 (Figure 6.20). An eighteen-storey block of flats for the lower end of the owner-occupier market, the building imitates the scale and forms of a huge palace such as Versailles. The architects argued that

> the exercise showed us it was possible to build symbols (theatres, temples, triumphal arches, etc.) which . . . could be transformed into habitable spaces . . . that it was important to be able to use the vocabulary and elements of the architecture of the past and to bring these within the reach of the whole society.[7]

Unfortunately symbolism took precedence over practicality and some of the flats have low ceilings and poor lighting owing to the fact that the classical forms imposed restrictions on the fenestration. Moreover, the columns have been transformed into living spaces or house the emergency stairs. Other postmodernists use decoration to make lighthearted witty jokes. The TVAM studio at Camden Lock in London by Terry Farrell, 1983, has a row of fibreglass eggs in eggcups perched on the jagged roofline to symbolise the fact that the company produces breakfast-time programmes.

THE CHARACTER OF THE FAÇADE

If we look at the forms of the façade, we may notice certain features are more prominent than others. The façade may be symmetrical or asymmetrical. The general emphasis may be vertical or horizontal. Tall chimneys, doors and windows and very steeply pitched roofs contribute to a vertical stress. Ribbon windows, flat or very shallow pitched roofs and long balconies may contribute to a horizontal stress. The number and size of features can alter the character of a façade. Few small openings place the stress on large areas of wall, a solid mass; many large windows break up the wall emphasising the voids. The façade may appear simple or complex and it may appear quite different at different times of day according to how the light falls on it. The emphasis on the various elements determines whether an aspect is stressed or if the façade is balanced.

Façades can be subdivided into vertical sections which we call bays*. The divisions may be marked by any regular vertical feature such as arches, columns, pilasters, buttresses or windows. Thus a façade can be discussed in terms of the number of bays and their treatment. The horizontal divisions of a façade may be marked by a plinth, the alignment of window sills and lintels, stringcourses, a cornice* or a flat roof. Some bays may be recessed, others may project such as at Dulwich College Art Gallery and Mausoleum, London, 1811–14, by Sir John Soane (see Figure 6.14). The windows and doors may be deeply recessed, there may be a deeply projecting porch or hood over the door, and there may be sculpture in niches, pilasters, engaged columns* or large buttresses subdividing the wall. The repetition of elements and their arrangement may create a rhythm within the façade. Many varied but repeated elements may suggest a restless rhythm, simple elements widely spaced may create a gentle rhythm, and many large, bold elements a vigorous rhythm. The spacing and size of elements may be utilised not only to create rhythms but to express emotions so that widely spaced columns may suggest a 'stately, serene, and meditative' feeling, while closely spaced columns may appear 'tense and forbidding'.[8]

HARMONY AND MODULAR PROPORTIONS

We all have our own tastes and preferences, and different cultures employ different aesthetic criteria. Nevertheless many buildings throughout the world which we admire and feel comfortable with have been designed according to carefully calculated proportions; we discussed this when looking at function and space. Close examination of a façade may reveal the use of a geometric grid, and if we measure the length and height of a façade, the dimensions of windows and their spacing and other prominent features which compose a façade, we may find the employment of related measurements based on ratios or harmonious proportions. The façade of Santa Maria

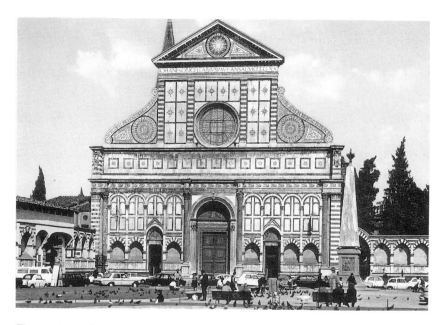

Figure 6.21 Santa Maria Novella, Florence, Italy, 1456–70 (Leone Battista Alberti) (photo: © Hazel Conway)

Novella, Florence, Italy (Figure 6.21), by the renaissance architect Alberti can be analysed in terms of proportions which are quartered, halved, doubled or tripled. It can be circumscribed by three large and equal squares, two side by side at the base and one centrally placed above. If these squares are subdivided into quarters we have the dimensions of the scrolls which flank the upper storey. The entrance bay is composed of six squares which are a quarter of the size of the squares used to give the dimensions of the scrolls; the height of the entrance bay is one and a half times its width. Further subdivisions reflect the same ratios and nothing can be added to or taken away from the façade without destroying its harmony.[9]

Many buildings which are simple and have little ornament give pleasure because of the careful use of proportions. Georgian terraces which consist of brick or stucco façades with undecorated openings rhythmically disposed can be very pleasing (see Figure 2.5). The clarity of design and harmony of their façades is determined by the proportions of an order, real or imaginary. If there is no order we call such buildings astylar. Looking at the pilasters between the windows we can see how its divisions, the base, shaft and capital, determine the horizontal divisions of the façade. The dimensions of this order also provide the module for determining the dimensions of windows and doors and their horizontal spacing. The best of modernist design also reveals a concern for proportion. Le Corbusier had his own

methods for ensuring pleasing proportions to lend dignity to the undecor-
ated forms of his buildings. He analysed both gothic and classical buildings
to determine the principles of the composition of their façades. Eventually
he developed his own proportional grids or 'regulating lines' and a pro-
portional system, called the Modulor, which we discussed in Chapter 4. The
Hungarian modernist, Erno Goldfinger, who worked chiefly in England
greatly admired buildings of the classical tradition and the stark drama and
austerity of Alexander Fleming House, Elephant and Castle, London, 1959,
is matched by the careful geometry and proportions of the boldly expressed
frame (see Figures 10.13, 10.14).

We can observe various features and the particular emphasis given to parts
of the building but to understand these fully we need to do more than just
look at façades. We need to understand the function of each part, the
distribution of spaces within the building, the materials and structural
system deployed and the approach to aesthetics of the architect or builder.
The final form of any building is the product, as we have seen, of many
influences and the exterior reflects not only the outlook of the patron,
architect and builder and their particular predilections, but the geographical,
social, cultural and economic context in which the building was constructed.
To appreciate buildings more fully it is essential to place them in this broader
context.

Chapter 7

Site and place

So far we have been concentrating on individual buildings, but we also need to stand back and consider their location, site and physical context. If we are visiting a building in person then we know where it is located, but if we are faced with a photograph or drawing, then we need to know about the building's geographical location and whether it is in a city, a small town, a village or in the countryside. We are used to seeing photographs of single buildings in books and magazines. These are often taken from the 'best' angle, in the most advantageous conditions, with the sun shining and when the building has been newly painted or just constructed. It is often quite a shock to see how different a building looks in reality, when it is not isolated artificially, but is seen together with its neighbours in perhaps less than perfect conditions many years later. A photograph often cannot tell us how a building relates to the road, to other open spaces such as squares, parking lots and gardens and to the neighbouring buildings, or what sort of access there is to it. A street map of the town or village, or an Ordnance Survey map of the district, may help us to build up a picture of the location.

There is always a practical reason for the location of buildings although it may not be apparent. Buildings have been grouped together for defence, for commercial reasons as in a market or a seaport, for religious reasons as in the great medieval monastic centre at Vézelay in France, or for leisure purposes as in the eighteenth-century spa towns of Baden-Baden in Germany or Bath in England. They may have been grouped to reflect the power of the king, the church, the government or the local landowner. A group of buildings by a crossroads may initially have started with an inn, which provided a resting place for travellers. In southern California the missions set up by the Spanish at the end of the eighteenth century were strategically placed a day's journey on horseback apart. With the industrial revolution, industrial centres grew up initially near appropriate water supplies to power the mills and subsequently near supplies of coal and iron. It was only with the development of the railways and the gradual introduction of mass transport that people could gain a measure of choice as to where they lived. Before then most people walked to work and so had to live nearby. What we think of as the

picturesque huddle of medieval buildings grouped around a church or market place had a practical basis that related directly to the distance between home and place of work. The crowded dwellings around a port such as London in the Roman and medieval periods related directly to the need to be near work that was casual and available on a first come, first served basis. If the initial grouping of buildings was for strategic, commercial, religious, industrial, governmental or leisure purposes, the layout of the town may still reflect that original purpose. Versailles outside Paris was built to testify to the power of King Louis XIV, while the layout of Washington reflected the power of the newly independent United States. In Bath the Royal Crescent and the Circus were created in the early eighteenth century in order to attract upper- and middle-class patrons to take the waters. Bath became the fashionable place to visit and to be seen, although some criticised the new layout and thought that after the completion of the Circus and the Crescent 'we shall probably have a Star; and . . . all the signs of the Zodiac exhibited in architecture.'[1]

Land that has been built on, or for which there is permission to build, is more valuable than agricultural land, and city-centre land is generally more valuable than land in the suburbs or on the outskirts of cities. The cost of land has a direct bearing on the types of building that it is economic to construct. The pattern of land ownership, the controls imposed by local authorities and the availability and cost of land may inhibit or encourage the architect or builder. If landowners are concerned to maintain property values when leasing out the land, they may impose controls on building quality which will affect the design. This indeed occurred on many of the large London estates when they were opened up to building development in the eighteenth and nineteenth centuries. Other factors may also significantly affect the quality and type of building. In the late nineteenth and early twentieth centuries the transport network of London expanded and the new train and underground facilities brought with them the opportunity of developing suburban housing ever more distant from the centre of London. The type of housing that was built depended not only on the cost of land but also on the fare structure available on the different lines. The development of areas of working-class housing in an arc to the north-west and north-east of London related directly to the fact that cheaper workmen's fares were available on the lines serving these areas.[2]

Today commercial buildings are built on inner-city sites and housing is rarely provided, not because it is not needed, but because the return on the capital investment would be too low. When we look at the location of buildings we need to consider what the commercial opportunities and limitations were. Towns and cities are not static, they change and evolve. Houses built for individual families may be broken up into apartments and bedsitters, and a once-prosperous residential district may then offer accommodation that poorer members of the community can afford. The location

of particular types of buildings also needs to be considered, for city centres change their character. Churches were built originally in the centre of towns to be accessible to the population. When these centres were taken over by shops, offices and other commercial ventures and the population moved to the suburbs, these churches became redundant and new ones were needed in the suburbs to serve the communities there. Today we are witnessing another major change in the location of a particular type of building, the shopping centre. New shopping centres and supermarkets are increasingly being located on the outskirts of town, with good parking facilities and often motorway links with other urban centres. As people still spend approximately the same amount on shopping, this means that city-centre shops suffer and are liable to be closed down. The assumption behind this new location is that everyone has access to private transport; and it disregards the elderly and those who do not own a car. The location of particular types of building may be due to zoning. As cities expanded and became more complex, so solutions were put forward for confronting their problems. Zoning was a solution that was widely adopted after the Second World War. It meant physically separating the industrial areas, the commercial centres, the cultural centres with their theatres, concert halls and cinemas and the residential districts. Zoning seemed at the time to be a way of solving the complexity and chaos of cities, but it has subsequently been recognised that it has led to other problems.

TOPOGRAPHY AND ORIENTATION

If a building is situated at the top of a hill, against a hill, or on level ground, or by a river, lake, or the sea, this information will enable us to determine whether its position is exposed or sheltered, dominating or hidden. A building set at the top of a hill is in an exposed, prominent position and this confers a significance which its size may not necessarily command. From this information we would also begin to understand if the building had been designed to take advantage of a particular view, or to turn its back on some eyesore. The orientation, or the direction that a building faces, is important in relation to climate. If we know a building's geographical location, its orientation and whether its main façade faces north, south, east or west, we are then in a better position to deduce whether it has been designed to take advantage of the sun, to catch any likely breezes, or be sheltered if the sun and wind are excessive.

In some cultures orientation has a deeper significance than the practical response to climate. Geomancy is an important aspect of Chinese culture and whenever a new construction is proposed the *feng shui* man is consulted on the most auspicious orientation and siting of the building. The basic principle of *feng shui* is that there are streams or currents of 'cosmic breath' that run through the earth. These strongly influence the fortunes

of individuals and their descendants, according to how they place their houses and their graves. Similarly, they influence the occupants of buildings such as commercial offices, according to the building's orientation in relation to the winds (*feng*), the waters (*shui*), the hills and the valleys.[3] The advice of the *feng shui* man was sought on the siting and orientation of the Hongkong and Shanghai Bank (Norman Foster Associates, 1986), and on such internal features as the angle of the escalators, in order to bring the maximum fortune to the enterprise.

The form of buildings may also be determined by the dimensions of the site and the desire for maximum profit. In Leeds the plots of land available for building on, as the city expanded towards the end of the eighteenth century, were long and narrow and owned by individual smallholders. These plots became available for building on one by one, and as they did so their owners were concerned to develop each plot to its maximum potential, regardless of how their development related to those on adjoining plots. The result was a warren of housing with no properly planned streets, and the development of a housing type that subsequently became associated with some of the worst slum features of the nineteenth century, the back-to-back. As the name implies, these houses were constructed in terraces or rows, sharing the rear wall with the next row. Because back-to-backs had doors and windows on the front only, there was no through ventilation and they had limited light. Moreover, the only running water was a standpipe which served a large number of dwellings, and people had to share communal privies. The filth that they had to live in and the consequent mortality rate became notorious.

The dimensions and features of a site are important in other ways. Some sites are an awkward shape and this may determine the form of the building. The Maison du Peuple in Brussels, 1896–9, was located on a circular *place* and its curved façade was designed by Victor Horta* to reflect this. Architects and builders may have to take into account, or may be inspired by, features on a site such as a rocky outcrop, a stream or trees. In Falling Water, Pennsylvania, Frank Lloyd Wright designed the house around the natural features of the rock and waterfall (Figure 7.1). Ernest Gimson's* Stoneywell Cottage at Ulverscroft, Leicestershire, was inspired by the nearby outcrop of granite which seems to merge with the cottage. The irregular forms of the cottage and varying floor levels also reflect the rock formation (see Figure 8.8). The use of local materials was another way of relating a building to its surroundings. This was a technique adopted by arts and crafts architects such as Edward Prior* and Charles Rennie Mackintosh* in Britain and by Greene & Greene in the USA.

So far we have been talking about buildings on sites on the ground. Above a building is open space which belongs to the building, up to a ceiling determined by the aviation authorities. In Chicago the ceiling is 2,000 feet. Air rights buildings are those built over other buildings or over structures

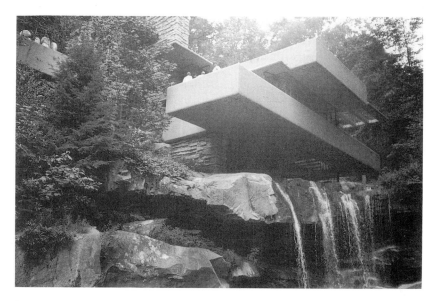

Figure 7.1 Falling Water, Bear Run, Pennsylvania, USA, 1936 (Frank Lloyd Wright) (photo: © Hazel Conway)

such as roads or railways. They are a new phenomenon that has resulted from new technology, coupled with the desire of landowners and developers to exploit the potential of expensive land in urban centres as fully as possible. In London there are examples of air rights buildings over existing railway termini at Charing Cross on the Thames (Embankment Place, see Figure 6.6) and at Liverpool Street Station. Although these buildings do not occupy a site on the ground we still need to relate them to their surroundings.

APPROACHES

The approach to a building can tell us many things. The scale of the path to the main entrance may be short and just wide enough for one or two people, in which case we would probably conclude that we are looking at a dwelling. It may be very long, lined with trees and large enough for cars and carriages and we may still be approaching a dwelling, but a much more imposing one. The approach may take us to an underground car park from which we enter the building and the main entrance may not be immediately visible from the street. The route to the main entrance determines how we approach the building and in a sense sets the scene for it. It may be a direct route or a circuitous one, it may be grand and imposing, friendly, mysterious, or menacing, and its design will affect how we first see our destination. At Chiswick House the approach via the entrance gates directs our attention

increasingly on the house in front of us (see Figure 6.3). It is a processional route, that is to say it is part of the design to reinforce the significance of the house and to focus our attention on it. A processional route is one of the ways in which the significance of a major building such as a palace, cathedral or monument is reinforced. The Champs-Elysées in Paris is a processional route terminated at one end by the Arc de Triomphe in the Place de l'Etoile. In New Delhi Edwin Lutyens designed the Viceroy's House to terminate the processional route leading to it, but the gradient between it and Baker's* Secretariat Building is such that the Viceroy's House is almost hidden until you are upon it. The Indian Government refused to alter the gradient to the gentler slope that Lutyens needed and he complained bitterly about having met his Bakerloo.

The classical emphasis of town planning involved positioning a major building, such as a church or cathedral, to close a vista, but not all major buildings were designed to terminate vistas. St Paul's Cathedral in London was designed by Sir Christopher Wren* to be glimpsed between the buildings around it. Wren's initial plan for the City of London after the fire in 1666 was based on the principle of churches, including the new St Paul's, terminating lengthy vistas. When this plan was rejected, his revised plan for St Paul's responded to the fact that rebuilding after the fire was already taking place and the cathedral was being enclosed by buildings, as it had been before the fire.

In baroque town planning, the most important building became the focus of not just the immediate surroundings, but of the whole urban environment. The seventeenth-century palace of Versailles designed for King Louis XIV was the focus of a series of avenues that radiated from it. Versailles provided the model for Potsdam and Karlsruhe, Germany, St Petersburg, Russia, and elsewhere in the eighteenth century. In Karlsruhe (1715) thirty-two avenues converge upon the palace. Pierre L'Enfant's* plan for Washington was based on similar baroque ideas, but instead of a palace, the focal points are the Capitol and the White House. From them streets radiate and cross each other (Figure 7.2). It is an interesting contradiction that a form of town planning associated with an absolutist monarchy should be applied to the capital city of a democracy opposed to virtually all the principles that Versailles stood for.

There is immense variety not only in the approach routes to buildings, but also in the materials used for them. The scale, colour and texture of the materials may have been chosen to relate to the fabric of the building and its surroundings in a particular way. Large paving stones will give a very different feel from gravel, small-scale bricks, cobbles or granite setts. If a fine-grained material is used the approach route will look like a continuous ribbon. The use of large paving stones with wide grouting*, or roughly cut setts, will break up this continuity and could have the effect of apparently foreshortening the approach route.

GARDENS AND LANDSCAPE

The approach to a building may be through a garden or landscape, which provides its setting. We need to understand the functions of this setting and the relationship between it and the building, but often the two are treated as separate entities. Gardens have many functions: they provide additional areas for dining, playing and entertaining, and these may be surrounded by hedges or other planting so that they indeed appear like outside rooms. Gardens have been seen as a form of earthly paradise: places for meditation and contemplation where the imagination is inspired; or places to relax and enjoy the surroundings. They need not feature plants, they may concentrate solely on medicinal or herbal plants, they may include a variety of small buildings; and they may embody important ideas of the society of the time. The major civilisations of the Middle East, China, India, Japan, Europe and the Americas have developed particular forms of garden (Figure 7.3). It is important to try to understand a house together with its garden and to understand what the functions of the garden were and how it was perceived when it was first designed.

In some periods, such as the early renaissance in Italy, the garden was distant from the house, sometimes on the other side of a road; in other

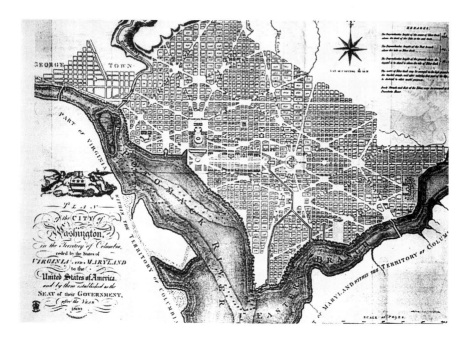

Figure 7.2 Plan of Washington, 1800 (Pierre L'Enfant)

periods the relationship between the two was most important. Designing the garden to give architectonic* support to the house implied giving a more formal structure to the garden near the house. One of the criticisms of Capability Brown's* eighteenth-century English landscapes was that he designed the informal planting of trees and grass and the gently rolling contours of the land to sweep right up to the house, which then looked as if it was sitting in a field. Formal planting near the house not only related to the symmetry and structure of a classically designed house, but also gave the inhabitants a more interesting view from the windows than trees, grass and cattle. The area around a house may also be designed as transitional space, partly inside and partly outside. Conservatories are a prime example, but terraces and patios also perform a similar function, for if they are sheltered they can be used even if the weather is not very good.

If the house and garden are located in the country the relationship between the garden and the surrounding countryside needs also to be considered. A view beyond the garden may not only provide delightful vistas; it may also encourage the owners to feel that their garden extends as far as the eye can see and this could increase their status. This is known as appropriation and Humphry Repton*, who was designing at the end of the eighteenth and beginning of the nineteenth centuries for the established landowners as well as for the newly emerging middle-class patrons, was fully aware of its charms to his clients.

We associate gardens primarily with houses because this is where they first developed, but other buildings are also landscaped, particularly today. The landscaping for a commercial or industrial building may include not only the access routes and car parks; it may also extend to the planting inside the buildings themselves. The recent introduction of atria has provided enormous opportunities for interior landscaping.

CHANGES IN THE SETTING

The surroundings, approach, the garden and the landscape around a building may have changed radically since it was first built. A once isolated country mansion or farmhouse may, with the expansion of a neighbouring town, be surrounded by more recent buildings; or the building of a new road may cut off part of the garden. Infill development may have taken place in the garden or in the spaces between buildings (Figure 7.4). We cannot understand the intentions of the architect, builder or patron if we are not familiar with the original site. Nor can we identify and appreciate the way a building was designed to respond to various features of the site if we do not know what it was like originally.

Similarly towns and villages do not stand still and the reasons for their initial development may long since have been replaced by something else, for

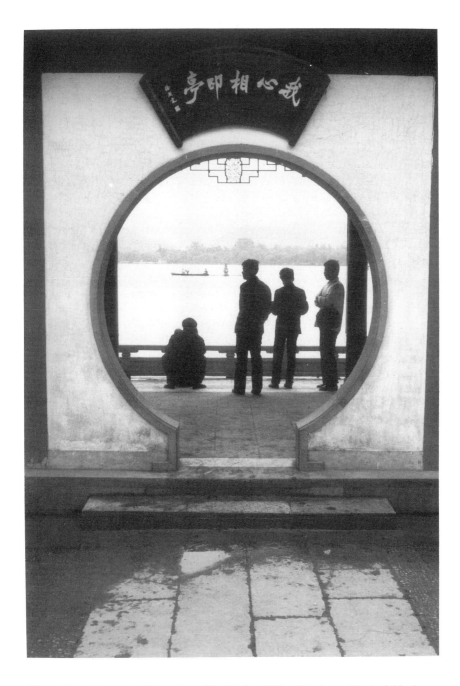

Figure 7.3 Moongate, Hangzhou West Lake, China (photo: © Rosie Atkins)

Figure 7.4 Crammant Cottages, Leicester, *c.*1850 (photo: Hazel Conway)

they will only survive if they respond to change. Today we prize towns and districts untouched by time, such as Bruges in Belgium, whose fortunes reached a peak in the fourteenth and fifteenth centuries. Since then time has passed Bruges by – until it was rediscovered by the tourist industry. If no new use can be found for them, then buildings, villages and towns may go into decline and ultimately disappear. Groups of buildings and indeed whole towns and villages may disappear for other reasons. Famine, flood, plague and war have resulted in whole settlements being wiped out and it may not be until many centuries later that their existence is revealed by excavation or by aerial photography. Changes in the policy of land ownership or the whim of patrons may also result in the wholesale removal of groups of buildings. In the mid-eighteenth century when English landowners were expanding their estates and enclosing common land, the view from the country house became all-important. If a village or hamlet happened to be in the way, it was removed and rebuilt as a model village elsewhere. Milton Abbas in Dorset designed by William Chambers* (1773–86) and Nuneham Courtenay in Oxfordshire are just two examples. Indeed Nuneham Courtenay was the subject of Oliver Goldsmith's poem, *The Deserted Village*.

Today the planning of new road or rail links can mean the destruction of whole areas, and redundant buildings such as docks and warehouses may be pulled down to make way for new developments. If historic buildings are

threatened by such development, they may, if they are deemed of sufficient importance, be saved by moving and reconstructing them – in industrial museums if they are industrial buildings or in museums of building. These museums provide excellent opportunities for seeing both the exteriors and interiors of a range of buildings. There are, however, a number of points to bear in mind on such visits. Firstly, since the buildings have been moved from elsewhere their setting is no longer the original one, even though the museum may have made a good attempt to recreate the original urban or rural setting. Secondly, all museums have to follow rigorous safety regulations to ensure the protection of visitors. Few of the buildings on display at such museums were designed with any form of fire regulations in mind, yet if numbers of visitors are to enter them, then the museum must ensure that they can leave quickly and safely. This may result either in alterations to the building, or more frequently in restrictions in the areas to which visitors are allowed access.

If redundant buildings are to survive then new uses must be found for them. This may also mean changes to their setting, or even a completely new use for that setting. Lofts in New York which were formerly warehouse space have been converted into prestigious apartments. If many such transformations occur, then an area will ultimately become gentrified; that is, it will change from a commercial to a desirable residential district. When the redundant Albert Docks in Liverpool found new uses as museums, shops, restaurants and housing, new uses also had to be found for the dock basins. These now flourish as marinas. Whole towns have changed their use: for example, colonial Williamsburg in Virginia is now a complete museum. At the other end of the scale changes in setting also include those that occur underfoot when an area is pedestrianised. This can mean changes in the materials, colour and texture of the surface, the removal of kerbstones and reducing the level of the pavement. All these changes affect the setting of the buildings and the approaches to them, and may affect their commercial viability.

DENSITY AND GRAIN

Another aspect of the physical context of buildings concerns how they relate to each other and how they contribute to the urban density. Urban density is the relationship between the solid elements, the buildings and the spaces such as the streets, squares, gardens, parks, sports fields, rivers and lakes around them. It can be measured in terms of population density (people per hectare or per square mile), in terms of the number of houses per hectare, the number of square metres of office space, the number of factory units per hectare and in many other ways.

Urban density and urban grain are related and it is primarily the width, pattern and plan of the streets that determines the urban grain. The grid

system of laying out streets so that they intersect at right angles has been known since Kahun in Egypt some 5,000 years ago. It was used by the Greeks and Romans and it has been the preferred way of planning new settlements ever since. Narrow streets and small-scale buildings give a fine grain; wide streets and large buildings give a coarse grain and there are many variations between these two extremes. A coarse grain tends to be associated with large areas of flat land. If large areas are set aside for a widespread infrastructure of sewage, water and roads, it presupposes that the land was cheap and resources plentiful. Los Angeles and new colonial towns such as Harare, Zimbabwe, are examples of coarse grain.

Most settlements were not planned systematically, but evolved and developed over decades and centuries along narrow winding streets and footpaths. The result was a fine grain of streets lined by small-scale buildings. This type of fine grain is associated in Europe predominantly with the medieval period: the medieval street pattern and scale of buildings is still evident today in many European cities. The plan of Barcelona shows clearly the fine grain of the Barrio Gotico, the medieval centre of the town, and the contrasting coarse-grained grid plan of the nineteenth-century Eixample (Figure 7.5). The City of London still retains its medieval street pattern, but the streets are now lined by modern buildings, so although the grain of the street pattern has been retained, the scale of the buildings has changed radically.

The urban grain is part of the identity of individual towns; buildings need to be seen in the context of their particular urban grain and in terms of whether they respect that grain or not. If developments occur which do not respect the grain, it can gradually become eroded. The recent trend of replacing a group of buildings, each with its frontage on the street, by one building that takes up a whole block, has the effect of coarsening the grain of an area. We may wish to preserve the grain because it is part of the historic character of a particular environment, or for aesthetic reasons, and we need to balance this against the recognition that societies develop and change, as do people's needs.

A coarse urban grain is associated with wide streets. How we experience the urban grain will depend on whether we are walking, stationary, or travelling by bus or car. A long straight road, whether it was designed to focus on a major building or to promote traffic flow, can present a daunting prospect to even the keenest walker. We may enjoy the pavement cafés and watching the people going by on the Parisian boulevards far more than trying to walk along them from one end to the other. In a city such as Los Angeles which was largely designed for the motor car no one would consider walking the whole length of Wilshire Boulevard which stretches for some 16 miles. When we walk around a town, or sit relaxed in a square, our views are restricted to a few hundred metres. This range increases to thousands of metres when we travel by car or bus. Some buildings or groups

of buildings have deliberately been designed to be seen at speed by people driving by. The Hoover Factory to the west of London was designed by Wallis, Gilbert & Partners* in the 1930s to be seen by people travelling by at a speed of 30 m.p.h. (see Figure 6.19).

SPACE AND ENCLOSURE

How we perceive buildings depends not only on whether we are walking or travelling at speed, but on their size and the space around them. Scale and site are closely interrelated, for our perceptions about the size of buildings are related not only to our own size, but also to the building's position and the relative sizes of the neighbouring buildings and spaces. The skyscrapers clustered on Manhattan Island, New York, do not dominate each other unless they are extraordinarily high in comparison with their neighbours. The twin towers of the World Trade Center (Cesar Pelli*) dominate the Manhattan skyline, just as Canary Wharf in London's Docklands, one of the highest buildings in Europe, by the same architect, dominates the landscape

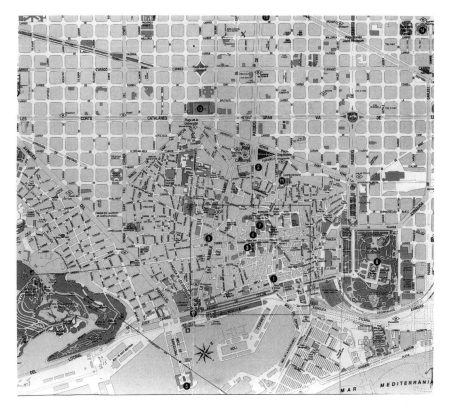

Figure 7.5 Barcelona, plan (Spanish Tourist Office)

for miles around (Figure 7.6). Yet when you stand near it, it can be hidden by the adjacent buildings. If buildings are very tall we need to be able to stand well back in order to see them. Many of the major cathedrals face open space, so their main façades can be seen as a whole, but it is often difficult to gain more than occasional glimpses of the other sides.

The feeling of space and light around buildings depends on the relationship between their height, the width of the street or size of the open space and how the shadows fall. A group of tall buildings lining a street can create a very dramatic environment, but if the street is always in shadow the feeling of enclosure can become very oppressive and it can seem like a canyon. In a square the feeling of enclosure depends on the dimensions of the open space, the heights of the surrounding buildings and the location of the streets leading into and out of the open space. The Circus in Bath gives a satisfying feeling of enclosure due to the height of the buildings, the distance across the open space and the fact that the three streets that provide access are not positioned directly opposite one another. The Place de la Concorde in Paris by contrast generates no feeling of enclosure since it is very wide in comparison with the height of the surrounding buildings. Where streets intersect the placing of buildings at the corners has an important effect on our perceptions of the spaciousness of the junction. If the buildings form right angles, maximising the use of building land, there will be a strong sense of enclosure at the crossroads. If they are angled around the intersection, then this encourages a feeling of openness, as well as giving greater visibility.

The relationship between buildings and the street line also affects our sense of enclosure. Buildings may stand directly on the street, be set back from it, or turn their backs to it. The building line determines how far forward towards the street buildings can come and local by-laws often dictate this. A straight building line means that all the buildings will be the same distance from the street, whether this is curved or straight, and whether the buildings are terraced or row houses, detached or semi-detached. This may result in the feeling that the buildings form a wall along the street, particularly if the street is not very wide and the buildings are closely spaced or terraced. If the buildings are different distances from the street, they have varied set-backs. This encourages a feeling of spaciousness and variety, even though the street itself may be narrow and the buildings closely spaced. Straight streets enable us to see clearly what is ahead, unless there is a dip in the ground. Curved streets encourage traffic to go more slowly and may also promote a sense of mystery and variety, for we do not know what lies around the corner. In today's urban environment the unexpected may also become the unwelcome and in the design of pedestrian areas and subways it is most important to be able to see what lies ahead, for reasons of personal safety.

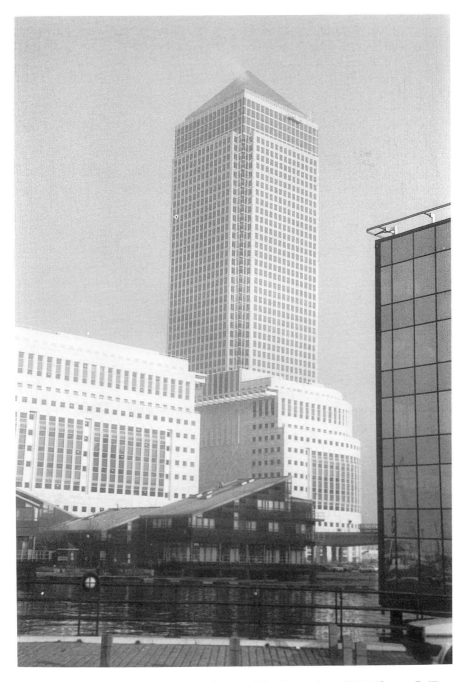

Figure 7.6 One Canada Square, Canary Wharf, London, 1992 (Cesar Pelli)
(photo: © Hazel Conway)

SAFETY

The question of safety is an important one if we are looking at urban buildings. We now understand more about the organisation of cities and the functions of different kinds of space and their role in promoting or inhibiting safety. As part of post-Second World War planning and reconstruction many cities were zoned and separate areas allotted to housing, commerce, industry and entertainment. It is now recognised that while zoning may have brought some form of order to cities, it has also had other effects which are of direct concern to the question of personal safety. With zoning the cultural districts come alive in the evenings, but are deserted for the rest of the day, the commercial districts are used during weekdays, but are deserted in the evenings and at weekends, and residential districts tend to become dormitories inhabited during the daytime by the very young, the very old and the unemployed. If there are few people around then an area becomes potentially dangerous, for cities are full of strangers. It is people who make cities safe places to be in. We tend to think that the function of streets is to carry traffic, but they also relate directly to the question of safety in the city. The function of streets is to accommodate strangers and the more a street is used, the more safely it can accommodate them. People like to watch others and they will not use streets unless they have a reason to do so. Streets with shops, newsagents, bars and restaurants in them are used day and evening and if there are a lot of different activities in an area then it will be used by a variety of people, for a variety of purposes and at different times. The area will then be a lively and safe one to be in.[4]

Another aspect of personal safety in the urban environment concerns the question of accessibility. This in turn relates to the identification and differentiation between public space, private space and semi-public space. Public spaces include the streets, squares, parks and plazas which people are free to use and congregate in, if they wish to do so. Private space, as its name suggests, is space where use is restricted to a small number of people. The garden of a private house is private space for the use of the residents and their guests. We know immediately if there is an intruder in our private space, because we can distinguish between those who have a right to be there and those who do not. With semi-public space this distinction is not so clear. Semi-public space includes a range of different types of space which the public can use on certain conditions. The front gardens of houses and apartments are semi-public space for they mark the transition between the street, which is public space, and the house or apartment, which is private space. This type of semi-public space may be used by those who have a proper reason to do so, such as the families that live there and their friends. It may also be used by a whole range of people who have an intermittent need to be there, such as the postman, the people who come to read the gas and electricity meters and those who come to do repairs. It can also be used

by those who have no right to be there, such as thieves, muggers and burglars. It is when it is impossible to differentiate between legitimate and illegitimate users of semi-public space that problems arise. It is now recognised that many of the design failures associated with 1960s and 1970s mass-produced housing are directly linked to this problem of differentiating between people who have a right to be there and those who have not.[5] If people do not know who their neighbours are, they are unable to distinguish between those entitled and those not entitled to be there. Furthermore, the shared areas such as the corridors, the lifts, the hallways and the immediate surroundings to these buildings are places where anyone can lurk and the links between buildings make ideal getaway routes for illegitimate users. Design disadvantagement was the term used to pinpoint such negative design features of housing estates and much work has been undertaken to rectify them.[6]

SENSE OF PLACE

From experience we recognise that there are urban environments and groups of buildings that we respond to positively and others that we respond to negatively. We may enjoy the small scale and variety of a winding street of buildings that has developed over centuries and we may, for completely different reasons, enjoy the drama and scale of the skyscrapers of Manhattan Island, or those of La Défense to the west of Paris. Although very different, these environments have a sense of place that makes them individual and memorable. The absence of these qualities was summed up succinctly by Gertrude Stein when she was asked, after a visit to Oakland, California, how she liked it there. 'There?' she replied. 'There was no there, there!' Whether we are visiting a historic town, an industrial district, a residential area, or one that is a mixture of uses and periods, we know whether we respond positively or negatively to it and we can recognise the presence or absence of a sense of place. We can probably go further and identify the particular characteristics that we find appealing in particular environments, but the difficulty comes when we try to establish broad, generally applicable criteria.

We may admire the regularity of eighteenth-century Georgian terraces and the mid-nineteenth-century Parisian boulevards that were developed under Napoleon III and Baron Haussmann*, with their strictly controlled rooflines, but our reactions to the regularity of 1930s ribbon development* or to 1960s mass-produced housing may be rather different. In order to understand such reactions we need to consider when regularity stops being harmonious and becomes monotonous, and we need to ask when variety stops being pleasing and becomes a mess. We also need to think about how much our attitudes are conditioned by current prejudices. Much of the architecture of the 1960s and 1970s is viewed so negatively today that it is

almost impossible to be objective about it. The influence of postmodernism has encouraged us to concentrate on the exterior of buildings, for that is the way that many postmodern buildings command attention, but the groups of buildings that comprise our cities have functions and form, and occupy space. The urban environment is not a stage set, and buildings occupy three dimensions, not two. If we look critically at buildings from any period we need to look at how they came to be where they are, the pattern of land ownership, their functions as well as their form, and we need to differentiate between constructional problems and social problems. Much of the mass-produced housing of the 1960s and 1970s shows signs of both, but many of the solutions to the social deprivation evident in the graffiti and vandalism in various parts of cities lie in the political arena, rather than in the realm of architecture.

Sense of place may result from the use of particular materials, or the styles of the buildings; it may be to do with the history, or the geography of an area and it can be found in any part of the world. Until the advent of powered transportation and the mass manufacture of materials, most buildings were constructed out of local materials, unless the patron commanded considerable wealth. The use of local materials and the variations in the ways in which they were used led to wide differences in the colour and texture of buildings in each region. In England we can still enjoy the special sense of place that results. The weatherboarded* and tile-hung houses of East Sussex can readily be distinguished from the red brick houses of north-west Leicestershire; the mellow, golden stone walls and the grey stone roofs of buildings in the Cotswolds contrast with the whitewashed and thatched cottages of Devon and Cornwall. The flint walls and red pantiled roofs found along the coast of north Norfolk are very different from the timber-framed* buildings common in Shropshire. Today because materials are readily transported nationally and internationally the local character that resulted from the use of local materials is being eroded.

The qualities that give a place its particular identity are so varied that it is impossible to list them all, but the one factor that all such places have in common is that people recognise their individuality and unique identity. It is the recognition of this unique identity and the desire to retain it that has led a number of cities to issue design guides. In England the *Essex Design Guide* advocated the use of particular materials and techniques appropriate for that region of the country but not appropriate for other regions.[7] Many cities are now producing their own guidelines; for example, San Francisco has produced a detailed analysis which pinpoints what makes the city centre and some of its residential districts special. In order that the special qualities associated with San Francisco's sense of place be respected and preserved, the guidelines stress that new developments should respect the local topography and set-back patterns, should emphasise corner buildings and respect the degree of the surrounding ornamentation. This does not mean

that new developments, planning and layout should copy past styles, or those of neighbouring buildings. In Portland, Oregon, the central city plan has twenty guidelines. Unlike San Francisco these do not focus on the design details of individual buildings but on the physical surroundings and on the public enjoyment of the city: public spaces, landscaping, ease of access, public art, diversity and vitality.

In the US system of planning the objectives and methods are explicit, so everyone knows where they stand. In Britain by contrast the planning system is pragmatic and relies on *ad hoc* discretionary control. Birmingham recently became the first city to adopt Francis Tibbalds's *City Centre Design Strategy*.[8] The intention of this is similar to some of the US city guidelines, that is to improve the city centre, although it has no statutory force. Among the subjects covered are redefining the street frontages, reinforcing the city's topography and the protection of views. In a section on high-rise buildings Tibbalds indicates that the straight point block* forms are no longer welcome. Possible alternatives include rotundas, stepped ziggurats, pyramids and cluster forms. If the site is such that only point blocks are possible then these should be enlivened by making the top more expressive, by adding a hood, by emphasising the services such as radio and telecommunications masts, or by adding sculptures.[9]

The aim of many design guides is to try to ensure that a particular sense of place is preserved, but there are many problems. Attitudes change and a design guide written a decade ago would be subject to severe criticisms today, yet the decisions taken about planning and development today affect the future. The rigid application of design guides, or the insistence on the preservation of particular historic characteristics to the exclusion of all else, could mean that nothing new was ever built and all new development would have to be dressed up in an approved historic fancy dress. A measure of flexibility is needed so that the merits of new features and developments can be weighed up, for there is much more to architecture than front elevations and the fashionable style of the moment.

CONSERVATION

Many countries have now introduced measures to protect their historic buildings and areas. France was one of the first to do so, having produced lists of historic buildings from the 1840s. From 1882 ancient monuments have been scheduled in Britain, but it was not until 1944 that official lists of historic buildings were drawn up under the Town and Country Planning Act. Today structures as diverse as telephone boxes, grave stones, terraced housing, piers, stables and churches are listed. The designation of whole areas as worthy of preservation, whether or not they contained listed buildings, did not occur in Britain until 1967. The 1967 Civic Amenities Act made it possible to designate as Conservation Areas 'areas of special

architectural or historic interest, whose appearance it was desirable to preserve or enhance'. These range from industrial areas such as Nottingham's Lace Market, to workers' housing, wealthy suburbs such as Holland Park, London, and medieval villages such as Chipping Campden in the Cotswolds. One in fifty buildings in Britain is listed and most historic cores of our towns and cities are now designated conservation areas. This means that a very wide variety of vernacular, industrial, monumental, civic, religious and private buildings and environments are protected. It does not mean that no alterations whatsoever are permitted; moreover, as there is little government grant aid to repair and enhance, much is dependent on private owners or local authorities. By contrast in France fewer buildings and areas are protected, but their financing and control comes from central government.

Although many people agree on the importance of conserving historic architecture, views vary as to what should be preserved and why. The criteria for conservation initially focused on what were perceived as old and 'beautiful' buildings and areas. Today historical significance, technological innovation, the major works of architects important in their day and threats of alteration or demolition to important modern buildings are among the factors considered in Britain. Our tastes change and what was seen as an unimportant building or area a decade ago may be deemed much more significant today. The preservation of historic buildings is just one part of the problem, for an appropriate use then needs to be found for them. Although we value old buildings we cannot clutter the environment with empty shells which have no practical use and there is a limit to the number of museums that can be housed in old buildings. In a period of concern for the future of the planet, reusing old buildings makes both economic and environmental sense, particularly since many of them use less energy for heating and cooling than do new buildings.

Chapter 8

Styles and periods

Identifying styles is an important part of looking at buildings, but restricting ourselves solely to questions of recognition would imply that architecture is similar to train spotting or stamp collecting. Here we explore what we mean by styles and periods, rather than trying to define them. We look at how we identify styles, initially by common characteristics, but there is much more to styles than this. In that excellent book *The Classical Language of Architecture* (London, 1985) John Summerson said that it was a mistake to try to define classicism because it was not just about the use of particular forms, it was to do with the classical spirit and philosophy which informed the use of those forms. Consequently the term 'classicism' had different meanings in different contexts. We will examine some of the ways in which we divide architectural history into periods and the difficulties associated with this, for the concept of a period may be drawn from different disciplines and this influences our perception of our subject.

STYLES

Styles take their name from the physical or visual features of buildings (classical, art nouveau), from historical periods (Queen Anne revival*, Jacobean*), or from a geographical area (Indian, Chinese). Some styles such as modernism were identified before they came into being, while others such as art deco acquired their name long after they achieved their greatest popularity. The concept of style is used in all the visual arts such as architecture, art and design, not only by historians but by archaeologists, anthropologists, sociologists and philosophers. Archaeologists often employ stylistic analysis, alongside an investigation of materials and techniques, in order to date and identify architectural remains and other finds. Architectural historians use stylistic analysis as an important tool of identification, although in recent years the amount of attention paid to style has been increasingly questioned. There are numerous examples of books that focus on particular styles, and the history of architecture has often been presented as a series of styles that follow one another chronologically. This

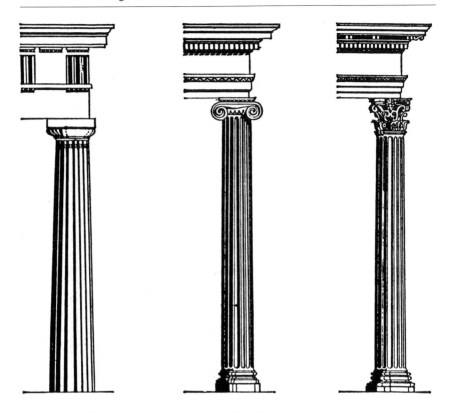

Figure 8.1 The orders: (a) Doric, Ionic, Corinthian

was the method applied by Bannister Fletcher in *A History of Architecture on the Comparative Method* (London, 1905). He looks at styles chronologically and compares and contrasts them in order to identify the specific characteristics of each style. He compares the decorative mouldings of ancient Greek and Roman architecture and compares the round-headed openings of English medieval Norman-style cathedrals with the various types of pointed-arched openings of the gothic style.

If we say a building is in a particular style this implies that there are other buildings or artefacts that share similar features. Not all the buildings which comprise the group will necessarily be identical in form, for they may vary in how many characteristic features they share. Most buildings in the group will have a large number of the features that characterise the style, but not every building will have all of those features. We expect gothic cathedrals to have piers, buttresses and openings with pointed arches. Some windows are simply lancet* with no tracery, others have plate tracery*, and yet others curvilinear tracery*. Often there is no single physical attribute that is both necessary and sufficient for membership of a style. In other words,

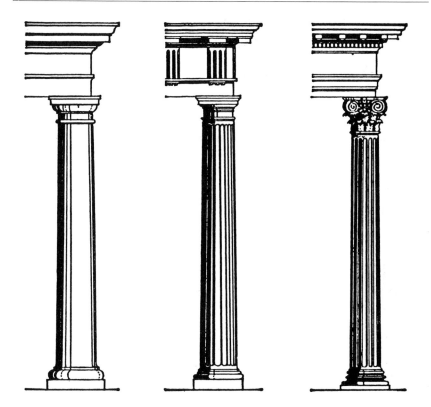

Figure 8.1 (b) Tuscan, Roman Doric, composite

we cannot say that a building is not gothic just because it does not have buttresses, or conversely that every building that utilises buttresses is gothic. C.F.A. Voysey, the arts and crafts architect of the late nineteenth century, employed buttresses in his domestic architecture and we do not call his work gothic (see Figure 6.16). Style is defined through the physical or visual characteristics of buildings. Structural elements such as columns, protective elements such as hood moulds that shield openings from the weather, and decorative features such as the carving on a moulding may all be used to identify a style.

The classical style is one of the most pervasive, and new interpretations of classicism continue to be made today. The classical style of architecture originated in the temple architecture of ancient Greece which was based on a post and lintel system of construction using columns. Three types of column were developed by the Greeks: Doric, Ionic and Corinthian. The ancient Romans further developed this mode of construction in their religious, military, civil and engineering structures, adding two further types of column, the Tuscan* and the composite*, as well as the arch, the dome and

the vault to their repertoire of forms (Figure 8.1(a) and (b)). Columns are used structurally to support a lintel and decoratively to enliven façades or walls. Each type of column is associated with a superstructure or the entablature of a particular design, and this together with the column is called an order. Each order is also associated with an identifiable standard treatment of the windows, doors, openings, mouldings and ornament of the building in which they are used. The classical style is also associated with symmetry, proportion and a harmonious relationship between the elements that comprise the building. Some classical buildings employ one order, others such as the Roman Colosseum, AD 70–82, or the Farnese palace, Rome, built between 1534 and 1548, may employ several orders. In both these buildings a strong plump Tuscan or Doric order controls the design at basement or ground-floor level. The orders become progressively more slender and elaborately decorated so that there is an Ionic order at first-floor level and a Corinthian order at the top of the façade.

Although we have so far identified the classical style in terms of the orders, symmetry, proportion and harmony, a building does not have to employ the orders to qualify as classical in style. The proportions and layout of Georgian terraces derive from an order but many did not actually employ one. Other buildings which are not classical may nevertheless suggest the character and proportions of a classical building. The Villa Savoye, 1928–9, by Le Corbusier is a reinforced concrete frame structure the forms of which echo the post and lintel structure of a Greek temple with its peripteral colonnade* (Figures 8.2, 8.3). The outer pilotis of the supporting frame of the villa can be seen all the way round the building at ground level. At first-floor level the pilotis are hidden by the walls. The parallel with the Greek temple is emphasised by the fact that the pilotis are spaced with a strong regular rhythm, and the piercing of the external walls at first floor-level by ribbon windows gives a horizontal stress reminiscent of an entablature or frieze. Although this is a modernist building in style we recognise the classical influence.

Variation within styles

Sometimes a building type or style is transmitted to another country through travel, trade, colonialism or war. In adopting a foreign style, local architects or builders will tend to modify it to suit the new circumstances. The plans and the symmetrical façades with twin towers, of seventeenth-century Spanish missionary churches in New Mexico, USA, derive from baroque churches in Spain but they are different from contemporary Spanish churches because the local American Pueblo Indians built them of adobe, not stone. Consequently the buildings have no carved decoration and the battered walls which are plastered with clay are rough and austere, and are unbroken by windows because of the hot, semi-arid climate.

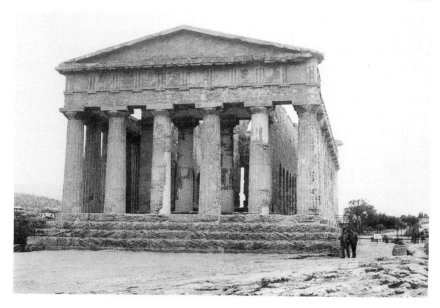

Figure 8.2 Temple of Concordia, Agrigento, Italy, *c.* 440 BC (photo: © Hazel Conway)

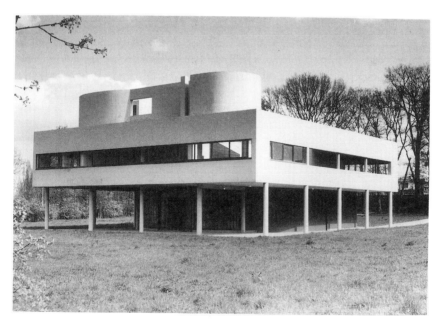

Figure 8.3 Villa Savoye, Poissy, France, 1928–9 (Le Corbusier) (photo: © Hazel Conway, courtesy of the Fondation Le Corbusier)

From time to time architects become interested in reviving styles from the past. The revived style may differ from the original as a result of many factors such as different building types or materials, technologies, or social and philosophical outlooks or because the style is being utilised in a different geographical location. During the period of neo-classicism* in the eighteenth century the revived Greek and Roman styles were modified in many different ways. John Nash's Carlton House Terrace, London, 1827–9, has cast iron columns, a material unknown to the ancient Greeks. Railway stations did not exist in ancient Greece, yet P. and P.C. Hardwick's Euston Station, London, 1835–9, was in a Greek revival style. Some neo-classical buildings are an eclectic mix of different classical prototypes such as William and Henry William Inwood's* St Pancras Parish Church, London, 1819–22. This employs elements from several ancient Greek buildings: the Tower of the Winds (top right), the Choragic Monument to Lysicrates (middle right), and caryatids* from the Erechtheum (centre) (Figure 8.4). Benjamin Latrobe had nationalist reasons for modifying the columns of the United States Capitol, Washington, DC, 1815–17. He replaced the acanthus leaf decoration of the column capitals with an American motif, the ear of corn, and for the fluting of the shaft he substituted stalks of corn.

If we look at some of the revivals of classicism that have occurred in different countries, under different political and economic conditions, it becomes evident that using style as the common factor linking buildings does not help us to understand anything very significant about them. In the eighteenth century classicism was revived in France as part of the enlightenment. Inspired by the rationalism and intellectual ferment of the period, architects such as E.L. Boullée* and C.N. Ledoux questioned the baroque and rococo architecture of the early eighteenth century and sought to understand the essence of the classical tradition. In their new classical designs they did not just copy antique originals but took the spirit of ancient architecture with its simplicity, symmetry, order and proportion to create very novel buildings such as E.L. Boullée's project for a monument to Newton which is composed of a sphere encircled by cypress trees without the use of orders (Figure 8.5). In the United States the passion for the Greek revival in the early nineteenth century was part of the search for a national identity. The perceived parallel between America's earlier fight for independence and the contemporary Greek Wars of Independence, ancient Greek democracy and the formation of the American democratic system, encouraged the design of government buildings, churches, houses and even stores in the form of Greek temples to symbolise cultural and political independence.[1] In contrast during the early twentieth century the neo-classical architecture of the National Socialists in Germany was designed to give a stature and legitimacy to an authoritarian regime that was ultimately to be despised worldwide and to create buildings of colossal scale to impress and overpower spectators. Today some postmodern architects use classicism

eclectically and irreverently to brighten up the surroundings in a light-hearted manner. Charles Moore* *et al.*'s Piazza d'Italia, New Orleans, 1975–80, uses classical elements to give a sense of place and familiarity to an area used by an Italian community (Figure 8.6). Superficially these buildings employ classical features but if we know more about the context we can see that they are very different. To understand these particular forms of

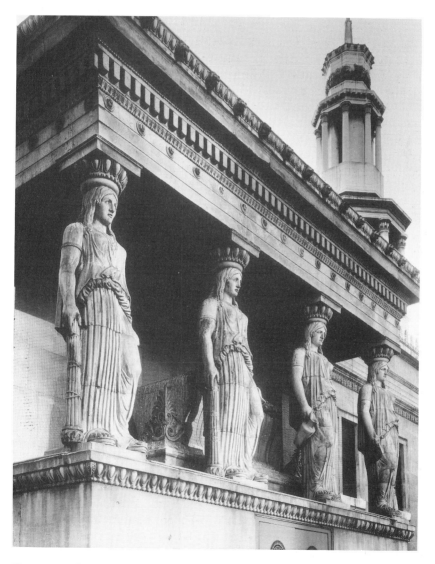

Figure 8.4 St Pancras parish church, London, 1819–22 (W. & H.W. Inwood) (photo: © Martin Charles)

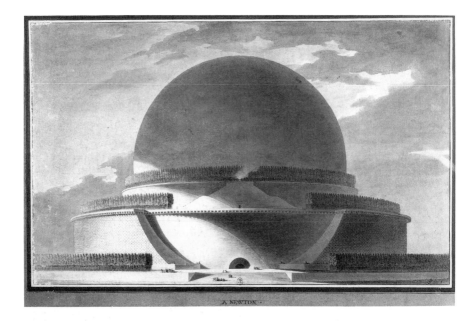

Figure 8.5 Monument to Newton, project, 1784 (E.L. Boullée) (© Bibliothèque Nationale)

classicism, we need to know the particular reasons for the revival of this style at that time and in that place, and this applies to any revival in any period. We also need to discuss the 'message' given by these buildings at the time that they were built.

In the early nineteenth century in England A.W.N. Pugin consciously and passionately committed himself to reviving the medieval gothic style, as the only style suitable for a Catholic architect living in that period. Pugin did not initiate this revival, for from the mid-eighteenth century Horace Walpole* and others had taken great delight in the medieval gothic style and the associations with chivalry that it conjured up. Strawberry Hill, Twickenham, Middlesex, Horace Walpole's gothick home, created from 1748 onwards, was an exercise in the free and romantic use of gothic details to create the desired effect (Figure 8.7). The 'k' at the end of the word 'gothick' indicated that there was little intention of recreating precise medieval forms, or indeed of using those forms in the way that they were used originally. Carved stone details from tombs and canopied niches from churches were used to create decorative timber fireplace surrounds and bookshelves. By contrast Pugin pioneered a more authentic and rational approach to the gothic revival. He coupled his religious zeal with a great archaeological understanding of the original medieval structures. These two

Figure 8.6 Piazza d'Italia, New Orleans, Louisiana, USA, 1975–80 (Charles Moore, Perez Associates Inc., Urban Innovations Group, and Ron Filson) (© 1978 Norman McGrath)

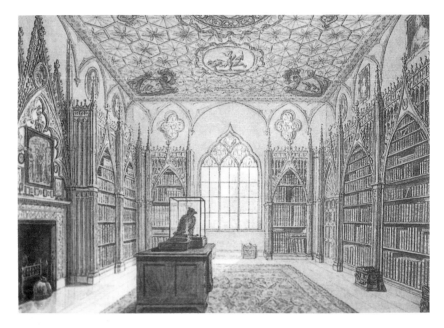

Figure 8.7 The Library, Strawberry Hill, Twickenham, Middlesex, 1754 (John Chute) (© *Country Life*)

examples, the gothick and Pugin's use of the gothic in the gothic revival, show how styles may be used for very different reasons with consequently very different results.

One further example illustrates how buildings which share common stylistic features may arise from quite different circumstances. The development of the modernist style in architecture occurred in Europe between the world wars. The characteristics we associate with modernism are the use of new materials such as steel or reinforced concrete, a frame structure, a flat roof, smooth undifferentiated wall surfaces with little weather coping such as sills and mouldings around openings, and lack of ornament. When Nikolaus Pevsner traced the origins of modernism back to the nineteenth century in his book *Pioneers of Modern Design* (London, 1936) he considered technological developments, social and moral ideas and visual criteria. One of the architects that he identified with the early stirrings of modernism in Britain was the arts and crafts architect C.F.A. Voysey, who employed little or no decoration in his buildings (see Figure 6.16). Many of the houses Voysey designed had white painted roughcast walls, they employed no historicist decoration, and he made drawings to ensure that no standard builders' mouldings were included in window, door and other

joinery detailing. Pevsner suggests these forms presage modernism, but Voysey later in life expressed vehement opposition to modernism and its dogmatic use of new materials and techniques.[2] His work developed from British vernacular architecture and he disliked the way some modernists rejected traditional materials and past architectural forms such as pitched roofs. Some early twentieth-century modernist architects may have been influenced by Voysey's principles of honesty and integrity, and may have admired the lack of ornament in his work, but Voysey should not be seen as a pioneering modernist, because his aims were quite different. We should be wary of classifying buildings purely by stylistic criteria, for they may have little or nothing in common philosophically with that style.

Styles and dating

Architecture in different periods and geographical locations tends to vary in style reflecting the different social, economic and cultural contexts. It was thought that if changes in style could be linked with changes in society, whether technological, economic, ideological or social, we might understand the reasons for stylistic change. Furthermore, since style relates to society in a particular place and at a particular time, it could also be used as a tool for dating. Stylistic evidence could be used either on its own or with other evidence to date buildings of any period. The other types of evidence might range from surviving documents such as a patron's brief for a building to scientific evidence such as radiocarbon dating. If no other evidence was available, then style alone could be used for dating buildings.

There are many problems that can arise in seeking to use styles as a method of dating buildings. The Renaissance style developed in Italy in the fifteenth century. It is associated with the reuse of the ancient Roman classical orders and principles of architectural design. The style subsequently spread through Germany, the Low Countries and France, not becoming fashionable in England until the second half of the sixteenth century. In each country the style was modified by local stylistic idioms. In the Netherlands the renaissance style was combined with decorative tall gables, strapwork* and obelisks, and the orders themselves were banded*. Sometimes several styles may coexist at the same time and in the same place, each evolving and developing at its own pace, or even borrowing elements from one another. The waxing and waning of styles does not necessarily happen with clearly defined beginnings and endings. There may be buildings which prefigure a developing style, or a style may be employed in the regions long after it ceased to be employed in a fashionable metropolitan context.

Styles have life cycles in which they are born, grow, mature and decline. The identification of early, middle and late phases in a style may be a matter of the chronological development of that style, or there may be a moral judgement involved, for the word 'decline' in itself implies a moral judge-

ment as well as a chronological one. Some building styles may be seen to represent avant-garde, radical approaches, others are seen as archaic survivors of an outmoded tradition. However, what was perceived as archaic and unfashionable yesterday may be reappraised today. Gothic and classical styles still continue to be revived and reworked in the late twentieth century. Modernists criticised this revivalism as being irrelevant to twentieth-century problems, but postmodernists look at these styles afresh and believe they can make a valuable contribution to twentieth-century architecture.

Non-styles and movements

Although buildings may share characteristics and can be grouped visually and stylistically, there are sometimes significant attributes that are not visual. The visual characteristics of the Crystal Palace (see Figure 2.1), for example, are not nearly so important as its method of construction. Rather than trying to classify the Crystal Palace stylistically it would be more useful either to group it with buildings that share similar constructional techniques of prefabrication or that use similar materials of iron and glass, or to group it in terms of its function with other exhibition buildings.

Buildings may be classified according to the ideas and approaches of the architects or builders. Some groups of architects such as the futurists* and the expressionists published manifestos declaring their aims. In classifying groups and movements according to shared ideas and aims such as futurism and expressionism, we confront similar problems to those encountered with style. Although there may be a manifesto declaring the aims of the group, the buildings designed by its members may not always fulfil all of the aims. Some movements such as the arts and crafts movement encouraged individual creativity as part of their aim. We may link the architects of this group together because of their belief in the unity of the arts, their view that humble vernacular buildings could be both practical and delightful, and their support of the principles of honesty in design and use of materials. The application of these aims, however, resulted in very different buildings depending on the vernacular tradition the architects chose to develop and their personal interpretation of the principles (Figure 8.8, and see Figures 2.7 and 6.16).

One further example illustrates the diversity of architectural classification that is not stylistically based. It also indicates how the particular concerns of those studying the architecture of the past can lead to emphases that we would perhaps dispute today. The Chicago school of architects working in the USA in the 1880s and 1890s included Burnham & Root*, Holabird & Roche* and Louis Sullivan, and is associated predominantly with the development of a new form of building, the skyscraper or high-rise office building. Modernist historians writing in the 1930s, such as Siegfried Giedion, H.R. Hitchcock and Nikolaus Pevsner, focused on the Chicago

school because it seemed to them significant for three main reasons. Chicago school architects developed a new structural system, the frame structure, they utilised a new material, steel, and they reduced ornament and historical elements in the forms of their buildings. The Chicago school storyline that suited modernist interpretations was that the architects and engineers of the group pioneered the 'skin and bones' style of the modernist office block. The Chicago school was used as a means of exploring, if not confirming, preconceived notions of the links between technological and aesthetic changes in architectural production. Today we might wish to look at these buildings differently, questioning the aesthetic significance of buildings which display their structure at the expense of ornament. We could examine the pressures imposed by patrons which led to such basic solutions. We might even look more closely at the ornament employed on some of these buildings, especially in the entrance halls, and find the work of Louis Sullivan of particular interest because he developed his own personal style of ornament. The Chicago school is still a useful concept because it focuses on a location and period that was important in the technical development of skyscraper office design and it raises questions about the development of styles and their interpretation.

Figure 8.8 Stoneywell Cottage, Leicestershire, 1898 (E. Gimson) (photo: ©
Rowan Roenisch)

Vernacular styles

There is a marked difference in the pace of stylistic change between pre-industrial and industrial societies. In the former, styles hardly seem to change at all. Vernacular buildings belong largely to preindustrial societies, but remnants of vernacular traditions survive in societies undergoing economic and political change as they move towards market and industrial economies. This was true in the west from the fourteenth to the nineteenth centuries and it is also true of many other regions of the world today. We will look at vernacular architecture in one of the countries of Africa that we have visited. In Zimbabwe, despite nearly a century of colonial rule, followed by independence in 1980, we can still find many examples of vernacular architecture belonging to the two major indigenous peoples, the Mashona and Ndebele, and also other groups living in the country such as Malawians who first came as migrant labourers (Figure 8.9).

The forms of vernacular buildings derive from traditional practice. They are often constrained by local natural resources and lack of transport, so the forms vary from region to region. Building tends not to be a professional activity and the methods are passed down from mother to daughter and from father to son. Practical, material, social, religious, ritual and other reasons encourage the adherence to forms used by previous generations. We tend to view such societies as conservative and there seems to be little choice over the style used for design and construction, but there may in fact be more variety among the buildings than we would initially expect. Individuality and social differences may be expressed through material, construction, form or decoration, and a chief's dwelling will be larger and more elaborate than the other dwellings. It may even use imported materials or be built by specially trained builders.

The Mashona homesteads consisted of several circular sleeping, cooking and storage huts, built of poles and *dhaka* (clay) with thatched roofs. Today the use of manufactured materials in the cities is spreading to rural areas; bricks, concrete, string and wire are being utilised for the building of traditional homes. Aspirations among rural people are changing and as this happens so western house forms are introduced into domestic architecture. The purchase of western-style furniture also encourages the building of rectangular rooms rather than adherence to the traditional round hut. It is interesting to note that change is not all in one direction, and while wealthy Mashona who live in the city may build a western-style bungalow they may still insist on the traditional separate cooking hut alongside. The point is that vernacular buildings are not 'just traditional', they are as consciously designed as buildings in advanced market economies and can exhibit marked complexities of style. Forms have varied and styles have evolved albeit at a very slow pace by western industrial standards. However, where market and

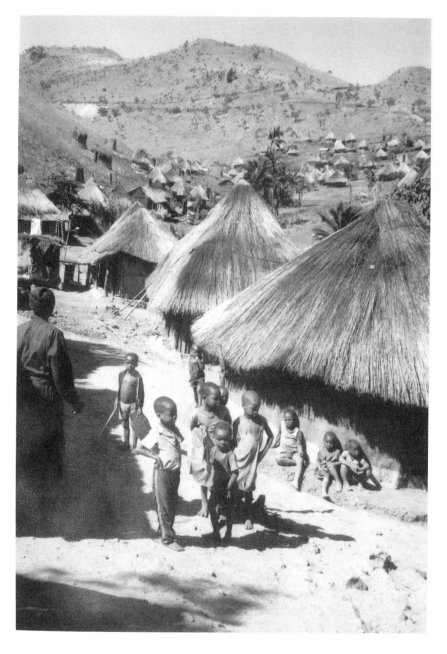

Figure 8.9 Malawian miners' village, Tengenenge, Zimbabwe (photo: © Hazel Conway)

industrial economies impinge on traditional societies changes may begin to occur at a faster rate.

Style and the market economy

We recognise that in certain periods buildings share features that give them a recognisable style. As time passes styles change, but pinpointing the precise reasons for stylistic change is no easier than trying to account for any other form of historical change. Some believe that style ultimately has mysterious causes that cannot be identified.[3] Others have sought to identify the precise links between society and the stylistic forms generated, although the relationships may not necessarily be direct or predictable.[4] The heightening of concern with style in all the visual arts seems to be a characteristic of market economies and industrial production, particularly with the development of capitalist economies. Such economic systems constantly require new markets, products, technologies and materials. The resulting growth in trade and communications fuels an interest in other lands and cultures and this in turn widens the knowledge of other styles. In some periods the flux and change of styles seems to accelerate, in others change is much slower. The development of neo-classicism, the picturesque, the gothic revival and a growing interest in exotic styles from China and India in the eighteenth century in France and Britain were paralleled by great political, economic and technological changes. Wars, revolution, expanding industry and trade were accompanied by a growing criticism in all areas of culture and changing attitudes towards the past. All this was accompanied by a swift succession of different styles and indeed a plurality of styles at the same time.

Style and content

Style is usually discussed in terms of form, rarely in terms of content. We mentioned earlier how the gothick evoked chivalry and the crusades to those adopting it in the mid-eighteenth century. When Sanderson Miller*, the amateur gentleman architect of Warwickshire, built a sham gothick ruin in the grounds of his estate at Edgehill in 1746 Horace Walpole wrote after visiting it of the 'ruined castle built by Miller, that would get him his freedom even of Strawberry: it has the true rust of the Barons' wars'.[5] Any ruin could inspire melancholy, but to the mid-eighteenth-century mind gothick ruins conjured up images of heroism in the age of chivalry. The addition of small buildings to the eighteenth-century landscape was not just about providing places for shelter from the rain, or for picnicking, nor were they solely to close a vista, or to provide aesthetic delight. They were intended above all to inspire associations. Imitation classical Greek buildings such as the Tower of the Winds at Shugborough, Staffordshire, 1764, evoked Greek political philosophy and expressed the political ideal of liberty.[6]

Others such as the pagoda at Kew or the Indian bridge at Sezincote not only provided architectural variety, they inspired romantic visions of other climes and other cultures. Although we may not make the same associations today when we confront these buildings we need to recognise that form and style are also about meaning and content. They express ideas and values, as well as being about the presence of recognisable elements, and similar forms have been used to express both reactionary and progressive ideas as the example of neo-classicism illustrated.

Another aspect of this can be seen in the adoption of the Greek temple form for museums and banks in the nineteenth century. The 'museon' was originally a shrine of the muses of literature and the arts; then it became a repository for gifts and then a temple of the arts.[7] The use of the temple form for museums made that reference explicit to those with a classical education in the nineteenth century. The 'message' of the temple form used for banks was rather different. Since Greek temples based on this form had existed for thousands of years, it gave the message of trustworthiness. It was also a form associated with power and dignity, but in this instance transferred by association from a Greek god or goddess to the particular financial house. The message of power is still important: the architecture and the style of large and expensive office blocks is intended to convey their commercial power (see Figure 7.6).

Modernist architects were also interested in the 'meaning' of their buildings. They rejected the dark, claustrophobic interiors, the dirty, cramped and polluted cities and what they considered the dishonesty of borrowed styles that proliferated in the architecture of the nineteenth century. A new century required a new style of architecture appropriate to the new technology, the new constructional systems, materials and way of life that was emerging. Crisp geometric forms, clean light surfaces, airy uncluttered and open-plan interiors, large windows admitting plenty of light and opening onto gardens and terraces symbolised their bright new efficient vision for the future which they believed new technology and mass production would make available to everyone. It was both a radical and democratic view which, in requiring the rejection of traditional forms and materials, sometimes threw out the baby with the bathwater and has irritated those who prefer to cling to convention. It was a style that was seen by many to match the spirit of the period immediately following the Second World War when people in the west wanted to start afresh. However, political and economic pressures and inadequate research resulted in many failures, notably in the field of mass housing and flat roofs. It is now fashionable to condemn modernist buildings but we should try to understand their design in the context of the period in which they were built and the motivation of patrons and architects.

The debate on style and meaning is one that is very much part of postmodern architecture. In Britain domestic bliss is associated with a style

not evident in the domestic architecture of other countries. This style is called the vernacular revival and it is characterised by tiled pitched roofs, little dormers and gables, and the use of brick, half timbering, tile hanging and render for walls (Figure 8.10). In recent years these vernacular revival elements have not been limited to domestic architecture, but are added to large buildings such as supermarkets and stores (Figure 8.11). Partly this is in order to give them a domestic and friendly feel, partly in order to relate them to their domestic surroundings, and partly to make reference to the medieval barns which stored agricultural produce in the past (Figure 8.12). Tesco seems to have developed a particularly recognisable signature in this area but it is not alone, and love of tradition may seem to have been stretched to its limit. Today many people are concerned about the insensitive, overscaled, drab and abstract environments that were created in the name of modernism after the Second World War. They are rightly concerned about style and aesthetics and are looking for a harmonious, pleasing and meaningful built environment, but we need to be aware of the problem of overreacting against styles that at the moment are detested to such an extent that their true qualities go completely unrecognised.

PERIODISATION

There are many ways in which we can subdivide historical time. They range from arbitrary subdivisions into decades or centuries, to periods derived from style developments, other branches of history such as the reigns of kings and queens, or more complex subdivisions defined by economics or technology. The question of periods and styles is by no means straight-forward for it is not always possible to discuss them independently. Sometimes periods are given the names of styles and vice versa. In order to understand change in the built environment, the origins of a development or its influences, we need to focus on chronology and periodisation is a useful way of structuring our ideas.

Defining periods in terms of decades or centuries seems in a sense 'natural', for we often think of our own lives in terms of decades. If we are seeking to differentiate one period from another we will look for evidence of change and growth marking the beginning of a new period. Similarly we will look for evidence that signals decline at the end of a period. These changes rarely fit neatly into either decades or centuries. Books that focus on '1930s architecture' or 'the architecture of the eighteenth century' might appear to subdivide the subject neatly but not necessarily most appropriately, and there may be a tendency to impose arbitrary storylines in order to make the material fit the period.

Figure 8.10 Houses in Regent Road, Leicester, 1881 (Goddard & Paget) (photo:
© Rowan Roenisch)

Periods and style

One of the main ways in which we refer to the art and architecture of ancient Greece and Rome is to talk about antiquity, meaning ancient times. The antique period lasted some 1,200 years, from the eighth century BC to the fourth century AD. During the course of this period geographical boundaries changed and expanded. The Roman empire eventually extended as far west as the Spanish peninsula, north to the Black Sea, the Netherlands and England, south to the north African coastline and Egypt, and east to Asia Minor. A prodigious number of buildings were produced over a very long time span and in a very wide geographical area. Given the diversity of work produced, the period label antiquity is only useful in isolating for research two cultures that were seminal in the development of western arts.

The word 'classic' derives from the Latin and means 'of the highest class or rank'. It referred to the superior tax-paying class of Roman citizens. However, within architectural history the term has been developed to take on several meanings. The term 'classical' is often used to refer to the style of architecture that developed during antiquity and which we attempted to

Figure 8.11 Tesco supermarket at night, Amersham, Buckinghamshire (© Tesco Stores Ltd)

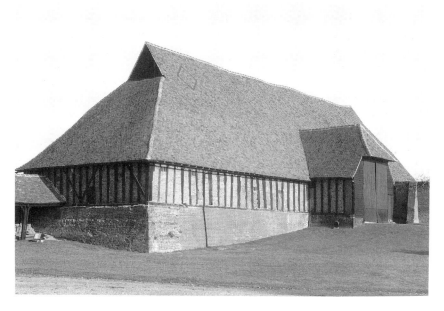

Figure 8.12 Wheat barn, Cressing Temple, Essex, *c.* 1255 (photo: © Hazel Conway)

define earlier (pp. 144–5). 'Classical' is also used as a label for buildings constructed in ancient Greece between *c.* 490 BC and 338 BC. The reason for calling the buildings of that period classical is that they are considered to have reached a peak of perfection, for this is the period when the Parthenon and the Erechtheum were built. The term 'classical' in this case is being used as a label for a particular period in Greek architecture and also implies a value judgement. Classicism is another related term. It is used to mean a revival or return to the principles of ancient Greek and Roman architecture, as in neo-classicism.

The use of a style label to denote a period encourages us to think that only that style existed during that period, or that if other styles existed, then they were inferior and unworthy of attention. For example, the architecture of the medieval period in Britain is often subdivided chronologically into Anglo-Saxon, Norman and gothic styles. The gothic style is then further subdivided chronologically into the early English style, the decorated style and the perpendicular style. The identification of these latter three styles derived initially from such features as the changing style of vaulting, piers and windows employed in churches, cathedrals, castles and palaces. These features only rarely appear in cottages, mills, farm houses or humble dwellings made of timber, mud or stone and so these styles are not applicable to

them. They are applicable only to polite architecture, because they are usually only found in those building types. Consequently if we are looking at a range of building types in the medieval period, we cannot subdivide that period chronologically using those stylistic labels for they are not appropriate. There may be a similar problem with the architecture of colonial and ex-colonial countries where there may be a tendency to focus on colonial-style buildings and ignore those of the indigenous population which are in a vernacular style. So when we are using style labels we should be careful not to assume that they can be used as period labels.

The renaissance is a term often used to denote both a period and a style. It embraces that period when the art, architecture and literature of antiquity were being rediscovered in Italy. The renaissance led to a flowering in all the arts – literature, painting, sculpture, garden design, the decorative arts and architecture – and gave its name to a style as well as to a period. Its influence spread throughout Europe and Russia. Like antiquity, the renaissance spanned a long period and took place in a wide geographical area. It is instructive to see how the term 'renaissance' is used in one of the standard textbooks on architectural history, Bannister Fletcher's *A History of Architecture on the Comparative Method* which is now in its nineteenth edition (London, 1987). In this textbook Bannister Fletcher has labelled 'renaissance' everything in European and Russian architecture from the fifteenth century to 1830. Although he acknowledges the development of mannerism by *c.* 1520 and the baroque style by *c.* 1630, he argues for the wider term 'renaissance' because 'it makes continuous acknowledgement of antiquity as the stylistic norm and paragon'.[8] There may indeed be some justification in differentiating certain European and Russian work from that elsewhere in the world by using the term 'renaissance' in this way, but it tells us little of significance of the full range of building styles in this period and place, nor does it distinguish between what was happening in different countries during this long time span. It ignores the distinction that Bannister Fletcher himself makes between mannerism, the baroque and the renaissance proper and it fails to differentiate between Palladianism* and neo-classicism in England during the eighteenth century. It ignores the fact that the gothic style survived and continued to be used for a small number of buildings right up to the mid-eighteenth century and then was revived and began to become widespread by about 1830. In addition during the eighteenth century other styles also emerged. There were the rococo and the picturesque, and exotic styles such as Muslim, Chinese, Indian and Egyptian were also imported into western architecture. Bannister Fletcher's subject is largely monumental or polite architecture; he is rarely concerned with the vernacular such as farm buildings, the homes of artisans and peasants, or even the manor house and parish church which form the bulk of buildings constructed in this period. The term 'renaissance' does little justice to this complexity.

Periodisation and other disciplines

The example of the renaissance indicates how important it is to identify the criteria used to define the chronological boundaries of a period. Periods may be defined by dynasties, empires or the reigns of kings and queens. One of the assumptions implicit in this form of periodisation is that there is a direct relationship between those holding the reins of political power and the built environment. In some cases this may be so and royal patronage may be a significant motor of change, but it cannot be assumed. If we look at the architecture of the Victorian period we can see some of the pitfalls that can arise. The Victorian period acquires its name from the reign of Queen Victoria (1837–1901). The most significant characteristics of the architecture of her sixty-four-year reign do not relate to her direct influence and patronage, nor are they confined by the boundaries of her reign. This period saw the development of new building types such as railway stations, the use of new materials such as iron and glass, new technologies such as prefabrication, and a proliferation of architectural styles. These changes did not occur solely within the period 1837–1901, for their roots lay in the changing economy and the new technological and architectural developments of the eighteenth century. Strictly speaking, the term 'Victorian architecture' should be applied only to work produced in Britain, or those areas of the world that were part of the British empire, yet it is a term often used to describe nineteenth-century North American architecture. The death of Queen Victoria in 1901 and the accession of Edward VII brought the end of the Victorian and the beginning of the Edwardian period, with the implication that Edwardian architecture was significantly different from that of the Victorian era. Yet no sudden architectural changes had taken place.

Two further examples, the modern period or modernism and post-modernism, illustrate different criteria we might use in defining periods. The modern period in western culture can be defined in a number of ways. Looking to economics or history we might locate its start with the end of feudalism and the beginnings of a market economy in the fifteenth century. The roots of the western social system were emerging at this time and this had an impact on all the arts. If, however, we identify the beginning of modernism with fundamental changes taking place in technology and in the physical environment, then we might look to the period of the industrial revolution. This took place towards the end of the eighteenth century with the development of urbanisation, industrial technology and new manufactured materials. If, on the other hand, we are only interested in style changes in architecture and design we might identify the beginning of modernism quite differently, for modernism as a style in architecture and design only emerged in the early years of the twentieth century. As we have seen, it is a style in which architects, conscious of the changed social and material conditions of the twentieth century, committed themselves to address those

changes. In exploiting the new technology and materials and rejecting past approaches to architecture they arrived at radical new forms, independent of the styles of the past. They therefore believed that their buildings most truly expressed the *Zeitgeist* or spirit of the age.

Postmodernism is a term that is applied to such diverse areas as philosophy, politics, economics, culture in general and architecture. To some it denotes a style, to some a period and to others it implies a whole new philosophical and critical approach to the world. Most critics agree that postmodernism has developed out of or after modernism and generally identify the period from the late 1960s as the time when postmodernism emerged. Given this common consent about the period we might expect to find similarities or links between the many disciplines in which the concept is applied but we find that as many questions are raised as answered. When examining architecture of the late twentieth century, critics note the plurality of styles. These include high-tech (see Figure 4.11), free-style classicism (Figure 8.6), neo-vernacular (Figure 8.11), classicism (see Figure 2.2) and deconstruction*. Postmodern philosophers are opposed to grand all-encompassing theories and to authoritarianism and we might be tempted to see the plethora of contemporary architectural styles as a healthy, democratic pluralism which parallels the relativism and diversity of interpretations which postmodern philosophers seek in philosophical argument. However, as we have noted, in many periods and places several styles have coexisted and during the previous modernist period modern movement architecture coexisted with art deco, classical, gothic, neo-Tudor and vernacular revival styles. We might therefore ask whether the current pluralism in architecture also expresses a postmodern condition. On the other hand, postmodernists might argue that unlike the previous periods when snobbery or the dogmatic theory of the *Zeitgeist* prevented an acknowledgement of a multiplicity of styles, today there is more widespread recognition and acceptance of diversity. They might also argue that all these architectural styles represent a critique of modernism, this being a style which postmodernists reject or wish to supersede. However, high-tech, which retains a faith in science and which emphasises the expression of up-to-the-minute technology and materials, can be interpreted as essentially modernist and many high-tech architects, such as Richard Rogers, would still accept the view that modernism is the only appropriate style for the late twentieth century.

Influenced by poststructuralism, postmodern linguists place particular emphasis on communication and interpretation. In parallel we might interpret many architects' current rejection of modernism as abstract, bland and alienating, and their preoccupation with ornament and styles from the past as a move to reintroduce communication and a sense of place into architecture. As we have seen, modernist buildings were not without meaning, albeit that which they communicated was often not recognised or has subsequently been found unacceptable. However, there may be some doubt as

to precisely what meanings are intended by the unconventional play of classical, vernacular or gothic forms in recent architecture. Such forms may seem familiar, they may blend more harmoniously with neighbouring old buildings, but do they communicate more effectively than buildings from any other place or period? As we pointed out when discussing classicism, the meaning of architectural forms is not intrinsic to those forms, it can vary within particular social and cultural contexts, and it is necessary to be familiar with the intentions of the patron or architect to understand the meaning. We might legitimately ask whether communication is a genuine concern of all contemporary architects or whether form and colour are often being explored to satisfy the inexhaustible demands of the market for novelty. Indeed it might well be argued that contemporary variety in architecture is more the result of market forces requiring ever more distinctive and seductive buildings. As such we might find it more helpful to link the pluralism of late twentieth-century architecture to developments in the economy in this period which have also been labelled postmodern.

Some economists use the term 'post-Fordism'*, rather than 'postmodernism', to describe the economies of the northern hemisphere in the present period. They have examined the changes wrought by finance capital, modern communications, microchip technology and computers. They also point to the changes brought about by the politics of the 1980s, of President Ronald Reagan in the United States and Prime Minister Margaret Thatcher in Britain. From these they have pinpointed the major economic changes which characterise and differentiate the post-Fordist period from the preceding modern period: the move away from the welfare state and state-owned industries, increased emphasis on entrepreneurial activity, profit-making and the free market, and increased consumption through diversification of production. Postmodern economists argue that, in contrast to the preceding modern period with its emphasis on mass production of identical products, these changes have led to greater emphasis on consumerism, marketing, advertising and variety in products in the late twentieth century. It is then clear that if we wish to isolate as distinctive and postmodern the stylistic plurality of architecture in the late twentieth century we will have to examine carefully the processes involved in producing buildings and the nature of patronage and architectural practice in the late twentieth century to see if there are significant changes which might support our case. These examples highlight the constant need to be cautious in assuming that there are neat explanations. Understanding architecture requires careful research and analysis.

Chapter 9

Sources

Earlier chapters of this book have indicated some of the complex issues that we need to be aware of when trying to understand buildings. In this chapter we can do no more than open the way to research on buildings. Our aim here is to identify basic questions which are essential to most studies of buildings and then go on to give some guidelines on the most important documentary and written sources for buildings. In addition we discuss the significance and uses of oral history to more recent architecture.

BASIC QUESTIONS

Where we begin and what we can discover depends on our aims and on the type of evidence we have at our disposal. In some cases we may not have any physical evidence of the building at all but will be relying totally on documentary evidence. In others the situation will be reversed. However, the following is a check-list of questions which form the basis of any attempt to understand buildings.

1 What is the date of the building?
2 Who was the patron or client?
3 What was the brief for the commission?
4 Who was the architect and/or builder?
5 What was the cost of the building and what have been the costs of usage and maintenance?
6 What was the original function of the building and how was it used?
7 Which parts of the building are original and which are alterations?
8 What are the materials and methods of construction?
9 What are the form and style of the building?
10 What was the location of the building; has the character of the original site and surroundings changed?
11 What were the responses to the building at the time of its construction? What have been subsequent responses?

12 What was the social, cultural, economic and political context in which the building was constructed?

APPROACHES TO ANSWERING THESE QUESTIONS

Documents and written records offer insights into buildings, but in practice when seeking to understand buildings we undertake a mixture of reading, searching in documents, analysing plans and surveying the built fabric. The types of sources available are determined by not only the building type we are examining but also its date, its location and the chance survival of information. Generally there is a better chance of tracing the home of an important local dignitary, a government building or an important religious building than a peasant house or row of workers' cottages. Fewer records will survive for older buildings. On the other hand, if we are examining contemporary vernacular architecture in Africa, the major sources will be direct observation and oral evidence. There is no one path of research that is the same for every building and situation. This chapter only suggests some sources to look out for and indicates the most obvious places where these might be found.

In trying to find the answers to basic questions we need to be methodical and critical. We need always to cross-check information. For example, if we are relying on oral evidence we need to remember that language can be imprecise and memories may be fickle; where possible we should attempt to find other supporting evidence. It is important to keep a record of the sources used and helpful to record any negative searches. Often material which at first seems irrelevant will at a future date appear significant and if a careful record is kept it will be easier to retrace. Accuracy is important because subsequent interpretation will be based on this information.

DATING

Dating is usually uppermost in our minds when we begin since the date will focus the rest of our research, determining the types of document that might exist and the historical and material circumstances within which the building was constructed. In previous chapters we have mentioned some of the problems of dating buildings from physical evidence. A survey of the building's fabric soon reveals complexities since most have been altered or adapted over the years and we soon find ourselves looking for more than one date. The use of documents to help with dating is also fraught with pitfalls and depends on the chance survival of relevant information. There is no one way to search for the date and no one document will provide it. A building plan, for example, may often be dated but this date is often not the same as that when construction commenced or finished. At the outset of any study of buildings, however, it is crucial to attempt to identify the period, if not

the precise date, at which the building was constructed, and the first step is to use secondary sources.

SECONDARY SOURCES

There are two categories of source material: primary and secondary. In general primary sources are contemporary with the building or period being examined. They may include the building itself, a client's brief, a bill of quantities, a surveyor's report, a building plan, the press coverage of the opening of the building, a description in a diary, or legislation affecting buildings in a particular period and place. Secondary sources are interpretations of a building or period by later individuals, historians, critics or writers. In practice there is no rigid boundary between the two: it really depends on the aims of the individual studying the sources. A history of architecture written today and concerned with architecture since the Second World War would generally be considered a secondary source. However, should we wish to look at historiography, that is the way architecture in the later twentieth century has been written about, then such a book would be considered a primary source.

To save going over ground already covered by others it is always wise to see if someone else has already researched and published on a building. Later on in the research we may wish to come back to secondary sources such as periodical literature, general histories, architectural and building studies, in order to place the building in a broader context. Whether we are studying a local building or not the best place to find out whether anyone has written about it is the local library. If it does not have a particular book, it is usually possible to order from other libraries. Otherwise a more specialised library, perhaps at a college or university, or a national architectural library, may contain relevant books and journals.

If the building is local the local reference library, council, museum or records office may have information. If a building has a specialist function, like a church or town hall, then the institution or organisation associated with it may have produced its own leaflet or brief account which can save a lot of leg work. For example church guides can usually be purchased at a modest price within the church.

For many large towns and cities there are often books published on the local historic architecture; for example, in the USA, D.D. Reiff, *Washington Architecture, 1791–1861* (Washington, DC, 1971), and H.R. Hitchcock, *Guide to Boston Architecture* (New York, 1954). Local chapters of the American Institute of Architects also publish guides to cities listing the principal buildings. Broader surveys are very useful if one is attempting to look at buildings in more than one area, and so are the magisterial surveys such as the Society of Architectural Historians, *Buildings of the United States*, published from 1993 by the Oxford University Press, Oxford, which

aims to cover the whole nation in a state-by-state series. In Britain there is the wide-ranging selection and discussion of buildings to be found in the many county volumes of N. Pevsner and B. Cherry, *The Buildings of England*, *The Buildings of Wales* and *The Buildings of Scotland* (Harmondsworth, Penguin) and *The Victoria County History of England* (London, Oxford University Press).

Large numbers of buildings which are considered important or have been designed by those deemed to be significant architects are written about in general architectural histories, monographs and period and style studies. Even if the particular building is not mentioned in a general historical study it may be possible to understand its characteristics and roughly identify a period for its construction through a general architectural history. Such books may be of value in giving general guidelines relating to the building type, the approach to planning, the structure, its style and the geographical locations in which similar buildings are to be found. Social histories or histories of particular organisations and institutions may be very useful for understanding the design and function of building types such as schools, workhouses, prisons, hospitals, churches and buildings for particular industries.

With any history or published study of buildings it is wise to look at the author's bibliography and footnotes to identify which primary and secondary sources have been utilised. These can be followed up to cross-check the information or to see if there is further material. In all studies it is important to be aware of the stance taken by the authors towards their material and it is useful to approach secondary sources by asking who wrote the text and when it was first published. The date of publication can provide an indication of the author's viewpoint and the context in which the study was undertaken. Reading around a topic will reveal many inconsistencies and even contradictions from one author to another. A critical evaluation of texts builds up an understanding of a period and approaches to buildings.

PRIMARY SOURCES

The primary sources that are available may be used in many different ways and may present problems to the researcher. Very early documents may often require a specialist language knowledge. For example medieval documents in Britain may be written in Latin or Anglo-Norman. It may also be difficult to identify particular buildings in documents because identification is often only possible through the names of those who occupy or own the building and few buildings had street numbers or even names before the twentieth century. Street and road names can change, as can street numbering.

Primary sources should also be approached critically. We should attempt to understand the purpose behind the creation of any written source or

document which we examine since few of them were made to help us find out about buildings. Most contemporary accounts of buildings, documents and records which we class as primary sources represent a selection of information which has been acquired for a particular purpose. Understanding that purpose helps us to interpret such information. Often the most accessible building plans are those submitted to local authorities to control building design and prevent the construction of insanitary dwellings. Yet we may use them to discover the name of the architect or patron, as well as to examine the proposed building design. Nineteenth-century trade directories which we may use in our search to identify when a commercial building was first erected were published to advertise the business and obtain customers. There is no guarantee that the business occupied a particular building, only that it operated at a particular address at a particular date. Further research is needed to ascertain the precise details of the building.

Early documentary sources, accounts and architectural publications

There are few documentary sources available of any value before the sixteenth century. It is largely through excavation and archaeological research that we have come to understand ancient buildings. Plans survive of buildings in ancient Mesopotamia and Egypt; for example a statue in the Louvre, Paris, of Gudea of Lagash, Mesopotamia, shows a drawing table on the man's knees with an engraved plan. More common plans of this period are on clay tablets, limestone flakes, or papyrus. In ancient Greece no plans or elevations of buildings have survived.[1] However, inscriptions still survive which include specifications, contracts, accounts and lists of donors. It is interesting and perhaps reflects on the differing circumstances of ancient Greek and Roman architecture that we know the names of over a hundred Greek architects of c. 650–50 BC but hardly a single Roman architect.[2]

The writings of ancient authors give only scanty information about contemporary buildings. There is the guidebook of Pausanius describing what were then considered the chief cities and sanctuaries of ancient Greece in the second century AD but no writings of ancient Greek architects or art historians survive. However, there are summaries of Greek texts in the Roman writings of the elder Pliny, *Historia Naturalis*, AD c. 77, and references to Greek buildings and methods in Marcus Vitruvius Pollio (Vitruvius), *De Architectura*, before 27 BC. Although the latter was used as a source for renaissance architects, since it and Pliny's work were written from a Roman viewpoint they are not very reliable sources for knowledge concerning Greek architecture.[3] As a practising Roman architect, however, Vitruvius' writings do offer valuable insight into the architecture of his day.

Some medieval building accounts, drawings and manuscripts survive which refer to major works such as castles, mills, bridges, monasteries and colleges. After the sixteenth century the range of documentary sources for

buildings widens but various factors such as the type of tenure of the property, freehold, leasehold or copyhold will determine the types of document available. For example, leasehold properties did not have title deeds. Many documents will be found in local archive or public record offices, or with private owners or government, religious, corporate or institutional bodies. If the property is leased, then relevant documents will be found in the estate records of the landowner or the institution. The records of some building types may have changed hands and it will be necessary to trace such changes of ownership. For example, many early nineteenth-century parish schools in England were founded by voluntary societies or by private charities. Some of these records are now to be found among parish records.[4] In some cases common records may never have been made and often documents do not survive, particularly from the earlier periods. National registers of archives, local record and archive offices and libraries will often help in locating such source materal.

Published documents

Documents that are considered to be important are sometimes published to make them more widely accessible such as H.M. Colvin, *Building Accounts of King Henry III* (Oxford, 1971), or C. Guasti, *S. Maria del Fiore, la Construzione . . . Secondo i Documenti* (Florence, 1887). Many books of published documents take the form of extracts from the documents or may consist of compilations of many documents covering particular topics, periods and geographical areas, such as L.F. Salzman, *Building in England down to 1540* (Oxford, Oxford University Press, 1992), and L. Roth (ed.) *America Builds: Source Documents in American Architecture and Planning* (New York, Harper & Row, 1983). These may include contemporary descriptions of works of art and architecture or theoretical treatises as well as building accounts or patrons' briefs. It is becoming increasingly common for local museums and record offices to publish widely used documents in their collections, such as local hearth tax returns (which we look at later, p.180) and it is worth looking out for these. Although such publications are extremely convenient they need to be used with caution, particularly where only partial extracts are included or the document has been translated from another language. It is advisable to read any commentaries accompanying such publications or collections of extracts because they may include helpful remarks concerning the context and purpose of the documents. Many well-known original documents have been worked on by innumerable scholars and it is also always advisable to check what has been published concerning their interpretation. Some useful collections of extracts and documents are listed in Appendix II.

Architectural publications

The most accessible primary sources are works published on architecture since the sixteenth century. However, this material is generally only relevant to polite architecture. During the renaissance the works of ancient authors were studied and the first printed edition of the writings of Vitruvius appeared in 1486, followed by many further editions and commentaries. The writing of treatises also became popular, beginning with Leone Battista Alberti's *De Re Aedificatoria*, 1452 (published in Italy 1485/6), as well as books setting out the rules for the design and use of the classical orders such as that by Sebastiano Serlio, another Italian, in 1537. Architects too began to publish books on their own buildings such as the *Quattro Libri* (1570) by the Italian architect Andrea Palladio or studies of contemporary buildings such as the Frenchman J.-A. du Cerceau the Elder's *Plus Excellents Bâtiments* (1576–9). With the setting up of schools of architecture, for example the French Royal Academy in the seventeenth century, information on architectural education may be gleaned from published accounts of courses. The most widely read architectural handbook in France in the eighteenth century was François Blondel's *Cours d'Architecture* (1771–7).

From the renaissance onwards engravings and pattern books were published. Hans Vredeman de Vries of the Low Countries published *Architectura* (1577–81), which helped to spread architectural ideas throughout Europe. In Britain from the sixteenth century architects were exposed to imported architectural treatises and pattern books from Italy, France and the Low Countries, followed by translations of such works. It was not long before indigenous treatises were published. In 1563 John Shute's *First and Chief Groundes of Architecture* was published and in the eighteenth century the ambitious and perhaps most comprehensive English discourse on architecture became available, Sir William Chambers's *Treatise on Civil Architecture* (1759, 1768 and 1791). In the eighteenth century books aimed at advising builders on the design and construction of even the simplest buildings began to proliferate such as Batty Langley's *The Builder's Compleat Assistant* (1738). In the same period British architectural handbooks were also widely used in the colonies.[5]

With the rise of revivalism in Europe and the USA in the eighteenth century, interest in non-European architecture as well as archaeological studies of ancient European sites became increasingly popular. The many English publications included Sir William Chambers's *Designs of Chinese Buildings* (1757), the measured studies of ancient Greek architecture contained in James Stuart and Nicholas Revett's *Antiquities of Athens* (four volumes, 1762–1830), and *An Attempt to Discriminate the Styles of English Architecture* (1819), by the antiquarian Thomas Rickman, in which he invented the labels early English, decorated and perpendicular for the styles of English medieval architecture. By the nineteenth century in the USA

indigenous builders' and architectural handbooks such as Asher Benjamin, *The American Builder's Companion* (Boston, 1806), and J. Haviland, *The Builder's Assistant* (three volumes, Philadelphia, 1818–21), were widely available. The latter was the first of many to illustrate the Greek orders, and revived Grecian forms were to be widely popular in North American domestic architecture until as late as the Civil War of 1861–5.[6]

With improved methods of printing in the west in the nineteenth century, and the expansion of the building industry and architectural profession as a result of industrialisation and urbanisation, publications in the field of architecture proliferated to such an extent that it is not possible to do justice to them in a brief survey.

Newspapers and journals

Newspapers and journals are a major source of information on contemporary responses to buildings although in general only the more prominent public and commercial buildings will be privileged with comment. Local papers from the nineteenth century onwards often comment on new building proposals or the opening of new churches, cinemas, sports halls or shopping centres, large planning proposals, and prominent industrial and commercial buildings. At a national and international level professional architecture and building journals selectively cover the work of individual architectural practices, engineers or particular building companies, and discuss important new projects. From time to time they may survey the works of a particular architect, examine in detail a building type or look at buildings in a particular locality. Articles may illuminate the general social and economic context of contemporary architecture, as well as advise on available materials, processes and methods of construction in a period. The advertising in professional and technical journals may also be valuable in supplementing information on building professions, trades, materials and technology.

From the eighteenth century onwards it is possible to find local and national newspaper and magazine advertisements giving details of properties for sale. Some may refer to whole estates which are being offered for sale or broken up, others to individual buildings. They may include details of houses, estate farms and cottages. There may be plans, engravings or, in the twentieth century, photographs illustrating the property and details of the number of rooms, their sizes, and descriptions of fixtures and fittings.

Descriptions, paintings, drawings and photographs

The value of written descriptions and visual records of buildings varies, depending on when they were made, their accuracy and coverage of the building. There are accounts and sketches of ancient buildings made by

successive travellers and antiquarians from the middle ages onwards. Some of the early descriptions and drawings, although often partial and impressionistic, are valuable in giving us information concerning buildings or parts of buildings which no longer exist. For example the drawings of the Parthenon sculptures *in situ* by the French draughtsman Jacques Carrey were made in 1674. In 1687 an explosion in the centre of the building destroyed large parts of the side walls. However, Carrey's drawings recorded the full design of the frieze and enable us to identify the location of surviving fragments.

Topographical engravings and paintings showing views of towns and paintings of country houses and landscapes have been a popular subject for artists from at least the seventeenth century. In the eighteenth century picturesque taste in England also encouraged an interest in rural cottages and farmhouses. M.W. Barley's *Guide to Topographical Collections* (London, Council for British Archaeology, 1974) is helpful for locating British collections of topographical works. Topographical views can often be found in local and national museums, art galleries, stately homes or private collections.

From the eighteenth century many architects hired perspectivists to communicate, often seductively, their buildings to commissioning bodies and juries. Unfortunately few of these have survived. For example, one of the most important architectural competitions of the Victorian period was that for the Law Courts, London, in 1868. While photographs survive of the entries invited from eleven eminent architects, none of the original, and in some cases dramatic, drawings survive.

The most accessible architects' drawings are those reproduced in nineteenth- and twentieth-century architectural journals, and plans and drawings of buildings submitted to local authorities from the late nineteenth century for purposes of building control which we discuss later (p. 178). Some drawings and plans may be found in collections held by architects' professional bodies, museums and libraries, the archives of architectural firms, and institutions and private owners that have commissioned buildings.

Where they exist photographs are invaluable records. Aerial photographs may be helpful as evidence of plans, roofs and garden layout. Photographs of buildings may be found in public and private collections, local museums and libraries, and both local and national newspapers often have photographic collections. In Britain since 1955 the Royal Commission on Historical Monuments has recorded buildings of architectural and historic interest threatened with destruction. The archives of the Commission contain a large number of drawings, photographs and written accounts of buildings from all over the country from small rural dwellings to more substantial structures. Their large photographic collection which was founded in 1941 is known as the National Monuments Record. The Commission publishes inventories

and lists of buildings recorded as well as studies or surveys of particular types of building, or buildings of a town or region. In the USA the Historic American Building Survey (HABS) and the Historic American Engineering Record (HAER) similarly record buildings and engineering structures respectively.

Maps and plans

Maps may provide evidence of the age and changing shape of a building and its surroundings. They can be invaluable for helping to understand the original site with which the architect or builder had to contend. However, there can be problems of identifying buildings on old maps because they may have changed shape over the years with extensions or demolitions, the site and its neighbouring features may have altered dramatically with the construction of new roads or buildings and in some cases the map may not be accurate. It is often useful to start tracing an old building by commencing with recent maps which show the streets, and if it still survives the building, and then work backwards in time to older maps. The more useful larger-scale maps tend to be of recent origin (in Britain the 25 inch to the mile (1:2,500) Ordnance Survey maps began to be produced in the 1880s). The most useful sizes today are the 1:10,000, 1:2,500 and the 1:1,250.

There is a wide range of maps and plans available depending on the region and period. From the sixteenth to the nineteenth centuries engraved maps were often produced of towns and regions, although many are inaccurate and most are of small scale. They can sometimes be of value in locating isolated buildings. In Britain plans of individual parishes were made under the Enclosure Awards between c. 1760 and c. 1870 and the Tithe Commutation Act of 1836. However, not all parishes were subject to these acts. The former give the names of newly allotted land, the latter identify landholdings and their buildings.

Plans drawn up for legal or administrative purposes which relate to small plots of land, estates or whole parishes were produced precisely to identify landholdings or property units and can be useful. During the eighteenth and nineteenth centuries detailed plans of housing to be erected on estates were often prepared for developers. Urban landowners often had plans made and some exist from as early as the sixteenth century. Those for the Corporation of London, for example, include plans of individual buildings such as schools, hospitals, markets, prisons, bridges and parks.

It is possible to find plans of public utilities such as gas and sewerage works as well as plans showing drainage, water and lighting from as early as the late eighteenth century. In Britain these utilities had to obtain approval through private Act of Parliament. Mention should also be made of detailed plans relating to the construction and improvement of ports, docks and coastal architecture such as piers, quays and promenades.

Libraries with local studies collections and local record or archives offices usually keep maps of the neighbouring area. At a national level there may be a variety of map collections held by different institutions. In Britain there are map collections in the Public Record Office, the British Library, the Bodleian and Cambridge University Libraries, the national libraries of Scotland and Wales and the Royal Geographical Society. For a useful introductory survey of British maps see J.B. Harley, *Maps for the Local Historian* (Leicester, Blackfriars Press, 1972).

Building legislation

Building legislation can help to explain some aspects of construction and building form, and may be helpful in dating. Usually legislation is the result of a concern to safeguard buildings against fire, and to ensure the health, safety and the convenience of people living in towns. In some cases it made a tremendous impact on the form of new building, for example in England the regulation under Charles I in 1625 which controlled brick sizes. From the nineteenth century onwards much legislation has been enacted in many areas relevant to architecture, such as the Zoning Law in New York in 1916, which led to the stepped-back profile of skyscrapers, and in Britain the Tudor Walters Report (1918), and the Parker Morris Standards (1961), both of which recommended design standards for local authority housing.

The surveys and reports made by government as a basis for considering legislation such as the Report on the Sanitary Condition of the Labouring Population, made in 1842, provide useful information. This report surveyed mainly urban areas in Britain seeking to discover the links between disease, poverty, bad housing and other environmental factors. Reports such as this which contained information on overcrowding, dirt, disease, the size, condition and types of dwelling led to the Public Health Act of 1848 and eventually to the development of British building control.

Building controls

With the massive growth of urban areas in the nineteenth century building control became essential. By the 1860s most provincial centres in England had issued building regulations. In some cases these were independently worded local Acts, in others the regulations were based on the guidelines for local by-laws suggested in the 1858 Local Government Act. The 1875 Public Health Act rationalised sanitary control, extended it to all areas and in 1877 introduced a set of Model By-laws which were widely adopted. These controls aimed to regulate the structure of buildings for purposes of preventing fire, ensuring structural stability and health; the level, width and construction of new streets; the provision of sewerage; the spaces around buildings and their drainage. Despite widespread adoption there were still

local variations in the regulations, their interpretation and implementation. Thus, for example back-to-back houses continued to be built in the West Riding, Yorkshire, well into the twentieth century.

By-laws and building regulations are valuable in understanding aspects of building design. But perhaps of more significance for those wishing to study buildings is the fact that building control has required architects and builders to supply copies of all their plans of buildings to the local authority for inspection. These provide one of the most important sources of material for studying buildings from the late nineteenth century onwards. It is here that we may be able to find the names of patrons and architects, confirm the date of the design of a building and examine original measured plans and elevations. These are also a quarry for alterations and extensions to any building, including buildings originally constructed in a period before the introduction of building control.

In Britain these building plans are deposited with the local borough, urban and district councils or record office. The registers to these plans are chronological and are rarely indexed. A long search is usually necessary unless one knows the date of the building. For newer buildings questions of security may require that researchers obtain permission of the architect to inspect the plans.[7] In Chapter 10 we will discuss how to read and interpret plans, models and architectural drawings.

Title deeds

Deeds are documents recording the transfer of rights of freehold property from one person or body to another and require an understanding of legal terminology. They are usually kept by the owner's solicitor, bank or building society, although many old deeds are kept by local record offices. Since the transfer of property might take place as a result of a sale, through marriage or inheritance, deeds are somewhat random records of properties, occurring only when they change hands. Moreover, when an individual building belonging to a group, say a barn on a farm, is sold the deeds are not divided but remain with the larger unit, that is the rest of the farm.

Title deeds for individual properties are rarely relevant to religious institutions, municipal corporations or large landed estates. Here, either the property rarely changes hands in the ways indicated or, if it does, it passes as a whole to the next owner or heir. However, many great estates were sold at the end of the nineteenth and early twentieth centuries and deeds of individual properties may be found from this period.

The value of deeds in researching buildings is that they record change of ownership; properties with a special function are usually named, for example windmill, warehouse or parsonage; and they give the size of the site and its boundaries. These are usually defined with reference to the local geography or neighbouring landowners.

Taxation and rating records

Taxation records may be helpful in determining aspects of building form and even the nature of settlements. However, account needs to be taken of evasion and undertaxation when considering such information. The Hearth Tax was levied from 1662 to 1689 in England to replenish impoverished government coffers during the reign of Charles II. Many of the records relating to this tax are lost but from those that survive it may be possible to learn something of the size of dwellings or at least the number of rooms which were heated in houses. However, several categories of people were exempt, including some of the very poor, and it has been estimated that possibly some 40 per cent of households were not recorded in the Hearth Tax.[8] The Land Tax was an English property tax levied from the late seventeenth century into the nineteenth century. Most records survive for the period 1780–1832 when they were used for electoral purposes. These records rarely give a description of the property or its location, but simply list owners and occupiers, so over a long period we can reconstruct the ownership and occupancy pattern of every house in a town or village by comparing returns for each year.

Fire insurance records

From the early eighteenth century property could be insured against fire and often a small metal or ceramic plaque was attached to insured buildings giving the name of the insurance company and policy number. The records of some companies may still survive and these may give details of the function, valuation and building materials of the insured property. Insurance records may be found in record offices and the head offices of insurance companies.

Inscriptions on buildings and makers' marks on building materials

Careful study of buildings themselves may reveal written information that may help identify dates and the names of patrons and makers of materials. Initials of the architect or patron and dates may be carved on plaques set into walls, or may form part of the casting of a lead rainwater head. Building workers sometimes inscribed dates and initials onto timber components or masonry. The names represented by initials may be identified in directories, parish registers or wills. However, care should be taken in interpreting any inscriptions or embossing of materials. Weathering and the use of Roman numerals and letters may cause confusion and it may not always be clear to which part of the building an inscription refers. Moreover, it is important to check that the component which is inscribed is an authentic element of the original structure and not a later addition or derived from other buildings.

The archives of professional bodies and the building trades

Architects, engineers and surveyors often belong to a professional body and details of their membership and career may be traced through such bodies or institutions. Local branches of national institutions may also have information pertaining to local members. A general knowledge of these institutions and bodies is of inestimable value in understanding the nature of the profession and the way it was controlled at a particular date. In the USA architects belong to the American Institute of Architects (AIA), in Britain the Royal Institute of British Architects (RIBA). Most architects who are or were fellows or associates of the RIBA will be recorded at the British Architectural Library in London. The records date back to the founding of the RIBA in 1834 and are continually being updated with information about the individual architects as material becomes available. The library aims to collate the addresses, dates, education and training, professional career, bibliographical references and obituaries of each architect. In each area of the country there are also local branches of the RIBA which organise meetings, lectures and events for members and may publish a local journal or newsletter from which valuable information may be gleaned.

Books published on the history of particular crafts and trades are of inestimable value in contextualising the materials and methods used in the building industry in particular periods. Primary source material may be found in the archives of the guilds, trade unions and other organisations to which craftsmen and building workers belonged. Recently published is Christopher Powell's extremely valuable, albeit small, booklet, *Writing Histories of Construction Firms* (Englemere, The Chartered Institute of Building, 1992), which gives a wide range of sources for the history of firms engaged in building in Britain.

Company archives

Company archives may contain letters, business diaries, accounts, briefs, reports, architects' drawings and plans. Whether we are looking for information concerning an architectural practice, a building firm, auctioneers, estate agents or surveyors, or trying to find out about the construction of an industrial or commercial building, we may find company archives useful. In Britain company archives may be located by referring to the National Register of Archives of the Historical Manuscripts Commission. The register records documents and records deposited in archives and record offices throughout the country each year.

Estate and manorial records

Among the records of landowners, whether an individual family or institution, may be surveys and valuations of the land in their ownership. These may consist of written descriptions of buildings and land, sometimes accompanied by maps and plans; lists of leases and properties rented; the names of tenants and the annual value or rental; covenants for repair; accounts and correspondence relating to new buildings and to repairs.

Probate records

Inventories, which accompany wills, are detailed lists of the personal possessions of the deceased. Particularly relevant to domestic architecture are those from the sixteenth to the eighteenth centuries which itemise the contents of houses room by room. These may provide an indication of wealth, lifestyle and the usage of the rooms. However, it is rarely possible to relate early inventories to particular dwellings. Wills and inventories of the personal possessions of deceased persons are usually located together and kept in local record offices. Copies of wills made since the mid-nineteenth century in England and Wales are kept at St Catherine's House, 10 Kingsway, London, WC2B 6JP.

Trade directories, parish registers, census returns and electoral registers

The major sources for information on individuals living within an area are directories, parish registers, census returns and electoral registers. The availability of information will tend to depend on whether or not the patron was an important individual within the community. People in trade or business can usually be found listed in trade directories. Trade or commercial directories, which proliferate from the second half of the nineteenth century, but can be found as early as the late eighteenth century, give names of tradespeople and principal inhabitants of towns and villages. Often published annually, the directories contain alphabetical lists of names, trades and streets. They can be useful in tracing the existence of firms or individuals at particular dates. It is sometimes also possible to deduce a rough date for the initial occupation of a building simply by the appearance in the directory of the street number of a dwelling, or trade name of a business, although, as we have mentioned earlier, there is no guarantee that an individual or business occupied a particular building – only that the person or business operated from that particular address at that particular date. Armed with this date it is possible to focus perhaps to within a few months or years the search for the plans of a building through building control plan registers. It is important to

remember, however, that not all inhabitants are listed, and street numbers and names change.

Genealogical information may be traced through parish registers which give names of those baptised, married or buried in a parish. Census returns compiled from the mid-nineteenth century may help in identifying the names, occupations and numbers living in dwellings. They record the names of individuals within households in a street, their relationship to one another, ages, occupations and birthplace. As the franchise extended in the late nineteenth and early twentieth centuries, electoral registers have become useful records of adults occupying dwellings in each locality. Local record offices and libraries can advise on the location and availability of such records.

Oral history

So far we have concentrated on documentary evidence, where to find it and how to use it. We should, however, include an important area of historical evidence which is not based on documents; that is, oral history. By this we mean interviews and discussions with architects, patrons or users of a building. Some universities such as the University of California run oral history programmes and there may be oral history groups in many localities. There are limitations on oral history, as we mentioned at the beginning of this chapter. People may be prone to exaggerate, memories may be fickle and language may not be precise. Myths arise in relation to particular buildings and the individuals associated with them which may result in misleading anecdotes. It is always wise to cross-check information by interviewing more than one individual and to use documentary evidence.

Although important new public and commercial buildings are critically appraised in newspapers and journals it is often difficult to find written records of responses to other buildings. The most telling responses to buildings come not from the patron, architect, builder or even journalists and professional critics but from those who have to live or work in them. The users' views are rarely sought or made available in written form unless perhaps for sociological or other reasons a survey has been made. Tape-recording and even video-recording equipment is widely available today and offers wonderful opportunities for obtaining records of people's responses to twentieth-century buildings. Interviews may also be conducted with patrons and professionals involved with architecture, particularly those of an older generation who may remember buildings that no longer exist or for which there are limited written records.

In the twentieth century there may be professional tape recordings of radio, film and television interviews with those connected with the design or use of buildings. Radio, film and television company archives may prove fruitful quarries. In the 1930s in Britain, Europe and the USA there was

much debate on good design and the built environment which was promoted not only in books and journals but also on the radio. After the Second World War clean-sweep planning and modernist and postmodern-style buildings have kept architecture and the direction it should take in the news. Media concern is regularly focused on controversial planning issues and housing estates where there are problems. The accidental gas explosion in 1968 at Ronan Point, a tower block in London, which led to the progressive collapse of a poorly constructed building, and the deliberate destruction of 1960s housing blocks such as Minoru Yamasaki's Pruitt Igoe, St Louis, USA, in 1972, are two such cases. They led to extensive interviews on radio and television with patrons, architects, builders and users to contextualise the issues. For very different reasons the opening of prestigious buildings, new museums and galleries, or new buildings erected for major international events such as the Olympics, often arouses much media attention.

Chapter 10

Drawings, models and photographs

Drawings and models have one major function in common and that is communication. They are the means by which architects convey their ideas to other people, whether prospective clients or the public, or in detailed instructions for a builder. They are also the means by which architects develop those ideas. The analysis of a series of drawings of a particular building can reveal whether the architect's ideas changed during the evolution of the design or during the course of the construction. They can also give some insight into the architect's approach to design and provide a record of their intentions at a particular moment. The type of detail given in a plan will depend on its purpose. A large scale giving constructional specifications in great detail may be necessary in order for craftspeople to carry out instructions, whereas a small scale giving few details may be all that a client would require to be convinced of the merits of a project. Plans should give the north point to show the orientation of the building, for this determines the type of natural light that will be available.

Drawings, which can include plans, elevations and sections as well as sketches, give us 'access' to buildings even if they are on the other side of the world. They reveal how the shape of the exterior relates to the interior, and they enable us to see how the inside of a building works. They show the general structure and whether it has loadbearing walls or is a frame construction; they show how the different floors relate to each other and the size, shape and disposition of the rooms. We can also see where the windows, the fireplaces, chimney flues and other services are placed. By analysing the plans we can see the relationship between stairs, halls and passageways and the rooms they serve, and we can see the ways in which people are able to move around inside the building. Plans also help to indicate the kinds of activity that are possible in a building. If the building is still in existence we can compare the drawings with the building itself, but we may well find that there are differences between the two. These may be because the architect or client changed their minds during the course of construction, or they may be due to changes to the building that have taken place over many years. If we have additional information such as photographs we can relate these to the

drawings, for the more information we have, the more we are able to discover.

Some buildings may exist only in the form of plans. Competitions, for example, may result in the submission of plans from many contestants, but only the winner succeeds in having his or her building constructed. Drawings may also be the only evidence extant of ephemeral structures, such as exhibition buildings which have been erected for a few months and then pulled down, or buildings that have been demolished or damaged by war. Designs by visionary architects, such as Boullée's design for the monument to Newton, exist only on paper but may be very influential (see Figure 8.5). More recent visionary architects include the Japanese Metabolists* and the English Archigram* group who were inspired by the technology of the early 1960s to produce utopian city schemes, many of which were influenced by space research imagery. Archigram advocated a flexible, disposable, machine-age architecture which was popular, anti-heroic and free from historical styles. Their imagery was absorbed by contemporary architects; indeed it is arguable whether the Pompidou Centre in Paris (Renzo Piano and Richard Rogers, 1974) or the Lloyds Building in London (see Figure 4.11) would have been possible without this influence.

PLANS

A plan is a horizontal plane through a building, often drawn at waist level, so that it shows the windows. As its name implies the ground plan is the plan of the ground floor. In British terminology this is the floor at ground level and the floors above are numbered consecutively – one, two, three. In European and American terminology the ground floor is numbered the first floor and the floors above are numbered consecutively – two, three. So a British first floor is an American or French second floor. In this book we use the British system of numbering. When faced with plans labelled ground floor, first floor, second floor, it is important to understand which system of numbering is used and how the floors relate to the ground level outside. The ground floor may not be the only floor with exits and entrances at ground level. A building on a steep site may offer the opportunity to design exits and entrances at ground level for several floors.

Today there are agreed conventions for indicating the mode of construction of a building, the rooms, doors, windows, fireplaces and the circulation routes, that is the stairs, halls and passages (Figure 10.1). In earlier periods architects developed a variety of conventions and some of these are more difficult to decipher than others. Figure 10.2 shows Antonio Gaudí's original plan for the third storey of the Casa Milá apartment block in Barcelona. The windows in the main wall of the building can be seen as the dark spaces which appear at intervals in the thick white line around the edge of the plan. Occasionally a thin wavy line extends outside this boundary wall and this

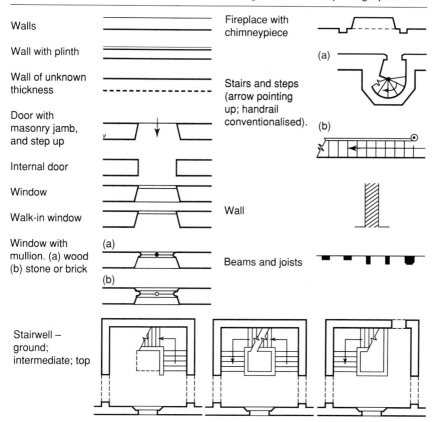

Figure 10.1 Architectural drawing conventions

denotes the balconies. The rooms have curving walls with no corners and are like a necklace of bubbles threaded together. These rooms are separated by winding passages and there are also a number of internal rooms without windows, which may perhaps be store rooms. We can see that the building has two large internal courtyards, each with stairs, but the direction of the stairs is not indicated. There is a curtain wall, shown by a single line around each courtyard, supported by rectangular pillars; elsewhere the white circular dots indicate columns. Between the two large courtyards are two circular spaces to which there is no access, but there are small windows facing onto them so we may conclude that they are light wells. The material of construction is not indicated but from the floor plan the exterior walls, which are of concrete, appear to be loadbearing, while the floors are supported by columns.

Figure 10.2 Plan of third floor of Casa Milá, 1906 (Antonio Gaudí)

Figure 10.3 is a street plan and this shows a building shaded, set back from the street with the front door probably facing east. It seems to adjoin the building to the north, but it is unlikely that it is semi-detached, because the adjacent building is quite different in form and is the end of a terrace of similar houses. To the south is the garden of the house in the next road.

Figure 10.4 shows the ground- and first-floor plans of part of a mid-Victorian house marked on the street plan. From the thickness of the walls we can see that the building is of masonry construction, with loadbearing external and internal walls. Looking now at the ground plan we see that the front door (A) leads into a lobby and to the right a door (B) leads into the hall. From the lobby there is also a door leading to a conservatory (C) which has a low masonry wall with glass on top. Continuing straight through this conservatory double doors lead to the garden. The two reception rooms are symmetrical about the inside front door (B) and each has a bay window (D) and fireplace (E). Opposite the fireplace in each room is a shallow bay and in the reception room (F) this has been broken through and has double doors giving access to the conservatory (C). The stairs with handrail and newel post* face the inside front door and the arrow indicates that the stairs ascend

to the floor above. The dotted lines of the stairs indicate that the stairs turn round and continue up over the passageway below.

Looking at the first-floor plan we can see that this second flight of stairs is much shorter and leads to a landing (G) with a window at the end of it. This window, which faces south, looks out over the lobby roof (H) and the corners of that roof are emphasised by two round circles which represent stone balls. We have seen from the street plan that to the south of this building is a garden and this would imply that plenty of light comes into the house from the windows on this side of the building. Two rooms lead off the landing, room (I) has a bay and two cupboards but no fireplace, while room (J) has no bay. Both rooms also have small windows set in their south-facing walls. At first-floor level the conservatory (C) appears to be made of glass since the walls are drawn as two closely spaced lines. If these plans were on tracing paper we could literally place them on top of each other in order to see how the two floors relate to each other. We would find that the interior loadbearing walls continue through the two storeys; this is a characteristic of all loadbearing constructions. Notice also that the front bay continues up

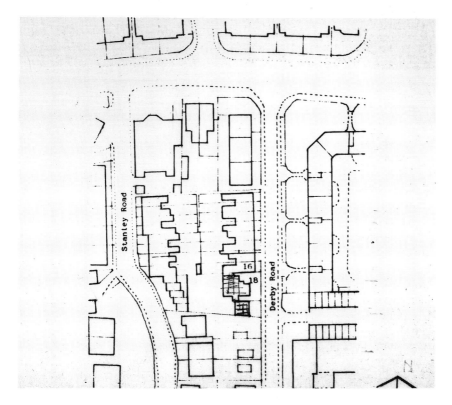

Figure 10.3 Street plan showing location of a Victorian house (Ordnance Survey)

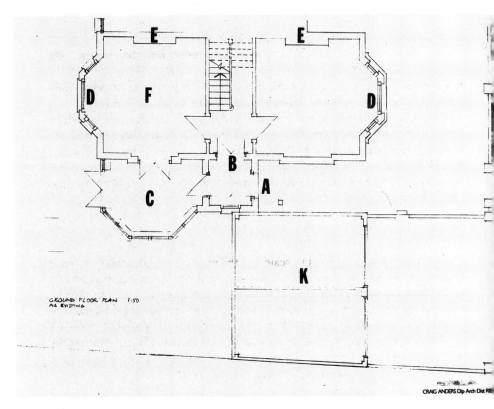

GROUND FLOOR PLAN 1:50
AS EXISTING

CRAIG ANDERS Dip Arch Dist RIB

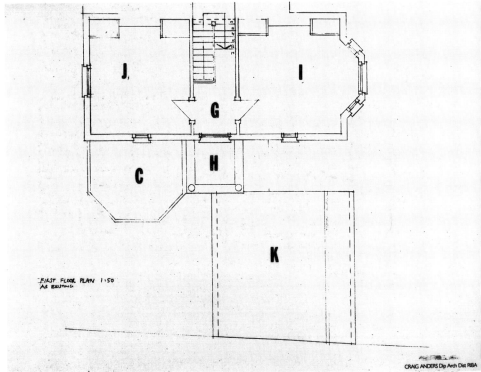

FIRST FLOOR PLAN 1:50
AS EXISTING

CRAIG ANDERS Dip Arch Dist RIBA

Figure 10.4 Ground and first-floor plans of part of a Victorian house (*c.* 1868) (Craig Anders)

through the first floor, but that the bay at the rear does not. As this is only part of a plan and we know it is a house, we can conclude that the kitchen and bathroom are located in the part of the house not included in these plans. Comparing the ground- and first-floor plans we can see that the structure (K) to the south of the front door appears in outline only on the first-floor plan and therefore is a single-storey building. It has no windows or other features and from the location and dimensions it would appear that these are two single garages.

Scale

Plans and models are always to scale and the main factor governing the scale chosen is the level of information to be given. Some sketches may also be to scale, but freehand explorations of ideas will probably not be. Until 1971 all scales in Britain were in imperial measurements (e.g. ¼ inch:1 foot represents a scale of 1:48). Since 1971 the metric scale has been used. A scale of 1 cm:1 metre represents a scale of 1:100 and this is quite sufficient to show the relationship between rooms. Figure 10.4 was originally drawn at a scale of 1:50 but has been reduced for inclusion in this book.

Figure 10.5 Askham Hall, Yorkshire, 1885 (Chorley & Cannon) (*Builder*, 1885)

The house in Figure 10.4 has a simple plan compared to that of a large Victorian country house (Figure 10.5). Such an elaborate plan can only be understood if one knows something about the way life was conducted inside its walls by the owner's family and their servants. The basic rules underlying this plan concern the social dynamics of day-to-day life in an era when servants were an essential part of running the household, but their contact with the family had to be minimised. It is possible to see from this plan that the main stairs lead off the entrance hall and there are several stairs used by the servants. It is also possible to see how the family and the servants moved around the building by different routes, where and under what circumstances they saw each other, and how the various spaces were used at different times of the day. This plan is not symmetrical, nor is there any axial

Figure 10.6 Ground floor plan of Syon House (Robert Adam, 1772) (© Penguin Books Ltd)

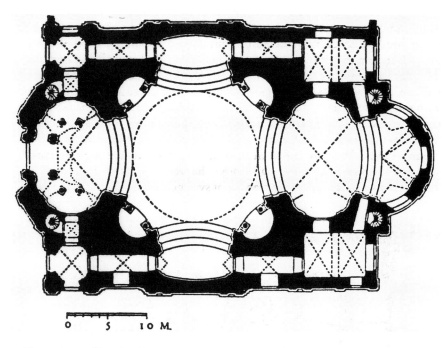

Figure 10.7 Church of Brunau, near Prague, 1708–15 (C. Dientzenhofer)

emphasis. The main family rooms are grouped around the entrance hall, while the business room can be reached by a separate private entrance.

Axial plans such as that shown in Figure 10.6 are largely associated with classical architecture. An axial plan means that the building is designed so that it is symmetrical about either one or both axes. Syon House (Robert Adam*, 1772) is classical in the sense that its decorative vocabulary derives from classical sources. All four façades are symmetrical about their centre point and the interior spaces are symmetrical on either side of the north/ south axis. The rooms are all geometrically shaped and each is based on a classical prototype. The basilica-shaped entrance hall has an apse at either end and it leads through to the domed rotunda*, or pantheon, at the centre. Classical planning involves symmetry, the organisation of clearly defined axes, hierarchically planned rooms and, in skilled hands, the clever use of *poché*, that is the spaces between the main rooms. Note in this plan the insertion of winding stairs in the *poché* between the hall and the anteroom to the left.[1] The classical tradition continues to the present day, but not all buildings that display classical motifs externally have classically planned interiors.

The plan of Syon House shows that the spaces of each room are separate and distinct from each other. By contrast Figure 10.7 shows how a sense of

movement is created in a baroque church by means of a series of overlapping ellipses. This sense of movement is carried even further by the same architect, Christian Dientzenhofer, in the church of St Nicholas, Prague. There the elliptical forms of the plan overlap and set up their own rhythms, while the ribs which spring from the piers and support the roof and ceiling form another series of ellipses which are offset from those below. These rhythms resonate at roof and ground level in what has been called 'syncopated interpenetration'.

The Beaux Arts system of planning which developed at the Ecole des Beaux-Arts in Paris in the late nineteenth century was applied to major projects throughout France. Leading American architects such as H.H. Richardson* and C.F. McKim* were trained at this school and the Beaux Arts consequently became a major influence in the USA. Charles Garnier's Paris Opéra is an excellent example of Beaux Arts planning and it was widely praised for its composition and logic (Figure 10.8). The logic derives from Viollet-le-Duc's theories of architectural change, from classical principles and from the need to create a building of national prestige, while at the same time accommodating the practical requirements of staging an opera. The site of the Opéra determined the overall rectangular shape of the plan. If we look at this plan in detail we can see that the most important space and central

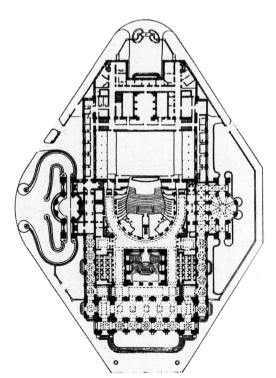

Figure 10.8 Second-level plan of the Paris Opéra, 1861–75 (Charles Garnier)

focus is on the horseshoe shape of the auditorium in the centre. Both axes of the plan bisect here. The next most important space is the stage (above it). Along the major vertical axis Garnier positions a sequence of spaces: the grand foyer and staircases to the south of the auditorium; the artistes' rooms to the north of the stage. Garnier separates the primary volumes within the plan, but relates them to each other in a composition that has both logic and harmony. Foyers separate each element from its neighbour and the circulation routes around the periphery of the plan provide a further organising framework which articulates the whole, so the overall composition has logic, harmony and a hierarchy of elements.

Elevations

An elevation is a frontal view of a building, drawn accurately to scale, with no perspectival distortions, for it is drawn as if seen from infinity. When we look at a building we see it in perspective from wherever we are standing and not in elevation. Elevations enable architects to study the geometric proportions of the façade. In Figure 10.9 Palladio offers his client two alternative solutions for the façade of his palazzo at Vicenza in Italy. On the left the ground floor is more heavily rusticated and the windows are more strongly

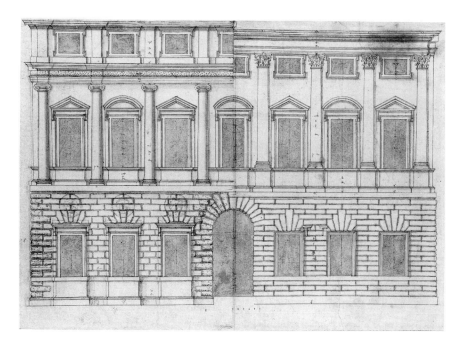

Figure 10.9 Designs for the Palazzo da Porto Festa, Vicenza, *c.*1549 (Andrea Palladio) (© British Architectural Library, RIBA)

emphasised. Above, the Ionic half columns are surmounted by a heavy entablature and an attic storey, whereas on the right the giant order of Corinthian pilasters embraces both the *piano nobile* and the attic storey and gives a lighter and more unified design.

From the mid-eighteenth century the publication and exhibition of measured drawings, sketches and paintings of the buildings of ancient Greece, Egypt, the Middle East and India introduced European architects to an enormous range of new types and styles of building. Figure 10.10 shows an elevation of a pagoda at Cambaconam, covered in intricate carving, which was presented to the Rajah of Tanjore. The French government employed an artist, Charles Texier, to travel to the Middle East in the 1830s to make drawings. These were much admired in Britain and important architects such as Owen Jones* and William Burges* had copies of his works in their libraries.

Sections

A section through a building is a vertical plane through its interior, the internal counterpart to the elevation. Like an elevation a section cannot be seen in real life, even if a building is in the process of demolition and the exterior wall has been removed, because it is drawn with no perspectival distortion. Sections enable an architect to show how the internal spaces relate to each other and they provide the opportunity for showing schemes for interior decoration. The longitudinal section of the Paris Opéra shows the spaces for the stage, the auditorium, the foyer and the support facilities behind the stage (see Figure 4.6). Four elevations, plans and a section (bottom left) of a village school and master's house can be seen in Figure 10.11. From the plan we can see that the school to the right of the master's house is subdivided into two spaces, one for the girls (right) and one for the boys (left). Each space has a fireplace and a door in the same wall as the fireplace. If we look at the section we can see these clearly, for the section is taken just in front of this wall. Behind the boys' schoolroom and the master's house on the left are a classroom, with a closet leading off and a porch. There is no access from the school to the master's house. The section through the master's house is taken through the entrance hall and we can see the door that leads to the kitchen, the stairs and the door to the bedroom over the kitchen. The structure of the roof of the master's house is a kingpost construction and the two dark vertical lines are loadbearing walls, one of which supports the weight of the flèche, while the other forms the end wall of the master's house. The walls at either end of the building are shown broken by windows.

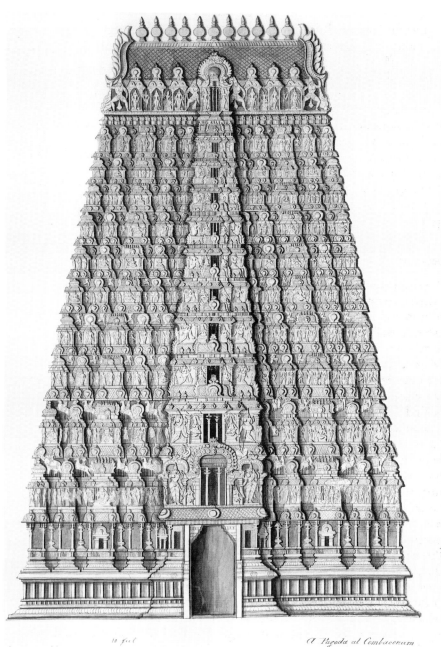

Figure 10.10 Elevation of a pagoda at Cambaconam, India, 1838 (© British
Architectural Library, Drawings Collection)

Perspective drawings

Perspectives are the most readily understood of all architectural drawings and the technique used affects the way that we respond to them. Colour may be used to highlight particular features, perspectives may emphasise the most attractive viewpoints and the building may be presented in a delightful setting. Indeed one of the criticisms of drawings was that in skilled hands their beauty could captivate a client, even though the building itself was of little architectural merit. Drawings are still used today to inform and impress prospective clients. Speculative builders produce glossy brochures of what a new housing complex will look like when completed and the hoardings around major new developments often show artistic visions of the completed project, with the sun shining, the trees in full leaf and everyone smiling.

Plans, sections and elevations enable us to 'see' a building in three dimensions, but we can only see two of those dimensions at a time. The techniques that have been developed to show a building in three dimensions are the isometric projection and the axonometric projection.

Isometric and axonometric projections

The portable cottage illustrated in Figure 10.12 appears like a perspective, and we can see more than one side of the building. It is an isometric projection, where the plan has been distorted in order to give a three-dimensional illustration of the building. To create this isometric projection the plan has been turned through an angle so that the right-hand corner of the plan is nearest us. The angle between the front and side façades has become 150° instead of 90°. The plan is no longer a rectangle and the diagonals have been distorted, but the verticals are still vertical and they are to scale.

An axonometric projection differs from an isometric projection because it does not distort the plan, which remains rectangular and true to shape and scale. The plan is tilted to an angle of 45° to provide the third dimension, and the verticals are also drawn to the same scale. This is the most accurate and most informative method of projection, as the proportions of both the plan and the volume remain true and it is much used by architects today. Figure 10.13 shows an axonometric projection of the offices of Alexander Fleming House, in south London, with a cinema in the foreground. The rectangular plans of the blocks to the rear have been rotated through 45° and the vertical dimensions are all to scale. The buildings are of frame construction (note the pilotis on the far left); we can see how many floors there are in each block and their dimensions; and we can see the lift service shaft with its mechanical housing on the roof. If we compare this projection with a perspective drawing (Figure 10.14) we can see clearly how much more information is given in the former.

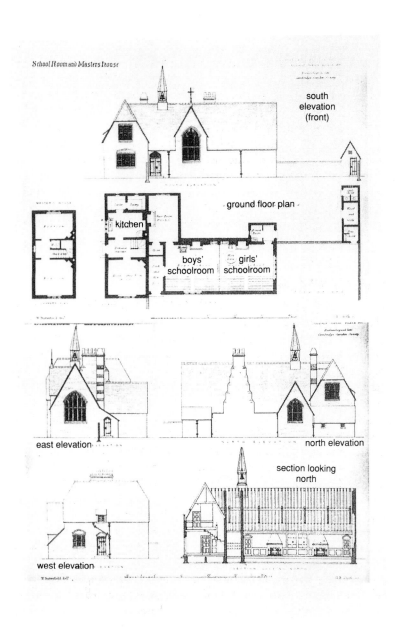

Figure 10.11 Village school and master's house (William Butterfield)
(*Instrumenta Ecclesiastica*, 1852)

Figure 10.12 Isometric projection of a prefabricated portable cottage for the Australian colonies (William Manning) (J.C. Loudon, *Encyclopedia of Cottage, Farm and Villa Architecture*, 1853)

MODELS

Like the plans, sections and projections that we have been discussing, models are another means of communicating the ideas of architects to the public and to clients. Models can be very seductive. Beautifully made of wood, crisply modelled of plaster, or carved out of polystyrene, they remind us of the doll's houses, model farms and railways that we played with as children. The seductiveness of models is not only to do with their size and the materials used, it is also to do with the clarity and cleanliness of the forms, the way they are lit and the way the shadows fall. They represent pure, ideal buildings that are removed from their context and are not subject to the wear and tear of weather and time. Models may seem more truthful than drawings because they present a three-dimensional version of a proposed building, but they may not necessarily be simpler to interpret. Problems arise when we try to move from the models to understanding what the full-sized buildings will look like. This is an ideal world we are entering and we are Gulliver looking down on Lilliput. Even if the models are finely detailed and fully coloured, and include people, trees and cars in scale with the buildings, the world that they inhabit has no litter, no graffiti, no poor or elderly, and we have no clue about where the sun might shine. No wonder most of us find it so hard to translate that model world into the full-scale built environment.

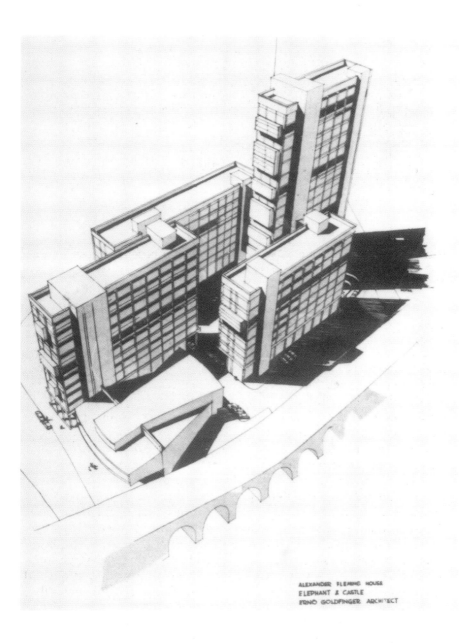

ALEXANDER FLEMING HOUSE
ELEPHANT & CASTLE
ERNÖ GOLDFINGER ARCHITECT

Figure 10.13 Axonometric projection of Alexander Fleming House, 1960 (E. Goldfinger) (© British Architectural Library, RIBA)

There are a number of different types of model, each serving a distinct purpose and when we look at models of buildings we need to know why they were constructed. In the evolution of their ideas architects use design models as aids to the design process. In order to present their ideas to clients or committees, for exhibition or public criticism, they use presentation models. A third category is the working model used to guide builders in the construction work and in the internal and external details. Models can also include visionary, futuristic designs that are independent of practical considerations. Another broad group of models are those that display groups of buildings and their interrelationship. Site models and master plans can cover hundreds of hectares, as can topographical models which reproduce cities or regions complete with geographical and natural features. A further complication concerns chronology. Models may be made before a building is constructed, they may be made during its construction, or long after it was completed. Models of, say, classical buildings may depict them at the time that the models were constructed; if the buildings no longer exist, these models may be our only source of information. The little clay model in Figure 10.5 is almost all we

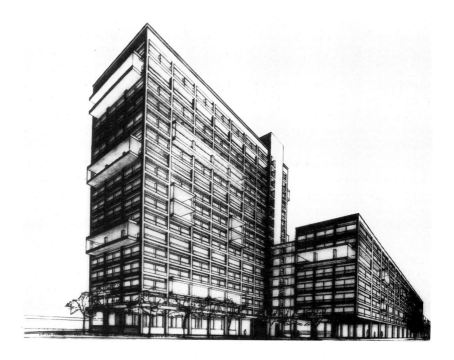

Figure 10.14 Perspective drawing of Alexander Fleming House (© British Architectural Library, RIBA)

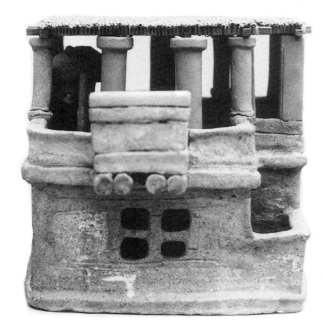

Figure 10.15
Clay model of
Minoan house
from Arhánes
(© Heraklion
Museum)

know about Minoan buildings of this kind. Models have been made out of wood, cardboard, plastic, metal, stone, slate, wax, cork and plaster of Paris. Plaster of Paris was found to be unsuitable for delicately ornamented parts, particularly if the models were to be handled frequently. This problem was solved by the invention c. 1843 of papyrus powder, which was a form of very fine papier mâché. Many models were only intended to last for a short time and as they were fragile and difficult to store comparatively few have survived.

The use of models by architects has a long history. We know that they were used throughout the building of St Peter's in Rome. As the renaissance spread north through Europe, so did the use of models. In Britain their use increased in the mid-seventeenth century and Wren used models to demonstrate solutions to structural problems, to instruct workmen and to impress his clients.[2] Wren's best-known model, of St Paul's Cathedral, was a presentation model of wood, designed to impress by its rich decoration, the imposing classical forms and the grandeur of its size, for it was large enough to walk through (scale 1 inch to 1.5 feet). James Gibbs's model (1721) of St Martin-in-the-Fields, London, is also in this tradition, with every detail of both the exterior and the interior clearly carved in wood and the bracing of the roof clearly indicated. During the course of the eighteenth century the use of models declined, owing partly to the development of skill in the building trade and partly to the emergence of the architectural profession. A major exception to this trend was John Soane, who was one of the few

architects working in the period 1780–1830 to use architectural models extensively. He used them not only to develop his design ideas but also to instruct masons and carpenters and to persuade clients. In 1804 Soane bought two cork models of ancient Roman buildings, the Temple of Vesta at Tivoli and the Arch of Constantine. Today these models, which are on display in the Sir John Soane's Museum, London, provide evidence of how those particular buildings appeared at the time the models were constructed in the late eighteenth century. In 1834 Soane bought twenty small plaster of Paris models of ancient Greek and Roman buildings by the French model maker François Fouquet. These were then called restorations, but today we would call them miniature reconstructions. Soane had been influenced by earlier French examples of architectural museums and the Model Room that he set up was in effect an architectural museum. In it he included the models that he had purchased, together with models of his own buildings, 108 of which survive.[3] In the nineteenth century the use of models increased and many were displayed at the numerous international exhibitions of that period. In the first of these, the Great Exhibition of 1851, more than seventy models were shown, most of them of bridges and engineering projects, but they also included a model of Decimus Burton* and Richard Turner's Palm Stove at Kew and a model of the Assize Courts at Cambridge (T.H. Wyatt and D. Brandon, c. 1840) which was made of cardboard. In the 1862 International Exhibition in London, there were twenty-six English models including one of Bilbao railway station in Spain and one of the industrial village of Saltaire, by H.F. Lockwood, but the number of French models was so great that a separate catalogue was issued. The Museum of Construction in London held a collection of models and when this was disbanded some went to the Victoria and Albert Museum, but many were lost.[4] Today models can be uncovered in a wide variety of locations ranging from local history museums to architectural museums and from churches to country houses. One of the grandest of all the nineteenth-century models is the 11-foot-long silver-plated Parliamentary model of the Forth Bridge (1882), so-called because it was put before Parliament in order to secure backing for the project. It is still on view in the Science Museum in London.

Design models are more than three-dimensional representations of plans and elevations. They provide a means of testing ideas about space, proportion, scale, massing and the relation between vertical and horizontal planes, and they can be used to test hypotheses about lighting, structure and rigidity. If the forms envisaged are very complex this may be the only way to test their viability. To arrive at the complex forms of the church of Santa Coloma (Figure 10.16) Gaudí worked with an engineer and sculptor on a large wire and canvas model. They experimented with the tension forces and calculated the catenary system by attaching small known weights to the model. These tension forces were then converted into those of compression, by inverting the structure. Only the crypt of the church was completed, but

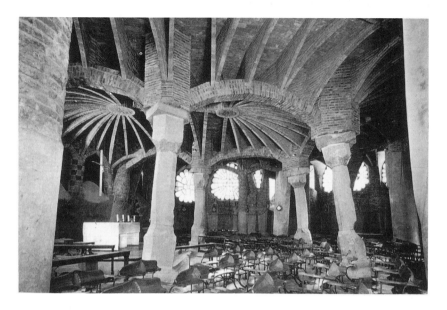

Figure 10.16 Crypt of Santa Coloma (1898, 1908–14) (Antonio Gaudí)
(photo: © Hazel Conway)

it was from the ideas that he tested here that Gaudí went on to develop his
ideas for the cathedral of La Sagrada Familia in Barcelona. Today Balkrishna
Doshi*, one of India's foremost architects, has used computer modelling to
evolve forms similar to those at Santa Coloma church. The Doshi Gupta
(Cave), 1994, in Ahmedabad is a semi-underground gallery constructed of
reinforced concrete, for the artist M.F. Hussain (see frontispiece).

Design models combined with photography enabled architects to experi-
ment with a range of effects. When Charles Garnier was evolving his ideas
for the Paris Opéra in 1861, he used a model with interchangeable parts. A
model of the complex Opéra can be seen in the Musée d'Orsay, in Paris.

Figure 10.17 shows a design model of an infants' school. Here we can see
how ideas of space are being explored, not only in terms of the internal
spaces of the building, but also the relationship of the building to its
surroundings. The main focus of the building is the large central space which
in effect forms the hub of a wheel. Around this space are smaller spaces
which face out, on the side nearest us, onto the surrounding landscape. To
the rear there appear to be no windows. We can see that the building is set on
a gentle slope, with tall trees protecting it to the rear. Figure 10.18 shows a
structural model of the same building, showing the structure of the roof over
the central space and how this relates to the lower roofs over the smaller
spaces. Structural models are a useful way of learning how a building is

constructed, for once it has been completed much of the structure may be hidden (Figure 10.19).

Presentation models are the means by which architects communicate their ideas to their clients. Some presentation models show the building in great detail, indicating not only the materials of construction, but also the detailing of doors, windows, roofs. This presentation model of the infants' school is of wood and is of the same colour throughout. From it we can see clearly how the central roof marks the importance of the space underneath and how the surrounding spaces and their roofs relate to it, but we would need further information in order to understand what materials were to be used on the exterior and interior (Figure 10.20). The model of the Richmond Riverside development is in full colour and it is possible to read from the model where brick would be used and where stone, the materials for the roof and the details of the columns, doors, windows and cornices (Figure 10.21). Indeed we can see much more of the details from this model than we can of the building itself when we are standing on the ground. When plans were being considered for this sensitive riverside site, several proposals were put before the public, who were asked to indicate their preference. The vote was overwhelmingly for this group of neo-Georgian buildings. Their external appearance would lead one to think that they were houses, but these façades front open-plan offices. Indeed the label on the model proclaims that it is a 'Masterly conceit disguising an ordinary office building, it denies the structural logic of classicism'. Since the technology of today's offices demands deep spaces between ceilings and the floors above, this has led to some rather unfortunate compromises. The round-headed and Venetian gothic windows have their heads blocked off by the floor above, so the effective window is the rectangular part only and the floors can be clearly seen crashing across (Figure 10.22). This unhappy fact could not be deduced from the model, for the windows are all painted black with white glazing bars and there is no indication of the thickness of the floors. The only way this could have been detected would have been from a comparison between a section and the model.

Master plans and site plans

In recent years the controversy that has raged over the development of major sites in London, Paris and elsewhere has perforce focused on models of the proposals. In Paris when I.M. Pei's* model of the glass pyramid forming the new entrance to the Louvre was unveiled, there was an outcry. The criticisms focused on the stark contrast between Pei's proposal, the architecture of the Louvre, and the desecration of one of France's foremost cultural monuments that would result. Once the actual pyramid opened, opinion changed and it was greeted with general enthusiasm. This underlines the point that the relationship between models and full-scale architecture is not a

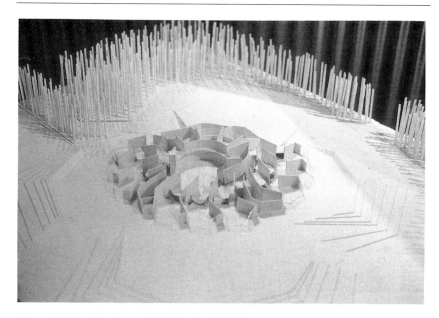

Figure 10.17 Design model of Stoke Park Infant School, 1989 (Colin Stansfield Smith)

Figure 10.18 Structural model of Stoke Park Infant School (Colin Stansfield Smith)

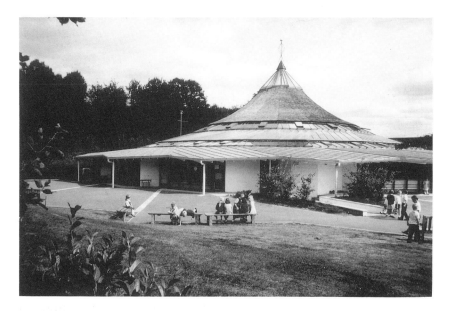

Figure 10.19 Stoke Park Infant School as completed (Colin Stansfield Smith)

simple one and the difficulties are not only to do with the problems of learning to read models. Models can simulate but rarely achieve the subtleties of architecture and its environment. If they are presented by developers anxious to secure planning approval, detailed questions and criticism may not necessarily be encouraged. Furthermore if criticisms of projects are made predominantly in terms of current stylistic preferences and dislikes then the debate on issues that are just as, or even more, important may not even be voiced.

Models are the main method used by developers and architects to put their ideas over to the public and to the planning authorities. In London the recent proposals for developments at Paternoster Square around St Paul's Cathedral, the King's Cross lands, the South Bank of the Thames, and Peter Palumbo's proposals for the City of London have all involved models. If we look at the model of Norman Foster Associates' proposal for the King's Cross lands (Figure 10.23) we can see that the high-rise office blocks around the open park space, the low-rise housing surrounding the commercial buildings, the Victorian train sheds of King's Cross and St Pancras Stations in the foreground all appear as simple outline blocks. No detail is given of the form, colour or material of these buildings: they all appear uniformly white. The function of this model is not to show the buildings in detail, but to explore the space available and show how it can be used in a commercially viable way. The model does not show how the proposed development

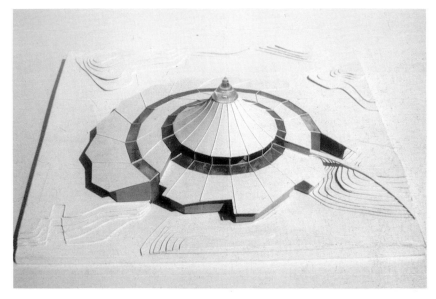

Figure 10.20 Presentation model of Stoke Park Infant School (Colin Stansfield Smith)

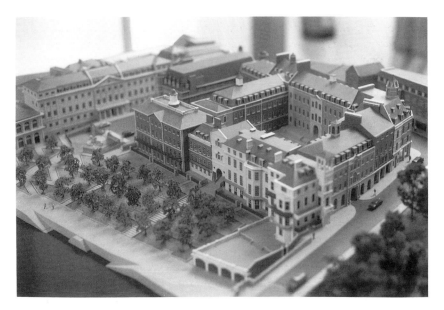

Figure 10.21 Presentation model of Richmond Riverside (Quinlan Terry) (© London Borough of Richmond upon Thames, Libraries and Arts Division)

Figure 10.22 Detail of Richmond Riverside (photo: © Hazel Conway)

relates to the existing environment, and the only existing buildings that are included in it are the stations and the four gasholders.

Topographical models

Topographical models are rather different from the architectural models that we have been discussing so far, for they provide detailed representations of a city or region and include the geographical and natural features as well as the buildings. One of the largest collections of topographical models in Europe was held in the Museum of Plans and Reliefs in Les Invalides, Paris. It comprised 140 models of French strongholds and towns at a scale of 1:600. These date largely from the eighteenth and nineteenth centuries and for 200 years they were used for strategic purposes. In 1986 the government decided to transfer the collection to Lille, but because of the protests voiced by historians only part was transferred and put in store there.[5] These models provide important evidence of the topography of particular towns contemporary with them and they also illustrate another of their uses, for strategic purposes. Because of the scale and expense involved in building topographical models and because they are usually built for a specific purpose, they are rarely updated. One major project that was subsequently partially updated was the model of New York commissioned by Robert Moses, the chief planner and architect in charge of city parks, housing projects and highways.

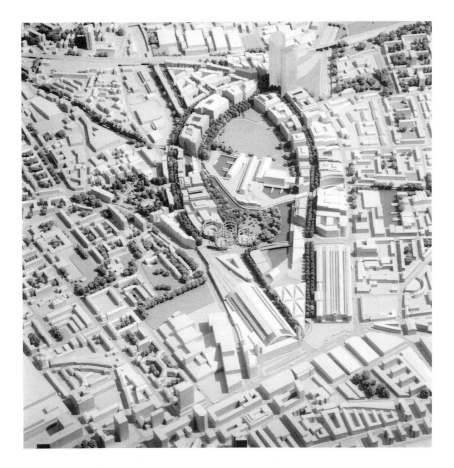

Figure 10.23 Model of Kings Cross redevelopment (Sir Norman Foster & Partners) (photo: © Richard Davies)

This model commemorating the 300th anniversary of the founding of New York was exhibited at the 1964 World's Fair held in Flushing Meadow. It featured the five boroughs of New York on a scale of 1 inch to 100 feet, but its main significance was that it was envisaged by Moses as a tool to be used by architects, planners, community groups and all those involved in the development of New York City in the future. Indeed in the early 1980s it was used by a civic group to demonstrate how out of scale was Donald Trump's proposal for Television City. Today it is on display in Queen's Museum, New York, and although partially updated, some recent developments such as Battery Park City and South Street Seaport have not been included.[6]

Since models may range from finely detailed urban environments with

trees, cars and people to almost abstract sculptures, what guiding principles should we apply when we look at them? Some architects think that in order to put across architectural ideas a certain degree of abstraction is important. Plain wooden models and those painted white or grey not only allow architects and clients to keep their options open regarding the materials, the final finish and colours of their buildings, they also tend to abstract the building from its surroundings. Grey and white models tend to show form better because the shadows are sharp and curved surfaces are therefore easier to read. For their presentation of the Sainsbury wing extension to London's National Gallery, Venturi and Rauch presented an all-white model which distanced and abstracted the building from its surroundings.

If we are looking at models on display we need to be very aware of where our eyes are in relation to the model. Bird's eye views will give an overall picture, but once the development has been built such a view will never be experienced. In evaluating a model it is important to try to look at it as if from street level. Some models are displayed on high plinths for this reason, but if the exhibition has been designed by someone taller than average, those of us who are smaller than average may have difficulty in seeing the models at all. Models that are fully coloured and detailed also require thinking about because of the colours used. If an exact colour match of brick were used on a model, it would appear very brash. Normally we see buildings from some distance, so if the colour used on models is equivalent to the material as seen from approximately 100 yards, then the model will not appear too gaudy.

If we compare the details of a model with those of the actual building we can see just how difficult it is to convey such information accurately in miniature. This difficulty combined with the great expense incurred in model making has led some people to predict that the days of the model are numbered. With the introduction of computer-aided design (CAD), the screen is tending to replace the drawing board in the later stages of the design process. Computerised model making builds on CAD and software packages are already available. The sophistication now available with these techniques can be seen in the competitions held by the Constructing Industry Computing Association. These include three-dimensional modelling and visualisation and two-dimensional architectural and engineering drawings. In industrialised countries most architectural practices today employ CAD, not to generate design ideas or the architectural concept, but to produce accurate, speedy and detailed drawings. In this computer age manual drawing is still central to architectural design. It is used largely as a problem-solving activity to sketch out and work through a series of ideas or alternatives. Once the design has evolved and there is a need to develop detailed measured drawings and specifications then CAD comes into its own. This work may be handed over to technicians who run the system. Computers can be used to generate various views of the proposed structure

quickly so as to test out the design or produce working drawings; they may even be used to enhance the original design.

PHOTOGRAPHS

Like the other means of communication that we have been discussing, photographs can provide documentary evidence for studying architecture, provided we can interpret the evidence that they present. Even the most amateur photographer knows how to achieve different effects according to the presence or absence of the sun, the angle at which the photograph is taken, the grain of film used and the variety of techniques that can be used in printing. Exploring the way that shadows fall at different times of the day helps us to train our eyes to see more perceptively. In the hands of a skilled photographer a building, or part of it, may become an almost unrecognisable essay in light and shade. Indeed in the 1920s and 1930s the work of some photographers was inspired by the clarity of the form of modernist buildings. In turn their photographs of these buildings helped to promote modernist images, and the black and white photographs encouraged the belief that these buildings were white-walled, whereas many were painted in pastel colours. Add to these factors the presence or absence of people and a photographer's wish to record a specific building for a specific reason, or to achieve a particular effect or create a certain mood, and it becomes clear that the use of photographs as documentary evidence is by no means straightforward. Since we are concerned with interpreting the evidence presented by photographs, we will concentrate on some of the problems that photographs may present.

The photographs of buildings that appear in books are one of our major sources of information, yet these photographs tend to reinforce a particular notion of what architecture is about. They are usually of single buildings, whereas we tend to experience buildings in groups. A photograph of a single building gives it a significance just by virtue of the fact of isolating it from its surroundings. This privileging tendency is accompanied by the tendency to see all photographs in terms of their aesthetic qualities. Both black and white photography and colour photography, by their very nature, emphasise the surface qualities, form and ornamental details of their subjects. They therefore tend to reinforce the attitude that architecture is predominantly about aesthetics and style. This is further reinforced by the tendency of most architectural photographs to show only the front of a building. With no further information about the rest of the building such as how it was constructed, its interior organisation, or what it is used for, we might run the risk of thinking that the study of architecture is about the study of façades (façadism). If these photographs are read in conjunction with plans and models of buildings, then a much fuller evaluation of the building becomes possible.

Photographs can range from family snapshots to details of construction in progress. These latter could provide valuable evidence on methods of working in the building industry, the existence or lack of safety measures, as well as providing information on how particular buildings were constructed. Similarly photographs of slum clearance, of buildings in the process of destruction or refurbishment, can also reveal structural details. Archives such as the National Buildings Record have photographs of buildings that no longer survive, as well as of those that do. Photographs of street scenes can provide evidence of the physical context of a building at that period, but we may need to develop skills in dating such evidence. The style of the cars, buses, horse-drawn vehicles or street furniture may provide clues which will help us to date them. Photographs of interiors can provide valuable information on the materials used for fireplaces, floors and walls, how much natural lighting there was and what forms of artificial lighting were used. Since interiors may remain unchanged for long periods it can be difficult to date them and a more reliable clue may come from the way people dress since this tended to change more frequently. Family photographs are another area of possible information and with recent changes in technology we should perhaps now include film and video as further sources. Since this is such a complex and enormous field photographs should whenever possible be used in conjunction with other evidence as a means of trying to understand buildings.

Notes

1 INTRODUCTION

1 MORI 3867, London, 1990.

2 WHAT IS ARCHITECTURE?

1 Le Corbusier, *Towards a New Architecture*, London, Architectural Press, 1946, p. 31.
2 *Ecclesiologist*, vol. 41, 1851, p. 269.
3 N. Pevsner, *A History of Building Types*, London, Thames & Hudson, 1976.
4 J. Needham, *Science and Civilization in China*, vol. 4 *Physics and Physical Engineering*, Part III *Civil Engineering and Nautics*, Cambridge, Cambridge University Press, 1971, pp. 81–5.
5 *Builder*, vol. 34, 1876, p. 10, quoted in J. Mordaunt Crook, 'Architecture and history', *Architectural History*, vol. 27, 1984, p. 556.
6 RIBA MSS, SP4/1, 15 June, 1835.
7 N. Pevsner (founding ed.) *The Buildings of England*, revised by B. Cherry, Harmondsworth, Penguin, 1951– .
8 Andrew Ballantyne, 'The Curse of Minerva', *Society of Architectural Historians Newsletter*, no. 51, spring 1994, pp. 1–2.
9 Prince Charles, *A Vision of Britain*, London, Doubleday, 1989, p. 45.
10 C. Jencks, *The Language of Post-Modern Architecture*, London, Academy Editions, 5th edn, 1987.
11 P. Blundell Jones, 'In search of authenticity', *Architects' Journal*, 1991, 30 October, pp. 26–30; 6 November, pp. 32–6; 4 December, pp. 22–5; 1992, 8–15 January, pp. 29–32.

3 WHAT IS ARCHITECTURAL HISTORY?

1 D. Watkin, *The Rise of Architectural History*, London, Architectural Press, 1980.
2 Ibid., Chapter 2.
3 Ibid., pp. vii–viii.
4 D. Watkin, *Morality and Architecture*, Oxford, Clarendon Press, 1977.
5 Regius Professor of History, Oxford, 1884, quoted in J.M. Crook, 'Architecture and history', *Architectural History*, vol. 27, 1984, p. 570.
6 M. Swenarton, 'The role of history in architectural education', *Architectural History*, vol. 30, 1987.
7 *Architects' Journal*, 12 June 1991, p. 14.
8 N. Jackson, *Report of Architectural History Education in Undergraduate*

Departments of Architecture, Philadelphia, Society of Architectural Historians, 1989, p. 1, in G. Wright and J. Parks, *The History of History in American Schools of Architecture 1865–1975*, Princeton, Temple Hoyne Buell Center for the Study of American Architecture, Columbia University, Princeton Architectural Press, 1990.

4 FUNCTION, SPACE AND THE INTERIOR ENVIRONMENT

1 George Michell, *The Penguin Guide to the Monuments of India*, vol. 1, Harmondsworth, Penguin Books, 1989, pp. 65–6.
2 J. Reynolds, *The Great Paternalist: Titus Salt*, London & New York, Maurice Temple Smith & St Martin's Press, 1983, pp. 80–1.
3 D. Hayden, *The Grand Domestic Revolution*, Cambridge, Mass., MIT Press, 1981, pp. 108–10.
4 Vitruvius, *De Architectura: Books I–IV*, London, Heinemann/Cambridge, Mass., Harvard University Press, 1970, pp. 207–9.
5 R. Wittkower, *Architectural Principles in the Age of Humanism*, London, Tiranti, 1962, pp. 109–10.
6 Le Corbusier, *The Modulor*, London, Faber & Faber, 1951.
7 R. Wittkower, *Architectural Principles in the Age of Humanism*, London, Tiranti, 1962, p. 7.
8 Jill Franklin, *The Gentleman's Country House and Its Plan 1835–1914*, London, Routledge Kegan Paul, 1981, p. 130.
9 Bernard Rudofsky, *Architecture Without Architects*, London, Academy Editions, 1973, Figures 114 and 115.

5 MATERIALS AND CONSTRUCTION

1 D. Hey, *Packmen, Carriers and Packhorse Roads*, Leicester, Leicester University Press, 1980, p. 122.
2 W.H. Pierson, Jr, *American Buildings and Their Architects: the Colonial and Neo-Classical Styles*, New York, Anchor Books, 1976, p. 461.
3 Peter Collins, *Concrete*, London, Faber, 1959.
4 Further information can be found in J.E. Gordon, *Structures: or Why Things Don't Fall Down*, Harmondsworth, Penguin, 1983, and Mario Salvadori, *Why Buildings Stand Up*, New York, W.W. Norton, 1990.
5 For the many varieties of arch and vault, see J. Fleming, H. Honour, N. Pevsner, *The Penguin Dictionary of Architecture*, Harmondsworth, Penguin, 1983.
6 J.E. Gordon, *Structures: or Why Things Don't Fall Down*, Harmondsworth, Penguin, 1983, p. 216.
7 C.W. Condit, *The Chicago School of Architecture*, Chicago, University of Chicago Press, 1975, p. 23.
8 P. Blake, *Frank Lloyd Wright: Architecture and Space*, Harmondsworth, Penguin, 1963, p. 69.
9 C.A. Hewett, *The Development of Carpentry 1200–1700, An Essex Study*, Newton Abbott, David & Charles, 1969.

6 THE EXTERIOR

1 For example, Connell, Ward & Lucas, 66, Frognal, Hampstead, London, 1936–8, and Mendelsohn & Chermayeff, House at Chalfont St Giles, Buckinghamshire, 1935.
2 George Michell, *The Penguin Guide to the Monuments of India*, vol. 1, Harmondsworth, Penguin, 1990, p. 68.

3 N. Pevsner, *An Outline of European Architecture*, Harmondsworth, Penguin, 1968, p. 238.
4 *Chambers Twentieth Century Dictionary*, Edinburgh, Chambers, 1987, p. 100.
5 A. Ballantyne, 'Downton Castle: function and meaning', *Architectural History*, vol. 32, 1989.
6 Le Corbusier, *Towards a New Architecture* (*Vers une Architecture*, 1923), London, Architectural Press, 1970, p. 23.
7 Statement by Ricardo Bofill in *Architectural Design*, 5/6, 1980.
8 J. Summerson, *The Classical Language of Architecture*, London, Thames & Hudson, 1985, p. 26.
9 R. Wittkower, *Architectural Principles in the Age of Humanism*, London, Tiranti, 1962, pp. 45–7.

7 SITE AND PLACE

1 T. Smollett, *Humphrey Clinker*, London, Everyman, 1968, p. 34; first published 1760.
2 A. Jackson, *Semi-detached London*, London, Allen & Unwin, 1973.
3 E. Lip, *Chinese Geomancy*, Singapore, Times Books International, 1979.
4 J. Jacobs, *The Death and Life of Great American Cities*, London, Penguin, 1965.
5 0. Newman, *Defensible Space, People and Design in the Violent City*, London, Architectural Press, 1973.
6 A. Coleman, *Utopia on Trial: Vision and Reality in Planned Housing*, London, Hilary Shipman, 1985.
7 L.M. Smales and B. Goodey, *The Essex Design Guide for Residential Areas*, Essex County Council, 1973.
8 F. Tibbalds, *City Centre Design Strategy*, Birmingham City Council, 1991.
9 *Architects' Journal*, 20 March 1991, p. 15.

8 STYLES AND PERIODS

1 W.H. Pierson, Jr, *American Buildings and their Architects: The Colonial and Neoclassical Styles*, New York, Anchor Books, 1976, pp. 417–8.
2 Sandra Millikin and Tim Benton, *Art Nouveau*, Units 3–4, Course A305, Milton Keynes, Open University Press, 1975, pp. 20–1.
3 D. Watkin, *The Rise of Architectural History*, London, Architectural Press, 1980, p. viii.
4 For example: A. Hauser, *The Social History of Art*, London, Routledge Kegan Paul, 1962.
5 Quoted in D. Watkin, *The English Vision*, London, John Murray, 1982, p. 51.
6 Ibid., p. 30.
7 J.M. Crook, *The British Museum*, Harmondsworth, Penguin, 1973, p. 19.
8 Sir Bannister Fletcher, *A History of Architecture*, London, Butterworth Press, 1987, p. 805.

9 SOURCES

1 J.J. Coulton, *Greek Architects at Work*, London, Granada Publishing, 1977, p. 53.
2 Ibid., p. 15; M. Wheeler, *Roman Art and Architecture*, London, Thames & Hudson, 1964.
3 William Bell Dinsmoor, *The Architecture of Ancient Greece*, New York, W.W. Norton & Co., 1975, p. xviii.
4 H.M. Colvin, *A Guide to the Sources of English Architectural History*, Oakhill, The Oakhill Press, 1967.

5 W.H. Pierson, Jr, *American Buildings and their Architects: the Colonial and Classical Styles*, New York, Anchor Books, 1976, p. 464.
6 H.R. Hitchcock, *Architecture Nineteenth and Twentieth Centuries*, Harmondsworth, Penguin, 1990, pp. 121, 598.
7 S. Martin Gaskell, *Building Control: National Legislation and the Introduction of Local Bye-Laws in Victorian England*, London, Bedford Square Press, 1983.
8 N. Aldridge (ed.) *The Hearth Tax*, Hull, School of Humanities and Community Education, Humberside College of Higher Education, 1983.

10 PLANS, MODELS AND PHOTOGRAPHS

1 J. Summerson, *The Classical Language of Architecture*, London, Thames & Hudson, 1985.
2 J. Wilton-Ely, 'The architectural model', *Architectural Review*, vol. 142, 1967, pp. 27–32.
3 M. Richardson, 'Model architecture', *Country Life*, vol. 183, no. 38, 21 September 1989, pp. 224–7.
4 J. Physick and M. Darby, 'The architectural model during the Victorian period', *Marble Halls*, Exhibition Catalogue, London, Victoria and Albert Museum, 1973, pp. 13–16.
5 B. Fortier and P. Prost, *Casabella*, vol. 51, no. 533, March 1987, pp. 44–53.
6 A. Bussell, *Progressive Architecture*, vol. 70, no. 7, July 1989, p. 21.

Appendix I

Glossary

abutment: a solid structure from which an arch springs and which resists the thrust of an arch or vault.

Adam, Robert (1728–92): highly acclaimed British architect, decorator and furniture designer who worked in an original, elegant and light neo-classical style. Some of his notable works are the interior designs for Kedleston Hall (1759 on), Osterley Park (1761–80) and the planning and decoration of Syon House (begun 1762).

aesthetic: relating to the principles and perception of beauty in the visual arts.

aesthetics: the study of the principles of taste which form the bases of criticism in the arts.

aggregate: broken stone, gravel or sand which is added to cement to make concrete.

Alberti, Leone Battista (1404–72): influential Italian architect and theorist who produced the first architectural treatise of the Renaissance. *De Re Aedificatoria* (1452) focused on proportion, the orders and town planning. His few buildings were remodellings of earlier ones, with the exception of the churches of S. Sebastiano (1460) and S. Andrea (1470) in Mantua which he designed.

Alen, William van (1883–1954): US architect who studied at the École des Beaux-Arts in Paris and designed high-rise commercial buildings. The best known, the Chrysler Building, New York, 1928–30, combines modern construction with art deco ornament based on motor car motifs.

ambulatory: space for walking round the east end of a church, behind the altar.

apse: polygonal or semi-circular chancel or recess.

Archigram: a group of avant-garde English architects which included Peter Cook, Warren Chalk and Ron Herron. Their founding pamphlet, *Archigram I* (1961), advocated a consumerist, disposable environment, space capsules and 'clip-on' technology.

architectonic: pertaining to architecture in the broadest sense. A formal garden around a classical building gives the building architectonic support.

architrave: the lowest part of an entablature; also the lintels, jambs and mouldings surrounding an opening.

art deco: an eclectic style fashionable in the 1920s and 1930s in Europe and the USA. It originated at the Paris exhibition of 1925 and was inspired by avant-garde art such as fauvism, cubism, futurism and expressionism. Its sources also included motifs from ancient Egypt, the Russian ballet, Aztec temples and contemporary machinery.

art nouveau: a style which evolved in Europe and the USA in the 1890s, in reaction against historical revivals. It reached a peak at the turn of the century. Its leading motif is a sinuous, sometimes vegetal, often tense line, which was particularly

suited to ironwork columns and railings. In architecture it led to asymmetry and novel curving plans.

arts and crafts: *see* arts and crafts movement.

arts and crafts movement: a revival of traditional crafts and vernacular architecture in the second half of the nineteenth century in Britain, Europe and the USA. Inspired by the gothic revival and particularly the ideas of John Ruskin and William Morris, architects and designers sought creativity and originality through a return to traditional materials and techniques, honesty in design and joy in high standards of craftwork.

Arup, Ove (1895–1988): British engineer who trained in Denmark and was senior partner in Ove Arup Partners from 1949 and Arup Associates from 1963. This has offices all round the world. Significant buildings associated with Arup include the Penguin Pool, London Zoo, 1939, Hunstanton Secondary Modern School, Norfolk, 1954, Sydney Opera House, 1973, and the Beaubourg Centre, Paris, 1977.

asphalt: black or dark brown bituminous substance derived from oil, used as a waterproof roofing material when mixed with rock chippings or other material.

atrium: an open-air court at the centre of a Roman house; in contemporary architecture a central glazed lightwell in multistorey buildings, sometimes used as communal space.

Baker, Sir Herbert (1862–1946): English architect best known for his work for the South African and Indian governments. He designed the Union Administrative Buildings in Pretoria and the Secretariat Building and Legislature Building in New Delhi.

banded order: a column broken by plain or rusticated rectangular blocks of stone.

Barlow, William Henry (1812–1902) & Ordish, Roland M. (1824–86): Barlow was a civil engineer who worked on railway projects and the Clifton Suspension Bridge, 1860–4. Ordish worked in an engineering office, assisted in the design of the Crystal Palace and worked with architects who included Owen Jones and George Gilbert Scott.

baroque: a classical style of architecture which developed in Italy in the seventeenth century and spread to other parts of Europe. It is characterised by exuberant sculptural forms, complex spatial relationships and illusionistic effects.

basilica: a Roman hall; a building with a nave, two aisles and an apse at one end.

batter: a wall that is thicker at the base and slopes inwards towards the top.

battlement: an indented parapet.

Bauhaus: German design school (1919–33) which promoted modernist architecture and design. It was closed by the Nazis in 1933. The New Bauhaus opened in Chicago in 1937.

bay: a vertical division of a building marked by buttresses, an order, openings, or the main divisions of the roof such as units of vaulting or rafters.

bearing element: part of a building that carries weight or is loadbearing.

Blomfield, Sir Reginald Theodore (1856–1942): English architect and architectural historian much influenced by R.N. Shaw and English and French renaissance styles. He promoted the neo-Georgian revival in the early twentieth-century in England. His books include *A History of Renaissance Architecture in England 1500–1800* (1897) and *A History of French Architecture 1494–1661 and 1661–1774* (1911–21).

Bofill, Ricardo (1939–): Spanish architect who founded the Taller de Arquitectura in Barcelona in 1960. Well known for many residential complexes in Spain and France which feature a distinctive, expressive and monumental form of post-modernism, the group has used revived gothic, classical and Egyptian forms.

Borromini, Francesco (1599–1667): important Italian architect who worked in Rome in the baroque style. S. Carlo alle Quattro Fontane (1637–41) displays his

radical spatial ingenuity.

Boullée, Etienne-Louis (1728–99): influential French neo-classical architect and teacher, known for his expressive projects of monumental scale, which utilised simple geometric forms and innumerable columns.

bracing: in framed structures a subsidiary member located near or across the angle of two main members in order to stiffen the joint.

Bramante, Donato (1444–1514): Italian renaissance architect whose Tempietto of S. Pietro in Montorio in Rome (1502) is perhaps the first great monument of the high renaissance. Pope Julian II became his patron and commissioned him to draw up plans for the Vatican and for St Peter's.

brise-soleil: horizontal and/or vertical elements on the outside of a building, designed to shade windows and large areas of glass from the sun.

Broderick, Cuthbert (1822–1905): Yorkshire architect best known for the design of Leeds Town Hall and Corn Exchange and the French renaissance-inspired Grand Hotel at Scarborough.

Brown, Lancelot (Capability) (1716–83): architect and landscape designer whose landscapes were created out of 'natural' elements such as the contours of the land, lakes, rivers and extensive tree planting, rather than the introduction of buildings or formal planting.

Burgee, John: *see* Johnson, Philip & Burgee, John.

Burges, William (1827–81): gothic revival architect who was particularly interested in French and English gothic forms and whose work is distinguished by exuberant carving. His main works are Cork Cathedral, additions to Cardiff Castle and the remodelling of Castel Coch for his patron the Marquess of Bute.

Burlington, Lord (1694–1753): the widespread fashion for English Palladianism was largely due to Lord Burlington. Chiswick House, his best-known work, was based on Palladio's Villa Rotunda. With William Kent, his *protégé*, Burlington dominated English architecture for thirty years and in 1730 he published Palladio's drawings of the Roman baths.

Burnham & Root: Daniel Burnham and J.W. Root formed a partnership in Chicago and played an important part in the development of the Chicago School in the 1880s and 1890s. Their best-known buildings are the Montauk Building, the Monadnock Building and the Masonic Temple.

Burton, Decimus (1800–81): son of a successful London builder, he became involved in the development of Regent's Park, London, where he designed the Colosseum. His Hyde Park improvements include the screen at Hyde Park Corner. He has been credited with designing both the Great Conservatory at Chatsworth (Paxton, 1836) and the Palm House, Kew, 1844–8, despite the fact that he had no experience of horticultural buildings. The latter was designed by Richard Turner, ironmaster of the Hammersmith Ironworks, Dublin, in conjunction with Burton.

cantilever: a horizontal projection that appears to be self-supporting but which is supported by downward forces on the other side of a fulcrum. Balconies and canopies are often cantilevered.

capital: the head of a column or pilaster.

caryatids: female figures used instead of columns to support an entablature or similar feature. Male figures are known as *atlantes*.

castellated: a battlemented parapet.

Chambers, Sir William (1723–96): the most important official architect of his day, Somerset House in London is one of his best-known works. In his youth he made voyages to India and China and through his writing advocated the drama of Chinese landscape design at a time when Brown's landscapes were in vogue. The Pagoda in Kew Gardens, London, is Chambers's only extant Chinese building.

chancel: the east end of a church reserved for the choir and clergy, in which the main altar is placed.

Chareau, Pierre (1883–1950): French architect and furniture designer who with Bernard Bijvoet designed the modernist Maison de Verre in Paris. This featured glass bricks in the façade and other mass-produced components in the interior.

cladding: external covering or skin applied to a building for protection or for aesthetic purposes.

classical: pertaining to the architecture of ancient Greece and Rome.

clerestory: windows or openings in the upper part of a building. Usually applied to the windows in the main walls of a church, above the aisle roofs.

cob: a mixture of clay and straw or chalk, used to build walls.

column: a free-standing upright pillar, circular in section. In classical architecture it consists of a shaft, capital and base (except in the Greek Doric order).

composite order: late Roman order combining Ionic and Corinthian elements.

concrete: a mixture of water, sand, stones or broken stone and a binder which hardens to form a hard mass like stone. Binders may be of varying type. For example the ancient Romans used volcanic dust and lime whereas today Portland cement is commonly used.

concrete, prestressed: stretched steel reinforcing cables are inserted into the concrete either before or after casting. These place in compression those areas of the concrete that will be subject to tension when building loads are introduced. Prestressed concrete uses materials more economically and the resultant concrete is more crack resistant.

concrete, reinforced: concrete with steel rods or mesh embedded. The two materials have complementary roles, the concrete withstanding compressive forces, the steel tensile ones.

coping: covering to a wall to throw off water.

corbel: projecting block supporting a beam or other horizontal element. A vault or arch can be constructed from a series of corbels each projecting from the one below it.

Corinthian order: the most elaborate of the Greek orders, invented in Athens c. 500 BC and developed later by the Romans. The column is fluted and the capital ornamented with foliage, usually the acanthus leaf. The entablature is very ornate.

cornice: the top projecting section of an entablature, or any projecting moulding along the top of a wall, arch or building.

curvilinear tracery: ornamental intersecting work made up of compound or ogee curves found in the upper part of windows, screens, panels and vaults. Associated with the decorated period of English gothic.

deconstruction: an analytical approach to architectural design associated with the work of architects such as Bernard Tschumi and Peter Eisenman; a method of analysing the meaning of architecture.

decorated style: phase of English gothic architecture of the period 1250–1360, characterised by decorated surfaces and curvilinear tracery.

dome: a convex covering over a circular, square or polygonal space. Domes may be hemispherical, semi-elliptical, pointed or onion-shaped.

domestic revival: associated with the arts and crafts movement and an interest in national vernacular buildings, it is characterised by the revival of vernacular styles and techniques. The domestic revival occurred in Britain, northern Europe and the USA between c. 1860 and the First World War; it is sometimes known as the vernacular revival style.

Doric order: the earliest of the Greek orders, it was used on the Parthenon. The Greek Doric column is fluted and has no base, whereas the Roman Doric column has a base. The capital is a curved cushion capped by a flat square slab, and the

entablature has a frieze consisting of alternating blocks with vertical grooves and either plain or decorated panels.

dormer: a vertical window with its own roof, placed in a sloping roof.

Doshi, Balkrishna Vithaldas (1927–): trained in Poona and Bombay. Worked with Le Corbusier in Paris and India (1951–7) and with Louis Kahn in India (1962–72). Since 1977 senior architect with Joseph Allan Stein and Jai Rattan Bhalla in New Delhi and Ahmedabad, designing major commercial, institutional, housing and town planning projects. Major works include: the Indian Institute of Management, Bangalore, 1977–83; Gandhi Labour Institute, Ahmedabad, 1980–4; and, with the Vastu-Shilpa Foundation, Aranya Township Low-Cost Housing Project near Indore, from 1988.

drip mould: a projecting moulding over a window, door or arch to throw off rainwater and prevent it running down the face of a wall.

dry stone walling: a wall built of masonry laid without mortar.

eaves: the lowest overhanging underpart of a sloping roof.

Ecole des Beaux-Arts: school in Paris providing academic architectural training from 1819 and open to students of any nationality. It promoted a form of rational classicism. Associated with it were the advanced studies at the French Academy in Rome taken by the annual winners of the Prix de Rome. It attracted many architects from the USA in the nineteenth and early twentieth centuries.

engaged column: a column which is attached to a wall. Engaged columns may just touch the wall, so that they are still circular in cross-section or they may be half columns, or any variation between these.

Erskine, Ralph (1914–): English architect who settled in Sweden in 1939. His international reputation came with the Byker housing project in Newcastle-upon-Tyne (1969–80) in which the residents were consulted throughout the design process. Among his recent work is the Ark in west London, 1992, a commercial office with communal spaces, on a difficult site.

expressionism: a term applied to an architecture of emotion and ideals which developed in northern Europe prior to the First World War and lasted until *c.* 1925. It includes the housing estates of the Amsterdam School (Michel de Klerk); in Germany the fantastic sketches of Hermann Finsterlin, the buildings of Hans Poelzig such as his Grosses Schauspielhaus in Berlin and Erich Mendelsohn's Einstein Tower at Potsdam. Many elements associated with art deco and with postmodernism today have their roots in expressionism.

façade: the exterior front of a building.

Farrell, Terry (1938–): English postmodern architect whose extensive redevelopments in London include Vauxhall Cross and Embankment Place.

Fischer von Erlach, J.B. (1656–1723): leading Austrian baroque architect, appointed court architect of Vienna in 1704. His masterpiece is the Karlskirche, Vienna, which has an oval plan echoing Roman imperial models.

fissile: material that is easily split.

flat arch: a level, horizontal arch in which the voussoirs radiate from one centre, as in a true arch. Sometimes the flat head of the arch is composed of bricks on edge, or a soldier course.

floriated: carving representing leaves or flowers.

flushwork: decorative use of flint in walling. The flints are split or knapped to expose the black core and to give a fairly flat surface. They may also be chipped to give a square end and laid to give pleasing patterns.

Foster, Sir Norman (1935–): leading English late modernist architect, his best-known works include the Willis, Faber & Dumas Insurance offices in Ipswich, the Hong Kong and Shanghai Bank Headquarters in Hong Kong and the Mediathèque in Nîmes, France.

four-centred arch: an arch of four arcs, associated with the late medieval period.

Fowke, Captain & Scott, Henry (Francis Fowke 1823–65, Henry Scott 1822–83): both were Royal Engineers. Fowke became Inspector of the Department of Science and Art in 1853 and was followed there by Scott. Fowke's work included the National Gallery in Dublin, the Royal Scottish Museum in Edinburgh, the Victoria and Albert Museum quadrangle, and with Scott, the Royal Albert Hall in London.

frame building: *see* frame structure.

frame structure: any building carried on a frame as distinct from loadbearing walls.

Fuller, R. Buckminster (1895–1983): American architect and inspiring teacher, his Dymaxion House, 1927, was a project for low-cost mass-produced houses. His geodesic domes developed post-1945 were based on the principle of space-frames and were made in a variety of materials. One of the best known is the US pavilion at the Montreal Exhibition, 1967. His writings are collected in *The Buckminster Fuller Reader*, edited by J. Meller (London, 1970).

futurism: a movement dating from 1909 to the First World War in Italy comprising all the arts, including architecture. The futurists stressed the importance of new technology and sought to break the bonds of history. They were thus an important influence on the development of modernism.

gable: upper part of a wall at the end of a pitched roof, so triangular in form. Normally straight-sided, but there are many variations.

gablet: a small ornamental gable that has its roots in medieval houses where it functioned as a vent for smoke in the era before chimneys were used.

Garnier, Charles (1825–98): French architect who trained at the Ecole des Beaux Arts, Paris, and the French Academy in Rome 1842–54. He made his name with the sumptuous design for the Paris Opéra, 1861–75, which crystallised the aspirations of the Second Empire.

Gaudí y Cornet, Antonio (1852–1926): Catalan architect whose work explored decoration and sculptural form. Backed by his patron Count Eusebio Güell, Gaudí's key works in Barcelona include the Parque Güell, the Palacio Güell and the cathedral of La Sagrada Familia.

Georgian: pertaining to the reigns of George I, II, III and IV (1714–1830).

giant order: an order where the columns rise through more than one storey.

Gimson, Ernest (1864–1919): English arts and crafts architect who became better known for his furniture designs. In 1893 he moved to the Cotswolds and worked with the Barnsley brothers.

gothic: period of architecture from the twelfth to the sixteenth centuries. The style is characterised by soaring effects, pointed arches, ribbed vaults, clustered shafts and walls pierced by large windows and supported by buttresses.

gothic revival: a movement dating from the late eighteenth and early nineteenth centuries which revived the gothic style and craftsmanship.

Graves, Michael (1934–): leading American postmodern architect whose Public Services Building, Oregon, and Humana Tower, Louisville, illustrate his free and colourful adaptation of classicism.

Greene & Greene (Charles Greene 1868–1957, Henry Greene 1870–1954): southern Californian architects whose work was mainly domestic and was influenced by both the arts and crafts movement and by Japanese principles of joining wood. The Gamble House in Pasadena has been preserved with its original furnishings and is open to the public.

Gropius, Walter (1883–1969): architect, educator and director of the Bauhaus at Weimar and Dessau, Germany, where he introduced a new approach to the training of artists, architects and designers. The influence of the Bauhaus teaching methods and philosophy spread to schools and colleges throughout Europe and

the USA, persisting until the 1970s, and was a central influence on the development of modernism. With the rise of National Socialism Gropius left Germany in 1934, going first to Britain and subsequently to Harvard University, USA, where he continued teaching and also set up his own company, The Architects Collaborative.

grouting: a thin coarse mortar used to infill between paving stones or setts in order to keep them firmly in place.

Guimard, Hector (1867–1942): French art nouveau architect whose Métro station entrances are still a feature of Paris.

hammerbeam truss: a complex roof structure which avoids the use of a low tie beam. It is named after two short projecting horizontal beams (hammerbeams) on opposite sides of the wall, which do not meet. Each supports a vertical post (hammer post) and/or an arched beam (brace), which in turn supports a horizontal beam or collar, which ties in the rafters. The hammerbeams are themselves supported on curved braces rising from corbels.

Hardwick, P. & P.C. (Philip Hardwick 1792–1870, Philip Charles Hardwick 1820–90): father and son team of architects. Euston Station in London, with its huge Greek Doric propylaea (now demolished), is probably their most famous building.

Hardy, Holzman, Pfeiffer Associates: US architectural company with headquarters in New York.

Haussmann, Baron G.-E. (1809–91): entrusted by Napoleon III to make sweeping improvements to Paris, where he introduced long boulevards which meet at *ronds points*, and vistas terminated by major buildings such as the Opéra, in a baroque form of town planning. It is largely due to Haussmann that building heights were controlled.

Hawksmoor, Nicholas (1661–1736): original English baroque architect, pupil of Wren and Vanbrugh, whose masterpieces include six London churches.

herringbone brickwork: has the bricks laid diagonally instead of horizontally, so that they form a zigzag pattern.

hip: *see* hipped roof.

hipped roof: roof with the ends inclined like the sides, so there are no gables.

Holabird & Roche (William Holabird 1854–1923, Martin Roche 1855–1927): engineers central to the development of the steel-framed skyscraper in Chicago. The Tacoma Building, with its reduced historical ornament, extensive glazing and projecting bays, exemplifies their contribution to the Chicago School.

Hood & Howells (Raymond Hood 1881–1934, John Mead Howells 1868–1959): winners of the *Chicago Tribune* building competition in 1922, with a gothic-style skyscraper. Hood's McGraw Hill Building in New York was one of the first modernist skyscrapers.

Hopkins, Sir Michael (1935–): late modernist architect whose work such as the Schlumberger Research Laboratories, Cambridge, exploits the potential of modern technology and tentlike forms.

Horta, Victor (1861–1947): Belgian art nouveau architect whose structural use of iron enabled him to make innovations in the planning of buildings. At the same time he achieved stunning decorative effects.

Howells, John Mead: *see* Hood & Howells.

Howland, Maria Stevens (1836– ?): American feminist and socialist who believed in economic independence for women, free love, cooperative housekeeping and scientific child care. She visited the Familistère at Guise in France, which inspired her attempts to set up similar industrial cooperative communities in the USA and Mexico.

impost: the member or point in a wall from which an arch springs.

inglenook: a recess beside a fireplace for a bench or seat.

Inwood, W. & H.W. (Henry William Inwood 1794–1843, William Inwood 1771–1843): father and son architects of one of the key Greek revival buildings in England, St Pancras Parish Church, London.

Ionic order: used by both the Greeks and the Romans, the order has a rectangular capital with four spiral projections, or volutes.

Jacobean style: English renaissance style of the period of James I.

jetty/jettie: a projecting or overhanging storey in a timber-framed building.

Johnson, Philip & Burgee, John (Philip Johnson, 1906– , John Burgee, 1933–): Philip Johnson has been in the vanguard of modernism, postmodernism and deconstruction in America. With Henry-Russell Hitchcock he coined the phrase 'international style' for modernist architecture and he was initially a devotee of Mies van der Rohe's architecture. His own house in New Canaan, 1949, was built in homage to Mies's Farnsworth House. Johnson's AT & T Building, in New York, 1978–83, with its broken pediment roofline was hailed as postmodernism's first major monument.

Jones, Inigo (1573–1652): introduced the work of Palladio and Italian renaissance architecture to England. He was Surveyor of the King's Works and his outstanding buildings include the Queen's House, Greenwich, and the Banqueting House, Whitehall, London.

Jones, Owen (1809–74): designed the interior of the Crystal Palace and the courts in the Crystal Palace when it moved to Sydenham. His *Grammar of Ornament* which grew out of his travels in Spain, Greece and Egypt was a most influential book.

Kahn, Louis (1901–74): American architect who taught at the universities of Yale and Pennsylvania. His international stature came with his space-frame design for the Yale University Art Gallery, 1951–3 (with D. Orr) and the Richards Medical Research Building, Philadelphia, 1958–60, with its planning concept of served and servant spaces.

Knight, Richard Payne (1750–1824): English landscape gardening theorist and champion of the picturesque. His poem *The Landscape* (1794) attacked 'Capability' Brown's style of landscape gardening.

lancet window: a narrow window with a sharply pointed head, associated with the early English gothic style.

Lasdun, Denys (1914–): leading English architect in the period after the Second World War, his main buildings in London are the Royal College of Physicians, 1961–4, and the National Theatre, 1967–76.

lath: a thin strip of wood.

Laugier, Abbé (1713–69): French priest and neo-classical theorist, his *Essai sur l'Architecture* (1753) argued that classical architects of his day should return to the principles of the primitive hut as exemplified in Greek temple architecture. A rationalist who argued for an architecture reduced to its essential structural elements, such as columns, beams and rafters, he condemned pilasters and excessive ornament. He had a great influence on Jacques-Germain Soufflot and John Soane.

Le Corbusier (1887–1966): French/Swiss architect of central importance to twentieth-century architecture. His early interests were in mass-production housing (e.g. Dom-ino, 1914–5), town planning (plan Voisin, 1925, Ville Radieuse, 1935) and developing a new form of villa suitable to the machine age (e.g. Villa Savoye at Poissy, 1928–9). He summarised his ideas on housing in *Vers une Architecture* (1923). His designs for the League of Nations, Geneva, 1927, unbuilt, Centrosoyus, Moscow, 1928, the Salvation Army Hostel, 1928, and the Cité Universitaire, 1930–2, in Paris were very influential. A key member of the

International Congress of Modern Architecture (CIAM), Le Corbusier published its findings in *The Radiant City* (1933). This book became one of the powerful influences on post-war planning, along with his seminal design for housing, the Unité d'Habitation, Marseille, 1947. Other key post-war buildings which illustrated Le Corbusier's ideas of aesthetics and proportion were the pilgrimage chapel of Ronchamp, France, 1950–4, the Law Courts and Secretariat Building, Chandigarh, India, 1951–6, and the monastery of La Tourette, France, 1957–60.

Ledoux, Claude-Nicolas (1736–1806): French neo-classical architect of great imagination. The powerful simplicity of his work can be seen in his toll houses such as the Barrière de la Villette in Paris and in his designs for the ideal city of Chaux.

L'Enfant, Pierre (1754–1825): French painter and sculptor who volunteered to serve in America. In 1789 he offered to design the new federal capital and this was accepted by President Washington.

Lethaby, William Richard (1857–1931): English architect and educator of great importance to the arts and crafts movement. He became the first principal of the Central School of Arts and Crafts in London which based its principles on those of William Morris. His few buildings include Melsetter, Orkney, 1898, and a highly original church at Brockhampton, Herefordshire, 1900–2.

loadbearing walls: walls that carry their own weight and that of the floors and roof.

Lockwood & Mawson (Henry Fleetwood Lockwood, 1811–78 and Richard Mawson, 1834–1904, and William Mawson): a firm which practised in Bradford and subsequently in London, famous for the design of Saltaire in Yorkshire.

Loos, Adolf (1870–1933): a Moravian architect who worked for three years in Chicago and then moved to Vienna. He entered the *Chicago Tribune* competition (1922), but did not win it. Loos favoured a stripped classical style and in his writing such as *Ornament and Crime* (Vienna, 1908) was vehemently against the use of ornamentation.

Lutyens, Edwin (1869–1944): a leading English architect. Many of his arts and crafts-influenced country houses were designed in conjunction with Gertrude Jekyll, the garden designer. He also designed in the classical style and was involved in the planning of New Delhi where he built the huge Viceroy's House, 1912–31. He is also known for the design of many war memorials in northern France and the Cenotaph in London.

McKim, Charles Follen (1847–1909): studied engineering at Harvard and architecture at the Ecole des Beaux Arts, Paris. From 1879 a partner in McKim, Mead and White, one of the largest and most successful firms in the USA and worldwide. Inspired by the renaissance, the firm's projects were admired for their classical restraint, a major work being the Boston Public Library, 1895.

Mackintosh, C.R. (1868–1928): Scots architect, designer and painter, a key figure in the Glasgow School. Mackintosh's work was influenced by the castles and manor houses of Scotland and by the Vienna Secession. His work was exhibited in Vienna in 1900 and thenceforth became a stronger influence in Europe than in Britain. His major works include the Glasgow School of Art, 1896–1909, the Hill House, Helensburgh, 1902–3, the Scotland Street School, 1906, and a number of tea rooms for Mrs Cranston in Glasgow.

mannerism: associated with Italian architecture from Michelangelo to the early seventeenth century. It is characterised by the free application of classical motifs which is distinct from their hitherto normal usage.

Mawson, William: *see* Lockwood & Mawson.

Metabolists: a group of Japanese architects set up in Tokyo in 1960, who advocated changeable, flexible architecture. It included Kiyonori Kikutake and Noria Kurokawa.

Mies van der Rohe, Ludwig (1886–1969): German architect of central importance to

the development of modernism, Mies was director of the Bauhaus (1930–3). In 1938 he became Professor of Architecture at the Illinois Institute of Technology in Chicago and he subsequently designed a variety of buildings based on his philosophy of 'less is more'. In less talented hands his sophisticated detailing and massing resulted in 'glass box' commercial architecture in the 1960s and 1970s, which contributed to the reaction against modernism.

Miller, Sanderson (1716–80): contributed to the early phase of the gothic revival in England with the design of sham castles.

modernism: an umbrella term which includes those twentieth-century avant-garde movements which shared a concern for new technology, a rejection of any historical ornament, and the desire to create new solutions for planning, architecture and design appropriate to the social conditions of the twentieth century. It emerged in western Europe among a small group of architects and designers and achieved world-wide dominance after the Second World War, particularly for post-war reconstruction, commercial projects and mass housing. Postmodernists have attacked modernism since the 1970s for its lack of sensitivity to locale, its banal, repetitive and undecorated forms, lack of communication and the rigid application of zoning to planning. The modernist faith in new technological and planning solutions is still propounded by some contemporary architects such as Norman Foster, Richard Rogers and the Spanish engineer Santiago Calatrava and is termed late modernist or high-tech.

modernist: *see* modernism.

modern movement: *see* modernism.

monolith: a single stone of large dimensions.

monumental architecture: may not necessarily be large in scale, but is a term that traditionally has been applied to examples of high architecture: palaces, castles, important houses, churches and cathedrals.

Moore, Charles (1925–94): studied at Michigan and Princeton universities. A teacher as well as prolific architect who has reacted against modernism seeking to personalise architecture through historicism and symbolism. One of his most renowned projects is the Piazza d'Italia, New Orleans, 1975–80, where he collaborated with the Urban Innovations Group (UIG) of Los Angeles, Perez Associates of New Orleans and Ron Filson.

Morris, William (1834–96): poet, writer, designer and revolutionary, Morris was a major influence on architecture in both Britain and the USA. The arts and crafts movement, the heightening awareness of vernacular buildings, and the care of ancient buildings (he founded the Society for the Protection of Ancient Buildings in 1877), the problems of industrialisation and urbanisation were the subjects of his lectures and writings. His influence was carried forward into modernism.

moulding: contour given to the projecting features of a building.

mullions: slender piers dividing a window into two or more lights.

Nash, John (1752–1835): favourite architect of the Prince Regent (later George IV) for whom he designed Brighton Pavilion, 1802–21, Nash was a prolific architect happy to work in a variety of styles. This ranged from picturesque thatched cottages to buildings in the Indian, Chinese, classical and castellated gothic styles. His greatest work was the laying out of Regent's Park and Regent Street in London.

national romanticism: the turning towards national architectural traditions as part of a desire for national or regional identity. This took place at the end of the nineteenth and beginning of the twentieth centuries in Scandinavia, in England where it was inspired by the arts and crafts movement, as it was in America (the shingle style). Major examples include Copenhagen Town Hall and Tampere Cathedral.

nave: western part of a church, where the congregation sits. It may or may not be flanked by side aisles.

neo-classic: *see* neo-classicism.

neo-classicism: revival of the principles and spirit of ancient Greek and Roman architecture, which began in the mid-eighteenth century as a reaction against the baroque and rococo. The Grand Tour and the French Academy in Rome offered architects first-hand experience of ancient buildings, while other architects drew inspiration from the imaginative etchings of the Italian engraver G.B. Piranesi or from measured drawings such as those of the British architects J. Stuart and N. Revett. Not simply a sterile copying, but often a creative reworking of ancient forms and principles, neo-classical buildings vary from the rationalism of Soufflot's St Geneviève (Pantheon) in Paris, to the megalomania and geometry of Boullée's Monument to Newton and the elegant, decorative buildings and interiors of Robert Adam in Britain.

neo-Georgian: a style that makes reference to eighteenth-century domestic architecture, through materials (brick), roof forms and detailing. Much used by Quinlan Terry for substantial mansions in Britain and the USA it is also very popular in speculative housing developments. Doorways may be framed by classical pilasters, or details which hint at this; traceried fanlights, which in the original would be above the door opening, may be miniaturised and incorporated in the actual door itself.

Neumann, Johann Balthasar (1687–1753): an outstanding master of German baroque and rococo architecture, his masterpiece is the pilgrimage church at Vierzehnheiligen.

newel post: principal post at the beginning of a flight of stairs, which carries the handrail.

Norman: style of architecture introduced via the Norman conquest of England in 1066, it is characterised by semi-circular arches and massive piers and walls. Elsewhere in Europe it is called romanesque.

obelisk: a tapering shaft of stone, often square in section, with a pyramidical top. Introduced to Europe under the Roman empire from Egypt it subsequently became associated with funerary and commemorative architecture.

ogee arch: a pointed arch with double-curved sides, one concave, the other convex. It was much used in decorated and perpendicular gothic architecture and in Indian architecture of the sixteenth to eighteenth centuries.

open plan: a plan which is not subdivided by interior walls. Much favoured by modernists, the open plan in theory allowed living space to be organised as the users wished. In practice it meant that it was impossible for the various members of a household to pursue different activities within the space without conflict.

Ordish: *see* Barlow & Ordish.

Palladianism: deriving from the ideas of Palladio, Palladian architecture involved symmetry, a central emphasis in the façade and harmonic proportions. In Britain it was introduced first by Inigo Jones and subsequently in the early eighteenth century by Colen Campbell at Mereworth and Lord Burlington at Chiswick House.

Palladio, Andrea (1508–80): the most influential of Italian renaissance architects, Palladio sought to revive Roman ideas of proportion and planning. He introduced the idea of temple front porticoes on his villas and his influential villa La Rotonda (1567) featured porticoes on all four façades. It was this villa that influenced the design of Chiswick House, London. In 1570 he published his *Quattro Libri dell'Architettura* in which he set out his theories of architecture and his achievements as an architect.

pantile: S-shaped roof tile.

parapet: a low wall placed for protection where there is a sudden drop, such as on a rooftop, or the edges of a bridge.

Parsons, William (1796–1857): early nineteenth-century architect who worked mainly in Leicester.

Paxton, Sir Joseph (1803–65): head gardener to the Duke of Devonshire at Chatsworth, where he initiated a new system of iron and glass construction for greenhouses. This provided the experience and inspiration for his design of the Crystal Palace, 1851, the first large-scale prefabricated building.

Pei, I.M. (1917–): born in China, emigrated to the USA in 1935. Head of a prolific architectural practice and acclaimed for the glass pyramid, 1989, which forms the new entrance to the Louvre in Paris.

Pelli, Cesar (1926–): a member of the SITE group in the late 1960s, Pelli designed the twin towers of the World Trade Center, New York, and One Canada Wharf, Docklands, London, both for a while the highest buildings ever built.

peripteral colonnade: a single row of columns surrounding a building.

perpendicular style: the last phase of gothic architecture in England, it is characterised by window tracery with straight verticals and horizontals, flattened arches and complex vaulting, often fan vaulting. It developed during the fourteenth century and continued until the sixteenth.

Piano, Renzo (1937–): Italian architect best known for his work with Richard Rogers on the Pompidou Centre in Paris, 1971–7, a key late modernist building, and independently, the Olympic Stadium, Bari, Italy, 1989.

picturesque style: an English style characterised by eclecticism, asymmetry and variety of texture and materials, it was much in evidence in the work of John Nash. Pattern books published in the early years of the nineteenth century popularised the style.

piers: solid masonry supports with no base or capital; romanesque and gothic pillars; the solid support between openings in buildings.

pilaster: a rectangular column projecting slightly from a wall. In classical architecture it conforms with the order used.

pile: a concrete or timber pole driven into the ground to provide a foundation.

pilotis: slender pillars of steel or reinforced concrete which carry the weight of a building.

plan: horizontal section of a building, or a drawing or diagram depicting this.

planes: flat two-dimensional surfaces which may be vertical (walls) or horizontal.

plate tracery: decorative openings cut through the stone infill in a window head, which occurs in late twelfth- and early thirteenth-century gothic architecture.

plinth: projecting base of a wall; pedestal.

point block: a skyscraper or high-rise block of housing or offices with lifts and staircases in the centre; often square in plan, although occasionally circular or slightly rectangular. A slab block by contrast is rectangular in plan.

post-Fordism: a term used by postmodernists to describe a late capitalist economy where the emphasis has shifted from production to consumption. New information technology and an emphasis on diversity in the market has led to the dismantling of large-scale mass production, in favour of batch production, small businesses and a flexible part-time labour force. Entrepreneurial activity is encouraged in all areas of society and there is a greater emphasis on sectors associated with consumption such as the media, advertising, design, public relations and marketing.

postmodern: *see* postmodernism.

postmodernism: a style or critical approach in a variety of disciplines including architecture. Advocates are anti-modernism and the enlightenment, which are seen as authoritarian and insensitive to world cultures and individual needs, and

pro-pluralism, sensitivity to place and the use of ornament to encourage communication with the public.

prairie house: associated predominantly with the early work of Frank Lloyd Wright, the design was influenced by the open prairie of mid-western America. The houses featured open plans with a low, horizontal emphasis.

Price, Uvedale (1747–1829): landscape garden theorist and friend of R.P. Knight, Price defined the picturesque in a three-volume *Essay on the Picturesque*, which was his reply to Knight's poem *The Landscape*.

Prior, Edward (1852–1932): English arts and crafts architect whose butterfly plan houses took advantage of the views. He used local materials to link his houses physically with their immediate environment.

Pugin, A.W.N. (1812–52): a key influence on the development of the gothic revival through the fervent rhetoric of his writings which emphasised rationalism and moral values in design. He was a prolific designer of churches and their contents, and designed the furnishings of the Houses of Parliament. His best buildings included St Giles, Cheadle, in Staffordshire, 1841–6, Nottingham Catholic Cathedral, 1842–4, and his own house the Grange, 1843, and church, St Augustine's, 1846–51, at Ramsgate.

purlins: horizontal timbers which carry the common rafters of a roof giving intermediate support. The purlins themselves may be supported in a variety of ways.

Queen Anne revival style: influenced by Dutch seventeenth-century brick houses and English vernacular architecture, the buildings are of a domestic scale and feature decoration carved in red brick, shaped gables, sash windows, tall chimneys, steeply pitched roofs and asymmetrical composition. Much associated with the work of R.N. Shaw, W.E. Nesfield and the aesthetic movement, it was very fashionable for middle-class housing and for school buildings. It became known as the architecture of 'sweetness and light'.

rafter: inclined timber which forms the side of a roof, to which the roof covering is attached.

renaissance: a style which developed in Italy in the fifteenth century and spread throughout Europe. It represented a return to Roman standards and motifs but in France, Germany, the Low Countries and Britain it developed regional variations.

Repton, Humphry (1752–1818): leading English landscape gardener of the generation succeeding 'Capability' Brown and prolific writer on the theory and practice of the subject.

Repton, John Adey (1775–1860): architect and son of Humphry, John Adey worked in the office of John Nash, but was not always given credit for his work.

ribbon development: the development of buildings alongside newly built main roads.

Richardson, Henry Hobson (1838–86): studied both in the USA and the Ecole des Beaux Arts, Paris. Inspired by romanesque architecture, his public and commercial projects have monumental masonry forms and round-arched openings. Major projects include Trinity Church, Boston, 1873–7, and Marshall Field Wholesale Warehouse, Chicago, 1885–7.

Roche, Kevin, Dinkerloo, John & Associates (Kevin Roche 1922– , John Dinkerloo 1918–81): American architectural practice which made its name with the design of the Ford Foundation headquarters in New York, 1963–8.

Roche, Martin: *see* Holabird & Roche.

rococo: the last phase of the baroque in the early eighteenth century in France, Austria and south Germany. Characterised by decoration which is light in colour and form, even frivolous, asymmetrical and employing shell-like C and S curves. Rococo is rare in England, but is sometimes associated with the use of Chinese and early gothic revival forms (gothick).

Rogers, Richard (1933–): English late modernist architect best known for the design of the Pompidou Centre, Paris, 1971–7, with Renzo Piano, and for the Lloyds Building in London (1986).

Root: *see* Burnham & Root.

rotunda: a circular building, often with a colonnade around.

Ruskin, John (1819–1900): English writer and critic who had an immense influence on both the gothic revival and the arts and crafts movement. His major writings include *The Seven Lamps of Architecture* and *The Stones of Venice*, a particularly famous chapter of which is 'On the nature of gothic' which stressed morality in design and joy in labour and promoted Italian, particularly Venetian, gothic architecture.

Saarinen, Eero (1910–61): Finnish/American architect much influenced by Mies van der Rohe in his early career, Saarinen was among the leaders of the reaction against modernist minimalist architecture, and of the search for more expressive forms. This can be seen in his TWA Building, Kennedy Airport, New York, 1956–62, with its sculptural forms expressing flight.

sanctuary: a sacred cell within a temple, often containing a statue of a deity.

Scott, Sir George Gilbert (1811–78): prolific restorer and architect who built workhouses, churches and many public buildings. An admirer of A.W.N. Pugin, his most important works are St Nicholas, Hamburg, and in London, St Pancras Station and hotel, the Albert Memorial and the renaissance-style government offices in Whitehall.

Scott, Henry: *see* Fowke, Captain & Scott, Henry.

segmental arch: an arch in the form of a segment of a circle, drawn from a centre which is below the springing line.

semiology: the study of signs and symbols used to express ideas.

shaft: the trunk of a column between the capital and the base.

shingles: wooden tiles used for covering roofs and walls.

Short, Alan & Ford, Brian: a firm of British architects, originally of Peake, Short and Partners who are making their reputation with ecologically sound designs. One of their most important buildings to date is the Simonds Farsons Cisk Brewery in Malta.

Smirke, Sydney (1798–1877): English architect mainly known for the Carlton Club and for the British Museum Reading Room, London.

Soane, John (1753–1837): English architect who developed his own personal style which combined neo-classicism and the picturesque. Among his outstanding extant works are his own house, No. 13 Lincoln's Inn Fields, London, 1812–13, now Sir John Soane's Museum, and Dulwich College Art Gallery, 1811–14.

Spanish tile: roofing tile of half cylinder shape, but wider at one end.

springing: impost or the point at which an arch meets its support.

steel frame: steel structure which carries the weight of a building instead of loadbearing walls.

Steiner, Rudolph (1861–1925): German scientist, mathematician, artist, writer and founder of the Anthroposophical Society. The buildings erected in Switzerland for this society are attributed to him, but several architects were involved.

Stirling, James (1926–92): key English architect whose reputation was established with the Leicester Engineering Laboratories, 1959–63, with James Gowan, and reinforced when he won the competition for the Stuttgart Staatsgalerie Extension, completed 1984 (with Michael Wilford).

strapwork: decoration in the form of interlaced bands, used in the Elizabethan and Jacobean periods in England, but originating in France and the Netherlands.

stretcher: a stone or brick laid with its length parallel to the length of the wall.

stringcourse: a thin horizontal band of moulding on the exterior of a building.

stucco: a term often used loosely to mean a render or protective coat of lime or cement and sand on the outside or inside of buildings.

stupa: a hemispherical Buddhist funerary mound.

Sullivan, Louis (1856–1924): American architect who set up his own company, Adler & Sullivan, in Chicago in 1869 and was central to the development of the Chicago School of architecture.

tatami mat: a Japanese mat used as a floor covering and made from rice stalks.

Terry, Quinlan (1937–): English architect and keen advocate of revived classical architecture.

tie rods/beams: members which tie together two members, such as walls which are in danger of falling outward.

tile hanging: the cladding of walls with tiles.

timber frame: a frame structure made of timber.

transept: the transverse arm of a cruciform church.

triforium: gallery or arcaded wall passage facing onto the nave, at a level below the clerestory and above the arcade.

turret: a small tower.

Tuscan order: the simplest of the orders derived, it was thought, from Etruscan temples. It has a base, plain shaft, capital and frieze.

tympanum: the area above the lintel of a doorway and below the arch above it; the space enclosed by the mouldings of a pediment.

Utzon, Jorn (1918–): Danish architect and winner of the competition to design the Sydney Opera House, 1957.

Vanbrugh, John (1664–1726): foremost English baroque architect and playwright whose buildings include Castle Howard, 1699–1726, and Blenheim Palace, 1705.

Van der Rohe, Mies: *see* Mies van der Rohe, Ludwig.

Vasari, Giorgio (1511–74): Italian painter, author of the famous *The Lives of the Italian Architects, Painters and Sculptors* (1550) and architect of the Uffizi in Florence. Vasari's admiration and promotion of the work of Michelangelo had an enormous influence on architectural taste.

vault: an arched roof or ceiling of brick, stone or concrete.

Venturi, Robert (1925–): American postmodern architect and theorist whose *Complexity and Contradiction in Architecture* (New York, 1966) and *Learning from Las Vegas* (published with Denise Scott-Brown and Steven Izenour, Cambridge, Mass., 1972) provided a theoretical basis for postmodern architecture. Among his most recent buildings, in conjunction with the above partners, is the extension to the National Gallery, London (1986).

vernacular architecture: local or regional architecture using local materials, building skills and approach to design (see vernacular revival). Generally applied to architecture in preindustrial societies where there is no division of labour between designer and builder or where buildings have not been professionally designed.

vernacular revival style: *see* domestic revival style.

Viollet-le-Duc, Eugène-Emmanuel (1814–79): French architect, writer, scholar and restorer whose ideas on Gothic architecture influenced not only his contemporaries, but also the succeeding generation of architects such as Victor Horta and Hector Guimard.

Vitruvius Pollio, Marcus (active 46–30 BC): Roman architect and theorist of enormous influence in the early Renaissance, his ten-volume treatise on architecture, *De Architectura*, was the only one to survive from antiquity.

Voysey, Charles Francis Annesley (1857–1941): became a leading member of the arts and crafts movement in Britain. He built many houses and designed the furniture and all the details himself.

Wallis, Gilbert & Partners: a British architectural practice set up after the First

World War specialising in industrial buildings, many for American clients. Well known for factories along the Great West Road in London.

wall plane: two-dimensional surface of a wall.

Walpole, Horace (1717–97): not an architect, but a promoter of the revived gothic style in the mid-eighteenth century. His own house, Strawberry Hill, Twickenham, was designed in a fanciful gothick style.

weatherboarding: overlapping horizontal timber boards which cover a timber-framed building.

Webb, Philip (1831–1915): important theorist and architect of the English domestic revival and the arts and crafts movement. He designed the Red House (1859) for William Morris and many other houses in both the town and country.

Winckelmann, J.J. (1717–68): came from a humble Prussian background and worked as a librarian, chiefly in Rome. He rose to fame mainly from promoting Greek works of art and architecture, although he never visited Greece.

Wood, John, elder and younger (John Wood, 1704–54, John Wood, 1728–81): English architects, John Wood the elder's design for Prior Park, Bath (1735–48), was Palladian in style, but it was his redesign of the town of Bath (Queen Square and the Circus) which was his major achievement. His work was carried on by his son, who designed the Royal Crescent.

Wren, Sir Christopher (1632–1723): has been called England's greatest architect, for after the fire of London (1666) he designed his masterpiece, St Paul's Cathedral, and fifty-one city churches. His secular works include Chelsea Hospital, 1682–92, Greenwich Hospital, 1696 on, Tom Tower, Christchurch, Oxford, 1681–2, as well as many additions and alterations to major buildings.

Wright, Frank Lloyd (1869–1959): America's greatest architect whose work over his long life continually explored new ideas, from the prairie houses of the Chicago suburbs in the 1890s, to the Guggenheim Museum, New York (designed 1942, built 1960), from mass production houses and town planning (Broadacre City) to the Imperial Hotel, Tokyo (1916–20), and the Johnson Wax Factory, Racine (1936–9).

Appendix II

Further reading

This is a selective bibliography and does not aim to be complete. We have tried to cover a broad range of topics within the field of architecture and to indicate further sources of information. Many local history societies, libraries and record offices publish bibliographies and guides to sources and archives which are well worth investigating and we have included some examples in the bibliography below which have more than local value.

BIBLIOGRAPHIES AND GUIDES TO SOURCES

Bradfield, V. *Information Sources in Architecture*, London, Butterworth, 1983.

British Architectural Library *Catalogue of the Drawings Collection of the Royal Institute of British Architects: Cumulative Index*, London, RIBA, 1989.

Colvin, H.M. *A Guide to the Sources of English Architectural History*, Isle of Wight, Pinhorns, 1967.

Hall, R. de *A Bibliography of Vernacular Architecture*, Vernacular Architecture Group, Newton Abbott, David & Charles, 1972.

Harley, J.B. *Maps for the Local Historian: A Guide to the British Sources*, London, The Standing Conference for Local History, 1972.

Harley, J.B. and Phillips, C.W. *The Historian's Guide to Ordnance Survey Maps*, London, The Standing Conference for Local History, 1964.

Harper, R.H. *Victorian Architectural Competitions: an Index to British and Irish Architectural Competitions in the Builder, 1843–1900*, London, Mansell Publishing Ltd, 1983.

Harris, E. *British Architectural Books and Writers, 1556–1785*, New York, Cambridge University Press, 1990.

Harvey, J.H. *Sources for the History of Houses*, London, British Records Association, 1974.

Henstock, A. *Tracing the History of Your House: Documentary Sources for the History of Nottinghamshire Buildings 1500–1950*, Nottingham, Nottinghamshire Local History Association, 1988.

Historical Manuscripts Commission, *Architectural History and the Fine and Applied Arts: Sources in the National Register of Archives*, 4 vols, London, Royal Commission Historical Manuscripts, 1969.

Hitchcock, H.R. *American Architectural Books: a List of Books, Portfolios and Pamphlets Published before 1895 on Architecture and Related Subjects*, Minneapolis, University of Minnesota, 1965.

Kamen, R. *British and Irish Architectural History: a Bibliography and Guide to Sources of Information*, London, Architectural Press, 1981.

Mace, A. *The Royal Institute of British Architects: a Guide to its Archive and History*, London, Mansell Publishing Company, 1986.

Michelmore, D.J.H. *A Current Bibliography of Vernacular Architecture 1970–1976*, Aberystwyth, Vernacular Architecture Group, 1979.

Park, H. *A List of Architectural Books Available in America Before the Revolution*, Los Angeles, Hennessey & Ingalls, 1973.

Pattison, I.R., Pattison, D.S. and Alcock, N.W. (eds) *A Bibliography of Vernacular Architecture*, vol. III *1977–1989*, Aberystwyth, Vernacular Architecture Group, 1992.

Roos, F.J. Jr *Bibliography of Early American Architecture: Writings on Architecture Constructed Before 1860 in Eastern and Central United States*, Urbana, University of Illinois Press, 1968.

Russell, T. *The Built Environment*, vol. 1 *Town Planning and Urbanism – Architecture – Gardens and Landscape Design*, Godstone, Gregg Publishing, 1989.

Russell, T. *The Built Environment*, vol. 2 *Environmental Technology – Constructional Engineering – Building and Materials*, Godstone, Gregg Publishing, 1989.

Russell, T. *The Built Environment*, vol. 3 *Decorative Art and Industrial Design – International Exhibitions and Collections – Recreational and Performing Arts*, Godstone, Gregg Publishing, 1989.

Russell, T. *The Built Environment*, vol. 4 *Public Health – Municipal Services – Community Welfare*, Godstone, Gregg Publishing, 1989.

Smith, D.L. *How to Find Out in Architecture and Building: A Guide to Sources of Information*, Oxford, Pergamon, 1967.

Sokol, D.M. *American Architecture and Art; A Guide to Information Sources*, Detroit, Gale Research Co., 1976.

Standing Conference for Local History, The *A Directory for Local Historians*, The National Council of Social Service, London, 1970.

Stoddard, R. *Theatre and Cinema Architecture*, Detroit, Gale Research Co., 1978.

Sutcliffe, A. *The History of Modern Town Planning: A Bibliographic Guide*, Birmingham, University of Birmingham, 1977.

Tate, W.E. *The Parish Chest*, Cambridge, Cambridge University Press, 1969.

Wodehouse, L. *American Architects from the Civil War to the First World War*, Detroit, Gale Research Co., 1976.

Wodehouse, L. *American Architects from the First World War to the Present*, Detroit, Gale Research Co., 1977.

Wodehouse, L. *British Architects 1840–1976*, Detroit, Gale Research Co., 1978.

ABSTRACTS AND INDEXES

Art Index, New York, W. Wilson Company, 1933- .

Avery Index to Architectural Periodicals, Boston, Columbia University, 1973, 1979, 1985.

British Architectural Library *Architectural Periodicals Index*, London, RIBA), 1972.

British Architectural Library Database, London, RIBA, continuously updated.

British Humanities Index, London, Library Association, 1962- .

Gretes, F.G. *Directory of International Periodicals and Newsletters on the Built Environment*, London, 1986.

BIOGRAPHICAL DICTIONARIES AND ENCYCLOPAEDIAS

Colvin, H.M. *A Biographical Dictionary of British Architects 1660–1840*, London, John Murray, 1978.

Felstead, A., Franklin, J. and Pinfield, L. *Directory of British Architects 1834–1900*, London, British Architectural Library and Mansell Publishing, 1993.

Gray, A.S. *Edwardian Architecture: a Biographical Dictionary*, London, Duckworth, 1985.

Harvey, J.H. *English Medieval Architects: a Biographical Dictionary Down to 1550*, London, Batsford, 1954.

Morgan, A.L. and Naylor, C. (eds) *Contemporary Architects*, London and Chicago, Macmillan, 1987.

Placzek, A.K. (ed.) *Macmillan Encyclopaedia of Architects*, 4 vols, London, The Free Press, Collier Macmillan, 1982.

Richards, J.M. (ed.) *Who's Who in Architecture from 1400 to the Present Day*, London, Weidenfeld & Nicolson, 1977.

Withey, H.F. and Rathburn, E. *Biographical Dictionary of American Architects (Deceased)*, Los Angeles, New Age Publishing Company, 1956.

ARCHITECTURE AND BUILDING DICTIONARIES AND ENCYCLOPAEDIAS

Fleming, J., Honour, H. and Pevsner, N. *A Dictionary of Architecture*, Harmondsworth, Penguin, 1991.

Guedes, P. (ed.) *The Macmillan Encyclopaedia of Architecture and Technological Change*, London, Macmillan, 1979.

Hunt, W.D. Jr *Encyclopaedia of American Architecture*, New York, McGraw Hill, 1980.

Leick, G. *A Dictionary of Near Eastern Architecture*, London, Routledge, 1988.

Magnago Lampugnani, V. (ed.) *The Thames & Hudson Encyclopaedia of Twentieth Century Architecture*, London, Thames & Hudson, 1986.

McMullan, R. *Macmillan Dictionary of Building*, London, Randall MacMillan, 1988.

Oliver, P. (ed.) *Encyclopaedia of Vernacular Architecture of the World*, Oxford, Basil Blackwell, 1995.

Scott, J.S. *The Penguin Dictionary of Building*, Harmondsworth, Penguin, 1984.

Vynckt, R. van (ed.) *International Dictionary of Architects and Architecture*, London, Gale Research International, 1993.

GLOSSARIES

Curl, J.S. *English Architecture: an Illustrated Glossary*, Newton Abbott, David & Charles, 1977.

Curl, J.S. *Encyclopaedia of Architectural Terms*, London, Donhead, 1992.

Lever, J. and Harris, J. *Illustrated Glossary of Architecture 800–1914*, London, Faber and Faber, 1993.

RESEARCH AND RECORDING

Brunskill, R.W. *A Systematic Procedure for Recording English Vernacular Architecture*, London, Ancient Monuments Society, 1976.

Brunskill, R.W. *Illustrated Handbook of Vernacular Architecture*, London, Faber & Faber, 1978.

Buchanan, T. *Photographing Historic Buildings*, London, The Royal Commission on Historical Monuments of England, 1983.

Cocke, T., Findlay, D., Halsey, R. and Williamson, E. *Recording a Church: an Illustrated Glossary*, 2nd edn, London, Council for British Archaeology, 1984.

Dyos, H.J. (ed.) *The Study of Urban History*, London, Edward Arnold, 1976.

Eden, P. *Small Houses in England 1520–1820: Towards a Classification*, London, Historical Association, 1979.

Hutton, B. *Recording Standing Buildings*, Department of Archaeology and Prehistory Rescue: The British Archaeological Trust, University of Sheffield, 1986.

Iredale, D. *Discovering Local History*, Shire Publications, Aylesbury, 1985.

McDowall, R.W. *Recording Old Houses: A Guide*, London, The Council for British Archaeology, 1980.

Powell, C. *Writing Histories of Construction Firms*, Englemere, Construction History Society, 1992.

Rogers, A. *Approaches to Local History*, London and New York, Longman, 1977.

Royal Commission on the Historical Monuments of England, *Recording Historic Buildings: a Descriptive Specification*, London, HMSO, 1991.

Smith, J.T. and Yates, E.M. 'On the dating of English houses from external evidence' *Field Studies*, vol. 2, no. 5, 1968, pp. 537–577; published also as an offprint 1968, reprinted 1974.

Steane, J. *Upstanding Archaeology*, London, Council for British Archaeology, 1985.

COLLECTIONS OF DOCUMENTS AND EXTRACTS

Benton, T. and C. *Form and Function: a Source Book for the History of Architecture and Design 1890–1939*, London, Crosby, Lockwood, Staples, 1975.

Conrads, U. *Programmes and Manifestoes on Twentieth Century Architecture*, London, Lund Humphries, 1970.

Eitner, L. *Sources and Documents in the History of Art Series: Neoclassicism and Romanticism*, 2 vols, London, Prentice-Hall International Inc., 1970, 1971.

Eliot, S. and Stern, B. *The Age of Enlightenment: an Anthology of Eighteenth Century Texts*, 2 vols, East Grinstead, Ward Lock Educational in association with the Open University, 1979.

Frisch, T.G. *Gothic Art 1140–c.1450. Sources and Documents*, Toronto, University of Toronto Press, 1987.

Holt, E.G. *A Documentary History of Art: From the Classicists to the Impressionists*, New York, Doubleday Anchor Books, 1966.

Holt, E.G. *A Documentary History of Art: The Middle Ages and the Renaissance*, Princeton, Princeton University Press, 1981.

Holt, E.G. *A Documentary History of Art: Michelangelo and the Mannerists: The Baroque and the Eighteenth Century*, Princeton, Princeton University Press, 1983.

Pollit, J.J. *Sources and Documents in the History of Art Series: the Art of Greece 1400–31 BC*, New Jersey, Prentice-Hall Inc., 1965.

Pollit, J.J. *Sources and Documents in the History of Art Series: the Art of Rome c. 753–337 AD*: New Jersey, Prentice-Hall Inc. 1966.

Roth, L. *America Builds: Source Documents in American Architecture and Planning*, New York, Harper & Row, 1983.

Salzman, L.F. *Building in England Down to 1540. A Documentary History*, Oxford, Oxford University Press, 1992.

HISTORIOGRAPHY

Allsopp, B. *The Study of Architectural History*, London, Studio Vista, 1970.

Frankl, P. *Principles of Architectural History*, Cambridge, Mass., MIT Press, 1968.

Gombrich, E.H. *In Search of Cultural History*, Oxford, Clarendon Press, 1978.

Porphyrios, D. (ed.) *On the Methodology of Architectural History*, London, Architectural Design, 1981.

Watkin, D. *Morality and Architecture*, Oxford, Clarendon Press, 1977.
Watkin, D. *The Rise of Architectural History*, London, Architectural Press, 1980.

TOWN PLANNING AND BUILDING LEGISLATION

Benevolo, L. *The History of the City*, London, Scholar, 1980.
Braunfels, W. *Urban Design in Western Europe: Regime and Architecture 900–1900*, Chicago, University of Chicago Press, 1990.
Cullingworth, J.B. *Town and Country Planning in Britain*, London, George Allen & Unwin, 1988.
Garner, J.F. and Gravells, N.P. *Planning Law in Western Europe*, Amsterdam and Oxford, North Holland Publishing Company, 1986.
Gaskell, S.M. *National Statutes and the Local Community: Building Control – National Legislation and the Introduction of Local Bye-laws in Victorian England*, London, Bedford Square Press, 1983.
Hall, P. *Cities of Tomorrow: an Intellectual History of Urban Planning and Design in the Twentieth Century*, London, Blackwell, 1990.
Harper, R.H. *Victorian Building Regulations: Summary Tables of the Principal English Building Acts and By-laws 1840–1914*, London, Mansell Publishing Ltd, 1985.
Howard, E. *Garden Cities of Tomorrow*, London, Attic Books, 1985.
Knowles, C.C. and Pitt, P.H. *The History of Building Regulations in London 1189–1972*, London, Architectural Press, 1972.
Morris, A.E.J. *History of Urban Form Before the Industrial Revolution*, London, Longman, 1993.
Muir, R. *The English Village*, London, Thames & Hudson, 1983.
Mumford, L. *The City in History: Its Origins, Its Transformations and Its Prospects*, Harmondsworth, Penguin, 1961.
Osborn, F.J. and Whittick, A. *New Towns: Their Origins, Achievements and Progress*, London, L. Hill, 1977.
Ravetz, A. *Remaking Cities*, London, Croom Helm, 1980.
Sutcliffe, A. (ed.) *British Town Planning: the Formative Years*, Leicester, Leicester University Press, 1981.

BUILDING MATERIALS, CONSTRUCTION, TECHNOLOGY AND THE BUILDING INDUSTRY

Ball, M. *Rebuilding Construction: Economic Change in the British Construction Industry*, London, Routledge, 1988.
Banham, R. *The Architecture of the Well-Tempered Environment*, London, Architectural Press, 1984.
Beard, G. *Georgian Craftsman*, London, Country Life, 1966.
Bowley, M. *The British Building Industry*, London, Macmillan, 1966.
Brunskill, R.W. *Timber Building in Britain*, London, Victor Gollancz, 1985.
Clarke, L. *Building Capitalism: Historical Change and the Labour Process in the Production of the Built Environment*, London, Routledge, 1992.
Clifton-Taylor, A. *The Pattern of English Building*, London, Faber & Faber, 1987.
Clifton-Taylor, A. and Brunskill, R. *English Brickwork*, London, Ward Lock, 1977.
Clifton-Taylor, A. and Ireson, A.S. *English Stone Building*, London, Victor Gollancz, 1983.
Collins, P. *Concrete*, London, Faber, 1959.
Condit, C.W. *American Building: Materials and Techniques from the Beginning of*

the Colonial Settlements to the Present, Chicago, University of Chicago Press, 1982.

Davey, N. *A History of Building Materials*, London, Phoenix House, 1961.

Fitchen, J. *Building Construction Before Mechanisation*, Cambridge, Mass., MIT Press, 1989.

Fox, A. and Murrell, R. *Green Design: a Guide to the Environmental Impact of Building Materials*, London, Architecture Design and Technology Press, 1989.

Gordon, D.G. and Stubbs, S. *How Architecture Works*, New York, Van Nostrand Reinhold, 1991.

Gordon, J.E. *Structures: Or Why Things Don't Fall Down*, Harmondsworth, Penguin, 1983.

Hewitt, C.A. *The Development of Carpentry, 1200–1700, An Essex Study*, Newton Abbott, David & Charles, 1969.

Hobhouse, H. *Thomas Cubitt – Master Builder*, London, Macmillan, 1971.

Jope, E.M. *Studies in Building History*, London, Odhams, 1961.

Powell, C.G. *An Economic History of the British Building Industry 1815–1979*, London and New York, Methuen, 1980.

Salvadori, M. *Why Buildings Stand Up*, New York, W.W. Norton, 1990.

Singer, C. *et al.*, *A History of Technology*, 7 vols, Oxford; Clarendon Press, 1954–78, vol. 8, 1984.

White, R. *Prefabrication: a History of its Development in Great Britain*, London, HMSO, 1965.

Yeomans, D. *The Trussed Roof: Its History and Development*, Aldershot, Scolar Press, 1992.

THE ARCHITECTURAL PROFESSION

Brockman, H.A.N. *The British Architect in Industry 1841–1940*, London, Allen & Unwin, 1974.

Coulton, J.J. *Greek Architects at Work*, London, Granada Publishing, 1977.

Harvey, J. *The Master Builders: Architecture in the Middle Ages*, London, Thames & Hudson, 1971.

Jenkins, F. *Architect and Patron: a Survey of Professional Relations and Practice in England from the Sixteenth Century to the Present Day*, London, Oxford University Press, 1961.

Kaye, B. *The Development of the Architectural Profession in Britain: a Sociological Study*, London, Allen & Unwin, 1960.

Saint, A. *The Image of the Architect*, London and New Haven, Yale University Press, 1983.

HISTORIES OF ARCHITECTURAL THEORY

Collins, P. *Changing Ideals in Modern Architecture 1750–1950*, London, Faber & Faber, 1971.

Gifford, D. *The Literature of Architecture: The Evolution of Architectural Theory and Practice in Nineteenth Century America*, New York, E.P. Dutton, 1966.

Hermann, W. *Laugier and Eighteenth Century French Theory*, London, Zwemmer, 1985.

Macleod, R. *Style and Society, Architectural Ideology in Britain, 1835–1914*, London, RIBA, 1971.

Pevsner, N. *Some Architectural Writers of the Nineteenth Century*, Oxford, Clarendon Press, 1972.

Swenarton, M. *Artisans and Architects: the Ruskinian Tradition in Architectural Thought*, London, Macmillan, 1989.

Wittkower, R. *Architectural Principles in the Age of Humanism*, London, Academy Editions, 1988.

HISTORIES OF ARCHITECTURE

Banham, R. *Theory and Design in the First Machine Age*, London, Architectural Press, 1976.

Barley, M. *Houses and History*, London, Faber & Faber, 1986.

Benevolo, L. *The Architecture of the Renaissance*, 2 vols, London, Routledge & Kegan Paul, 1978.

Berkeley, E.P. (ed.) and McQuaid, M. (asst. ed.) *Architecture: a Place for Women*, New York, Smithsonian Institution Press, 1989.

Blunt, A. *Art and Architecture in France 1500–1700*, Harmondsworth, Penguin, 1980.

Blunt, A. *et al. Baroque and Rococo Architecture and Decoration*, London, Elek, 1978.

Bognar, B. *Contemporary Japanese Architecture and its Development and Challenge*, New York and Wokingham, Van Nostrand Reinhold, 1985.

Braham, A. *The Architecture of the French Enlightenment*, London, Thames & Hudson, 1989.

Brunskill, R.W. *Illustrated Handbook of Vernacular Architecture*, London, Faber & Faber, 1971.

Burnett, J. *A Social History of Housing 1817–1970*, London, Methuen, 1986.

Bussagli, M. *Oriental Architecture* 2 vols, London, Faber, 1989.

Craig, M. *The Architecture of Ireland from the Earliest Times to 1880*, London, Batsford, 1989.

Creswell, K.A.C. *A Short Account of Early Muslim Architecture*, Harmondsworth, Penguin, 1989.

Curtis, W.J.R. *Modern Architecture Since 1900*, London, Phaidon Press, 1991.

Davey, *Arts and Crafts Architecture: the Search for Earthly Paradise*, London, Architectural Press, 1980.

Davies, C. *High Tech Architecture*, London, Thames & Hudson, 1988.

Davies, P. *The Splendours of the Raj: British Architecture in India 1660–1947*, London, John Murray, 1985.

Denyer, S. *African Traditional Architecture: an Historical and Geographical Perspective*, London, Heinemann, 1978.

Dinsmoor, W.B. *The Architecture of Ancient Greece: an Account of Its Historical Development*, London, Batsford, 1975.

Dixon, R. and Muthesius, S. *Victorian Architecture*, London, Thames & Hudson, 1978.

Donnelly, H.C. *Architecture in the Scandinavian Countries*, Cambridge, Mass., MIT, 1992.

Doordan, D.P. *Building Modern Italy: Italian Architecture 1914–1936*, Princeton, Princeton University Press, 1989.

Drexler, A. (ed.) *The Architecture of the Ecole des Beaux-Arts*, London, Secker & Warburg, 1977.

Egbert, D.D. *The Beaux-Arts Tradition in French Architecture*, Princeton, Princeton University Press, 1980.

Fletcher, Sir Bannister *A History of Architecture*, 19th edn, London, Butterworths, 1987.

Frampton, K. *Modern Architecture: a Critical History*, London, Thames & Hudson, 1985.

Friedman, M. (ed.) *De Stijl 1917–1931: Visions of Utopia*, Oxford, Phaidon, 1982.

Girouard, M. *Sweetness and Light: the Queen Anne Movement 1860–1900*, Oxford, Clarendon Press, 1977.

Grodecki, L. *Gothic Architecture*, London, Faber, 1986.

Guidoni, E. *Primitive Architecture*, London, Faber, 1987.

Hayden, D. *The Grand Domestic Revolution: A History of Feminist Designs for American Homes, Neighbourhoods, and Cities*, Cambridge, Mass., MIT, 1981.

Handlin, D.P. *American Architecture*, London, Thames & Hudson, 1985.

Hitchcock, H.R. *Architecture Nineteenth and Twentieth Centuries*, Harmondsworth, Penguin, 1990.

Hoag, J.D. *Islamic Architecture*, London, Faber, 1987.

Ikonnikov, A. *Russian Architecture of the Soviet Period*, London, Collets, 1988.

Jencks, C. *Architecture Today*, London, Academy Editions, 1988.

Jencks, C. *The Language of Post Modern Architecture*, London, Academy Editions, 1991.

Jordy, W.H. *American Buildings and Their Architects*, vol. 3, *Progressive and Academic Ideals at the Turn of the Century*, New York, Doubleday & Co. 1976.

Jordy, W.H. *American Buildings and Their Architects*, vol. 4, *The Impact of European Modernism in the Mid Twentieth Century*, New York, Doubleday & Co. 1976.

Klotz, H. *The History of Postmodern Architecture*, Cambridge, Mass., MIT Press, 1988.

Kopp, A. *Constructivist Architecture in the USSR*, London, Academy Editions, 1985.

Kostof, S. *A History of Architecture: Settings and Rituals*, New York, Oxford University Press, 1986.

Krautheimer, R. *Early Christian and Byzantine Architecture*, Harmondsworth and New York, Penguin and Wiley, 1987.

Kubler, G. *The Art and Architecture of Ancient America: the Mexican, Maya and Andean People*, Harmondsworth and New York, Penguin & Wiley, 1984.

Macdonald, W.L. *The Architecture of the Roman Empire*, vol. 1 *An Introductory Study*, Yale, Yale University Press, 1982.

Macdonald, W.L. *The Architecture of the Roman Empire*, vol. 2 *An Urban Appraisal*, Yale, Yale University Press, 1986.

Mercer, E. *English Vernacular Houses: a Study of Traditional Farmhouses and Cottages*, London, HMSO, 1975.

Michell, G. (ed.) *Architecture of the Islamic World: Its History and Social Meaning*, London, Thames & Hudson, 1978.

Middleton R. and Watkin, D. *Neoclassical and Nineteenth Century Architecture*, 2 vols, London and Milan, Faber & Faber and Electa, 1987.

Murray, P. *Renaissance Architecture*, London, Faber, 1986.

Muthesius, S. *The High Victorian Movement in Architecture 1850–1870*, London, Routledge & Kegan Paul, 1972.

Nishi, K. and Hozumi, K. *What is Japanese Architecture: a Survey of Traditional Japanese Architecture with a List of Sites and a Map*, Tokyo and New York, Kodansha International, 1985.

Onians, J. *Bearers of Meaning: the Classical Orders in Antiquity, the Middle Ages, and the Renaissance*, Cambridge, Cambridge University Press, 1988.

Papadakis, A. and Watson, H. *New Classicism: Omnibus Volume*, London, Academy Editions, 1990.

Papadakis, A., Cooke, C., and Benjamin, A. *Deconstruction: Omnibus Volume*, London, Academy Editions, 1989.

Pevsner, N. *An Outline of European Architecture*, Harmondsworth, Penguin, 1968.

Pevsner, N. *Pioneers of Modern Design from William Morris to Walter Gropius*, Harmondsworth, Penguin, 1975.

Pevsner, N. *A History of Building Types*, London, Thames & Hudson, 1986.

Pierson, W.H. Jr *American Buildings and Their Architects*, vol. 1, *The Colonial and Neo-Classical Styles*, New York, Doubleday & Co., 1970.

Pierson, W.H. Jr *American Buildings and Their Architects*, vol. 2, *The Corporate and Early Gothic Styles*, New York, Doubleday & Co., 1978.

Platt, C. *The Architecture of Medieval Britain: a Social History*, Yale, Yale University Press, 1990.

Pope, A. U. *Introducing Persian Architecture*, Iran, Soroush Press, 1976.

Richards, J.M. *The Functional Tradition in Early Industrial Buildings*, London, Architectural Press, 1975.

Robertson, D.S. *Greek and Roman Architecture*, Cambridge, Cambridge University Press, 1969.

Rosenberg, J., Slive, S. and ter Kuile, E.H. *Dutch Art and Architecture 1600–1800*, Harmondsworth and New York, Penguin & Wiley, 1972.

Roth, L.M. *A Concise History of American Architecture*, New York and London, Icon Editions, Harper & Row, 1979.

Russell, F. (ed.) *Art Nouveau Architecture*, London, Academy Editions, 1983.

Saint, A. *Towards a Social Architecture: the Role of School Building in Post-War England*, London and New Haven, Yale University Press, 1987.

Service, A. *Edwardian Architecture*, London, Thames & Hudson, 1977.

Sickman, L. and Soper, A. *The Art and Architecture of China*, Harmondsworth and New York, Penguin & Wiley, 1971.

Smith, W.S. *The Art and Architecture of Ancient Egypt*, Harmondsworth and New York, Penguin & Wiley, 1981.

Stewart, D.B. *The Making of a Modern Japanese Architecture 1868 to the Present*, Tokyo and New York, Kodansha International, 1988.

Stillman, D. *English Neo-classical Architecture*, 2 vols, London, Zwemmer, 1988.

Summerson, Sir J. *Architecture in Britain 1530–1830*, Harmondsworth, Penguin, 1983.

Summerson, Sir J. *The Architecture of the Eighteenth Century*, London, Thames and Hudson, 1986.

Susuki, H., Banham, R. and Kobayashi, K. *Contemporary Architecture of Japan 1958–1984*, London, Architectural Press, 1985.

Tadgell, C. *The History of Architecture in India: from the Dawn of Civilization to the End of the Raj*, London, Architecture, Design and Technology Press, 1990.

Tafuri, M. *History of Italian Architecture 1944–1985*, Cambridge, Mass. and London, MIT Press, 1991.

Tarn, J.N. *Five Per Cent Philanthropy: an Account of Housing in Urban Areas Between 1840–1914*, Cambridge, Cambridge University Press, 1973.

Torre, S. (ed.) *Women in American Architecture: a Historic and Contemporary Perspective*, New York, Whitney Library of Design, 1977.

Tzonis, A. and Lefaivre, L. *Classical Architecture: the Poetics of Order*, Cambridge, Mass. and London, 1986.

Tzonis, A. and Lefaivre, L. *Architecture in Europe Since 1968*, London, Thames & Hudson, 1992.

Walker, L. (ed.) *Women Architects: Their Work*, London, Sorella Press, 1984.

Ward-Perkins, J. *Roman Imperial Architecture*, Harmondsworth, Penguin, 1981.

Ward-Perkins, J. *Roman Architecture*, London, Faber, 1988.

Watkin, D. *English Architecture: a Concise History*, London, Thames & Hudson, 1979.

Watkin, D. *The English Vision: the Picturesque in Architecture, Landscape and Garden Design*, London, John Murray, 1982.

Watkin, D. *A History of Western Architecture*, London, Lawrence King, 1992.

Watkin, D. and Mellinghoff, T. *German Architecture and the Classical Ideal 1740–1840*, Cambridge, Mass., MIT Press, 1987.

Whiffen, M. and Koeper, F. *American Architecture 1607–1976*, London and Henley, Routledge & Kegan Paul, 1981.

Wit, Wim de (ed.) *The Amsterdam School: Dutch Expressionist Architecture 1915–1930*, Cambridge, Mass. and London, MIT Press, 1983.

Wittkower, R. *Palladio and English Palladianism*, London, Thames & Hudson, 1989.

Appendix III

Useful addresses

International organisations

Europa Nostra, Federation for the Protection of Europe's Architecture and National Heritage, 35 Langvoorhout, 2514EC The Hague, Netherlands
International Council on Monuments and Sites (ICOMOS), 75 rue du Temple, 75003 Paris, France
Union Internationale des Architectes (UIA), 51 rue Raynouard, 75016, Paris, France

Algeria

Union of Architects, BP100, Code 16050, Kouba, Algiers

Argentina

Federation of Architects, Achaval Rodrigues 50, Nueva Cordoba 5000, Cordoba

Australia

Museums Association of Australia, 659 Harris Street, Ultimo, NSW
National Trust of Australia, Observatory Hill, Sydney, NSW
National Trust of Queensland, Box 1494 GPO, Brisbane, Queensland 4001
National Trust of South Australia, Ayers House, 288 North Terrace, Adelaide, South Australia 500
National Trust of Tasmania, PO Box 711, Launceston, Tasmania 7250
National Trust of Victoria, Tasma Terrace, Parliament Place, Melbourne, Victoria 3002
National Trust of Western Australia, Old Perth Boys' School, St George's Terrace, Perth, Western Australia
Royal Australian Institute of Architects, 2 Mugga Way, Red Hill, Canberra, ACT 2603
Town and Country Planning Association, Red Ridge Road, Scotts Creek, South Australia 5000

Austria

Bundesingenieurkammer, Bundesfachgruppe-Architekten, Karlsgasse 9, A-1040 Vienna

Bahamas

Institute of Bahamian Architects, PO Box 1937, Nassau

Bangladesh

Institute of Architects, GPO Box 3281, House No. 51, Road No. 5, Dacca 2

Barbados

Institute of Architects, The Professional Centre, Noranda, Collymore Road, St Michael

Belgium

Fédération Royale des Sociétés d'Architectes de Belgique, 21 rue Ernest Allard, Brussels 1000
Fondation pour l'architecture, 55 rue de l'Ermitage, Brussels

Bermuda

Institute of Bermuda Architects, PO Box HM2230, Hamilton 5

Bolivia

Colegio de Arquitectos, Casilla de Correo 8083, Av. 16 de Julio 1490, 5 Piso, La Paz

Botswana

Botswana Institute of Development Professions, PO Box 827, Gabarone

Brazil

Instituto des Arquitectos, rua Bento Freitas 306, 4#CEP 01221, São Paulo

Brunei

Pertubuhan Ukur Jurutera Arkitek Brunei, PO Box 577, Bandar Seri Begawan, Brunei Darussalam

Bulgaria

Union des Architectes, 3 rue Evlogui Guergiev, 1504 Sofia

Burma

Society of Architects, 186 Phayre Street, Rangoon

Cameroon

Ordre des Architectes, BP 926, Yaoundé

Canada

Canadian Centre for Architecture, 1920 rue Baile, Montreal
Heritage Canada Today, PO Box 1358, Stn B, Ottawa, Ontario
Royal Architectural Institute of Canada, 55 Murray Street, Suite 330, Ottawa
2327175

Central America

Federacion Centroamericana de Arquitectos, 0 Calle 15–70, Coloniz El Maestro,
Guatemala

Chile

Colegio de Arquitectos de Chile, Casila 13377 – Alemeda O'Higgins 115, Santiago
de Chile

China

Architectural Society of the People's Republic of China, Pai Wang Chuang, West
District, Beijing

Colombia

Sociedad Colombiana de Arquitectos, Carrera 6a 26–85 2 Piso, Apdo Aero 27765
Bogota

Commonwealth of Independent States

Union of Architects, 3 Chtchousseva Road, Moscow K1

Costa Rica

Colegio de Ingenieros y Architectos, PO Box 120, San Jose

Cuba

Union Nacional de Arquitectos e Ingenieros, Humholdt N 104, Esquina Infanta,
Vendada, Havana

Cyprus

Cyprus Civil Engineers and Architects Association, Anis Kominis 12, PO Box 1825,
Nicosia
Kibris Turk Muhendis Ve Mimar, Odalari Birligi 1 Sehit Ibrahim Ali Sok, Lefkosa,
Mersin 10

Czech Republic

Society of Architects, Letenska 5, 11845 Prague 1

Denmark

Danske Arkitekters Landsforbund, Bredgade 66, 1260 Copenhagen K

Dominican Republic

Colegio Domincano de Ingenieros y Arquitectos, Calle Padre Billini 58, Zona Colonial, Aptdo 1514, Santo Domingo

Egypt

Society of Architects, 30 26 July Street, PO Box 817, Cairo

El Salvador

Asociacion de Ingenieros y Arquitectos, 75a Avenida Norte, 632, San Salvador

Ecuador

Colegio Nacional de Arquitectos, Casilla 7261, Nunez de Vela 500, Sector Inaquito, Quito

Ethiopia

Association of Engineers and Architects, PO Box 53–08, Addis Ababa

Fiji

Association of Architects, 21 Desvoeux Road, PO Box 1015, Suva

Finland

Association of Architects, Etelaesplanadi 22A, SF-001 30 Helsinki
Museum of Finnish Architecture, Kasarmikatu 24, Helsinki

France

Académie d'Architecture, Hotel de Chaulnes, Place des Vosges, Paris
Association Nationale pour la Protection des Villes d'Art, 39 Avenue de la Motte-Piquet, Paris 75007
Centre d'Architecture, Pavillon de l'Arsenal, 21 Boulevard, Morland, Paris 4e
Centre de Création Industrielle, Centre Georges Pompidou, Paris 75191
Conseil National de l'Ordre des Architectes, 7 rue de Chaillot, Paris 75016
Institut Français d'Architecture, 6 rue Tournon, Paris 75006
Société pour la Protection des Paysages, Sites et Monuments, 39 Avenue de la Motte-Piquet, Paris 75007
Vieilles Maisons Françaises, 93 rue de l'Université, Paris 75007

Gabon

Ordre des Architectes, PO Box 872, Libreville

Germany

Bauhaus Archiv, Museum für Gestaltung, Klingelhoferstrasse 13–14, D 1000, Berlin 30
Bund Deutscher Architekten, Ippendorfer Allee 14b, 5300 Bonn
Deutsches Architekturmuseum, Schmainkai 43, Frankfurt
Deutscher Heimatbund, Simrockstrasse, 5300 Bonn 1
German Federation for Housing and Planning, Suebenstrasse 1, 5300 Bonn 2
German Architects and Engineers Association (DAI), Theatreplatz, 5300 Bonn 2
Werkbund Archiv, Schlossstrasse 1, 1 Berlin 19

Ghana

Institute of Architects, PO Box M272, Accra

Gibraltar

Society of Architects, 23 Sunnyside House, Naval Hospital Road, Gibraltar

Greece

Association of Greek Architects, 3 Ipitou Street, Athens
National Trust for Greece, 31 Southampton Row, London, WC1B 5HW

Guatemala

Colegio de Arquitectos, 7a Calle A, 7–11 Zona 9

Guernsey

Society of Architects, Roseneath, Grange, St Peter Port

Guyana

Society of Architects, PO Box 10606, Georgetown

Hong Kong

Institute of Architects, 15th Floor, Success Commercial Building, 245–251 Henessy Road, Wanchai

Hungary

Magyar Epiteszek Kamaraja es Dienes Laszlo u 2, 1088 Budapest VIII

Iceland

Arkitektafelag Islands Freyjugotu 41, 101 Reykjavik

India

Indian Institute of Architects, Prospect Chambers Annex, 3rd Floor, Dr D.N. Road Fort, Bombay 400 001

Indian National Trust for Art and Cultural Heritage, 71 Lodhi Estate, New Delhi
110003

Indonesia

Institute of Architects, J1 Raya Pasar, Minggu KM16 Pancoran, Jakarta 12780

Iran

Society of Iranian Architects, 584 Pahlavi Avenue, Tehran

Iraq

Union of Iraqi Engineers, Committee of Architects, Mansoor, Baghdad

Ireland

Irish Georgian Society, Leixlip Castle, Leixlip, Co. Kildare
Irish Architectural Archive, 73 Merrion Square, Dublin 2
National Trust for Ireland, Tailor's Hall, Back Lane, Dublin, 8
Royal Incorporation of Architects of Ireland, 8 Merrion Square, Dublin 2

Israel

Association of Engineers and Architects, 200 Dizengoff Road, PO Box 3082, Tel
Aviv 63462

Italy

Associazione Nazionale Ingegneri ed Architetti Italiani, 24 Piazza Sallustio, 00187
Rome
International Centre for the Study of the Architecture of Andrea Palladio, Domus
Comestabilis – Basilica Palladiana, CP 593, 36100 Vicenza
National Institute of Architecture, Palazzo Taverna, Via di Monte Giodana 36, 00186
Rome
National Institute of Urbanism, Via Sta Caterina da Siena 46, 00186 Rome
Italia Nostra, National Association for the Preservation of the Historical Artistic and
National Heritage of the Nation, Via Nicolo Porpora 22, 00198 Rome

Ivory Coast

Conseil National de l'Ordre des Architectes, BP 278, Abidjan 17

Jamaica

Institute of Architects, PO Box 251, Kingston 10

Japan

City Planning Institute of Japan, Building Kei 6F, 3–4 Koujimachi, Chiyoda-Ku,
Tokyo
Institute of Architects, Kenchiku-ka Kaikan, 2–3–16 Jingumae, Shibuya-ku, Tokyo
150

Jersey

Association of Jersey Architects, 21 Parade Road, St Helier

Korea (North)

Union of Architects, Jongro Junguek Street, Pyong-Yang

Korea (South)

Korean Institute of Architects, 1–117 Tonhsung-dong Chongno-gu, CPO Box 1545, Seoul

Lebanon

Order of Engineers and Architects, PO Box 113118, Beirut

Lesotho

Architects, Engineers and Surveyors Association, PO Box MS1560, Maseru 100

Luxembourg

Council of Architects and Engineers, 8 rue Jean Engling, L1466, Luxembourg

Malawi

Malawi Institute of Architects, PO Box 941, Lilongwe

Malaysia

Institute of Architects, Perturbuhan Akitek Malaysia, 4/6 Jalan Taligsi, PO Box 10855, Kuala Lumpur 2984136

Malta

Chamber of Architects and Civil Engineers, 1 Wilga Street, Paceville, St Julians

Mauritius

Society of Architects, c/o Ministry of Works, Phoenix

Mexico

Federacion de Colegios de Arquitectos de la Republica Mexicana, Av. Veracruz 24, Mexico City DF 06700

Mongolia

Union of Architects of the MPR, PO Box 4128, Ulan Bator

Morocco

Ordre des Architectes du Maroc, Washington Square, Residence Moulay Ismail – C5, Rabat

Netherlands

Bond van Nederlandse Architekten, P Bus19606, Postrekening 71518, 1006 Amsterdam
Architecture Institute, Museum Park 25, Rotterdam

New Zealand

Institute of Architects, 13th Floor, Greenock House, 102–112 Lambton Quay, PO Box 438, Wellington

Nigeria

Institute of Architects, Professional Centre, 2 Odowu Taylor Street, Victoria Island, PO Box 178, Lagos

Norway

Norske Arkitekters Landsforbund, Josefines Gate 34, 0351 Oslo 3

Pakistan

Institute of Architects of Pakistan, 36-T, Gulberg 2 Lahore

Panama

Sociedad Panamena de Ingenieros y Arquitectos, Av. Manuel Espinosa B, AP 7084, Panama 5

Papua New Guinea

Institute of Architects, PO Box 1278, Port Moresby

Peru

Colegio de Arquitectos, Apartado 5972, Av. San Felipe 99, Lima 11

Philippines

United Architects of the Philippines, Cultural Centre, Roxas Boulevard, Metro Manila

Poland

SARP, UL Foksal 2, 00959 Warsaw

Portugal

Associacão doa Arquitectos Portugueses, rue Barata Salguerio 36, Lisbon 2

Puerto Rico

College of Architects, Apartada Postal 73, San Juan 00902

Romania

Union of Architects of the Republic of Romania, 18–20 rue Academiei, 70109
Bucharest

Senegal

Ordre des Architectes, Ministère de l'Urbanisme et de l'Habitat, BP 253 Dakar

Sierra Leone

Institute of Architects, PO Box 1189, Freetown

Singapore

Institute of Architects, 20 Orchard Road, SMA House 02–00, Singapore 0923

South Africa

Institute of Architects, Northwards, 21 Rock Ridge Road, Parktown 2193, PO Box
31750, Braamfontein 2017, Johannesburg

Spain

Consejo Superior do los Colegios de Arquitectos, Paseo de la Castellana 12 4,
Madrid 28046

Sri Lanka

Institute of Architects, 120/10 Wihjorama Mawatha, Colombo 7

Sudan

Institute of Architects, Dar El Muhandis, PO Box 6147, Khartoum

Suriname

Unie van Architeken, Postbus 1857, Paramaribo

Swaziland

Association of Architects, PO Box A387, Swarzi Plaza, mba bna

Sweden

Svenska Arkitekters Riksforbund, Norrlandgatan 18, 111 43 Stockholm
Swedish Museum of Architecture, Skeppsholmen, 5–111, 49 Stockholm

Switzerland

Architekturmuseum, Pfluggasslein 3, Basel
Schweizerischer Ingenieur und Architekten Verein, Postfach 8039, Zurich

Syria

Ordre des Ingénieurs et Architectes Syriens, Amze Square, Dar Al Mouhandiseen Building, PO Box 2336, Damascus

Taiwan

National Union of Architects Association, 9F1 396 Kee-Lung Road, Section 1, Taipei 10548

Tanzania

Architectural Association, PO Box 567, Dar es Salaam

Thailand

Association of Siamese Architects, 1155 Phaholyothin Road, Bangkok 10400

Trinidad and Tobago

Institute of Architects, PO Box 585, Port of Spain, Trinidad

Tunisia

Ordre des Architectes, 11 rue de l'Arabie Saoudite, Tunis 1002

Turkey

Chamber of Architects, Konur Sokak 4, Yenisehir-Ankara

Uganda

Society of Architects, PO Box 9514, Kampala

United Kingdom

Alexander Thomson Society, 1 Moray Place, Strathbungo, Glasgow G41 2AQ
Ancient Monuments Society, St Andrew by the Wardrobe, London EC4 5DE
Architects and Surveyors Institute, 15 St Mary Street, Chippenham, Wilts, SN15 3JN
Architectural Association Inc., 34–6 Bedford Square, London WC1B 3EG
Architecture Foundation, Economist Building, 30 Bury Street, London SW1Y 6AU
Architectural Heritage Society of Scotland, 3 Barony Street, Edinburgh EH3 6NX
Art and Architecture Society, Dunsdale, Forest Row, East Sussex, RH18 5BD
Art Workers' Guild, 6 Queen Square, London WC1N 3AR
Arts Council of Great Britain, 14 Great Peter Street, London SW1P 3NQ
Avoncroft Museum of Buildings, near Bromsgrove, Worcs
Beamish Industrial Museum, Co. Durham
British Architectural Library, 66 Portland Place, London W1N 4AD
British Architectural Library, Drawings Collection, 21 Portman Square, London W1H 9HP
British Association for Local History, Shopwyke Hall, Chichester, West Sussex, PO20 6BQ
British Library, Great Russell Street, London WC1

Brooking Collection Trust, Woodhay House, White Lane, Guildford, Surrey, GU4 8PU

Building Centre, 26 Store Street, London WC1E 7BS

Buildings Special Interest Group, Institute of Field Archaeologists, University of Liverpool, Department of Archaeology, 12 Abercromby Square, Liverpool L69 3BX

Business Archives Council, 185 Tower Bridge Road, London SE1 2UF

Cathedral Architects' Association, Harcourt Office, Hemmingford Grey, Huntingdon, Cambs, PE18 9BJ

Charles Rennie Mackintosh Society, Queen's Cross, 870 Garscube Road, Glasgow G20 7EL

Chiltern Open Air Museum, Chalfont St Giles, Bucks

Civic Trust, 17 Carlton House Terrace, London SW1Y 5AW

Construction History Society, The Chartered Institute of Building, Englemere, Kings Ride, Ascot, Berks, SL5 8BJ

Council for British Archaeology, 112 Kennington Road, London SE11 6RE

Country Houses Association Ltd, 41 Kingsway, London WC2 6UB

Documentation and Conservation of the Modern Movement, DOCOMOMO, Shoreditch Studio, 44–6 Scruton Street, London EC2A 4HH

Ecological Design Association, 20 High Street, Stroud, Glos, G15 1AS

English Heritage, Fortress House, 23 Savile Row, London W1X 2JQ

European Vernacular Architecture Research Unit, London Guildhall University, 117 Houndsditch, London EC3A 7BU

Folly Fellowship, 21 Kent's Green, Kingswood, Bristol BS15 1XU

Fortress Study Group, Carfax Publishing Co., PO Box 25, Abingdon, Oxon, OX14 3UE

Georgian Group, 37 Spital Square, London E1 6DY

Historic Houses Association, 2 Chester Street, London SW1X 7BB

Historical Association, 59A Kennington Park Road, London SE11

Historical Geography Research Group, Department of Geography, University College, London, 26 Bedford Way, London WC1H OAP

Ironbridge Institute, Ironbridge Gorge Museum, Ironbridge, Salop, TF8 7AW

Institution of Civil Engineers, Great George Street, London SW1P 3AA

International Planning History Society, Department of Civic Design, University of Liverpool, PO Box 147, Liverpool L69 3BX

Ironbridge Gorge Museum, Ironbridge, Salop

Lutyens Trust, Goddards, Abinger Common, Dorking, Surrey

Men of the Stones, The Rutland Studio, Tinwell, Stamford, Lincs, PE9 3UD

National Monuments Record Centre, Kemble Drive, Swindon SN2 2GZ

National Register of Archives, Quality Court, Chancery Lane, London WC2 1HP

National Trust, 36 Queen Anne's Gate, London SW1 9AS

National Trust for Scotland, 5 Charlotte Square, Edinburgh EH2 4DU

Public Record Office, Ruskin Avenue, Kew, Surrey, TW9 4DU

Pugin Guild, 157 Vicarage Road, London E10 5DU

Regency Society of Brighton and Hove, 38 Prince Regent's Close, Brighton BN2 5JP

Royal Archaeological Institute, c/o Society of Antiquaries, Burlington House, Piccadilly, London W1VC 0HS

Royal Commission on Historical Monuments (England), Fortress House, Savile Row, London W1X 2JQ

Royal Incorporation of Architects in Scotland, 15 Rutland Square, Edinburgh EH1 2BE

Royal Institute of British Architects, 66 Portland Place, London W1N 2AD

Royal Society of Ulster Architects, 2 Mount Charles, Belfast BT7 1NZ

Scottish Society for Conservation and Restoration, Glasite Meeting House, 33 Barony Street, Edinburgh EH3 6NX

Society for the Protection of Ancient Buildings, 37 Spital Square, London E1 6DY

Society of Antiquaries, Burlington House, Piccadilly, London W1V 0HS

Society of Architectural Historians, Brandon Mead, 9 Old Park Lane, Farnham, Surrey, GU9 0AJ

Thirties Society, *see* Twentieth Century Society

Town and Country Planning Association, 17 Carlton House Terrace, London SW1Y 5AW

Twentieth Century Society, 70 Cowcross Street, London EC1M 6DR

Ulster Folk and Transport Museum, Cultra, near Holywood, Co. Down, N. Ireland

Vernacular Architecture Group, 16 Falna Crescent, Coton Green, Tamworth, Staffs, B79 8JS

Victorian Society, 1 Priory Gardens, London W4 1TT

Weald and Downland Open Air Museum, Singleton, near Chichester, West Sussex

Welsh Folk Museum, St Fagans, near Cardiff, South Glamorgan CF5 6XB

William Morris Society, Kelmscott House, London W6 9TA

Women's Design Service, Johnson's Yard, 4 Pinchin Street, London E1 1SA

United States of America

American Institute of Architects, 1735 New York Avenue, NW Washington DC 20006

American Planning Association, 1776 Massachusetts Avenue, NW Washington DC 20036

American Society of Civil Engineers, 345 East 47th St, New York, NY 10017

American Society of Landscape Architects Inc., 1733 Connecticut Avenue, NW Washington DC 20009

Art Institute of Chicago, Michigan Avenue, Adams Street, Chicago, Illinois 60603

Asphalt Institute, Asphalt Institute Building, College Park, Maryland 20740–182

Building Research Board, 2101 Constitution Avenue, NW Washington DC 20418

Center for Communal Studies, University of Southern Indiana, Evansville, Indiana 47712

Colonial Williamsburg Foundation, PO Box 1776, Williamsburg, Virginia 23187–1776

Cooper-Hewitt National Museum of Design, Smithsonian Institution, 2 East 91st Street, New York, NY 10128

Frank Lloyd Wright Foundation, Taliesin West PO Box 4430, Scottsdale, Arizona, 85261

Frank Lloyd Wright Home and Studio Foundation, 951 Chicago Avenue, Oak Park, Illinois 60302

Getty Conservation Institute, 4503 Glencoe Avenue, Marina del Rey, California 90292–6537

Henry Ford Museum and Greenfield Village, 20900 Oakwood Boulevard, PO Box 1970, Dearborn, Michigan 48121

Illinois State Museum, Springfield, Illinois 62706

Library of Congress, National Archives Building, 8th Street, Pennsylvania Avenue, NW Washington DC 20408

National Museum of the American Indian, Smithsonian Institution, 3753 Broadway at 155th Street, New York, NY 10032

National Trust for Historic Preservation, 1785 Massachusetts Avenue, NW Washington DC 20036

Society of Architectural Historians, 1232 Pine Street, Philadelphia, PA 19107–5944

Urban Institute, 2100 M St, NW Washington, DC 20037
Urban Land Institute, 1090 Vermont Avenue, NW, Third Floor, Washington DC
 20005

Uruguay

Sociedad de Arquitectos, Casilla de Correo, 176, Montevideo

Venezuela

Colegio de Arquitectos, Apartao 781480 La Urbina, Sector North 1070 A Caracas

Vietnam

Union Des Architectes, 23 bid Dinh Tien Hoang, Hanoi

Zaire

L'Ordre des Architectes, BP 3657, Kinshasa-Gombe

Zambia

Institute of Architects, PO Box 34730, Lusaka

Zimbabwe

Institute of Architects, Riembata, PO Box 3592, 256 Samora Machel Avenue East,
 Harare

Index